PATRICK HENRY BRUCE: AMERICAN MODERNIST

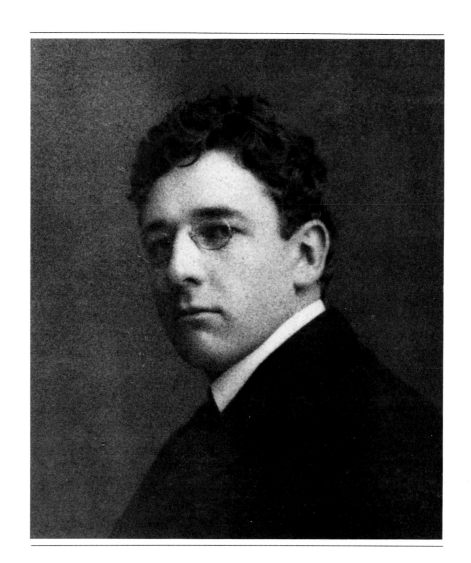

PATRICK HENRY BRUCE
AMERICAN MODERNIST

A CATALOGUE RAISONNE

WILLIAM C. AGEE & BARBARA ROSE

THE MUSEUM OF MODERN ART/NEW YORK AND

THE MUSEUM OF FINE ARTS/HOUSTON

To Elita Agee and Jerry Leiber

Copyright © 1979 by The Museum of Modern Art/All Rights Reserved

Library of Congress Catalog Card Number 79-64632

Clothbound ISBN 0-87070-259-9/Paperbound ISBN 0-87070-260-2

Designed by Nora Sheehan

Type Set by Boro Typographers, Inc., New York, N.Y.

Printed by The Arts Publisher, Inc., New York, N.Y.
with W. M. Brown & Son, Inc., Richmond, Va.
Bound by Sendor Bindery, New York, N.Y.

Printed in the United States of America

This book and the exhibition it accompanies have been made possible
by a grant from the National Endowment
for the Arts in Washington, D.C., a federal agency

Frontispiece: Patrick Henry Bruce, c. 1901–02

The Museum of Modern Art, 11 West 53 Street, New York, New York 10019

The Museum of Fine Arts, Houston, 1001 Bissonnet, Houston, Texas 77005

CONTENTS

LIST OF COLOR PLATES

ACKNOWLEDGMENTS

WE HAVE so many to thank who have helped us in the difficult task of assembling this retrospective exhibition, which is also Patrick Henry Bruce's first one-man show, that we could not possibly acknowledge adequately all who have made this project possible. First, we wish to thank the generous lenders to the exhibition. Only their willingness to share their paintings has enabled us to bring together for the first time the full range of Bruce's work. We are particularly grateful to Alan Shestack, Director of the Yale University Art Gallery, for permitting us to borrow the fragile Compositions in the Société Anonyme collection.

Without the support and encouragement of William Rubin, Director of the Department of Painting and Sculpture of The Museum of Modern Art, our efforts could not have come to fruition. We also wish to thank John Elderfield, Curator of Painting and Sculpture of The Museum of Modern Art, and Dr. Peter Mooz, Director, and Frederick Brandt, Associate Curator of the Virginia Museum for their kind cooperation and collaboration.

For many years, we were virtually alone in our conviction of Bruce's greatness. Without the constant aid and sustaining enthusiasm of Benjamin Franklin Garber, the person most responsible for the preservation of Bruce's oeuvre, the memory of Patrick Henry Bruce would not have endured through the long years of neglect of his work. As Henri-Pierre Roché was Bruce's sole supporter during his lifetime, Mr. Garber uniquely carried on Roché's mission, collecting materials and paintings and encouraging research on Bruce. His interviews with Bruce's widow, Helen Bruce, provided us with invaluable documentation and clues for further investigation.

We are also especially grateful to Bruce's son, Roy Bruce, and his niece, Virginia Payne Ahrens, for their generous help in reconstructing Bruce's career. With the aid of the artist's address book, loaned to us by Mrs. Ahrens, we were able to pick up a trail that had nearly grown cold with the passing years. Others who provided vital information were Marguerite Matisse Duthuit, Pierre Matisse, Sonia Delaunay, Céline Fildier, Michel Seuphor, and Charles Ratton. We also wish to express our gratitude to Mme X, who prefers to remain anonymous, who shared Bruce's last eight years and was able to give us insights, documents, and photographs that permitted us to know, for the first time, exactly what happened to Bruce when he disappeared from the art world.

Our special thanks also go to Kenneth Cook of South Boston, Virginia, and Mr. and Mrs. Charles W. Porter III, of Woodside, Henrico County, Virginia, friends of the Bruce family who provided material for Bruce's early years that was immensely helpful to us. Carlton Lake, Acting Director, Humanities Research Center, University of Texas at Austin, was extremely generous in sharing archival material with us; and we are most grateful to François Truffaut for permitting us to read the Journals of Henri-Pierre Roché in Paris. Mr. and Mrs. Henry M. Reed of Montclair, N.J., kindly made available and permitted us to use the very important correspondence of Arthur B. Frost, Jr., and his family.

Linda Nelson, Librarian of The Museum of Fine Art, Houston, deserves our particular gratitude for her tireless and meticulous research in the compilation of the *catalogue raisonné* as well as of the documents and essays. Edward Mayo and Ann Feltus, as well as Connie Malone and Karen Bremer, also of The Museum of Fine Arts, Houston, gave much assistance in the myriad details of the catalogue and exhibition.

Our research assistants, Laura Giles, Katherine Solomonson, and Susan Putterman, helped in the difficult task of collating a huge amount of material. In Paris, Monique Nonne did a superb job of researching French sources. We would also like to thank our friends Hèléne and Josué Seckel and Joan Washburn for their help. Others who have aided us in our search for Patrick Henry Bruce include Gail Levin, Donald Karshan, Brenda Richardson, Flora Irving, Milton Brown, Nini Ohman of the Moderna Museet, Eleanor Apter of the Société Anonyme collection, Jeanette Flam of the University of Pennsylvania Museum, John R. Lane, Hélène Lamp of the Museeum voor het Vlaamse Culturleven, and Robert Reeves Solenberger, who generously provided information regarding his uncle, Harrison Reeves.

We have been fortunate to work with the superb staff of the Department of Publications of The Museum of Modern Art, which is producing this book in conjunction with The Museum of Fine Arts, Houston. Martin Rapp, Tim McDonough, Susan Weiley, and Nora Sheehan have all shared our enthusiasm and have provided invaluable assistance at every turn.

To Elita Agee and Jerry Leiber, and to our children, who heard more about Patrick Henry Bruce than perhaps they cared to, must go our greatest and lasting gratitude for their extraordinary patience and tolerance.

WILLIAM C. AGEE and BARBARA ROSE

PATRICK HENRY BRUCE: AMERICAN MODERNIST

THIS *catalogue raisonné* of the American Cubist Patrick Henry Bruce (1881–1936), the fruition of many years of research, is the result of our shared commitment to giving Bruce the place he merits in the history of art. When Bruce, a direct descendant of his namesake Patrick Henry, committed suicide in New York City on November 12, 1936, he was completely unknown. Yet he had been an intimate of Gertrude and Leo Stein, the student of both William Merritt Chase and Robert Henri, and the organizer (with Sarah Stein) of Matisse's school, as well as the friend of fellow Americans Edward Hopper and Man Ray. He had lived above Matisse's apartment, loaned Picasso money, and was "like family" to Sonia and Robert Delaunay.[1] He visited the ateliers of Picabia, Man Ray, Lipchitz, Derain, Brancusi, Léger, Chagall, and the other masters of the School of Paris, was admired by Duchamp, and regularly exhibited in both the Salon d'Automne and Salon des Indépendants, as well as in the historic 1913 avant-garde "Erster Deutscher Herbstsalon."[2]

When we began our search for Patrick Henry Bruce, we had many questions, not the least of which was why this man—so esteemed by his contemporaries—had dropped completely out of sight. At the outset, we had little idea what he looked like or why he destroyed his papers, most of his paintings, and finally himself. One reason we found it difficult to locate Bruce in group photographs was because we were looking for the wrong man. For every time Bruce changed his style, he changed himself as well. From the bearded, plump, Bohemian young man Marguerite Duthuit remembers from her father's class, he became a svelte, clean-shaven dandy. Our quest took us to two continents and four countries, and eventually the trail led us to eight more countries. Because we began with fragments, clues, leads, and intuition, our work was often more like sleuthing or solving a jigsaw puzzle than

traditional art history. Our detective work required comparing notes and making deductions. We have been fortunate in our collaboration, which enabled us to come to mutual conclusions regarding Bruce's chronology, his working methods, and the reconstruction of his oeuvre. They are the result of our joint efforts, a few scattered documents, and interviews with those surviving friends and relatives who remember Bruce. We needed the corroboration of our collaboration because so much about Bruce was a mystery. As we quickly found, we were dealing with a taciturn, self-effacing, antisocial personality who became more and more withdrawn from the world, his family, and finally any colleagues, and who did his best to leave this world without a trace. For the few close to him, he was unforgettable, "un homme parfait, trop parfait," according to one friend;[3] but for most, even those artists like Marcelle Cahn and Florence Henri, who exhibited with him, there were either dim souvenirs or no memory at all of this enigmatic scion of one of America's oldest and most illustrious families, who sailed for Europe in late 1903 and eventually returned to the United States only to end his life at the age of fifty-five.

Our work was further complicated by the many errors in the existing meager literature. For example, although Bruce died on November 12, 1936, the date of his death was always given—and often continues to be—as 1937, until 1965 when William C. Agee located his death certificate in the New York City files. Since after 1905 Bruce never dated his paintings, which he also stopped signing after 1916, virtually all the dates assigned the works have had to be constantly reconsidered in the light of new information. Dating the late works was a particular problem because it seemed unlikely, if not impossible, that an American painter could have anticipated the development of a classicizing Cubism before the twenties. Yet we have found documents that prove Bruce was

painting his architectural still lifes at least as early as 1918, and that these paintings were seen in the avant-garde salons and exerted an influence on other artists.

Nor has Bruce's relationship to Synchromism been clarified, though it is as a so-called Synchromist that he has won whatever recognition he has had. Bruce certainly knew Morgan Russell, a fellow student at the Matisse school, and perhaps even Stanton Macdonald-Wright, but he neither considered himself a Synchromist nor subscribed to their theories, neither exhibited with them nor gave any of his paintings Synchromist titles. Nevertheless, of the group of young American painters in Paris that included Russell, Macdonald-Wright, and Bruce's close friend Arthur B. Frost, Jr., among others—artists who were interested in the idea of combining Fauve color with Cubist structure—only Bruce was in daily contact with Robert and Sonia Delaunay, the leading theoreticians of Orphic Cubism.

Although Bruce's work first became more widely known through the exhibition "Synchromism and Color Principles in American Painting, 1910–1930," organized by William C. Agee in 1965 at M. Knoedler and Co., Inc., he never allied himself with any school, even unofficially. On the contrary, he broke with one teacher after another, ultimately renouncing Delaunay as well, to go his own way in search of a personal and unique style that is an original contribution to Cubism as well as to color abstraction. In his final search for the "absolute," Bruce came to reject much that he was taught and practically everything he saw, preferring to spend his time studying the Old Masters at the Louvre rather than talking art at the cafés of Montparnasse that he frequented during his youth. A demanding artist to begin with, he became ever more demanding both of himself and of others.

Because he stopped exhibiting in 1930 and left Paris in 1933, sending the few paintings he had not destroyed to his friend the novelist Henri-Pierre Roché, it has been presumed that Bruce stopped painting in 1933. However, new information has established that in fact Bruce continued to paint, and that when he sailed for America on July 29, 1936, he took with him a roll of twenty paintings in his late geometric style.[4] In addition, although we know that Bruce destroyed many works (some of which, fortunately, we may reconstruct from photographs), there was some confusion about the exact number of paintings that remained, because in the published version of Roché's text on Bruce, the number he sent to Roché in 1933 was given as fifteen.[5] Roché divided Bruce's oeuvre into three "manners": the early Fauve-Cézannesque style, the Futurist middle period, and the final "third manner" of Cubist still lifes based on architectural themes. Of the first period, we have recovered some seventy paintings, some brought to America on a roll by Bruce's wife, Helen, on a trip to the United States in 1911. Among these early works are his Armory Show entries and the paintings that he exhibited in 1916 at the Montross Gallery and that remained in the United States. The six Compositions purchased by Katherine Dreier, five of which are now in the Société Anonyme Collection at Yale, and the other now in the collection of The Museum of Fine Arts, Houston, are all that remain of Bruce's "second manner." For although he painted at least a dozen canvases as large as Morgan Russell's famed Synchromy in Orange: To Form, we can only speculate on these big Orphist paintings, since Bruce destroyed them all. As for the "third manner," we have located not "a few," fifteen, or twenty-one paintings as Roché variously indicated,[6] but twenty-five still lifes in the geometric architectural style, all of which appear to have come originally from Roché. And of course there is still the unanswered question of the disposition of the twenty canvases painted between 1933 and 1936 that Bruce brought back to America with him.

These are not the only problems that remain to be resolved. There is the argument over whether Bruce actually finished the majority of his late paintings. We believe that since these are the canvases he himself chose to preserve, editing his oeuvre himself (just as he controlled every square inch of the picture surface) instead of allowing the selective historical processes to operate normally, we are indeed dealing with finished works in every sense of the word. He had actually established the precedent earlier, since a great number of his paintings of 1908-12 are "unfinished" to one degree or another, but all carry his signature. In his essay on Cézanne in the catalogue *Cézanne: The Late Work,* William Rubin discusses the problem of the *non-finito* and concludes that those late paintings in which parts of the canvas are left bare fulfill Cézanne's intent[7] and that indeed they do represent finished works. Throughout his life, from his early student years in Paris until his death, Cézanne, and not his own teacher, Matisse, whom he came to regard somewhat critically, was Bruce's principal model. He was well acquainted with Cézanne's late works, in which areas of canvas are left primed but unpainted, and we believe he took these, specifically the sober, monumental still lifes, as an example of the repetition of a single motif in search of an absolute. As Cézanne and Monet (whom he also greatly admired) worked in series, so did Bruce.

Besides Cézanne's well-known example, there is the entire art historical tradition of the sketch and the unfinished picture—the *esquisse* and the *ébauche,* which in the nineteenth century came to be seen as ends in themselves. When Bruce was young, he sought spontaneity in rapidly executed *alla prima* oil sketches done from nature; later in his life he preserved freshness by leaving areas of the canvas bare in carefully plotted compositions that were as much the result of mental construction as of direct observation. That these paintings are finished we have no doubt.

In fact, new information regarding Bruce's working habits leads us to conclude that the paintings entirely covered with paint were perhaps in some cases considered relatively unsuccessful by Bruce, who, in his quest for perfection, would redraw and then repaint virtually the same composition on another canvas.

Bruce stopped exhibiting because he believed his work could not be understood in his own time. He was right. Close to a half century has passed and his work still has not taken its proper place in the canon of modernism. Not until the sixties could anyone, save Roché, Katherine Dreier, Man Ray, Marcel Duchamp, and Michel Seuphor, fully appreciate the radicality and originality of Bruce's contribution. A few artists, most notably Frank Stella and Ron Davis, saw the Bruces in the Agee exhibition and were able to respond to them because they were working in related styles. Barbara Rose was in the process of writing *American Art Since 1900* at the time, and she completely revised the book to incorporate Agee's findings and publish a Bruce painting (recently acquired by The Museum of Modern Art) in color.[8]

Since that time it has been the authors' wish to see all the extant Bruce paintings exhibited together and correctly catalogued so that his art may be properly assessed. During the course of our collaboration, we have reached joint conclusions, including our fundamental belief that had Bruce left anything more than a fragment of an oeuvre (barely 100 paintings remain), he would long before now have been considered one of the masters of twentieth-century art. As it is, the originality of his contribution has led us to believe that toward the end of his life he ultimately influenced Matisse, his former teacher. For although he learned from Matisse the fundamentals of color usage, including black and white, Bruce's new interpretation of the refined pastel harmonies of pale blues and pinks antedates Matisse's studies for the Barnes Collection murals, in which the juxtaposition of pink and

blue is used to such exquisite effect. That Bruce was on Matisse's mind when he was planning the murals for Dr. Barnes is documented by the recollections of George L. K. Morris, who met Matisse on a train in January 1931, when Matisse was returning to France after having studied the projected location of his murals. Over a long meal on the boat train, Matisse asked Morris if he "knew the work of the American painter Patrick Henry Bruce, who had been among his pupils." Morris said he had seen a few paintings but had found them dry. "That doesn't make any difference," Matisse snapped.[9]

On December 16, 1948, Henri-Pierre Roché wrote Katherine Dreier: "I wish someday there should be somewhere a general show of what is left of his last periods (including the one you have). If he was not so unknown we could start a small society of 'friends of Patrick Bruce.' But he would not have accepted the word 'friends.' "[10] As we continue our search—which is far from complete—for the man who for so many years has fascinated and eluded us, we welcome others to join our growing society of the "friends of Patrick Henry Bruce."

WILLIAM C. AGEE and BARBARA ROSE

NOTES:
1. Sonia Delaunay, interview with Barbara Rose, Paris, April 1978, and Céline Fildier, interview with Barbara Rose, Paris, February 1979.
2. Gabrielle Buffet-Picabia, interview with Monique Nonne, Paris, February 1979; Helen Bruce to B. F. Garber, in conversation, 1958-60.
3. Letter from Céline Fildier to Mary Bruce Payne, November 26, 1936, courtesy of Roy Bruce.
4. Céline Fildier, a friend of Bruce's sister, Mary Payne, has provided much new information regarding Bruce's last years. Interview with Barbara Rose, Paris, February 1979.
5. "Memories of P. Bruce," a statement prepared in 1938 and corrected in 1948 by Roché, at Katherine Dreier's request, for the Société Anonyme catalogue, Yale University (see "Documents," p. 224).
6. Ibid.
7. William Rubin, "Cézannisme and the Beginnings of Cubism," Cézanne: The Late Work (New York: The Museum of Modern Art, 1978), pp. 151-202.
8. Barbara Rose, American Art Since 1900 (New York: Praeger, 1967).
9. George L. K. Morris, "A Brief Encounter with Matisse," Life, vol. 69 (August 28, 1970), pp. 44-46.
10. Letter from Roché to Katherine Dreier, collection of Société Anonyme, Yale University.

DOCUMENTARY PHOTOGRAPHS

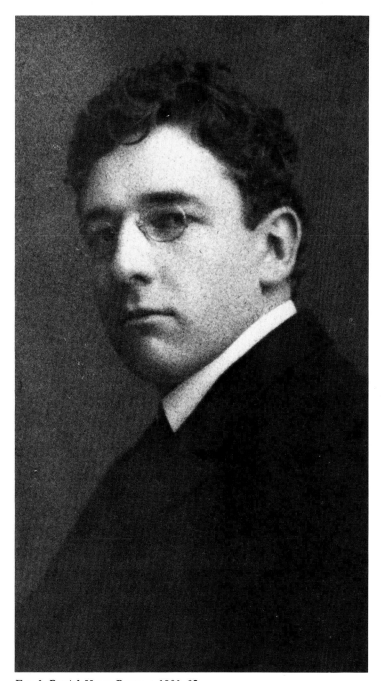

FIG. 1. *Patrick Henry Bruce, c. 1901–02.*

FIG. 2. *Berry Hill, near South Boston, Halifax County, Virginia.*

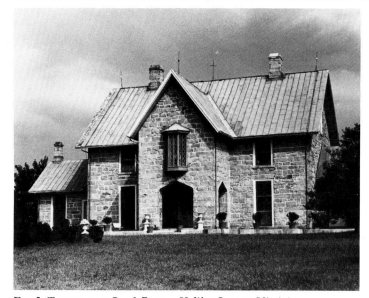

FIG. 3. *Tarover, near South Boston, Halifax County, Virginia.*

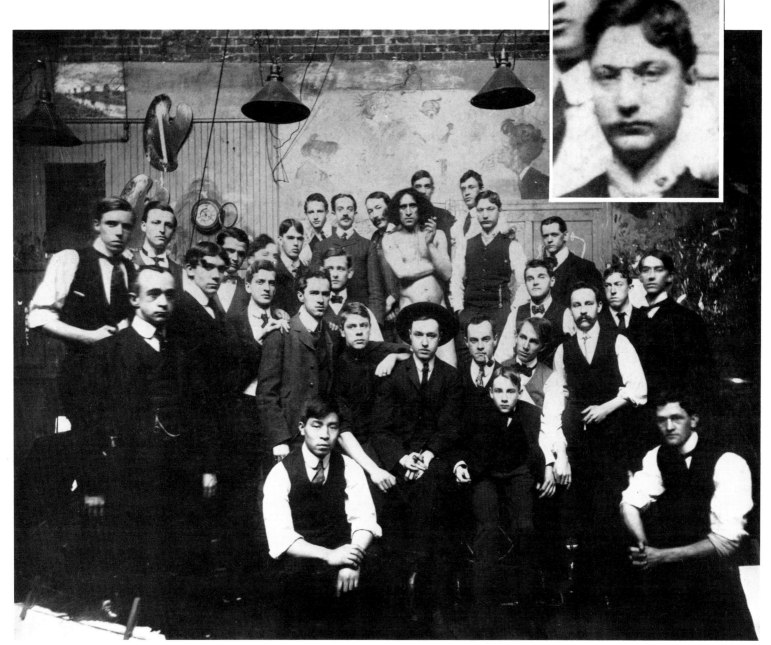

FIG. 4. *Henri class, February 9, 1903 (Bruce is at right of nude model).*

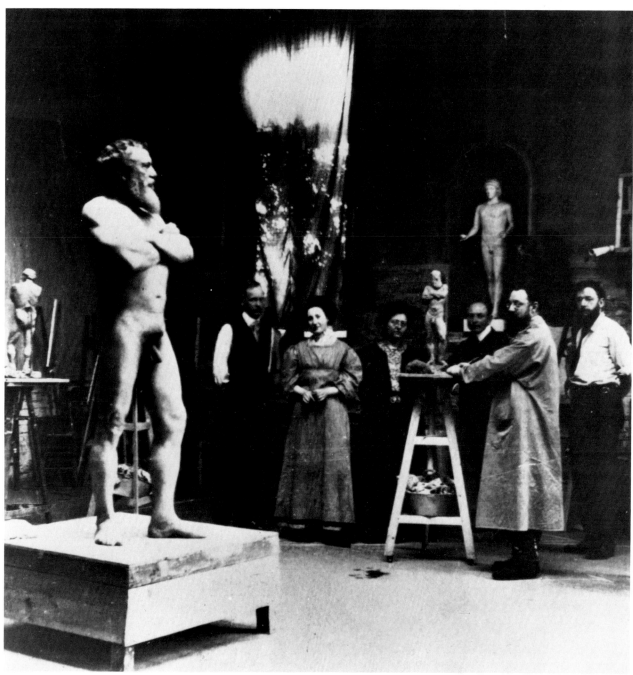

FIG. 5. *Matisse sculpture class, c. 1909 (Bruce is at far right).*

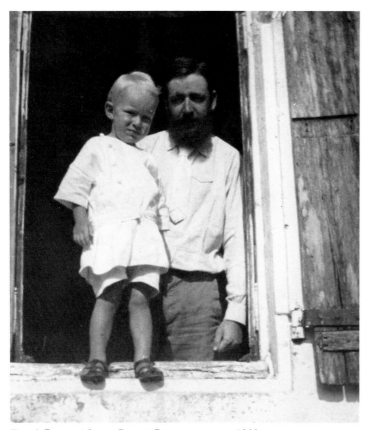

FIG. 6. *Bruce with son, Roy, at Boussac, summer 1909.*

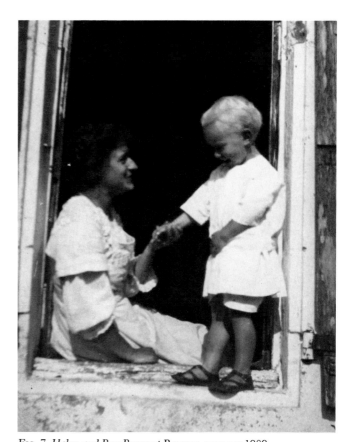

FIG. 7. *Helen and Roy Bruce at Boussac, summer 1909.*

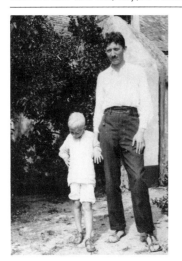

FIG. 8. *Roy Bruce with Arthur B. Frost, Jr., Belle-Île, summer of 1912 or 1913.*

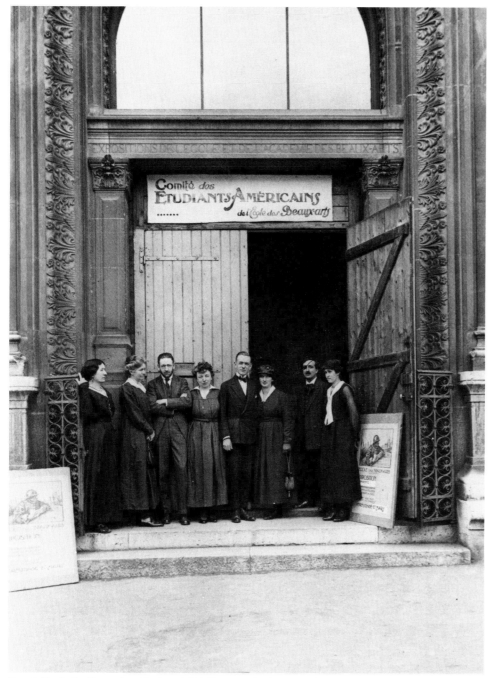

FIG. 9. *Ecole des Beaux Arts, Paris, c. 1918 (Bruce is third from left).*

FIG. 10. *Patrick Henry Bruce, c. 1930–33*

FIG. 11. *Patrick Henry Bruce, Paris, summer 1936.*

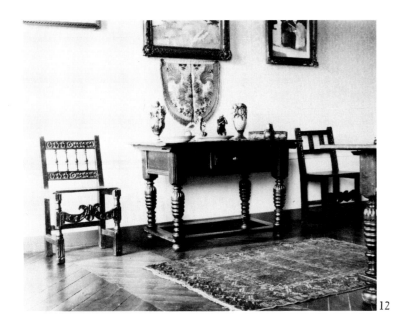

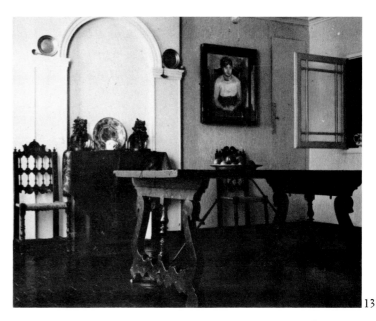

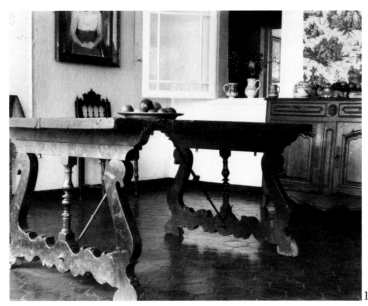

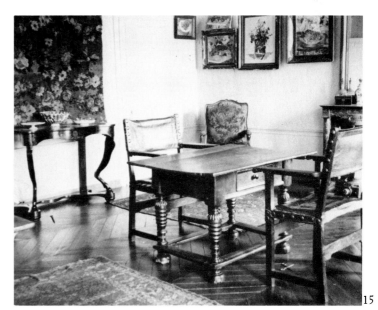

Fig. 12–15. *Interior of Bruce's apartment-atelier, 6 rue de Furstenberg, Paris, c. 1917–18.*

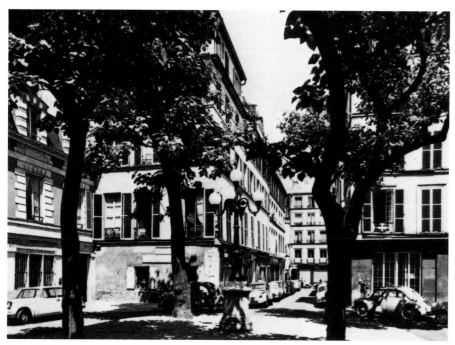

FIG. 16. *Rue de Furstenberg, Paris.*

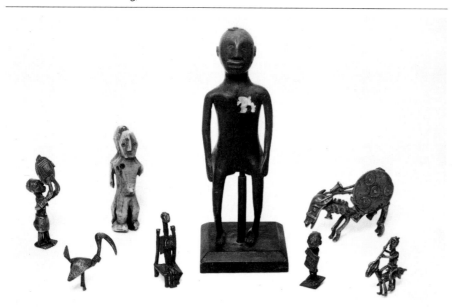

FIG. 17. *African sculptures owned by Bruce (now on loan to the University of Pennsylvania Art Museum).*

ALMOST FORTY-THREE YEARS AGO, on November 12, 1936, Patrick Henry Bruce died in New York, a suicide at the age of fifty-five.[1] His death went unnoticed. He had not exhibited since 1930, in Paris, where he had lived from 1904 until his return to New York a few months before his death. Few recognized the loss then; and even today Bruce remains a vastly underrated and little-known artist. American art history has remained so static that Bruce has been viewed, at best, as a peripheral figure in the history of modern art. Yet America had lost a major artist whose accomplishment ranks with or surpasses the best of his generation and far outdistances a hundred artists whose reputations maintain secure places in our histories. That must be said, because Bruce's painting carries a weight, conviction, and authority—and quality—that demand our recognition.

EARLY YEARS: 1881–1902

ALTHOUGH WE HAVE LEARNED a great deal about his life and art over the last fifteen years, we still know relatively little about Bruce, and there are still whole periods of his life that remain a mystery. Even his exact date and place of birth are still uncertain. His birth certificate gives Bruce's birthday as March 25, 1881, at Long Island (one of the Bruce homes that burned down some time ago), in Campbell County, south central Virginia.[2] However, family history records his birth as March 21, 1881, at Tarover, another Bruce family home in adjacent Halifax County. A great-great-great grandson of Patrick Henry, he was born into a family of once great wealth, the second of four children, two of whom died in infancy (see "Chronology"). His father was James Cole Bruce III, who married Susan Seddon Brooks, of Richmond, in 1878. It is known that they lived at Long Island, and that is probably where Bruce lived for the first four or five years of his

life. He would of course have made frequent visits to Berry Hill, the principal home of the large Bruce family, located just outside South Boston, in Halifax County. Reduced circumstances forced the family to move to Richmond in about 1885 or 1886.

We know nothing of Bruce in his very early years, and it is not until 1896 that we can begin to trace his biography. Both his parents were quite ill at this time, and as the eldest child, Bruce bore a heavy burden. His earliest known letter, of July 30, 1896, bespeaks an exceptional maturity for a young man just turned sixteen.[3] By 1899, at the age of eighteen, he was orphaned and had responsibility for his younger sister, Mary. It is from this early date that we can probably trace the extreme independence, the aloofness, and the reserve that were to mark his entire life.

After graduating from school in 1897, at the age of sixteen, Bruce worked successfully for a real estate firm during the day. Evenings he attended the Art Club of Richmond, studying primarily under Edward Valentine (1838-1930), a noted neoclassic sculptor who had been the pupil of Thomas Couture. Valentine, who became a close friend, did much to encourage Bruce's study of art. Bruce's dominant personality traits were firmly established by 1900: he was intensely serious, uncompromising, hard working, and deeply committed to becoming an artist. His sister, Mary Bruce Payne, remembered that in these days "all he lived for was to study art and go to Paris." Precisely when, or how he first developed his passion for art is unclear, for although he had come from a learned and cultured family, his ancestors evidenced no particular artistic training or talent. However, by the time Bruce was twenty, he had shown a precocious gift, as demonstrated by the highly accomplished charcoal sketch of December 1901 (cat. no. A2), the first extant work that can be precisely dated.

At this time, another trait was established—a firm and enduring respect for Old Master painting. Bruce copied reproductions of

Old Masters (cat. nos. A3, A4, A5a, and A5b) and would later (1905) make three copies from Titian in the Louvre, an indication not only of his studious habits, but also of a fundamental belief that new work must be based on, and could only spring from, a careful assimilation of the great traditions of painting. Bruce's interest in art in 1900–01 was so intense that he also attended the Virginia Mechanics Institute in Richmond, where Valentine taught freehand drawing; more importantly, he also studied mechanical drawing and drafting there, and made diagramatic drawings. This discipline lay dormant for fifteen years, before emerging as a fundamental pictorial ingredient of the geometric still lifes that he began in 1917.

Bruce's work of this period evidences a knowledge of James Whistler and John Singer Sargent, and of William Merritt Chase, the ranking teacher in America at the turn of the century. His knowledge plus his ambition led him to New York after his twenty-first birthday—probably some time in mid-1902—to study with Chase at the famous New York School of Art. There Bruce first worked with Chase, doing "attractive studies in an academic manner," as fellow-student Clarence K. Chatteron termed them.[4] Chatteron remembered Bruce as being "studious, self-confident, and talented." By early 1903, Bruce was studying under Robert Henri, who had just joined the faculty of the school. Henri's influence on Bruce was enormous. Bruce became a member of an entire generation who felt the tremendous impact of Henri's teaching and example as an artist.[5] Henri exhorted his students to approach their art through their intense observation and the immediate personal experience of the world around them —lessons Bruce was not to forget—and he persuaded Bruce to loosen his style in the manner of Velásquez, Manet, and Whistler.[6]

If at first apparently reluctant to change, Bruce quickly turned out to be a most accomplished pupil. His *War Portrait of W. T. Hedges* (present whereabouts unknown; presumed destroyed) of c. 1903 was so admired by Henri that he arranged to have it shown at the annual exhibition of the National Academy of Design in January 1904 and, later that year, at the Universal Exposition in St. Louis. The *Portrait of Littleton Maclurg Wickham,* 1903 (cat. no. A7), a striking painting rendered in an open, dashing brushwork and bravura tonalities, demonstrates that Bruce had quickly absorbed the example of Henri.

PARIS: 1904–12

DESPITE HIS DEEP ADMIRATION for Henri, Bruce was bent on following his early ambition and was in Paris by late 1903 or January 1904, at the latest. Unlike most American artists of the time, however, his trip seems not to have been motivated by any urge to absorb advanced French art. His letters to Henri demonstrate that his loyalties were still with his old teacher and the kind of art he inspired.[7] Bruce remained immune to newer French art for at least two years, exhibiting three-quarter and full-length figures in the Salon des Beaux Arts in 1904 and in the Salon d'Automne of 1905 and 1906, as well as at the Pennsylvania Academy from 1905 through 1907 and the Society of American Artists in New York in 1905. As he was to do throughout his life, he brought to his art at this time an uncompromsing, almost humorless, seriousness and dedication. His studio was frequented by young American painters—including Guy Pène du Bois, Maurice Sterne, and Edward Hopper—who respected his talent and approach and who would talk there for hours about painting.[8]

Although his art from 1904 through 1906 still primarily reflected his deep attachment to Henri, Bruce was not oblivious to French modernist art. He had been close to Edward Hopper at

the New York School of Art, and when Hopper visited Paris in October 1906 (staying until August 1907), it was Bruce who introduced him to the Impressionists, especially Sisley, Pissarro, and Renoir. Bruce, in turn, probably had been introduced to advanced nineteenth- and early twenty-century art by the Canadian painter James Morrice, who was working in a strong Post-Impressionist vein, and with whom Bruce was in frequent contact from as early as February 1904. Bruce's situation at this time was described by his closest friend, Arthur B. Frost, Jr. (1887–1917), whom he had met in the fall of 1906 through Walter Pach. In an undated letter from Paris (but probably of 1907 or 1908) to Augustus Daggy, a friend of the Frost family, he wrote:

> Bruce when he came here also saw the old and new together, but doing the old as well as he did, his success in the Salon, the fact that he did not know anyone here who was new or who was strong enough to show him the reason the new was the only modern thing, kept him doing the old until he came to asking himself [sic]. Then he laboriously and alone changed to the new thing. . . . He showed me that the only way a man can discover a new thing is to know all that is gone before and then produce his new thing on top of that. Then he will be subject to becoming old, as Manet has done, unless his personality is as strong as Rembrandt, Velásquez, Hals, Holbein, Greco or even Goya, who never can.[9]

Frost's account reveals Bruce's independent streak, his laborious methods, and his continuing reverence for the Old Masters.[10]

By mid-or late 1906, however, Bruce encountered the forces who were "strong enough" to indelibly impress on him the "modern thing." He met the Steins—Gertrude and Leo, Sarah and Michael—and became a frequent visitor at their open houses. There, through the paintings he could study closely and the many artists and writers he met, he rapidly became immersed in modernism, from Delacroix to Picasso and Matisse. And it was at the Steins, probably in early 1907, that he met Matisse, who became a good friend and close colleague. When the famous Matisse School was started at the beginning of 1908, Bruce was an original member, along with Hans Purrmann, Max Weber, and Sarah Stein.

It is from this time until well into 1912 that we can mark the second stage in Bruce's development. From his entire known career—a span of thirty-six years, from c. 1900 to 1936—only one hundred and eight paintings, plus fifteen photographic reproductions, still exist. Of the total, sixty-eight (plus five photographs) are from this period, and they fall into three distinct categories: still lifes, landscapes, and portraits. The still lifes predominate (fifty-three are extant) and establish his lifelong fascination with the genre.

Bruce exhibited still lifes at the Salon d'Automne in 1910, 1911, and 1912, and at the Salon des Indépendants in 1912, but we have no evidence as to which paintings these were. He usually signed his work of this period but never dated it, and since only one of these paintings has a secure date (cat. no. B42, 1911), it is still not possible to establish a fully reliable chronology for the years 1907–12. However, through intensive stylistic analysis, a few scattered documents, and witnesses' accounts, we can outline—with more confidence than we could even a few years ago—the directions his work took within this five-year period that began when he was twenty-six years old.

By mid-1907, Bruce's art was undergoing radical changes. Through the initial impact of Matisse he applied a rough, Fauve-like color to formats that recall Chase and Henri (cat. nos. B1, B2). At the 1907 Salon d'Automne, Bruce exhibited three paintings that Louis Vauxelles termed "des pseudo Manguin signes Bruce,"[11] an indication that his first attempts to absorb modernist art were characterized by broad areas of Fauve color. Matisse,

however, decisively discouraged his students from such precipi-
tous attempts to incorpoate his palette and approach, and Bruce,
evidently, quickly heeded Matisse's warning.[12] A few extant
works, of c. mid-1909 (cat. nos. B3–B5), show Bruce emulating
the luminous hues of Renoir; but like Matisse and Cézanne, he
quickly turned from what he took to be Impressionism's transi-
tory and fleeting effects. More importantly, however, these works
mark the beginning of Bruce's apprenticeship to the modern
masters, a journey he began with his usual intensity and thor-
oughness. His immersion in this study so preoccupied Bruce that
he did not exhibit again for a full three years, until the Salon
d'Automne of 1910.

The paintings of 1908–12 do not hide their sources—Matisse
himself noted that he never avoided the influence of other
artists[13]—but the best of them remind us that art can be both
derivative and good. Matisse insisted that his students study
nature, the Louvre and, above all, Cézanne, whom he termed
"the father of us all," and it is above all Cézanne to whom Bruce
gravitated. Cézanne, whose prestige was at its highest point in
these years, was of paramount importance for his fusion of
ordered and structured forms with high-keyed and palpable hues.
Other artists focused on either one or the other of these aspects
(Picasso, for example, maintained a continuing interest at this
time in Cézanne's structure, while ignoring his color), but Bruce,
like Matisse, strove to retain both.

In fact, by late 1909, Bruce had undertaken a single-minded,
almost obsessive, apprenticeship to Cézanne—as seen through the
eyes of Matisse—that seems almost to have been a moral obliga-
tion. It reminds us of Gorky's devotion to Picasso in the 1930s. If
one had commented on Bruce's reliance on Cézanne, one sus-
pects he would have been as shocked as Gorky when he was
taken to task for his obsession with Picasso—it was a matter of

unquestioned necessity. There is generally at least one, and often
more, close prototype for the majority of Bruce's Cézannesque
pictures (see Section B of the *catalogue raisonné*), and at points
it is almost as if Bruce had Venturi's *catalogue raisonné* in front
of him. His knowledge of Cézanne was nothing less than encyclo-
pedic, and he did not hesitate to draw, simultaneously and at
random, from all phases of Cézanne's work, be it early or late,
from the open and transparent paintings or the densely con-
structed work; in short, Bruce was constantly modifying and
alternating aspects of the touch and technique of Cézanne's
myriad styles. So too, like Cézanne, Bruce repeatedly returned to
the same motif, particularly in his series of a single vase of flowers
(cat. nos. B7–B20, figs. 1, 2). Many of these Cézannesque
works are extremely open, with large areas of unpainted canvas.
Most are signed, however, indicating that Bruce felt they were
finished enough, that they were "realized," or had something
worth preserving—an attitude that is at the heart of his geometric
still lifes of the twenties.

Bruce's concentration on painting still lifes from the immedi-
ate world around him was deeply rooted in Cézanne. Contem-
porary photographs of Bruce's studio-apartment at 6, rue de
Furstenberg (Delacroix, Monet, and Bazille had also lived
there), where he had moved by early fall 1910 and lived until the
spring of 1933, show the vases, tables, and other objects that
continually appear in his still lifes. In these paintings Bruce often
depicts a single motif—such as a bowl with fruit, a vase with
flowers, or at most, two or three vases or bowls around which are
clustered a few pieces of fruit—in order to concentrate intensely
on the pictorial realization of separate but interrelated forms.
Bruce looked closely to Cézanne for stylistic formats: a "close-
up" focus, tilted table planes, and high viewpoints to anchor
forms more securely to the picture surface (devices that Matisse

FIG. 1. Paul Cézanne. *Vase of Flowers*, 1900–03.

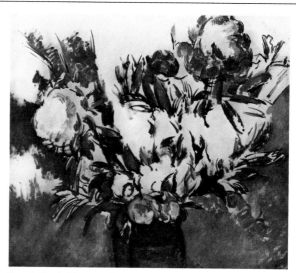

FIG. 2. Paul Cézanne. *Bouquet of Peonies in a Green Jar*, 1898.

was also using in his still lifes of the time). So, too, the facture of Bruce's paintings—open contours, planes bleeding into adjacent planes, and the modulation of planes through changes of hue as well as value—ultimately have their source in Cézanne.

However, it was Matisse who instilled Bruce's painting with the rich, tactile embodiment of color that was the hallmark of Bruce's art both then and throughout his life. Matisse, having worked closely with Signac, had undergone an intensive grounding in Neo-Impressionism; he knew well the elements of nineteeth-century color theory and undoubtedly passed them on to Bruce. Although his approach was more "intuitive," Matisse's teachings, stemming from his innate sense of the "chromatic substance of painting,"[14] constituted one of the largest single and most important (as well as intricate) bodies of color knowledge in modern art. Bruce absorbed Matisse's lessons of selecting color equivalents from the model and of carefully applying them so that each color modified the next and was modified in turn by new

touches, until a full, unifying color harmony was established. Through this process, which demanded constant and exacting adjustments of color, Bruce constructed a pictorial order based primarily on the supremacy of color.

These methods were intensified in a subcategory of Bruce's still lifes that might be termed his "foliage" pictures. They date, in all likelihood, from the summer of 1912. In these paintings, he concentrated at close range on flowers in a vase (an extension of the earlier vase-and-flower paintings) and then on a small area of foliage, blown up and pressed directly against the picture plane. Their sources are Cézanne's late watercolors of foliage (fig. 3), and a Cézanne of c. 1890–94 that Matisse owned (Venturi 613); but their heavy impasto, especially that of B64, is without precedent in either Cézanne or Matisse. While they retain the distinctive shapes of the foliage, they verge on abstract curtains of dense, rich, and closely gradated color volumes. They are part of Bruce's drive toward a density and fullness of structure

that had increasingly characterized his work, beginning in about mid-1911 (cat. no. B42).

This pattern culminated in the brilliant *Still Life (with Tapestry)* of c. 1912 (cat. no. B73), in which a vase (with flowers?), a bowl, and a plate are depicted on a table, and are set against and merge with a floral tapestry on the wall immediately behind. From the photographs of his apartment, we can identify the precise setting and objects with the exception of the vase, although other photographs do show one in the apartment similar to it (see fig. 12, p, 11). Bruce turned this formal setting of French elegance into a dazzling mosaic of pure and merging colors that realized Cézanne's dictum that "when color is richest, form is most complete."[15] A prototype can be found in Cézanne's *Vase of Flowers*, c. 1900 (Venturi 775; fig. 4). However, the more immediate inspiration for the painting may have been Matisse's fusion of textiles and objects in his interiors and in still lifes such as *Harmony in Red* of 1908–09 (The Hermitage, Leningrad), in which flowers, vessels, and tapestry designs are interwoven in broad arabesques of equal color density.

Yet such is the agitation of these colors that it is apparent that Bruce had moved away from Matisse's tranquil world of calm and restful surfaces. Bruce had met Robert and Sonia Delaunay in the spring of 1912, and in the *Still Life (with Tapestry)* as well as in several other dazzling paintings, such as the *Still Life (Red Cheeked Pears)* (cat. no. B52), probably done in the late spring of that year, Bruce began to investigate the purely optical qualities of color while maintaining a tightly structured, heavily impastoed surface. In addition to their fundamental debts to Cézanne and Matisse, these paintings, especially *Still Life (with Tapestry)*, with its swirling, interlocking hues, reveal the first influences of the Delaunays and of Orphist color. The tapestry painting is surely Bruce's final, and culminating, still life; it is his most ambitious still-life painting to date, and summarizes and incorporates all he had learned about color and structure up to that point. As such, we might well assign a date of early fall 1912 to it, as well as to two other still lifes (cat. nos. B71, B72) that are related by similarities of heavy facture and intense color. However, it is quite possible that all three were in fact done in

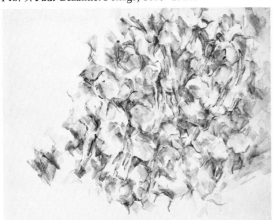

FIG. 3. Paul Cézanne. *Foliage*, 1895–1900.

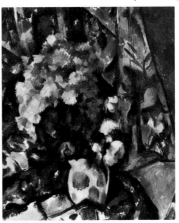

FIG. 4. Paul Cézanne. *Vase of Flowers*, c. 1900.

the late spring of 1912, before the Bruces went to Belle-Île for the summer, as they were also to do in 1913 and 1914.

For there, in the summer of 1912, Bruce did at least two (all that are extant) landscapes (cat. nos. B66, B67) that are unique in his oeuvre. They are distinctly Cézannesque in origin, but particularly in the second and more accomplished *Landscape,* there is evidence of a specific acknowledgement and awareness of Braque's paintings done in the summer of 1908 at L'Estaque (fig. 5), and shown that fall at Kahnweiler's.[16] The paintings mark Bruce's first incursion into the sources of Cubist structure and extend beyond anything Bruce would have found in, or could have extrapolated from, Cézanne alone. The *Landscape* is constructed by broad planes connecting with the sweeping arch and two verticals of the trees at the upper left, all having the effect of pulling the motif toward the center and front of the painting, and tending to flatten it in a way unprecedented in his work. At the same time, the painting demonstrates Bruce's mastery of color, But it is far more subtly and loosely brushed than the last still lifes. The greens are modulated in countless gradations, and are accented and contrasted by a gamut of hues ranging from gradations of rich, deep purples to ochres, browns, and a touch of red at the lower right center. The painting must be considered as a concluding, early masterpiece of Bruce's oeuvre, just as the *Still Life (with Tapestry)* is in another vein. A comparison of the *Landscape* with Bruce's first Orphist abstraction, the *Landscape* of late 1912–early 1913 (cat. no. C1), is particularly revealing. The division of planes and loose brushing indicate the forest scene as the "logical" precursor for the urban setting of the abstract *Landscape*. Thus it may well be that the *Landscape* was done after the tapestry painting and is the final representational work, done in the late summer of 1912, and leading Bruce directly into the world of Delaunay's Orphic Cubism. On the other hand,

having experimented with Cubist structure in the summer, Bruce may then have concentrated on bringing his color to its highest pitch in the *Still Life (with Tapestry)* after returning to Paris in the early fall. With the structure of one, and the color of the other well in hand, he would then have been well prepared to begin his first abstractions. The exact sequence eludes us; however, the paintings were done within a short time of each other and together they form the basis for a dramatically new phase of Bruce's art.

1912–16 ORPHISM AND BEYOND

BY NOVEMBER 1912, Bruce was discussing Cubism[17] and was becoming closer to the Delaunays.[18] From this time until well into 1916, Bruce was increasingly fascinated by the pulsating energies of the modern city. Through the immediate stimulus of the Delaunays, Bruce extended his intense love of color to a Cubist-based abstraction that could capture the dynamism of the twentieth-century city.

FIG. 5. Georges Braque. *Road near L'Estaque,* 1908.

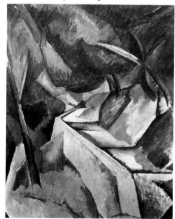

All we have of his painting from late 1912 to mid-1914, the third stage of Bruce's evolution, are photographs of four paintings from contemporary periodicals (cat. nos. C1, C2, C3, C4). But it is apparent from them, as well as from contemporary accounts, that by 1913 Bruce was part of a hybrid international group of artists that had quickly responded to Delaunay's liberation of color as a means of approaching nonfigurative painting. In October 1912, Guillaume Apollinaire termed the movement Orphic Cubism,[19] and its effects were apparent by early 1914 in the vivid color of de La Fresnaye, Léger, Picabia, Villon, Gleizes, Lhote, and Metzinger, as well as of Bruce and his fellow Americans, the Synchromists Morgan Russell and Stanton Macdonald-Wright. Nor were its effects confined to Paris. Kandinsky had first noticed Delaunay's work at the Salon des Indépendants of 1911 and had invited him to participate in the first Blaue Reiter exhibition in Munich that December. Delaunay also was visited in 1912 by Klee, Marc, and Macke, painters whose work almost immediately thereafter reflected a new intensity of color; for Klee, color was the pictorial instrument through which he found himself as a mature painter.

Bruce's *Landscape* (cat. no. C1), exhibited at the Salon des Indépendants in March 1913 and in the fall of that year at the "Erster Deutscher Herbstsalon" in Berlin, was probably begun in the late fall of 1912. It shows the flat, intersecting rectangular and curving zones of Delaunay's Cubism, and, though we know it only from a photograph, high contrasts of hue and value are readily apparent. It is a distilled urban view, reminiscent of Delaunay's *Fenêtre* of 1912 (The Solomon R. Guggenheim Museum, New York). The arch at the center upper left, encased in a sweeping upward curve, as well as the pyramid shape touching it at the center, may well be composite images of the Eiffel Tower, the very symbol of modern life for Delaunay and

the other Puteaux Cubists. The Tower was the subject of an entire series of paintings by Delaunay, and aspects of it constantly appeared in other major pictures, such as the monumental *Ville de Paris* of 1912 (Centre National d'Art et de Culture Georges Pompidou, Paris).

In the lower right of Bruce's *Landscape*, one can detect the naturalistic outline of what may be the dome of a venerable Paris cathedral. If this is accurate—and, working only from the photograph, it must remain supposition—we can relate the painting to Delaunay's preoccupation with contrasting the old and the new. Both in the Eiffel Tower series and the *Ville de Paris,* Delaunay simultaneously used a more traditional pictorial language and a modern Cubist idiom to portray within a single picture the transition from the nineteenth to the twentieth century. The same metaphorical passage of time appears in Raymond Duchamp-Villon's *The Horse* of 1914 (The Museum of Modern Art, New York) as it did in his writings, which established the Eiffel Tower as the embodiment of the modern cathedral.[20] Such themes also appear in the work of Gleizes, Metzinger, Lhote, and others, and represent a thematic variation of Cubism, distinct from the hermetic studio scenes of Picasso and Braque.

At the 1913 Salon d'Automne, Bruce exhibited two Compositions, only one of which survives in reproduction (cat. no. C2). It is extremely difficult to "read," but we can see the relation to Delaunay in the continuing use of Orphic-Cubist areas of high color and contrasting value. These planes appear to constitute a far more abstract picture, with greater movement and more aggressive, faster-tempoed rhythms than the *Landscape,* and thus it probably was done later, probably sometime in mid-1913. The painting brought considerable attention from Apollinaire, who spoke of it and Picabia's as being "what strikes one's gaze the most in this salon, what one sees best," while

noting that Bruce's work advances "this sensitive artist's cause."[21] By this time, both Bruce and his close friend Frost were well known as members of Delaunay's circle, the *école orphique*. Bruce's loyalty to Delaunay was no better expressed than by his protest to the organizers of the Armory Show over their refusal to hang Delaunay's large *Ville de Paris*. Samuel Halpert, Delaunay's old friend who acted as intermediary, reported that Bruce was the "only American painter at all considered by French artists."[22]

In late 1913 and early 1914, Bruce's art turned toward another aspect of Delaunay, namely the swirling, interlaced circular shapes of the latter's *Formes circulaires* and *Discs* of 1912–13. At the Salon des Indépendants in the spring of 1914, he exhibited a large and ambitious painting entitled *Mouvement, couleur, l'espace: Simultané* (cat. no. C4)—a burst of color attempting to incorporate all he had absorbed in the past two years. It was a large painting, approximately six feet square, judging from a contemporary photograph. Apollinaire's criticism that "the subject of his canvas is so vast that I am not at all surprised if the painter has been unable to take it all in" (although he also later noted that it was a more "personal work") probably was fair. However, the very title demonstrates Bruce's concerns at the time: the simultaneous and highly charged interplay of movement and color in a vast space, which reflected the impact of modern life on this group of artists.

We know from several accounts that Bruce, Frost, the Delaunays, and their friends regularly attended the gala dances held weekly at the Bal Bullier, an elegant and fashionable ballroom on the avenue de l'Observatoire in Montparnasse.[23] Bruce was fascinated by the multitude of contrasting movements and colors, as seen in his painting *Le Bal Bullier* of c. 1913–14 (cat. no. C3). This fascination, to continue for the next few years, had been hinted at strongly in the 1913 *Composition* and the

Simultané picture of 1914. The reproduction we have of *Le Bal Bullier* is poor, but again we can see interlocked and tumultuous shapes that derive from the Delaunays' circular forms, especially Sonia Delaunay's *Le Bal Bullier*, 1913 (Centre National d'Art et de Culture Georges Pompidou, Paris), but which are taken to an intensity of movement that is Bruce's own; in addition, high-keyed contrasts of hue and value are also evident.

At this time, Bruce and Frost were probably working from photographs, both their own and from magazines and newspapers. In a letter of September 18, 1914, from Belle-Île, Frost wrote to his father in the United States: "I want photographs to paint from. . . . Bruce wants dance halls, like Bullier, [flash light?] things, lots of women in modern clothes . . . crowds, café scenes are all interesting."[24] Frost was painting in a similar manner, and in a letter to his mother of August 1, 1914 he indicated their spirit by saying ". . . my simultaneous things look like 'la vie moderne,' autos, the grand boulevards, lights, etc. . . ."[25] Sonia Delaunay wore to the Bal Bullier brightly patterned clothes she had designed,[26] adding to the spirit of cosmopolitan gaiety that Bruce captured through his abstractions—paintings that represent a modern version of the urban café-concert scene made popular by Manet, Degas, Toulouse-Lautrec, Seurat, and the early Picasso

After the outbreak of World War I, Bruce rapidly became independent from the Delaunays. There is little evidence of his work or biography from mid-1914 to late 1915, but by early 1916, at the age of thirty-five, he had achieved his first full maturity as a painter. Only six large-scale Compositions, in addition to partial photographs of two other related works, remain from this, the fourth stage in his work. However, by any standard they rank with Marin, Dove, O'Keeffe, and Hartley as a crowning achievement of American painting at the time. We do not know

if the extant Compositions are his entire output of this period, nor do we have precise evidence of when the first was begun or how long he took to complete the series; but since they were sent to Frost in New York sometime in late 1916 or very early 1917, we can focus securely on 1916 as the date of execution, although the first two may have been started in late 1915.[27] They were shown in March 1917 at the Modern Gallery in New York, and one (*Composition II*) was shown at the Society of Independent Artists in April–May of the same year.[28] *Composition I* and *Composition II* were purchased in 1918, as was *Composition* VI in all likelihood; Katherine S. Dreier purchased *Composition III*, IV, and V in 1928 for the Collection of the *Société* Anonyme. Five were later donated to Yale University.

The Compositions extend Bruce's captivation with the dance hall and its myriad blend of colors and movements, aspects that were first explicitly announced in his *Le Bal Bullier*. The Frost letter of September 18, 1914 indicated Bruce's continuing interest in the subject, and Katherine Dreier reported in 1923 that the series was inspired by the "fancy-dress ball."[29] But the structure and format of the series derives not from what we presume to have been his most recent, prior paintings such as the *Simultané* painting, but rather from the 1913 *Composition*. It was a measure of Bruce's painterly intelligence that apparently, and rightly, he saw Delaunay's circular motifs as a dead end, with the greatest possibilities for extending his art lying in the more open, geometric color areas of his earlier pictures.

His continuing fascination with movement, emblematic of the new forces of the modern world, still refers to Delaunay but also suggests new stylistic affinities and common interests with the artists within the Puteaux circle, as well as others. For example, the downward zigzag thrust of *Composition III* (cat. no. C7), reminiscent of the 1913 *Composition*, calls to mind the similar movements of Marcel Duchamp's two versions of the *Nude Descending the Staircase* (Philadelphia Museum of Art) of 1911 and 1912. Duchamp, like Bruce, was working from photographs, though in Duchamp's case he was looking at the motion studies of Marey and Muybridge. *Composition II* (cat. no. C12), with its more blocklike shapes, bears a kinship to Picabia's preoccupation with the dance and movement, as in *Danses à la source* (Philadelphia Museum of Art) and *Procession Seville* (Herbert and Nannette Rothschild, New York), both of 1912, which were shown at the Salon d'Automne in that year. Although more curvilinear, and with a mood of ironic detachment, *Composition III* has the same kind of motion and thrust as Klee's *Laughing Gothic* (The Museum of Modern Art) of 1915, done just after Klee had transformed the dramatic influence of Delaunay to his own unique ends. Similar concerns also appear in futurist paintings, such as Severini's *The Blue Dancer* (Dr. Gianni Mattioli, Milan), 1912, and the *Dynamic Hieroglyphic of the Bal Tabarin* (The Museum of Modern Art), also of 1912.

The numerical designations of the Compositions were not Bruce's, but were assigned in the order in which they were purchased by Katherine Dreier. Based on stylistic analysis, we can postulate with some certainty the order of execution of the six paintings as follows: first, *Composition III*, then VI, V, and IV, and lastly I and II. In addition to its vertical format and downward-moving configurations (which retain a lingering vestige of figuration relating it to the 1913 *Composition*), *Composition III* suggests itself as the first of the series because of the rougher, more awkward, and tentative application of color planes—in contrast to the progressively more fluid and assured paint handling in the others. All of this is not to say that it is not a good picture, or is less successful. In fact, it is one of the best in the series and

is all the more moving because in it we are witness to Bruce in the act of becoming a fully original and independent artist.

Composition V (cat. no. C9) and *Composition* IV (cat. no. C10) open up and spread laterally, giving the sense of a broader, more panoramic interpretation of the multipaced sensations of the ballroom. As such, they are more ambitious in scope than either *Composition III* or *Composition VI* (cat. no. C8), which appear to be more of a close-up focus on one, or even several figures. Their facture, however, is still close to *Composition III* and *Composition VI* in the open, loose contours, bleeding planes, and brushed surfaces in which variations of hue and value are mixed within a single color zone. The color areas in these two pictures (they are also the largest of the paintings) are multiplied with such prolificacy that the pictures verge on losing their overall coherence and immediacy. Again, Bruce apparently sensed this, and *Composition I* (cat. no. C11) and *Composition II*, which I take to be the last of the series, are contracted and condensed into fewer and broader areas that convey the sense of a panoramic view without overcrowding or fragmentation, while still carrying a full pictorial intensity of color and shape. Further stylistic modifications between the early and later Compositions include: the elimination of figurative references; a shift from planar flatness to the clear suggestion of three-dimensional shapes; more closed and sharply defined contours, although bleeding of planes was not totally eliminated; fewer changes of value and hue within a given color plane; and fewer variations and numbers of value and hue in the overall chromatic scheme, with the areas of small "touches" of color of the early pictures almost totally eliminated in *Composition II*, the last of the group.

Bruce's systematic method of constructing abstract pictures was based on the mechanics of the optical laws of color. The Compositions recall the color planes of Cézanne and Matisse, magnified and abstracted through the example of Delaunay, and the lessons of constant and exacting adjustments of color learned earlier from Matisse. What, then, were these color principles common to Bruce, Delaunay, the Synchromists, and others of the time?[30] While all were dependent on color usage that had been codified by a long history of theories, made famous in the nineteenth century by Seurat and the Neo-Impressionists, it is crucial to remember, as the treatises themselves emphasized, that these laws were only valuable insofar as they could provide an initial technical basis to launch the intuitive process of the artist's sensibility. No law, no dictum, no treatise can ever in itself guarantee good art.

The fundamental sources for Bruce and the other color artists were Michel Eugène Chevreul's famous *De la loi du contraste simultané des couleurs* of 1839, which went through many later editions and translations; Ogden N. Rood's *Modern Chromatics*, published in 1879; and, more indirectly, the writings of Charles Blanc and Hermann von Helmholtz.[31] The primary theory for post-1900 painting was the law of simultaneous contrasts, first postulated by Chevreul and elaborated by Rood, which inspired Delaunay's *Discs simultanées* of 1912–13 and which also was at the heart of Bruce's mature work. Applicable to both hue and value, this law states that if two colors are juxtaposed each will be influenced by the complementary of the other, and if they are of different values the light color will become even lighter and the dark one even darker. The total effect will be an increased intensity and definition of color. As a corollary, Chevreul advanced the law of successive contrast, which states that a new color will be produced on the retina after the eye is shifted quickly from one color to another.

Chevreul advanced two other laws that were of considerable influence, the law of harmony of analogous colors and the law of

harmony of contrasts. In the first, adjacent colors or those separated by small intervals on the chromatic circle will produce harmonious combinations, as will colors of approximating values. The second states that a harmony will be produced by the interaction of colors or values widely separated on the chromatic circle. Related to and actually incorporating the law of harmony of analogy is the principle of gradation, by which colors in a given area are modulated to lighter or darker tones by small chromatic intervals. The principle of gradation was particularly recommended by David Sutter in 1880 and Rood, who quoted from John Ruskin's *Elements of Drawing* (1857), a book that championed its use.[32]

In *Modern Chromatics*, Rood included a chapter that came to be of special significance for Morgan Russell and Stanton Macdonald-Wright, but that was also used extensively by Bruce. This was the section on using colors in pairs or triads to produce harmonious combinations, achieved by employing two colors separated by ninety degrees on the color circle, or three colors that fall within regions divided by 120 degrees. In so doing, an initial, dominant color key was determined; thereafter, variations of this key, repeated in a few masses, could be used throughout the painting to provide a unifying whole of major and minor scales. Rood suggested changing one color on the triad to the left or right of the primary color to avoid a static or predictable combination, a practice followed by Bruce as well as by Russell and Macdonald-Wright.

We need only look at *Composition III* (see color plate 5) to see the infinite possibilities and variations of color these laws suggest. Bruce worked methodically, using frequent and heavy overpainting on each color area, which would modify and in turn be modified by adjoining areas. The picture, like the entire series, is constructed solely by configurations of color planes of varying hue, value, and tone. In keeping with the law of simultaneous contrasts, each color influences the hue and value of neighboring colors, giving the painting a heightened intensity and vibration. The dominant triad, grouped in varying masses, is based on the primaries, red, yellow, and blue, and can be seen in the parallel planes moving diagonally downward from center to lower center. Here, a yellow tinged with green is adjacent to a red with an orange tint, and above that is a bluish-purple plane, indicating Rood's suggestion to shift one color of the triad off the 120-degree division by one or two places. Below this section, toward the lower left, is another variant of the red-yellow-blue triad, and shifting off from this area, toward the lower left corner, still another, with the crimson-red and lighter blue both brushed with white to alter their values. This dominant chord is repeated, with still other mutations of hue and value: at the upper right center and upper left center; the upper right corner, where the yellow is shifted on the circle to orange-yellow; or, at the left central edge, when the yellow becomes an almost brown-orange in a triad of a particularly dark value, contrasting with the brilliant, high-keyed yellow of the center.

The minor, and contrasting, triad is based on the secondary colors, green, purple, and orange. It is most pronounced at the lower right corner, where a light purple is adjacent to a green plane, which in turn is bordered by an orange-crimson; this is a distinct shift on the circle, as recommended by Rood. To ensure compositional movement, not all triads and their mutations are parallel and adjacent planes, as they are in the center and right corner; all are contiguous in varying degrees, but one color of a triad may be part of a semicircle, or another of a triangle or still other configurations.

These formal variations of shape and size are as important for the painting's carrying power as the play of color. Thus, at

the lower center, a long, relatively narrow area of purple gently swings down to touch just barely a loose "square" of green. The square is fused with a larger orange section, which is defined on two sides by sharply delineated lines. A variation of the main chord at the very center contains rectangular, triangular, and curving areas, contiguous at various angles and in varying degrees. The infinite complexity of color application is also indicated by the simultaneous use of one color area in both the primary and minor triads. Therefore, the dark yellow-orange swinging in from the left center edge is the "top" of the blue and red wedges, along the side and the "bottom" of the curving green and purple areas that move up in the opposite direction. Or, one color may be the connecting area for two variations of the same chord.

The harmony of analogous colors is employed throughout *Composition III*, as, for instance, in the five contiguous areas of red in the lower left that begin with a zone of light hue and value, brushed heavily with white, and which then move through progressively more resonant shades, culminating in a dark red at the bottom edge of the painting. Contrasting colors—those far extreme lower right corner where a crimson-red is set against a apart on the chromatic circle—are used: for example, in the deep green. Bruce employed black and white in all the Compositions, progressively so in the last two of the series, to contrast and modify the spectral colors. This practice, recommended by Chevreul and Rood, gave an added richness since each painting had its own distinct chromatic characteristics.[33]

THE RADICAL UPHEAVALS of World War I drastically altered the situation of world art, and Bruce was no less affected than countless other artists. Gone were the prewar camaraderie and intense intellectual ferment of the Delaunay circle and the Puteaux group. Apollinaire and Duchamp-Villon had died in the war. Arthur B. Frost, Bruce's close friend, returned in early 1915 to New York, where he died in 1917, shortly before his thirtieth birthday. Morgan Russell moved from Paris to the south of France, Macdonald-Wright returned to the United States, and the vital interchange between the United States and Europe shifted to New York for the time. Bruce was virtually the only American artist who remained in Paris during, and after, the war. Indeed, he was one of the few major artists of any nationality who stayed in Paris during the war.

As noted, the Compositions mark Bruce's emergence as a fully mature and independent artist. In addition, as these paintings developed they also marked Bruce as an artist who was no longer assimilating or reacting to current art and ideas. By mid-or late 1916 he was, in fact, at the very edge of the avant-garde, shaping and defining the beginning of a new aesthetic that was emerging from the destruction of the old artistic order caused by the war. The progression of the Compositions was from the Simultaneist, Futurist interpretation of the movement and fusion of myriad figures, sights, sounds, and colors, to the more reductionist, orderly, and stable geometry of the last two, *Composition I* and *Composition II*. It is in this progression that Bruce became one of the original artists to first announce and define the move to a classicizing Cubism that in Paris was not widely defined until 1918. In the last two of the Compositions, Bruce declared his own call for a "new order," a call that in fact predates the more famous manifestos of Léger, Ozenfant, and Le Corbusier, and the art of the twenties. Bruce's shift was exactly contemporary with that of Juan Gris (fig. 6) and of Gino Severini, an artist whose vital role in the crucial shift from Simultaneism to classicism has been carefully documented by Christopher Green, but is still insufficiently recognized.[34]

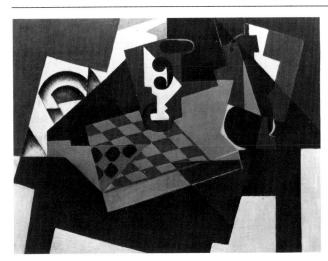

FIG. 6. Juan Gris. *The Chessboard*, 1917.

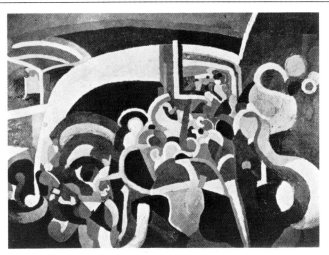

FIG. 7. Arthur B. Frost, Jr. *Colored Forms*, 1917.

The evolution of a more stable, geometric painting can be most effectively traced in the small magazine *Sic*, founded and edited by Pierre Albert-Birot.[35] *Sic* (subtitled "Sons, idées, couleurs, formes") was first published in January 1916, and ran for fifty-four issues, until the end of December 1919. Albert-Birot (1876-1967), still little known, was a Cubist-oriented painter and printmaker, but primarily a poet and writer, whose magazine in small measure helped to keep alive the spirit of the prewar avant-garde. The magazine began—like the first of Bruce's Compositions—as a platform for dynamic, Simultaneist art and thinking, as indicated by its very subtitle "Sons, idées, couleurs, formes," which in itself is an accurate description of Bruce's *Compositions III, VI, IV,* and *V*. Until May 1916, the magazine carried a distinct Futurist overtone, with Cubist-Futurist drawings by Severini and articles that stressed the movement and dynamism of modern life. In that issue, however, the tone begins gradually to change. In an unsigned statement, one of the many in a running dialogue on the times that Albert-Birot maintained throughout the existence of *Sic*, we read: "style = order = Volonté," which will bring the "next French renaissance."[36] By the fall issue of 1916, the trend toward a transition became more distinct: Apollinaire wrote that "the war will change things . . . we will move to a simpler expression, to attain a greater perfection."[37] The same issue contained a Severini woodcut, *The Modiste,* which was composed of far simpler and more geometric forms than his Futurist woodcuts that had appeared as late as the April issue.

Even more telling in this fall issue was the one-line declaration (again unsigned, but most likely written by Albert-Birot): "A work of art must be composed like a precision machine" ("Une oeuvre d'art doit être composée comme une machine de precision").[38] This declaration was expanded in the November issue by ". . . with these elements of knowledge the artist is going to *construct* a work as an architect makes a house with stone, metal, wood . . ." and ". . . from multiple emotions, he will consolidate and distill; . . . he is going to create a whole, an

ensemble, a form."[39] We have no evidence of contact between Bruce and Albert-Birot, but surely Bruce was well aware of *Sic*, as well as of the transformations evidenced in the work of Severini. What is striking is how precisely the transformation of ideas, the movement toward a new art in *Sic* coincides with the formal shift in Bruce's Compositions.

In late 1916, Bruce sent the Compositions to Frost in New York, where they remained and were later purchased by Katherine Dreier. The paintings had a tremendous impact on not only Frost (fig. 7) but on artists such as James Daugherty (1889–1973) (fig. 8) and Jay Van Everen (1875–1947) (fig. 9), to whom Frost had been teaching the principles of color abstraction. However considerable their impact in New York was, their removal from Paris had, in retrospect, dire consequences for Bruce, both personally and for his reputation as an artist. They were never shown publicly in Paris, and with the city virtually emptied of artists and critics, and because he sent them to New York immediately after their completion, they were probably

seen in his studio by, at best, a handful of people. As a result, just how direct and "logical" the evolution was from the last Compositions to the late geometric still lifes was missed then, and is only evident now, after more than sixty years. In addition, the geometric still lifes were only shown for the first time at the 1919 Salon d'Automne, the first large public exhibition to be held after the war. Thus, it appeared then (and has until now) that Bruce's late work appeared full blown as a response to the Purism of Ozenfant and Le Corbusier (Charles Edouard Jeanneret), as simply another echo of the by then well-established drive to a more rational and "scientific" art.

THE LATE WORK: 1917–36

IT IS NOT SURPRISING then, that the originality, the historical priority and importance, and the complexity of the late still lifes that he began in 1917 (far earlier than previously supposed) and on which he labored arduously for the remainder of his life, went

FIG. 8. James Daugherty. *Simultaneous Contrasts*, 1918.

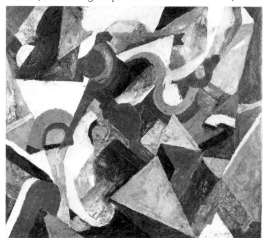

FIG. 9. Jay Van Everen. Untitled, c. 1918–20.

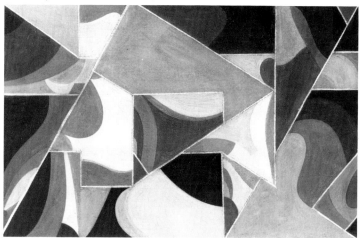

largely unnoticed. As his work received less and less acceptance in
the twenties, his natural reserve and aloofness came to border on
melancholy that often turned into periods of deep depression. He
was plagued by bad health, which only added to his moroseness.
As he became increasingly convinced that his work—his "folly,"
as he called it—would never be understood during his lifetime, he
drew more and more into himself until he led an almost totally
isolated life, a life that had already been wrenched by the death
of his best friend and the departure of his wife and son. At points,
his discouragement was so complete that he would give up
painting for months at a time and consider destroying all his
work.[40] By 1928, he was painting only for himself, exhibiting
infrequently, and showing his work rarely, only after careful
consideration, to but a few people.

It is small wonder. Roché wrote to John Quinn in 1920 that
Bruce was working "without recognition," and an exhaustive
search of the serious contemporary newspapers and periodicals
has turned up *only four references* to Bruce, all from the early
twenties. Two, in *L'Esprit Nouveau*, mention him only in passing
as an exhibitor at the Salon.[41] The other two came from Maurice
Raynal in 1922, when Bruce was at his peak of activity. Com-
menting on Bruce's three paintings at the Salon des Indépendants
in January, Raynal wrote that "Bruce is exhibiting three indisput-
able errors, although they are not without their charm."[42] Raynal
came down even harder on Bruce's two paintings at the Salon
d'Automne by stating: "One must be able to make mistakes, but
not take things too literally as does M. Bruce."[43] It would be
difficult to conceive of two more devastating attacks in the crit-
ical literature of the period. Even in the popular press, such as the
Paris edition of the New York *Herald Tribune*, the most generous
remark one can find is that his paintings are "attractive pieces."[44]
This kind of reception—if that is the word—led Roché to recall

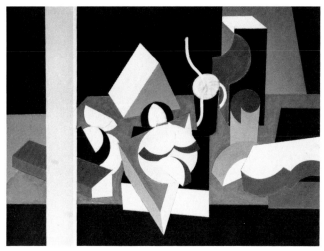

Fig. 10. Patrick Henry Bruce. *Peinture/Nature morte*, c. 1921–22. Cat. no.
D9. (1964 photograph, before alteration of the painting.)

later that Bruce stopped exhibiting because he felt his work was
considered "no more than nicely colored decorated surfaces."[45]

There are twenty-five extant geometric still lifes (twelve of
which are reproduced here, figs. 10-21). In 1933 Bruce destroyed
all but twenty-one of them[46] (he previously had given four others
to Roché and his friend Helen Hessell[47]). We do not know how
many he had actually painted by 1933 although he had exhibited
thirty-four between 1919 and 1930. They are neither signed nor
dated, and the sequence and chronology proposed here, which is
far from certain, is based on stylistic analysis and on a few
documents and eyewitness accounts.

THE CRUCIAL LINK in dating the still lifes and understanding
the coherence of Bruce's painterly development is a work that
only recently came to light. *Peinture* of c. 1917–18, in the collec-
tion of Rolf Weinberg (cat. no. D1), is clearly the first extant
late painting, and, just as clearly, is a distillation of the format

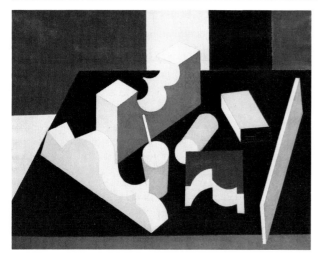

Fig. 11. Patrick Henry Bruce. *Peinture/Nature morte*, c. 1922–23. Cat. no. D10. (1964 photograph, before alteration of the painting.)

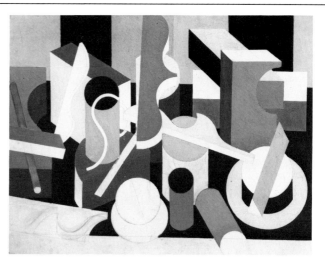

Fig. 12. Patrick Henry Bruce. *Peinture/Nature morte*, c. 1922–23. Cat. no. D11. (1964 photograph, before alteration of the painting.)

and elements of the last Composition, *Composition II*. Both this painting and the next-to-last, *Composition I* (cat. no. C11), contain well-defined three-dimensional elements such as triangular wedges, blocks, and a half cylinder, as well as curvilinear arches and the suggestion of a sphere. All of these elements appear, albeit in a more refined manner, in the still lifes. The triangular wedge at the upper right of *Composition II*, for example, emerges intact at the upper left of the Weinberg picture, and at the left center of *Peinture* of c. 1918–19 (cat. no. D2), which we take to be the second of the extant still-lifes, although it is faired and trued in the new still-life format. In similar fashion, these elements were to become part of the basic formal vocabulary of the late work. In addition to these specific elements, a comparison of *Compositions II* and cat. no. D1 reveals a distinct similarity in their "feel," their mood, and their viewpoint. The last Composition, as noted, is more a large-scale architectural still life based on condensed and more specific aspects of the Bal Bullier, rather

than the study of figures in motion of the earlier Compositions. The late geometric works, in turn, further distill this format, and transfer it to a more intimate and familiar setting—the interior of Bruce's atelier-apartment, where he had developed a passion for the genre in the years 1907–12.

There, Bruce decisively rejected the themes drawn from modern cosmopolitan Paris that had permeated his work since late 1912. He returned to the intense observation and rendering of the objects that made up the private world surrounding him in his apartment at 6, rue de Furstenberg, just as he had done in the Fauvist-Cézannesque paintings. With the possible exception of one picture, *Transverse Beams* (cat. no. D23), virtually every element in the late works is an object of which Bruce had intimate knowledge. Some of these elements may have been freely abstracted, condensed, or in part manipulated and adjusted for the sake of balancing the painting. However, it now seems certain that not a single element was a pure invention.[48]

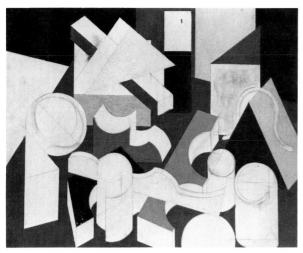

FIG. 13. Patrick Henry Bruce. *Peinture/Nature morte*, 1923–24. Cat. no. D13. (1964 photograph, before alteration of the painting.)

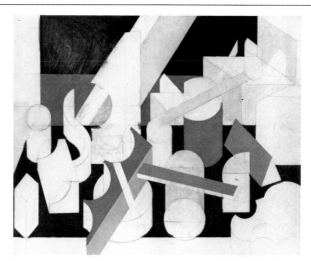

FIG. 14. Patrick Henry Bruce. *Peinture/Nature morte*, 1923–24. Cat. no. D14. (1964 photograph, before alteration of the painting.)

We still tend, reflexively and simplistically, to associate geometry with the cold, the impersonal, and the unfeeling. It is a measure of the richness—as well as the complexity and ambiguity—of Bruce's work that his geometric paintings appeal to the senses, evoking old artifacts that Bruce deeply loved; gathered from many countries and cultures, each has its own set of historical and personal connotations and references. They are objects that represent the intimacy and the pleasures of his private world.

For example, the basic plane of each painting is abstracted from the top of any one of the four antique tables we can identify in photographs of his apartment (see figs. 12-15, p. 11), two of which are probably 17th century, one Spanish, the other Dutch.[49] The lyre design of the elaborate stretcher and legs in these tables, as well as in two chairs, is the prototype, if not the precise source, for the open scroll work in cat. nos. D2, D5, D6, D7, D8, D9, D13, and D18.

Other readily identifiable objects from Bruce's everyday domestic life include a glass with a straw (cat. nos. D10, D28, D29), abstracted vases (also of widespread geographic origin including the Orient) with streamlined but, no less organic, plant life spilling out (cat. nos. D6, D7, D8, D9, D11, D15), and an orange with one or more slices cut out and carefully placed beside it (cat. nos. D6, D7, D8, D9).[50] We can also identify what may be a large round of cheese (cat. nos. D16, D17, D18). These three paintings also have in the background "collapsed beams" that, although radically altered, were probably suggested by the pilasters in Bruce's apartment (see fig. 13, p. 11).

The inventory of familiar items does not stop there. Especially intriguing is the pink-and-blue straw boater at the lower right of the painting in a private collection (D11) of c. 1922–23.[51] A variant of the boater—a derby—appears in cat. nos. D6 and D8, although this shape may also represent a cup and saucer. On top of the boater lies a long shape that distinctly suggests a mechanical engineer's scale, formed by an isoceles triangle at the front

(giving us a decisive clue as to how the late works were constructed). This element also appears in two paintings entitled *Peinture* of c. 1918–19 (cat. nos. D2, D4). Another basic tool of the draftsman, the ruler, appears in the first of this series (cat. no. D1), as does a pencil; the ruler then becomes a primary element in the last two works in the series (cat. nos. D28, D29). Furthermore, the half circles in cat. nos. D16, D17, and D18 suggest the type of magnets that architects and engineers use to secure their drawings to a wall or table.[52]

The most exotic artifacts are the African mortars and pestles (cat. nos. D26, D27), which we know from Rochés account were in Bruce's large collection of African art.[53] With this wide range of cultural and geographic sources in mind, we can readily understand Bruce's letter to Roché of March 17, 1928, in which he stated "I am doing all my traveling in the apartment on ten canvases. One visits many unknown countries in that way."[54] The letter indicates just how remote and withdrawn Bruce had become; now self-sufficient, he was finding all he needed for his painting—his "solitary pictorial chess," as Meyer Schapiro has remarked in another context—within the confines of his apartment.[55]

Even the seemingly most abstract pictorial device, the "vertical bar" that runs along the left side of nine paintings that constitute an entire subcategory of the late work (cat. nos. D6-D9, D19, D25-D28), has as its source the table used in the 1912 *Still Life (with Tapestry)* (cat. no. B73). There the right rear leg was flattened and pulled forward, evening out the surface and merging background and front. The vertical bar first appears in a shortened and divided version, in the same position at the lower right as in the tapestry picture, in cat. nos. D4 and D5 of c. 1919–20; it was moved to the left and first extended full length in cat. nos. D6 and D7 of c. 1920–21. The smaller variation then reappears, mixed in the "background," in cat. nos. D12 and D13; and then appears in the right foreground in the concluding extant works,

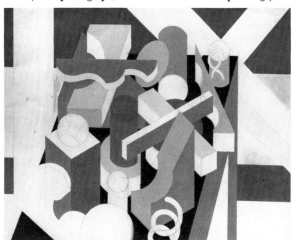

FIG. 15. Patrick Henry Bruce. *Peinture/Nature morte*, 1923–24. Cat. no. D15. (1964 photograph, before alteration of the painting.)

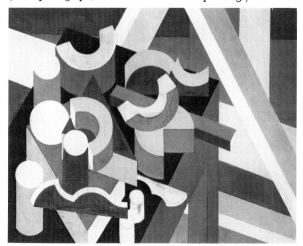

FIG. 16. Patrick Henry Bruce. *Peinture/Nature morte*, c. 1924. Cat. no. D17. (1964 photograph, before alteration of the painting.)

cat. nos. D28, D29. The use of this element, crucial to so many of the late works, is another demonstration of the continuity in the evolution of the geometric still lifes. In fact, the countless formal intricacies of the filigree elements may have been first suggested to Bruce by the sweeping curve and reverse curve of the table front in the 1912 *Still Life (with Tapestry)*.

These scroll-like elements, which I have compared to the designs of the tables and chairs in his apartment, would also have been well known to Bruce—as would other elements by another means. He had made his living by locating and selling antique furniture since 1910, if not earlier. By all accounts, his taste was impeccable, and he would haunt the innumerable antique and woodmakers' shops that to this day surround the rue de Furstenberg. We can reasonably assume that on these frequent excursions Bruce would study not only countless pieces of furniture, but would also handle wood cutouts lying about, pieces that had been discarded by the woodmakers and restorers.

FIG. 17. Patrick Henry Bruce. *Peinture/Nature morte*, c. 1924. Cat. no. D18. (1964 photograph, before alteration of the painting.)

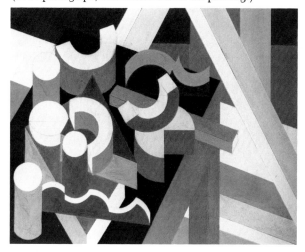

It is probable that Bruce took at least a few of them back to his studio, and either rendered them literally (as is suggested by the precision of forms in cat. no. D10) or transcribed from them his own formal variations.[56] However, given the repetition of so many identical elements, Bruce was most likely using the exact shapes he had found, rotating and repositioning them, and modifying their innate and relative scale according to the demands of the picture. For example, shapes such as the triangular wedge, the dowel, the upright vertical element with the concave cutout, are repeated consistently throughout the late work. All these elements have specific connections with furniture and woodworking. The vertical concave element, which appears in more than half the extant works and is the most frequently recurring element, was probably originally a support for bannisters or curtain rods, but was raised by Bruce to a vertical position.[57] The triangular block, depicted in a blown-up scale and close focus, is reminiscent of molding or supports used for reinforcing the undersides of tables. In the lower right of cat. no. D12, we find a quarter round molding; the helix at the lower center of cat. no. D15 suggests a wood spiral peeled from a lathe; and in cat. no. D24 the two reversed triangles may well be wedging blocks used to push apart pieces of wood at an equal distance. In cat. nos. D4 and D10, the thin strips—one curved, the other straight—may be strips of veneer. Thus, we can locate and identify an entire vocabulary of common woodworking shapes that in Bruce's pictorial syntax could evoke a whole gamut of moods and formal complexities. Having rejected the popular themes of modern urban Paris, he transformed an enclosed world, ancient and venerable, into a smaller and more compact format, but in an idiom that was no less modern.

With the discovery of cat. no. D1, the starting point of the late works, the pictures immediately following must now be

assigned earlier dates than previously given. Since Bruce chose to edit his work, this painting cannot necessarily be taken as the first painting to follow the last Composition; and there was probably at least one other painting done before cat. no. D2, which we take to be the second extant late work. Given their distillation from the last Compositions, and considering Roché's accounts, Bruce launched the late still lifes in 1917, and if cat. no. D1 is not from that year it surely was finished by early or mid-1918. The paintings thus share with Gris, Severini, Rivera, Picasso, Metzinger, and to a limited extent, Braque, a historical priority in the shift to a more volumetric, classicizing art, but clearly antedate the more famous moves in that direction that Léger, Ozenfant, and Le Corbusier made in their writings and work.[58]

Bruce entitled his late works either *Peinture* or *Nature morte*, although by reason of Roché's descriptions they have come to carry titles such as *Forms* and other variants. The extant paintings can be divided into six groups, each with its own formal

characteristics. In the first group, cat. no. D1, with two distinct planes (tables), is unique, but shares with cat. nos. D2 and D3 a small size and a close focus, with the objects placed at a severe tilt and highly magnified in relation to the total space. All three incorporate a tabletop that runs the full length of the canvas, breaking the edges of the surface edges. There are far fewer elements in cat. no. D3, which establishes, at an early date, a recurring working method. Bruce, in all the various categories, first puts in a number of objects, and then in subsequent variations, takes out at least two, and often more, elements, in a constant drive to distill and condense his paintings. As part of this process, the facture is also modified; it starts with a heavy impasto, roughly applied with a palette knife, and becomes progressively refined, although surfaces are by no means devoid of built-up paint. Throughout the twenties, the pattern is generally toward a more thinly painted picture, but it is not at all a consistent pattern. In certain works, especially in cat. no. D27, the

Fig. 18. Patrick Henry Bruce. *Peinture/Nature morte*, c. 1925–26 or c. 1928. Cat. no. D24. (1964 photograph, before alteration of the painting.)

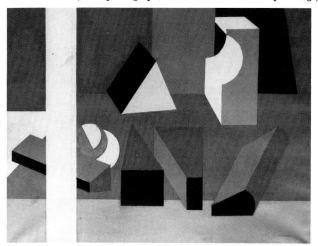

Fig. 19. Patrick Henry Bruce. *Peinture/Nature morte*, c. 1928. Cat. no. D25. (1964 photograph, before alteration of the painting.)

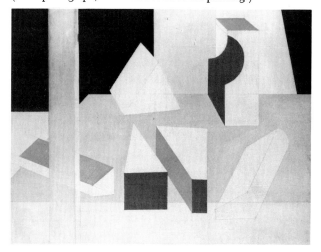

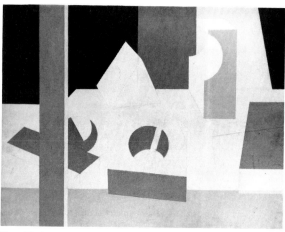

Fig. 20. Patrick Henry Bruce. *Peinture/Nature morte*, c. 1928. Cat. no. D27. (1964 photograph, before alteration of the painting.)

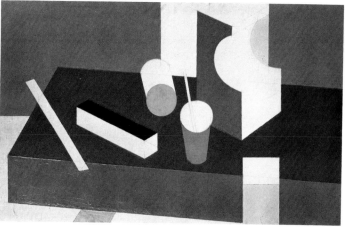

Fig. 21. Patrick Henry Bruce. *Peinture/Nature morte*, c. 1928. Cat. no. D28. (1964 photograph, before alteration of the painting.)

texture and technique (brush and palette knife) is even varied within the same canvas, shifting from part to part.

Cat. nos. D4 and D5, the second group, are marked by a placement of the table at a discrete angle to the bottom and left edge. Here and in later works Bruce constantly shifts the angle of the tabletop, just as he had done in his early work, which was based on similar Cézannesque adjustments. The table and objects are set further back in an implied space, and are viewed from a greater distance.

The third group is the "vertical bar" series, which it appears was begun about 1920 and then later continued in more distilled versions in the mid-and late twenties. Its nine pictures comprise the largest single category of the late work. In these paintings, the angle of the table is at the same diagonal on the left as in the preceding series, but the table is now both pushed further back and extended forward so that its front becomes a lateral plane running the full width of the front edge. More elements in more complicated dispositions are introduced, but their placement

and balance are now also more assured, and give a sense of a new confidence in handling the problems he posed for himself. For example, although these pictures give the illusion of being set into a deeper space, at the same time they project toward the viewer by the sharp thrust of the front triangle's point, which threatens to burst the plane of the picture's surface.

Cat. no. D6, which we date from c. 1920–21 and place as the first in this series, is another demonstration of the continuity in Bruce's development. The vertical bar is brushed with white to heighten the intensity of the blue, a practice he had learned from Matisse and had employed in the Compositions.[59] The brushing is also found in the sphere, the triangle at the rear, the left portions of the center block, and the cylinder at the right center. In addition, the technique adds an element of transparency to what otherwise appear as solid objects, and is just one of the myriad formal contradictions and ambiguities that permeate the late paintings, and one that was to appear again. This painting also contains two elements that help to substantiate that Bruce's

intense observation of the furniture in his apartment was a prime source for the elements in these works. At the right center a dowel lies across a scroll-shaped pattern that is very close to the curves of a table leg in the apartment (see figs. 13, 14, p. 11). Lying under the far left corner of Bruce's table is an identical dowel, which he used as a support for what was apparently a missing section of the stretcher. In the painting itself Bruce clearly rotated the placement of the two elements, but the combination of dowel and curving leg is too close to be a mere coincidence. Furthermore, the rotation and recombining of elements is a recurring device in Bruce's late work, particularly in the vertical concave element that appears in the majority of the post-1916 work.

In the fourth group, which dates from c. 1922–24 and which includes cat. nos. D11, D12, D13, and D14, the number and complexity of forms multiply dramatically. Elements are "piled" one upon the other, creating a layered effect; they press against the picture surface, sometimes cutting through either the bottom or top edge, or both. The tabletop and other shapes are tilted up so sharply that in several cases the elements become a sheer vertical or diagonal stretching across half the height or length of the canvas. The front edge of the table is close to, or coexistent with, the lower edge of the picture itself. Little distinction is made between front, middle, and deep spaces, creating the effect of a single plane. The late geometric still lifes all emulate the monumental grandeur of Cézanne's late still lifes, and in particular this and the next series appear to have as their prototype the drastic angle of the table and almost gravity-defying arrangement of elements found in Cézanne's *Apples and Oranges* of 1895–1900 (Venturi 732; fig. 22). Like Cézanne himself, Bruce was constantly studying the Old Masters, and it is a mark of the evolutionary process of Bruce's late work that he continues

in the tradition of Cézanne, whom he had studied so intensely in earlier years. This series also reveals Bruce's continuing debt to Cézanne in that they are consistently the most "unfinished" of the late works. Entire expanses of canvas are unpainted, serving to alleviate the otherwise tumultuous proliferation of shapes; in this sense they are among Bruce's most radical works, although all but one of the late works (cat. no. D2) have at least a small area that is left unpainted. As in Cézanne's late paintings, these areas relieve and let the densely painted and packed surfaces breathe. Tragically, however, the paintings in this fourth series have suffered the worst alterations because much of the rich drawing that ran through the portions of bare canvas was erased fifteen years ago. These alterations, which are described in detail in Section D of the *catalogue raisonné* are to be found in twelve of the extant late paintings.

Four paintings, three dating from c. 1924 by Roché's account—a reasonable date in view of the sequence of earlier paintings—

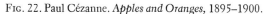

FIG. 22. Paul Cézanne. *Apples and Oranges*, 1895–1900.

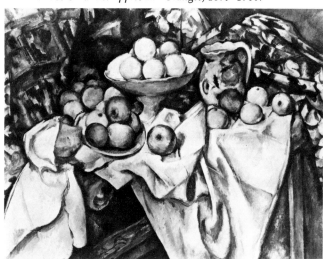

constitute the fifth group (cat. nos. D15-D18).[60] They can be termed the "triangular arch" or "collapsed beam" paintings because the inverted V dominates the new, and highly pronounced, architectural planes in the background; once again, these elements, as noted previously, call to mind the clean lines and formal austerity, especially in the pilasters, of Bruce's studio-apartment. Here, Bruce attempts to merge more completely the table and its objects with their spatial setting, by giving equal reign to the delineation of foreground, middle depth, and background. The table is more literally rendered, and is tilted more drastically than in any of the other series. The table front cuts the bottom edge, and the upper left corner intersects the architectural forms of the background. In cat. nos. D16, D17, and D18, Bruce progressively removed one or two elements, and in cat. no. D18, the final one of the series, he reached the balance he was seeking. This process of distillation was, as we have seen, characteristic of his working habits. Through the sheer number of elements incorporated, these paintings are perhaps the most complex and present the greatest array of formal and coloristic alternatives, almost to the point, as had happened before, where the picture verges on losing its focus and control, on becoming perhaps overly frenetic and complicated.

As in the development of the Compositions, Bruce gained a new assurance and control with a type of painting more suited to his temperament. Thereafter, he was able to incorporate and give equal play to shapes and colors at the front, middle, and back, while significantly reducing the number of pictorial elements. We first find this in the later "vertical bar" paintings of c. 1928 (cat. nos. D24-D27). Returning to an earlier format, and refining and distilling it, again became an overriding concern for Bruce. It reminds us, as Barbara Rose points out, of Brancusi's constant reworking of motifs as he searched for the absolute, for the "per-

fect picture." The later "vertical bar" paintings move from the tumultuous, multiplying shapes of the two preceding series into a more controlled and stable format. The paintings hereafter are organized around stricter horizonal-vertical axes; their format evens out so that we confront them directly; there is a more gradual spatial recession; and there is no longer the urge to fill every area with depicted shapes. Bruce found that he could "carry" the picture and sustain its depth and solidity by giving it room to breathe, through an increasing use of solid color planes, both at front and back, and within the table surface itself. No longer do objects break the lower edge; the frontal, projecting diagonal shape, also used in the triangular arch series, is pushed back, and settles more comfortably into the overall pictorial scheme.

As a result of this new confidence, which loosened up the painting within a more direct surface organization, Bruce gave freer play to familiar objects around him, such as the fruit, vases, and glasses already described. Furthermore, each object now more complete in itself, more self-sufficient, and less dependent on intricate formal conections with adjacent shapes.

This new format was extended to the point where Bruce could achieve full unity by using fewer objects, without tying one to another. For the first time, we now find some freestanding shapes, although each retains a crucial place in the overall pattern and structure. New distillations of color and shape and larger color planes encompass a relatively few shapes. The table becomes an extensive, uninterrupted surface, brought down to the lower edge of the canvas and sometimes just barely cutting it at the lower right. Each shape, each placement, each color is rendered with an exactitude that bespeaks years of work and experience, and a new assurance and confidence. We can speculate that Bruce now had come to grips with the fact that his work would not be understood

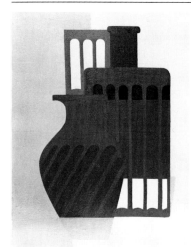

FIG. 23. Amédée Ozenfant. *The Vases*, 1925.

FIG. 24. Le Corbusier. *Still Life*, 1920.

or recognized, and having resolved this problem, he was free simply to paint for himself.

In the last two extant paintings (cat nos. D28, D29), we see Bruce at the height of his powers. Bruce looked back to cat. nos. D4 and D5 (the second group) for the basic motif, but then radically distilled them. Cat. no. D28 is identical in format to cat. no. D29 except that in the last painting the "insert" connecting the table and lower edge of the canvas is removed. In cat. no. D29 another color scheme is introduced. The shapes stand on their own, each conceived as a fully modeled entity. Here it should be noted that the bulk and separate space accorded each object always distinguishes Bruce's paintings from the more flattened and schematic shapes in the still lifes of Ozenfant (fig. 23), Le Corbusier (fig. 24), and Léger. In earlier paintings Bruce had employed a wide range of pearlescent, almost pastel hues, but in the late vertical bar paintings and the last two pictures, Bruce returned to richer and more simplified color, consisting of the primaries and a few of their variants. The

primaries in the last painting form the dominant chord and are heightened and contrasted by the deep black of the table, by creamy whites, and the gray of the cylinder; they are also set off by the light greens of the vertical planes at front and rear, as well as by the subtle gradation of the several zones of red toward the pink of the glass. The yellow straw strikes a binding and resounding note that is almost sublime. In the late pictures Bruce never graduated or contrasted hues within a given area, and values were kept at an equally high but modulated pitch. His touch became lighter, surfaces were kept more even, and he achieved a full, though not heavy, paint texture. It was in this painting that Bruce found the richness and balance that he took for his model for the paintings that he continued to work on steadily until he left for America in 1936.

Because we now know that cat. no. D29 is the last work—and not *Transverse Beams* (cat. no. D23), as previously assumed, we are faced with the question of dating the latter and placing it in sequence.[61] It may have been unique, but its facture, and its

calm and distilled mood lead us to believe that it was painted about 1928, just before or at the same time the late "vertical bar" paintings were done. We know from his letter of March 17, 1928 to Roché that Bruce was then working simultaneously on ten canvases, and thus we can conclude that these works were probably all from that time. I previously felt the painting was based on a distant view,[62] but I now am convinced that it is in fact an extremely close-focus, almost blown-up version of details of the wood elements he employed throughout the late work. (For a different interpretation, see Barbara Rose's essay, p. 43.) Certain elements suggest sources in earlier paintings. For example, the two flat vertical planes running from the center to the right corner, as well as the intersecting beams, are somewhat suggestive of the divisions within the "triangular arch" (or "collapsed beam") paintings. The long triangular block had appeared in the first still life (cat. no. D1); it may also be a magnified section of the engineer's scale that we have noted in works such as cat. no. D11 of c. 1922–23. The cut in the beam that runs diagonally downward from left to right is a "half-circle inlet," a cut that is very common in woodworking. The painting is set in a floating, airy space, the kind of surrealist space that Robert Goldwater, in another context, characterized as an "unreal space of unknown dimensions—a space neither flat nor deep, at once expansive and suffused, both impassable and immaterial."[63]

THE MOST TELLING commentary on the richness, the fullness of color and form of Bruce's late work might well be the following:

> "What a sharp, assured actuality they have! It was from this actuality, which does not merely appeal to the imagination, but is solid, lucid, scrupulously exact and has something austere, even laborious about it . . ."[64]

The passage was neither referring to Bruce nor written by a contemporary; rather, it comes from Goethe's *Italian Journey* of 1786, and is a description of Mantegna's paintings. From Guy Pène du Bois's account, we know how deeply Bruce loved Mantegna. Bruce, in particular, would have admired the archaelogical precision of construction and drawing in Mantegna, the exacting placement of verticals and horizontals, and the precise architectural renderings.

These characteristics indeed form a common bond between the construction and working methods of Bruce and Mantegna. Bruce began his late paintings by drawing in the elements, then painting them in, frequently overpainting in dense layers until he achieved the color harmonies he was seeking, in much the same way that he had in the Compositions. No matter what extent of repainting the forms underwent, however, x-rays prove that once the underlying drawing was finished, it was never changed.[65] The nature of the shapes themselves, but most especially the pencil drawing in the "unfinished" areas, makes it abundantly clear that Bruce established his formats through the procedures of the draftsman, the architect, and the mechanical engineer. We have demonstrated how Bruce's painting was based on the cumulative knowledge and study he absorbed in the course of a lifetime, each painting building on what had come before, as he reached back to reinterpret and distill all he had absorbed from his first years as a young student. Thus, to construct the geometries of the late work Bruce resurrected a discipline he had studied in Richmond when he was not yet twenty-one years old.

He employed the full battery of the mechanical draftsman's instruments—the T-square, the compass, scale, 30-60-90 degree triangles, and french curves, among others—so as to depict objects in three-dimensional volumes. Here again Bruce used an exacting discipline to create an intensely personal art filled with ambigu-

ities and complexities, a geometric art that is never truly "pure," that mixes countless formal variations and contradictions. He once stated that he was "trying to achieve depth and distance through color, rather than by perspective lines."[66] In fact, although at first glance the paintings appear to use exacting perspective, Bruce only occasionally uses a true perspective, be it one- or two-point, or even asymetric perspective. Rather, he employs oblique and isometric projections to achieve the sense of three dimensions.[67] Where he does use actual perspective—primarily in the triangular blocks at the rear of the "vertical bar" paintings—it is an extremely subdued and underplayed perspective, the lines of which would gradually merge only at an incalculable distance above and beyond the edge of the painting's surface. Where he wanted to—for the sake of the picture—Bruce was a master draftsman. For example, the vertical concave element in cat. no. D4 of c. 1919 is a perfect isometric (lines which run parallel), which does not appear again to this degree of exactitude until the last two paintings. The same element in cat. no. D1 is a badly rendered oblique projection; it is only technically an oblique, but that is because it better serves the picture by fairing the top edge with the edge of the canvas. On the other hand, in the *Transverse Beams*, Bruce renders an exceptionally beautiful isometric projection, as he does in the vertical concave element in cat. no. D25, also of c. 1928. Cat. no. D10 contains three of his most perfect isometrics in the scroll work, a particular *tour de force* of mechanical drawing given the difficulty in drawing the complex curving shapes. Yet at the right corner of the element at the far left, Bruce deliberately skews the projection and sends the right line off on an upward diagonal, again to better balance and weigh the painting. In many of the pictures (such as cat. nos. D14, D26, D27), Bruce deliberately mixes up and combines in the same painting a full repertoire of the draftsman's renderings. In

cat. nos. D14 and D26, the lines on the sides of the mortar begin, very slightly, to converge, but this could not be termed a true perspective because the top and bottom edges remain parallel. In cat. no. D27, Bruce barely suggests a vague perspective in one shape, while surrounding elements carry no hints of perspective at all. The unpredictable intermixture of subdued perspectives and oblique and isometric projections account in great part for the unsettling appearance of the paintings, and keep them from falling into a static mold, even within the pictures in a given series. Once again, Bruce uses the most seemingly exact "science" to create his own highly charged and personal art, just as in the Compositions he had used the so-called precise "science" of color theory to make paintings that were finally the product of pictorial intelligence and intuition.

The lines in the areas of bare canvas do pose one problem that may seem to be a contradiction. The Belgian painter Jozef Peeters visited Paris in 1921 and, of all the work he saw, he found Bruce's the most impressive. Michel Seuphor, who also knew Bruce, recalled that Peeters spoke of Bruce as insisting: "Line is only the border of surface. Line exists only as a draughtsman's tool. If line is apparent, it is a drawing."[68] How then do we account for the rich drawing we find in the late work? The answer lies in the fact that these pencil lines are always clear definitions of distinct and separate elements, and that they are indeed only used as the "border of surface." Bruce was doubtless objecting to painting in which random lines overlap or cut across distinct shapes. Such drawing would have been anathema to Bruce in his search for the "absolute," for a picture constructed by the four sides of the canvas, and in his drive for an art of classical purity. Thus, we can account for this apparent discrepancy, as well as understand precisely what he meant when on March 17, 1928 he wrote to Roché that "You should be well

prepared to appreciate my paintings after Greece,"[69] where Roché was about to travel.

The evolutionary, cumulative nature of Bruce's painting is also evident in the palette and color usage of the geometric still lifes. They share a similarity in construction in the relationship of the color planes to the early Fauvist-Cézannesque works and to the Compositions, and extend the color principles he had learned from Cézanne, Matisse, and Delaunay and the nineteenth-century theorists. The color volumes became more architectonic and crystalline; but the hues themselves, including the acid greens and purples, find their source in his earlier work. The number of hues are reduced and, with the exception of cat. no. D6, are flat and unmodulated. However, he employs series of major and minor triads, as well as infinite gradations of adjacent hues, just as he had in the Compositions. The major triad, based on the primaries—red, blue, and yellow—and the minor chord of the secondary colors—green, purple, and orange—are combined, interchanged, and alternated in a way that secures a place for Bruce as a modern master of color. The gradations of a hue can be infinite and subtle, as in the fourteen variations of blue in cat. no. D8, or the four shades of green and three of red in cat. no. D11. Or, he can employ the harmony of contrasts (also stemming from the Compositions) as in cat. no. D6, where a brilliant red is abutted to a garish purple, a jarring color note of an entirely different mood. Throughout, these colors are enriched and modified by strong elements of black and white (first used in the Compositions) especially black, as in cat. no. D9, where the role of the brighter hues reversed and they become chords playing against the lustrous blacks. As in the Compositons, the combinations are endless, and add an infinite richness and complexity to the paintings.

ALTHOUGH FEW in number, the paintings continue to yield countless formal and emotive problems, suggestions and relationships that can only be hinted at here. We are only now discovering his art (it cannot be said to be a rediscovery because it was almost entirely overlooked). We still have more questions than answers about the man and his art, and we can only guess where these extraordinary paintings would have led had Bruce not chosen to end his life. But we can be certain of one thing: his death marked the conclusion of the career of an exceptional painter, and was a loss that American painting could ill afford.

"It's true he didn't write many. But they were most beautiful. Even one is a lot, for certain things."
Saul Bellow, HUMBOLDT'S GIFT.

NOTES

1. The date of Bruce's death had almost always been given as 1937, and often has continued to be, even though I established the correct date in my *Synchromism and Color Principles in American Painting, 1910–1930* (New York: M. Knoedler and Co., Inc., 1965). The date was verified by Certificate of Death #24627, Department of Health, City of New York, Borough of Manhattan. The incorrect date stems from the statement on Bruce by Henri-Pierre Roché in the catalogue *Collection of the Société Anonyme* (New Haven: Yale University Art Gallery, 1950), p. 143. Roché said that in the spring of 1937 he learned Bruce had died several months earlier. Roché did not say Bruce had died in 1937, but that date had generally been accepted.

2. Most sources for Bruce's biography are given in full in the chronology, and many documents are reprinted in full. Thus, sources are generally footnoted in full in this essay only when they are not given in the chronology or document section of the book. The essay, therefore, should be read in close conjunction with these sections, as well as with the entries in the *catalogue raisonné*. In addition, the same abbreviated citations used in the *catalogue raisonné* for frequently mentioned sources are used in these footnotes.

3. Letter to Thomas Ashby Wickham at "Woodside," Richmond, Henrico County, Virginia (now in possession of Dr. and Mrs. Charles W. Porter III, of the same address).

4. Letter to William C. Agee, March 29, 1965.

5. For a full discussion of Henri and his impact, see William Innes Homer, *Robert Henri and His Circle* (Ithaca: Cornell University Press, 1969).

6. Chatterton letter, op. cit.

7. Reprinted in full (see "Documents," p. 214).

8. See the du Bois account, reprinted in full, p. 215.

9. Collection Mr. and Mrs. Henry M. Reed, Montclair, New Jersey.

10. Letter to Henri, December 7, 1905. (Collection of American Literature, Beinecke Rare Book and Manuscript Library, Yale University).

11. *Gil Blas*, September 30, 1907, p. 3.

12. For a full account of the school and Matisse's teachings, see Alfred H. Barr, Jr., *Matisse: His Art and His Public* (New York: The Museum of Modern Art, 1951), pp. 103, 116–18.

13. Guillaume Apollinaire, "Henri Matisse," *La Phalange*, December 15, 1907.

14. Lawrence Gowing, *Henri Matisse: 64 Paintings* (New York: The Museum of Modern Art, 1966), p. 6.

15. Letter to Emile Bernard, c. 1904, as quoted in George Heard Hamilton, *Paintings and Sculpture in Europe 1880–1940* (Baltimore: Penguin Books, 1967), p. 21.

16. For a superb, and pioneering, discussion of the importance of Braque's paintings done in the summer of 1908 see William Rubin, "Cézannisme and the Beginnings of Cubism," *Cézanne: The Late Work* (New York: The Museum of Modern Art, 1978), pp. 151–202.

17. In an unpublished letter of November 24, 1912 to his mother, Arthur B. Frost, Jr., commented that he and Bruce had "talked some" about Cubsim the previous night at the Steins (Collection Mr. and Mrs. Henry M. Reed).

18. Frost, who was working closely with Bruce, wrote to his mother in December 1912 (day uncertain) that "we are all interested in Delaunay. He seems to be the strong man who has come out of Cubism as Matisse was the strong man who came out of the Fauves." On June 20, 1913, Frost could write his mother that "Delaunay has discovered painting" (both letters, Collection of Mr. and Mrs. Henry M. Reed).

19. In a lecture at the Section d'Or exhibition held at the Galerie de la Boétie.

20. For a fuller discussion of the Puteaux Cubists and modern life, see George Heard Hamilton and William C. Agee, *Raymond Duchamp-Villon* (New York: Walker and Company, 1967), esp. pp. 89–103.

21. *L'Intransigéant*, November 19, 1913. (Reprinted in full in "Documents," p. 219, as are other critical comments quoted in this section.)

22. New York *Tribune*, March 23, 1913.

23. Sonia Delaunay, interview with William C. Agee, February 1964, and Barbara Rose, February 1978. The Frost letters also make frequent mention of the Bal Bullier.

24. Collection of Mr. and Mrs. Henry M. Reed.

25. Ibid.

26. Interview with William C. Agee, January 1964.

27. James Daugherty, in conversations with William C. Agee, 1964–65, and a letter to Katherine Dreier of February 12, 1949 (Société Anonyme Archives, Yale University) confirmed the date they were sent to Frost. Daugherty had an adjoining studio and was working closely with Frost in New York at that time.

28. Not at the Montross Gallery later that year, as I erroneously reported in my *Synchromism*, and in "Bruce."

29. Katherine S. Dreier, *Western Art and the New Era: An Introduction to Modern Art* (New York: Brentano's, 1923), p. 95. (See "Documents," p. 220.)

30. One hopes that, for once and for all, it will finally be recognized that Bruce was *not* a Synchromist. Like Russell and Macdonald-Wright, as well as the Delaunays and other European and American artists, Bruce was using a common set of color principles that are described herein. However, Bruce was using them to make a far different kind of painting than either Russell or Macdonald-Wright. I made this distinction quite clear in my *Synchromism*, but the confusion has persisted, as has the notion that my 1965 study *created* the confusion, as stated in Levin, *Synchromism*.

31. The best and most detailed account of nineteenth-century color theory and application is in William Innes Homer, *Seurat and the Science of Painting* (Cambridge: The M.I.T. Press, 1964.) Since the early twentieth century extended these theories intact, this book is also the best source for the color usage of this period.

32. David Sutter, "Les Phénomènes de la vision," *L'Art* 20 (1880).

33. James Daugherty, op. cit., reported that when Frost received the Compositions, he was so stunned by the incorporation of black and white that he immediately repainted his large painting *Colored Forms* of 1917 using these new elements.

34. Although Bruce is not mentioned, Christopher Green has brilliantly traced the evolution of this shift in his essay "Léger and L'Esprit Nouveau 1912–1928," in *Léger and Purist Paris* (London: The Tate Gallery, 1970), esp. pp. 32–37, and more fully in his book *Léger and the Avant-Garde* (New Haven: Yale University Press, 1976), esp. pp. 120–135.
 That even Matisse was not untouched by the influence of Gris and the new rationalism has been discussed by John Elderfield in his *Matisse in the Collection of The Museum of Modern Art* (New York: The Museum of Modern Art, 1978), pp. 105–07.

35. Green, *Léger and the Avant-Garde.*

36. No. 5, May 1916. No pagination.

37. *Sic.*, no. 8, 9, 10, August, September, October 1916. No pagination.

38. Ibid.

39. *Sic.*, no. 11, November 1916. No pagination.

40. See the Roché statement (reprinted p. 223), and the du Bois account (p. 215). In interviews with William C. Agee, January-February 1964, May Ray and Michel Seuphor also spoke of Bruce's withdrawn and discouraged manner.

41. *L'Esprit Nouveau*, no. 5, undated [1921?], p. 603; and no. 11–12, undated [1921?], p. 130.

42. *L'Instransigéant*, January 27, 1972, p. 2 (reprinted p. 220).

43. *L'Intransigéant*, November 3, 1922 (reprinted p. 220).

44. Paris, New York *Herald Tribune*, October 31, 1923, p. 2.

45. See Roché statement, p. 223.

46. See Roché statement, p. 223.

47. Helen Hessell, interview with William C. Agee, January 1964.

48. Previous writers referred to the paintings as being mechanical and invented, for example, T. B. H. [Thomas B. Hess] "Three U.S. Abstractionists," *Art News*, vol. 49 (December, 1950), p. 47. In my *Synchromism*, p. 36, I also suggested that they "function with the logic and sureness of a machine." In my "Bruce," p. 26, I wrote that the elements might be invented to some extent. However, intensive analysis of the paintings shows this to be far from the actual content of the paintings.

49. I am indebted to David B. Warren, Associate Director of The Museum of Fine Arts, Houston, and a leading expert in the field of decorative arts, for identifying the dates and sources of the tables, chairs, vases, and dishes in the photographs of Bruce's apartment.

50. Bruce was apparently obsessed with fresh fruit, especially oranges. This was related to B. F. Garber by Virginia Ahrens in 1962.

51. Confirmed by Roché's description of a canotier in his inventory of Bruce's paintings. See cat. no. D11.

52. I am grateful to Robert Jorda, a mechanical engineer of long experience, for helping to identify these objects.

53. Bruce had been collecting African art from an early date. His interest may have developed while studying in Matisse's sculpture class, where Matisse used African figures to demonstrate inherent qualities of volume.

54. Reprinted in full, "Documents," p. 222.

55. Meyer Schapiro, "The Apples of Cézanne: An Essay on the Meaning of Still," *Art News Annual*, 1968, p. 47.

56. Bruce's niece, Mrs. Virginia Payne Ahrens, recalls that on a visit to his studio in 1930 she did actually see three wood blocks (interview with Barbara Rose, November 1978).

57. The source of this and other elements was pointed out to me by Robert Jorda. In my "Bruce," I had suggested that the vertical concave element, and other shapes, might in part have stemmed from Bruce's African figures. However, I am now sure that only the mortar and pestle are African in origin.

58. For these artists in this context, see Green, *Léger and the Avant-Garde.*

59. James Daugherty, conversations with William C. Agee, 1964–65.

60. See "Documents," p. 223.

61. See my *Synchromism*, p. 50, and my "Bruce," pp. 29-30.

62. Agee, "Bruce," p. 29.

63. Robert Goldwater, *Space and Dream* (New York: Walker and Company, 1967), p. 27.

64. Johann Wolfgang von Goethe, as quoted in Renata Cipriani, *All the Paintings of Mantegna* (New York: Hawthorn, 1963), p. 110.

65. X-rays were taken of cat. nos. D1 and D6.

66. Bruce made the statement while Mrs. Virginia Ahrens was visiting him in 1930. It was recounted in an interview with William C. Agee, January 5, 1964.

67. I am indebted to Robert Jorda for the many hours he has spent with me demonstrating the functioning and character of these projections.

68. Seuphor, interview with William C. Agee, February 2, 1964.

69. See "Documents," p. 222.

The existing monuments form an ideal order among themselves,
which is modified by the introduction of the new (the really new)
work of art among them. The existing order must be, if ever so
slightly, altered; and so the relations, proportions, values of each
work of art toward the whole are readjusted; and this is conformity
between the old and the new.
— T. S. Eliot, "Tradition and Individual Talent," 1919

AN AMERICAN IN PARIS

THE favored subject of novelists, poets, composers, and film-
makers, the mythical American in Paris is one of the great
romantic themes of the twentieth century. Yet the reality of
those members of the "lost generation" who fled the narrow pro-
vincialism of America to seek adventure and liberation in the City
of Light, where the young, the gifted, and the revolutionary con-
gregated in the years before and after World War I, was more
often tragic than romantic. For the nonconformist spirits who
were attracted to high-risk situations, like the legendary daredevil
Harry Crosby and the doomed boxer-poet Arthur Craven, often
burnt themselves up in their own intensity. But theirs were minor
talents. A far greater loss was that of another American expatriate
who sought not distraction but greatness in Paris; an isolated and
solitary artist who finally achieved the totally original and radical
synthesis of the various modern movements he had assimilated
through years of study and labor, only to end his own life as a
penniless recluse.

In the heady days when Paris was, in the words of Ernest
Hemingway, a "movable feast," Americans from all classes and
regions were attracted to the most exciting city in the world,
where the modern spirit was announcing itself in all the arts. But
for Patrick Henry Bruce, France had a particular attraction. Since
colonial times, French culture had represented to Virginia aristo-
crats like Jefferson everything that was civilized and rational.
Even as a boy, copying illustrations from art books (cat. nos. A3–
A5) or studying the ancestral portraits that adorned the stately
antebellum mansions of the relatives and friends of the Bruce
family, Pat Bruce dreamed of the day he could follow the exam-
ple of his heroes, Whistler and Sargent, and leave behind the
provincialism of America for the rich culture of Europe, where
an artist might become truly great.[1]

For despite his outward modesty and reticence, Bruce harbored
large ambitions. His natural talent and facility had always been
recognized; he was a precocious artist encouraged to continue his
studies. Early on, he developed a pattern of aligning himself with
the most advanced art activity of the moment. Refusing the offer
of a good job in the real estate business in Richmond in 1902, the
recently orphaned Bruce left behind his family and, at the age of
twenty-one, enrolled in the New York School of Art. There
William Merritt Chase and Robert Henri were teaching the bold,
loose technique of the Munich School, challenging the tight
photographic realism of academic art. We know little about
Bruce's relationship with Chase; but we may speculate he painted
his first still lifes, the subject that would occupy him during his
mature years, in Chase's classes. For still life was a Chase spe-
ciality, whereas Henri, more interested in psychological expres-
sion, stressed figure studies and portraiture. In Chase's classes, the
virtue of the oil sketch, dashed off with the loaded brush, was
taught, often with demonstrations of the bravura technique by
Chase himself. An early portrait of a young girl, painted, accord-
ing to the sitter, in a few hours, is an example of Bruce's facility—
a facility he repudiated and criticized in others in later life[2] (cat.
no. A8).

Like Henri, who taught his students above all the virtues of

originality, Chase demanded that his students withstand criti-cism from academic minds: "Seek to keep up courage—even if you seem to be conceited," he advised.[3] It was an attitude that young Bruce, with his family pride and naturally aloof manners (sometimes perceived by others as condescending arrogance), would have found entirely compatible with his own inclination toward an independent spirit.[4] Chase was against transparent staining or tinting; both he and Henri stressed the importance of heavy impasto and the visible brushstroke, which gave a sensual vitality to the surface. During his later years, Bruce, with few exceptions, rejected transparency as well. Although they were later to part company, at the time that Bruce was a student at the New York School of Art Chase and Henri were in agreement about certain matters, particularly the high esteem in which they held the Dutch and Spanish genre painters who inspired Manet to work in a broad, generalized, painterly style.

In the summer of 1903 Chase took a class of students from the New York School to Holland to study the Dutch masters.[5] In the group was Helen Kibbey. One of the most gifted women students from the School, she was already a friend of Pat Bruce, and may have accompanied Chase to Holland also.[6] In any event, by early 1904 both Helen Kibbey and Pat Bruce were young American art students in Paris, in love with art and with each other. Talented, brilliant, and possessed of as salty a wit as her future husband—who was known for his sharp tongue and critical eye—Helen Kibbey, an Irish girl from Massachusetts, was more sociable, talkative, and outgoing than the intense, ambi-tious young man she posed for and soon married.

It was a function of Bruce's driving ambition, an ambition never openly admitted, that he moved ahead by ingratiating himself with his teachers and mentors. In New York Bruce had formed a warm friendship with Henri. In his first letter written to Henri from Paris, dated February 4, 1904, Bruce confided, "I am having a very delightful time with a studio by myself, and working hard. . . . When I look back on my stay in New York I realize how much I enjoyed it and I sincerely miss the fellows."[7] Among the fellow students he referred to were Walter Pach, Walt Kuhn, Samuel Halpert, Maurice Sterne, and Guy Pène du Bois, all of whom he would meet again in Paris. But his particular friend, apparently his closest companion during his year in New York, was Edward Hopper. Expressing his admiration for Hopper, with whom he would soon share his new enthusiasm for Post-Impressionism, Bruce wrote, "I expected Hopper to get the painting prize of course."[8]

Henri had been especially encouraging and helpful to Bruce. He had framed Bruce's *War Portrait of W. T. Hedges*, a study of a hunchback instructor at the New York School that had brought Bruce fame among his fellow students, and in January 1904, sent it to the National Academy of Design exhibition while Bruce was in Paris. On March 23, 1904, Bruce wrote a long letter to Henri expressing hope that he would "profit by your encourage-ment and live up to your hopes." During Henri's student years in Paris in the 1890s, he had formed a friendship with the Canadian landscape painter James Wilson Morrice, whom Bruce appar-ently contacted as soon as he arrived in Paris. By this time Morrice was a fairly successful Post-Impressionist; he imitated Vuillard and the Pont-Aven School, and later accompanied Matisse to Morocco.[9] Bruce mentions Morrice in several letters to Henri, from which we may conclude Morrice was probably his first con-tact with Impressionism.

Encouraged by Morrice to submit to the "new salon," Bruce informed Henri he was pleased that three paintings had been

accepted: a full-length portrait of Helen, a figure study of a man in a blue cape, and the head of a child laughing.[10] All three were typical Henri themes that would have been more in place in the exhibition of Henri students who showed together in New York a few years later as The Eight. Bruce, however, was hard at work establishing a reputation in Paris. Still following Henri's instructions, he picked up interesting subjects off the street to study them as picturesque types. Anxious for approval, he sent Henri photos of the man in the cape and the portrait of the boy: "The photo does not give it," he explained apologetically, "but I treated the blue cape and black hat in the silhouette, and the face and hand as the only light spots and these modelled only by the silhouette (on the edge)."[11] Henri was not impressed. He thought—correctly—that Bruce had no insight into character and psychology. Bruce was forced to concur: "I agree with you entirely as to how most of the human creatures are presented foolishly and uninterestingly and in a character they do not possess." Nevertheless, he continued painting full-length figure studies and portraits, apparently in a style related to Whistler.[12]

Nothing remains of these life-size figures or portraits painted by Bruce in Paris before he became converted to Post-Impressionism. We may conjecture that they were studio works, tonal studies painted with homage, not only to Whistler, but probably also to Henri's other heroes, Sargent, Manet, and the Dutch and Spanish painters who inspired them.[13] Expressing admiration for the two expatriated Americans in whose footsteps he hoped to follow, on May 3, 1904, Bruce wrote Henri: "I have come to the conclusion that artists are born, not made—and that they are few and far between. With the exception of the Whistlers and the Sargents in the new salon, I don't consider there is a big dignified portrait in the two shows." Still seeking his teacher's approval,

he assures Henri that the new works he will show at the Philadelphia Academy and in New York the next year are much better than the photographs he has sent. He plans to go to London to see the Whistler exhibition, hoping this will produce "new ideas and new work." He has become engaged to his classmate Helen Kibbey; he asks Henri, "Do you remember her in the School?"[14]

After a brief trip to America in 1905 to settle his father's estate and marry Helen, Pat Bruce returned to Paris with his bride. They rented a charming place in a garden on the boulevard Arago, which became a rendezvous for Americans like Maurice Sterne (who lived across the street), Samuel Halpert, Walter Pach, and Guy Pène du Bois. The Bruces entertained modestly but with style, and art was talked of "seriously, frowningly, with no funny business."[15] Bruce's last letter to Henri is dated in 1907. Apparently, once Bruce had become converted to Post-Impressionism the two drifted apart. In a few brief years the student had outdistanced his teacher. When Henri visited Paris in 1908, Bruce convinced him to see the Salon d'Automne, hoping to illuminate Henri as he had Hopper. But when Henri returned to America, he was not at all convinced of the validity of the French modernist "freaks." Instead he threw himself into promoting a new school of illustrational social genre that critics dubbed the Ash Can School and that dominated American art for decades.[16] In Paris, however, his restless former pupil no longer needed Henri's approval. For Bruce had a new master now: the leader of the "freaks," Henri Matisse himself. Transferring his loyalties as completely to a French father figure as he had once pledged them to Henri's aesthetics, Bruce was free at last to paint in the modern style.

THE FATHER OF US ALL

*I could mention the name of a great sculptor who produces some
admirable pieces, but for him a composition is nothing but the
group of fragments and the result is a confusion of expression. Look
instead at one of Cézanne's pictures: all is so well arranged in them
that no matter how many figures are represented and no matter at
what distance you stand, you will be able always to distinguish
each figure clearly and you will always know which limb belongs to
which body.*

—Henri Matisse, "Notes of a Painter,"
La Grande Revue, December 25, 1908

IN THE FALL of 1906, Patrick Henry Bruce made new friends who
were to play a decisive role in his life, helping him to integrate
himself fully into the School of Paris. Probably through Walter
Pach, who acted as a go-between for young Americans in Europe,
Helen and Pat Bruce met a family of Bohemian expatriates from
Baltimore. With a passion for modern art and an openness to
new ideas in common, the attractive young artist couple soon
became fast friends with Gertrude Stein and her brothers, Leo
and Michael. By the time Alice B. Toklas arrived on the scene in
1907, the Bruces were intimate with the various Stein camps.[17]
Soon Pat shared Leo's immense enthusiasm for Cézanne, on
whose virtues Leo could discourse endlessly. For Cézanne's works
were attracting special attention in the retrospective exhibition
in the Salon d'Automne of 1907, commemorating his death the
previous year. Sarah Stein, who idolized Matisse (as did her
brother-in-law, Leo), was also a painter. She and her husband,
Michael, had the greatest Matisse collection in their apartment in
the rue Madame. Between the collection on the walls of the rue
de Fleurus and that of the rue Madame, Bruce had adequate
opportunity to absorb the lessons of Fauvism at leisure.[18]

Through the Steins, Bruce was introduced to *le tout Paris* of
the arts, including those two battling lions of the moment,
Matisse and Picasso. Once again, he had managed to be at the
center of the action. The atmosphere of Gertrude's salon is vividly
evoked by Alice B. Toklas's description of a dinner party held in
the fall of 1907. Picasso was the guest of honor. After dinner,
more guests came:

> [Gertrude] introduced a good-looking red-haired man, Pierre
> Roché, who spoke a smattering of several languages including
> Hungarian; Hans Purrmann, a German painter devoted to Matisse;
> Patrick Henry Bruce, who with Mrs. Michael Stein had persuaded
> Matisse to open his school . . .[19]

Also present were Braque, Apollinaire, the American society por-
trait painter William Cook, and a young Russian girl, Olga
Merson, who later also joined Matisse's class. Thus, as he would
again later when it suited him, Bruce exchanged one group of
friends, the young American expatriates who were ex-Henri stu-
dents, for another, the far more stimulating group that gathered
at 27, rue de Fleurus. Cook and Olga Merson became good
friends. Jacques Lipchitz, who met the Bruces at Leo Stein's, as
well as Chagall, who Helen remembered as "very poetic and
beautiful," were among Bruce's new acquaintances.[20] In 1906,
both Matisse and Picasso became interested in African art. Bruce
must have taken part in their discussions, for by 1910 he too was
collecting African wood sculpture. Later he would become known
as an expert in the field.[21]

In April 1907, the Bruces traveled to Berlin so that Helen could
give birth to their only son, Marion Roy. Bruce felt conditions
were more sanitary in Germany; moreover, the Bruces had Ger-
man friends and had traveled several times to Berlin.[22] By 1912,
the German dealer Maurice Feldmann had bought several still
lifes from Bruce. These were among the only sales he ever made.[23]
After Roy's birth, Helen went to the Steins less often, but Pat was
still a regular at Gertrude's Saturday open house.[24] In the fall of

1907, the talk centered on persuading Matisse to teach the principles of Fauvism to the group of admiring young artists who frequented the Steins. Sarah Stein was already studying informally with Matisse. According to Toklas:

> Sarah had become the favorite pupil of Matisse at the School she and Patrick Henry Bruce had persuaded him to open. Sarah and Pat had the studio, a very large one near Matisse's flat and his studio, which had a low rental even for those days…Pat Bruce had a sharp eye and a sharper tongue. He thought Sarah Stein overdid the admiration of Matisse, as a man not as a painter, for Bruce was a sincere follower of the Matisse School of painting.[25]

As for Picasso, Bruce had dismissed him: "Bruce agreed with the opinion of Matisse concerning Picasso," Toklas recalled, "unsympathetic as a man and less than negligible as a painter." Bruce never changed this negative appraisal, although he enjoyed the idea of lending Picasso money, since with the income Helen had from her aunt, Bessie Kibbey, he was better off those days than Picasso.[26] Thus by 1907, the year Picasso rocked the Parisian art world with his *Les Demoiselles d'Avignon*, Bruce had already cast his lot decisively with the leader of the Fauves and not with the pioneer Cubist. Indeed his antagonism toward Picasso was such that at a critical point it would hinder his development. By 1909, Cézanne had become the focus of Bruce's interest. For the next three years, the young American spent his time absorbing everything Matisse had to tell him about Cézanne's understanding of the relationship between form and color. Eventually he would come to criticize the man Gertrude referred to as "le cher maître"; but for the time being Matisse was his unchallenged master.[27]

Matisse's "Notes of a Painter," published in *La Grande Revue* in late 1908, reveal the central place Cézanne played in Matisse's thought at this time. Sarah Stein's class notes made of Matisse's criticisms of student work tell us that what Bruce learned in class was how color functioned to model form in space.[28] This was the problem that would occupy him for the rest of his life. As long as spatial and structural considerations remained at the heart of Matisse's art, Bruce would be his loyal disciple. But when Matisse turned away from Cézanne, adopting a flatter, more decorative style, Bruce continued his own researches into the structural meaning of color as primarily an element of plasticity rather than as an emotional or sensual expression. For with his difficult, self-critical, ascetic temperament, Bruce was far more in tune with the grave, sober art of the master of Aix than with the joyful and increasingly luxurious hedonism of Matisse. Matisse's most serious and philosophically inclined student, Bruce was more loyal to Cézanne in the long run than Matisse himself.

Bruce had a lot to learn from Matisse's interpretation of "the father of us all," as Cézanne was called in class. And with his usual persistence and thoroughness, he did not leave his teacher's side until he had totally absorbed the lessons to be learned from both Cézanne and Matisse. As Matisse had once apprenticed himself to the masters, Bruce now learned the basis of Matisse's style by imitating—too slavishly many would say—Matisse's work. The first to join Matisse's class, Bruce was the last to leave. In a note to the Steins, addressed intimately to "Dear Family," Bruce wrote that he missed them (they were in Italy) and that he was "quite at a loss what to do with myself on Saturday night—except 'get drunk.'" As for the Matisse class, he informed them "the studio is in working order—and painting is going on all over the place, indoors and out—models—still life and *paysage*—but many of the artist's have left." Of the original group, only a few, including Purrmann, Weber, Gandé, and Olga Merson, were left to "fight it out."[29]

As he had managed to capture Henri's attention, Bruce now entered into a special relationship with Matisse. For in 1908 he had rented an apartment above Matisse's own apartment, in the same Convent of the Sacré Coeur, on the boulevard des Invalides, where Matisse also had his atélier. The classroom was the convent refectory on the ground floor, in one end of which Matisse made his sculpture. Thus Bruce was in daily contact with both Matisse and his works. It was at this time that, imitating the master, he grew a beard, seen in the photograph of Matisse with Bruce and the other students in his sculpture class (see p. 00, fig. 00). These were years of the analysis and assimilation of Post-Impressionism for Bruce. Sometimes he would paint the same motif in different styles derived from the leading Post-Impressionists. For example, in a series of still lifes of apples on a plate, the different versions reflect the influence of Cézanne (cat. nos. B50, B52, B54, B55), van Gogh (B72), and Gauguin (B53), respectively. By 1911, Bruce's still lifes of fruit and flowers were accomplished paintings in the brilliant Fauve style of Matisse's 1907 *Blue Still Life,* which he had apparently studied carefully, since it hung in Sarah Stein's living room.

That there was a warm friendship between Matisse and his young American student who was twelve years his junior is evidenced by Matisse's gift of a self-portrait drawing inscribed to Bruce.[30] According to Matisse's daughter, who often painted in the same class with her father's students, Matisse had a high regard for Bruce, whom he considered one of his most gifted and "sensitive" students at the moment when the quality of *sensibilité* was especially prized.[31]

Pierre Matisse and Marguerite Matisse Duthuit remember Bruce well, since they saw him daily during 1908. Bruce was cordial, but he seemed always preoccupied by some private problem he was trying to solve.[32] As a young child, Pierre Matisse

climbed the stairs to visit the Bruces. He was shocked at the looseness and sloppiness of Bruce's household, not at all like the well-ordered, disciplined Matisse ménage. He was particularly surprised to see the casual, negligent way Bruce treated his paintings, as if they were worthless.[33] The paintings were stacked all around the room, but face out—not toward the wall, as they should have been to be protected. Bruce was painting prolifically at the time, the still lifes set up by Matisse in the studio, landscapes, and portraits.[34] There is, however, no evidence Bruce ever painted the nude, although of course he must have since Matisse stressed painting the figure, and since Matisse's sculpture class, in which he was also enrolled, worked from nudes.

Often the Bruces would bring Roy, an active toddler, out into the courtyard of the convent to play. Helen Bruce was much shorter than her husband, with a head that seemed too large for her body. She was very fair, and had blond hair down to the ground, which she wore in an enormous braid across her head. Roy was a bit of a devil; when Bruce and Matisse would become engrossed in conversation, the boy, unnoticed, would take the keys out of all the furniture in the Matisse apartment.[35]

The paintings Bruce produced under Matisse's influence during 1910–12 represent his initial attempts to come to grips with the essence of Cézanne as the painter who first gave color a constructive role. As long as he lived, Cézanne, rather than any teacher or other influence, would remain Bruce's primary inspiration. In a touching gesture of homage, he painted Helen as Mme Cézanne (cat no. B27). Although his first years in Paris coincided with the height of Cézanne's popularity among younger artists, Bruce was not equipped to understand or appreciate the Salons of 1905, 1906, and 1907, which featured Cézanne's works, until Matisse opened his eyes. But by 1911, when Helen left for America with a roll of Pat's canvases plus samples of her own

work,[36] Bruce was painting in a highly assured Cézannesque style derived from Matisse that, while not yet original, was very accomplished. Using color contrast rather than light and shade to model form, between 1910 and 1912 Bruce began interpreting still life as a monumental subject. In Matisse's sculpture class, which Bruce also took, Matisse taught that the purpose of studying sculpture was to understand better how to represent volume in painting. No one took him more literally than Bruce, who managed to give a high degree of sculptural relief to his plates of fruit and vases of flowers through the disposition of warm and cool colors arranged in ascending and descending chromatic scales, separated into individual brushstrokes, each of which represented another angled plane in space.

The studies after Cézanne continued during the summers of 1911, in Boussac, and 1912, which the Bruces spent in Belle-Île-en-Mer, an island off the coast of Brittany. Here Bruce and Arthur B. Frost, Jr., by now inseparable companions, painted together and romped on the beach with Roy. Helen, who had by this time given up painting, cooked, sewed, and arranged still lifes of fresh flowers from the garden for Pat to paint. In a letter to Gertrude and Alice, Helen described the pleasures of Belle-Île.[37] In the summer of 1912, Bruce's attention focused on the theme of leaves, which he painted very close up with a thick impasto of swirling strokes in a technique more reminiscent of van Gogh than Cézanne—although his examination of the varieties of the shades and tints of green recalls Cézanne's landscapes and cool palette (cat. no. B65). Leaving areas of the canvas exposed around the central motif, Bruce is clearly inspired in some of these paintings by the late works of Cézanne, to whom he has now apprenticed himself with total dedication (cat nos. B58, B60–B63).

But Bruce was too ambitious to spend his life as a Cézanne imitator. He and Matisse had disagreed about theories; by this time Bruce was developing his own sense of priorities and becoming critical of his former teacher. In a card to Gertrude Stein, apparently written in the spring of 1912 while the Bruces prepared their departure for Belle-Île, Helen complained that Matisse had become as academic as a Beaux Arts professor.[38] Her attitude undoubtedly reflected Pat Bruce's decision to change his painting style.

It was time for Bruce to move on; but given the logic and consistency of his mind, any new influence in Bruce's life would have to represent a further step on the road he had already embarked on as a student of color theory under Matisse. It was perhaps inevitable that Bruce's new mentor should be the artist most involved in extending the scientific color theories developed by Seurat and Signac, with the aim of synthesizing them with Cubist structure in abstractions based on color relationships. Thus when Sonia and Robert Delaunay happened on Frost and Bruce out for a walk with Bruce's family sometime in the spring of 1912, their meeting was decisive. With his auburn beard, his collar open, wearing neither jacket nor tie, his bare feet shod in Raymond Duncan-style sandals *à la grecque*, Bruce was every inch the American Bohemian.[39] The Delaunays found much to talk about with these bright young Americans, and soon the two couples, with Frost often in tow, were visiting each other's studios and going out to cafés and exhibitions and to the popular Montparnasse dance hall across the street from the Closerie de Lilas, the Bal Bullier.

When the Bruces returned from Belle-Île in the fall of 1912, Pat began going regularly to the Delaunays to hear Robert lecture on color theory. Sometime that year, Bruce met another brilliant American, one who had been Santayana's protégé at Harvard, as Gertrude Stein had been William James's most promising student. Seven years younger than Bruce, Harrison Sprague Reeves,

like Bruce, had ancestors who fought in the Civil War. Also of Scotch descent, Reeves could trace his family to the Mayflower, which must have given a sense of kinship to the snobbish descendant of Patrick Henry. Reeves had been sent to Paris as a correspondant for the New York *World*. Apparently he moved in with the Bruces, for in two letters to Gertrude Stein of 1913 (one inviting her to dinner with Santayana), he gives his return address as 6, rue de Furstenberg, where the Bruces were living in a comfortable flat. Pat painted in the living room.[40] Reeves often accompanied Bruce to the Steins and the Delaunays. Talk at the Delaunays was not only of art, but of literature as well. Their large circle of friends included composers, writers, critics, poets, and fashion designers as well as artists, or at least those artists willing to listen to Robert Delaunay expound his interpretations of color theory. The mathematician Princet was a good friend, too; and Robert tried to incorporate advanced mathematical concepts as well as the fashionable esoteric "psycho-physics" of Charles Henry into his color theory, which he wished to anchor to the objective world of mathematics and science.[41]

Generous and amiable, the Delaunays did everything in their power to advance Bruce's career, frequently inviting him to exhibit with them, even after Bruce had rebuffed their social invitations. Friendship with the Delaunays had other advantages as well, for they had realized the artist's fantasy: they had a live-in critic. Apollinaire, deserted by Marie Laurencin, was living with them in the fall of 1912, promoting the work not only of Sonia and Robert, but also that of their friends. Although it is always assumed Bruce was deeply in thrall to Delaunay during the two years of their intimacy, he apparently maintained a formal relationship with the Delaunays, addressing them as "Monsieur" and "Madame" in notes, whereas Gertrude and Alice were "dear girls" or "dear family." In a note to Gertrude

and Alice, apparently written before leaving for Belle-Île in the summer of 1912, Bruce confides dryly: "The Delaunays have gone. T'was somewhat a relief. He was so kind about talking all the time that I found I was learning French too rapidly."[42] Although the Delaunays invited Bruce repeatedly to visit them in the country, as had Frost, Bruce always refused. Moreover, he seems to have regarded Delaunay's infatuation with "modern" subject matter as foolish, remaining true instead to Matisse's insistence that literary subjects had no place in painting. From Belle-Île he wrote Delaunay a tongue-in-cheek note in the summer of 1913 that expressed his sceptical attitudes toward progress and modern themes: "We have had aviation on Belle-Île. It was very pretty. I'm sending you a card signed by the pilot who flew on Sunday. He only broke three electric wires. The peasants have changed a lot. Last year they said 'dame oui' and this year they say 'oui dame.' "[43]

SYNCHROMISM AS PROPAGANDA

We ... decided to launch ourselves in the exhibition field, but about the same time Guillaume Apollinaire, the publicity writer for the Cubists and later for Marie Laurencin, was interested in Delaunay and we recognized him, G. A., as the man above all we had to slap down.... So, to escape the inevitable necessity of the French critic to drag us under a banner with which we had not the slightest affinity, we invented the word Synchromism....
 –Stanton Macdonald-Wright, Letter to Joan Washburn,
 March 14, 1971

THE YEAR 1912 was a turning point for Bruce. After this year of his decisive encounter with Delaunay, he painted no more portraits or still lifes from nature.[44] Even if he was to be an abstract painter for only a brief four-year period, he was now free to interpret color relationships as conceptual constructs as opposed to

observed phenomena. This liberation from the motif eventually permitted him to extend Cézanne's formal principles into a more abstract and purely intellectual order.

As the various Cubist factions warred with each other for the attention of Apollinaire, the one critic sympathetic to their efforts, and Kahnweiler, the one dealer anxious to show them (both were writing histories of Cubism), splinter factions proclaimed themselves as "movements" with a historical role. Not until the late sixties in New York did theory and novelty proclaim itself as innovation as noisily as it did in Paris in 1912–13. "Schools" of Cubism were identified and referred to in the press, assuring their members at least some brief place in the sun. Among those vying for attention most vociferously were two Americans who, like Bruce, were interested in the possibility of adding brilliant color to Cubist abstraction. Much has been made of Bruce's alleged relationship to Synchromism, a relationship that in fact did not exist. The source of this confusion is that two of Bruce's contemporaries, Morgan Russell and Stanton Macdonald-Wright, decided to promote themselves as "Synchromists" to compete with the Delaunays, who were being called "Simultaneists." Russell had been a fellow Matisse student with Bruce; but Bruce, whose social life consisted of Frost, the Steins, and Matisse himself, apparently did not spend time with Russell. Nor is there any indication of contact between Bruce and Russell's friend, Stanton Macdonald-Wright.[45] Neither Russell nor Wright was a regular at the Delaunays. Rather, they learned second-hand about Robert Delaunay's theories regarding a synthesis of Cubist form and Neo-Impressionist color, which were being hotly debated in the cafés of Montparnasse.

From his brother, art critic Willard Huntington Wright, Macdonald-Wright learned that artists' statements made good publicity; and since Apollinaire showed no signs of recognizing

their efforts, Russell and Wright set about to make their own propaganda with a manifesto of Synchromism. Their paintings were based on abstractions of the figure. Michelangelo's sculpture of the *Bound Slave* in the Louvre was a favorite point of departure.[46] The idea of diagramming an Old Master's works would not have occurred to an artist with Bruce's commitment to originality; and certainly he never signed a manifesto of any kind. While Russell and Macdonald-Wright were vigorously promoting their new "movement," Bruce was experiencing a brief but intense intimacy with the Delaunays. As he had earlier chatted with Matisse in familial surroundings, now he and Helen often shared the domesticity of the studio on the rue des Grands Augustins, within walking distance of their new apartment on the rue de Furstenberg. Although Robert was four years younger than Bruce, he was not only more advanced as an artist, he was also far better connected in the art world of Paris and Berlin, whose doors he helped open to the American friend whose talent he recognized.

After a summer in Belle-Île, Bruce wrote Delaunay on his return to Paris in September 1913: "I don't have enough paintings to send others to Berlin, but I thank you for having thought of me. I need to work."[47] Nevertheless, Bruce did send two paintings, both landscapes (cat. nos. C1, C2) to the "Erster Deutscher Herbstsalon" organized by Herwarth Walden at Der Sturm Gallery. Apparently Bruce, the only American other than Hartley to be included in the show, was invited because of Robert's interest in his work. These large paintings were his first abstractions. Even seen only in bad photographs in contemporary periodicals, their debt to Delaunay's The Windows is obvious. We can get some idea of them from Apollinaire's reviews of the Salon des Indépendants in the spring of 1913, and the Salon d'Automne the following fall, to which Bruce apparently submitted the same two paintings he sent to Berlin. At this time

Apollinaire was the most influential art critic in Paris; writing for *L'Intransigéant*, *Soirées de Paris*, and *Montjoie!*, he monopolized the art press. Reviewing the Salon d'Automne in November 19, 1913 in *L'Intransigéant*, Apollinaire praised the two paintings by Bruce that "gave prominence to this sensitive artist . . . The works of Bruce and Picabia are the most striking to the eye. And now painting addresses itself above all to vision." In another review of the same salon, he compares the "zones" of color in Bruce's *Composition* (cat. no. C2) with Roger de La Fresnaye's *Conquest of the Air*, saying that Bruce's painting is the only example of simultaneous color contrast in the salon.

Shortly after Apollinaire wrote approvingly of his first abstractions, Bruce apparently had a falling out with the poet-critic, who seems at this point to be gradually moving out of Delaunay's camp into that of Picabia. In an imperious note to Apollinaire of November 20, 1913, Bruce demands the return of some photographs he has loaned him: "I am surprised that after all your experience with pictures and photographs, you are not able to judge beforehand as to the value of black and white reproductions. Nor did it occur to me when you asked me to have pictures photographed that you were ignorant as to what the result would be."[48]

Apollinaire's next review of Bruce's work was sharply critical. Reviewing the 1914 Salon des Indépendants in *L'Intransigéant* (March 5, 1914), Apollinaire berated the Delaunay's young American protégé for overreaching himself: "I like the canvases Bruce showed at the Salon d'Automne better: here the subject of his canvas is so vast that I am not at all surprised if the painter has been unable to take it all in." The painting Bruce exhibited in that Salon was the largest he had ever attempted. In its subject matter and scale, it was an obvious challenge to Delaunay himself. Titled *Mouvement, couleur, l'espace: Simultané*, the

large abstraction was Bruce's most orthodox Orphist painting. As far as Apollinaire was concerned, Bruce was not up to the task he set himself. Another slap at Bruce's new ambition to rival Delaunay at his own game came from André Salmon. Reviewing the Indépendants in *Montjoie!* in 1914, where Bruce's painting was reproduced (on its side), Salmon concluded that *Homage to Bleriot* was Delaunay's most important painting since The Windows, but that in Mme Delaunay "form is broken and in M. Bruce it disappears." Eventually Bruce would be forced to admit he had no more gift for large-scale abstraction than he had for painting picturesque figures. But he was not yet ready to give up the challenge to equal the Old Masters that painting large-scale decorative public works implied. For in Paris before World War I, painting the "big picture" was as much a proof of mastery and ambition as it was in New York after World War II. It was the measure of an artist's maturity, an indication of confidence.

We know *Mouvement, couleur, l'espace: Simultané* (fig. 1) only through photographs, but it is illuminating to compare it with Morgan Russell's single major painting, *Synchromy in Orange: To Form*, 1913–14 (fig. 2), which is coincidentally roughly the same size, format, and date as Bruce's painting. Bruce, still influenced by the Delaunays, is painting whirling discs and transparent, interpenetrating planes of color. Russell, on the other hand, has begun to structure his opaque planes of color in terms of sculptural volumes, possibly because he was, at the time, more seriously involved in sculpture and in Picasso's volumetric Cubism than Bruce. Although Bruce also studied sculpture with Matisse, and as we know was among the first collectors of African art, he never made life-size, "heroic" figures like Russell's.[49]

An obvious source of Russell's impressive monumental abstraction from the figure were Picabia's over-life-size Cubist figure

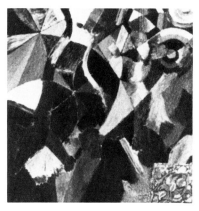 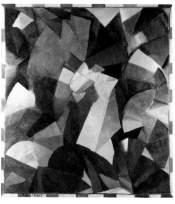 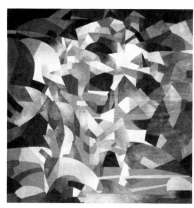

FIG. 1. Patrick Henry Bruce. *Mouvement, couleur, l'espace: Simultané,* 1913–14 (detail of an installation photograph; the tapestry in the lower right corner is not part of the painting) (*left*);

FIG. 2. Morgan Russell. *Synchromy in Orange: To Form,* 1913–14 (*center*); and

FIG. 3. Francis Picabia. *Danses à la source,* 1912 (*right*).

abstractions exhibited at the Section d'Or in 1912, such as *Danses à la source* (fig. 3). Russell, not attached to Delaunay, was looking at Delaunay's rivals, Picabia and Kupka, for inspiration, whereas Bruce was temporarily dominated by the personality and ideas of the couple who had adopted him as one of their family. Indeed, it seems that Bruce's intimacy with the Delaunays impeded his development. Both Russell's *Synchromy in Orange: To Form* and Picabia's *Negro Song* and *Physical Culture* were praised by Apollinaire when they were exhibited in the same 1914 Salon des Indépendants as Bruce's grandiose *Mouvement, couleur, l'espace: Simultané* that Apollinaire damned as a failure.[50] Bruce certainly understood that Russell, by following Picabia in painting abstractions from the figure, had forged ahead.

The possibilities of organizing opaque planes of color into dynamic compositions related to both the three-dimensional volumes of sculpture as well as to the rhythmic movement of the dance opened new vistas to Bruce. Whether through direct or indirect contact with Picabia, whose studio he and Frost visited with interest, by the time the Delaunays left for Madrid in the fall of 1914, Bruce had once again changed his style radically.[51] He had earlier proclaimed to friends his independence from Delaunay. Complaining about the cliques and the competition of the Parisian art world, Leo Stein wrote Lee Simonson on October 11, 1913:

Every one has a program and none have any critical sense—never saw so many little cliques. Russell and Wright find virtue in each other's work and in none other. Picasso and Braque are a world apart, and the six Futurists form an independent system. Delaunay stands in lonely grandeur on a mountain top. For a while he had Bruce in his train, but Bruce has ruptured the bond that left him revolving in Delaunay's sphere of influence and he is now a system all by himself.[52]

THE COMPOSITIONS

Picabia . . . is exhibiting his recent New York pictures . . . One of his subjects is a "Danse Negre"—a buck and wing . . . he saw on the east side . . . He shows us a grand shuffle of deep purple and brown curved globs of color—not the cubes this time. He interprets that clog dance in color exactly as Richard Strauss would in music.
—Jo Davidson in "Davidson's Sculpture Proves that Artist Has Ideas," CHICAGO SUNDAY TRIBUNE, MARCH 23, 1913

DESPITE HIS new theories that differed from Robert's, Bruce continued to frequent the Delaunays because as social connections they were invaluable. Indeed, even when they lost close contact with Bruce, they continued to praise his work and send people to see it. At the Delaunays, Bruce could run into Man Ray, H. P. Roché, and Tristan Tzara, destined to become leading figures of the Surrealist avant-garde after the war. A drawing of the Eiffel Tower by Robert commemorates the good times had at the Delaunays by artists and poets like Breton, Cendrars, Desnos, and Aragon, who signed the drawing. Across the bottom are the signatures: Arthur Frost "d'Amerique," Harrison Reeves "of New York," and P. H. Bruce "of Va."[53]

At the outbreak of the war in August 1914, many fled Paris. Bruce was still at Belle-Île in Brittany with Helen, Roy, and as usual, Frost, who apparently dogged their footsteps. Still recovering from an illness that had put him in a sanitorium, Frost decided to leave for America, as did many expatriate artists, including Alfred Maurer, Max Weber, Marsden Hartley and A. B. Carles. But Bruce, by this time thoroughly integrated into French society and a passionate Francophile, continued painting at 6, rue de Furstenberg.

Since he destroyed everything he painted between 1912 and 1915, we have no idea what colors Bruce was using, but we may presume he remained loyal to the high-key palette that Steichen found outdid Matisse in its "shrieking" garishness.[54] The last painting from nature by Bruce, the thickly painted, brilliantly colored *Still Life (with Tapestry)* of 1912 (cat. no. B73), contains small Impressionist patches of bright yellows, greens, pinks, and violets that became transformed into long, wide horizontal or diagonal strokes in the next group of extant works: the six Compositions of 1916 that Katherine Dreier hung as decorative panels in her Central Park West apartment[55] (cat. nos. C7-C12

and color plates 5-10). How much of Dreier's understanding of modern art was her own and how much she owed to Duchamp is arguable; however, writing in 1923 of Bruce's Compositions, which she identified as based on the motif of a costume ball, she shows considerable insight: "Bruce has continued his research, and has developed his abstract movements to a synthetic reality, which is monumental in its expression." Relating Bruce's Compositions to the Futurist Carlo Carrà's paintings, she concludes that Carrà's works "represent less of the monumental." Bruce's intention, she feels, is "to render motion through abstract forms of color." For her, his paintings were not too wild; rather they "shone and sparkled like some wonderful Eastern jewels."[56]

During the war, Henri-Pierre Roché was in New York; later, when he tried to trace Bruce's footsteps during this period, he found one of the few artists who remembered the silent, self-effacing American was Léger.[57] Although Léger was at the front, he spent his furloughs in Montparnasse. In 1913–14, Léger's new style, based on cylindrical volumes, was gaining attention as what was facetiously called "tubism"; and he seems to have replaced Matisse as the leader of those who would keep Cézanne's flame alive. There was much in Léger's art that Bruce could never accept, such as tonal modulation, and the separation of line from color. However, Léger's strong sculptural volumes in conjunction with Picabia's geometric, sculptural paintings of figures in motion, such as *Danses à la source, La Source,* and *Figure triste,* appear to have inspired Bruce to break with Delaunay's flat, decorative style and to seek to organize opaque, colored planes into volumes with a strong sculptural quality.[58] To take the next vital step in his development, Bruce would be forced to confront Cubism more seriously than he had in his ambitious but unrealized Orphist abstractions.

Indeed, from what we can discern, in *Mouvement, couleur,*

l'espace: Simultané Bruce was imitating Delaunay's semicircles and arcs (the principle motif of Bruce's lost *Le Bal Bullier* [cat. no. C3] as well) without really understanding their underlying Cubist syntax. Although in the summer of 1912 he had painted a landscape in the style of Braque's early Cubist *L'Estaque* series (cat. no. B67), Bruce's aversion to Picasso, both as a person and as a painter, appears to have prevented him from grasping the fundamentals of Cubist construction. As a Matisse pupil and admirer, he had developed sophistication as a colorist; but as a fanatical devotee of Cézanne, he would have thought Picasso diverged from the main road of Cézannisme. His problem, however, was that without understanding Cubism, it was impossible to paint genuinely abstract paintings. This was Bruce's dilemma in the years 1912–15, as he tried to catch up with later developments in Cubism carried out by Léger and Picabia, thus bypassing the Picasso problem entirely.

Apparently Bruce had allied himself so closely with Matisse

during the critical years when analytic Cubism was being formulated, that he ignored Picasso, whose flamboyant manner and anti-intellectual, untheoretical approach Bruce found antipathetic. While Russell and Weber studied the Spaniard closely, to the extent of copying his works, Bruce seems peculiarly blind to Picasso. On the other hand, Bruce's surviving landscapes from the summer of 1912 are reminiscent of Braque's L'Estaque paintings. Braque's cooler, more reserved and intellectual approach, untainted by primitivism of any sort, was more in keeping with Bruce's own taste. For despite his enthusiasm for African sculpture, Bruce's commitment was exclusively to civilized Western styles—to the point that he rejected all of the exoticisms popularized in Paris as novelties.

But Braque's art, totally rooted within the Western tradition, could appeal to Bruce. Indeed, we see an echo of Braque's 1911 *Still Life: Flute and Harmonica* (fig. 4) in Bruce's *Peinture/Nature morte*, c. 1920–21 (fig. 5). The general disposition of

Fig. 4. Georges Braque. *Still Life: Flute and Harmonica*, 1911.

Fig. 5. Patrick Henry Bruce. *Peinture/Nature morte*, 1921–22.

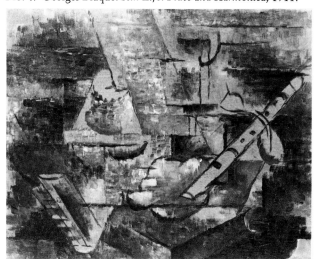

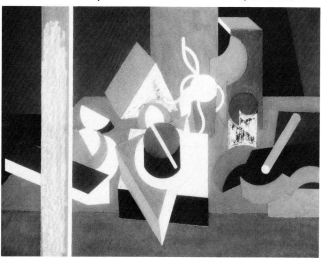

objects on a table, the projected wedges, and the dominant diagonal of the flute are all echoed in Bruce's paintings. However, because Bruce never went through an analytic phase when he became a full-fledged Cubist, his style was not based on the reconstitution of the facets of objects that had been fragmented during the analytic phase of Cubism. On the contrary, the peculiarity of Bruce's synthetic Cubist style is the completeness, the mass and gravity of the objects, which suggest fully sculptural three-dimensional volume rather than the flat planes parallel to the picture plane that synthetic Cubism inherited from its earlier, analytic phase.

Like the Cubist-Realists in America, Bruce had, as we shall see, a large debt to Duchamp, whose relationship to Cubism was uniquely antagonistic. Bruce, like Schamberg, Sheeler, Demuth, O'Keeffe, et. al., does not retrieve his hard edges from the open planes and painterly surfaces of analytic Cubism. Rather, like the American Precisionists, he chooses geometric objects as a *priori* compositional elements that are streamlined rather than analyzed. Analytic Cubism, no matter how close to abstraction it came, remained rooted in the world of observed phenomena. But once Bruce stopped painting from nature and began painting from photographs—the inspiration of the Cubist-Realists as well—his "reality" was an entirely conceptual construct. This accounts for the paradoxical abstractions he achieves in painting concrete objects.

It is difficult to trace this process of coming to terms with Cubism. Bruce apparently destroyed everything he painted in these years, including the works exhibited in the salons. We have a fragmentary notion of the paintings Helen Bruce called the "stovepipe" pictures, in reference to their cylindrical motifs, in photographs of Helen and Roy, apparently taken in 1915[59] (see fig. 7, p. 9). They reveal over-life-size paintings constructed of

angular, wedge-shaped planes of opaque color, no longer indebted to the Delaunays' transparent and overlapping circles and prisms, but to the more solid, more constructed geometric volumes that Picabia and Léger derived from Picasso. Both Helen Bruce and Sonia Delaunay remembered that Bruce's studio was full of these paintings when the war broke out.[60] Some of them apparently still existed in 1923, when Leon Kroll and his wife visited Bruce. Kroll recalled a life-size pink and blue abstraction of a boxer, who may well have been Reeves's and Frost's dissolute friend Arthur Craven. But during one of his periodic bouts of self-criticism, Bruce destroyed these paintings, the salvation of which Helen had referred to as her "life's work."[61]

Thus we may conjecture that Bruce, distressed by the negative criticism of his attempt to imitate Delaunay, was trying to evolve a more structured composition, which was already beginning to take on geometric characteristics in the cylindrical "stovepipe" paintings. These were probably large abstractions of figures—more than likely, given the cultural context, dancers or sports figures in movement. Such figure abstractions would have been a logical extension of Bruce's full-length figure paintings of 1905–06. In 1914–15, figures in motion were a favorite Futurist theme. Given Bruce's lifelong aversion to industrial subjects, moving figures represented a viable dynamic alternative to machine imagery. In the teens and twenties, many avant-garde artists searching for popular subject matter selected sports, especially boxing or soccer, and the new dances, especially the tango and fox-trot, to replace the themes of the popular spectacle of the circus, the picnic, the music hall, and the café concert that had occupied the Impressionists and Post-Impressionists.

Moreover, the Armory Show increased the interchange between Paris and New York, stimulating the growing Parisian infatuation with American popular culture. Picabia, Delaunay's flamboyant

Cuban rival, was among the first to see the possibilities of the new popular subject matter. In New York for the Armory Show, Picabia painted a series of large watercolors based on Manhattan's fast-paced nightlife. Three of these, including *Star Dancer and her School of Dance* (fig. 6), were reproduced in the New York *Herald Tribune*; and we know Bruce and Frost received American newspapers from time to time, and perused them in search of exciting themes.[62] Picabia returned from New York with tales of the excitement of Harlem night life; and at the Bal Bullier, ragtime began to replace conventional French pop music. The exoticism of black American music and dance, later brought to Paris by artists like Louis Armstrong and Josephine Baker, appealed to artists looking for an appropriately contemporary interpretation of the traditional themes of music and the dance.

In addition, Bruce had seen Picabia's *Negro Song* in the 1914 Salon des Indépendants.[63] The similarity between Picabia's New York watercolors and Bruce's Compositions is so striking it seems more than coincidental (fig. 7). Moreover, the pulsating rhythms of these, Bruce's most activated paintings, seem to reflect the new beat of popular music and dance, especially the sharp syncopation of black American music. An additional reason to think that Bruce was looking for subject matter in American popular culture is Reeves's preoccupation with American pop literature in 1914, when he published an article on the subject in *Soirées de Paris*.[64]

Since he took the trouble to ship them to America, we may conclude that Bruce thought well of his six Compositions, which are the liveliest, richest, and most radiant works he ever painted. But his infatuation with movement, light, and a jarring, acid palette was short lived. No sooner had the Compositions, with their debt to Futurist dynamism, left his studio than he began to turn to the more stable, ordered world that some leading Futurists—most notably Severini and Carrà themselves—were picturing in the static,

Fig. 6. Francis Picabia. *Star Dancer and her School of Dance*, 1913.

Fig. 7. Patrick Henry Bruce. *Composition II*, 1916.

metaphysical still lifes that replaced the mecanomorphic dynamic phase of Futurism. For the war had challenged the idea of progress, and a return to the values of traditional and especially classic themes replaced the forward-looking, fragmenting phase of Cubo-Futurism.

By the time Dreier praised Bruce's Compositions, they had been seen in a March 1917 exhibition arranged by Frost and Reeves at the Modern Gallery, a spin-off of Stieglitz's Gallery 291 that Agnes Meyer and Marius de Zayas had opened with Picabia's encouragement.[65] Reeves wrote the catalogue introduction that probably identifies the subject matter, but no copy has ever been found. *Composition II* was also seen in the 1917 Society of Independent Artists exhibition that was dominated by the scandalous R. Mutt case, and an unidentified Composition was shown in the 1920 Sociéte Anonyme show.

The works did not please critics, who saw them as derivatively Futurist.[66] Artists, on the other hand, realized that Bruce was exploring new territory with his technical experiments and attempts to create both space and light through color. James Daugherty, a painter who worked with Frost after Frost returned to New York in 1915, recalls the excitement when Frost unrolled the canvases Bruce sent him, for they seemed a radical departure:

> By adding black and white to color sequences and areas, the new canvases achieved a considerably more dynamic effect enhanced by applying the color in flat shapes and areas opaquely with a palette knife.[67]

Through Frost and Daugherty, Bruce's discoveries were widely circulated in New York. Thus Bruce's Compositions, painted in 1916 under the influence of Picabia, Léger, and probably Duchamp's shattered figure of the *Nude Descending the Stair-*

case, were the primary vehicle by which advanced Parisian color theory arrived in New York. Ironically, Bruce, who had nothing whatsoever to do with Synchromism, had transmitted, through the example of his paintings rather than through the bombastic and confusing statements of Russell and Macdonald-Wright, the essence of the scientific color theories of Neo-Impressionism. Herein lies the crux of the confusion of what Synchromism means to the history of American Art. As William Agee has pointed out, Russell and Macdonald-Wright had evolved a color theory articulated mainly in Russell's notes. Though wildly eclectic, these were based to a large extent on the ideas of the Canadian color theorist Percival Tudor-Hart. Russell's and Macdonald-Wright's acquaintance with the science of optics was at best superficial, whereas Bruce's intimacy with Delaunay had given him a much deeper grasp of the scientific sources, and his studies with Matisse had grounded him firmly in Neo-Impressionist color theory.

The superficiality of the Synchromist approach to color theory is exemplified in a statement by Russell's friend Andrew Dasburg:

> In my use of color I aim to reinforce the sensation of light and dark, that is, to develop the rhythm to and from the eye by placing on the canvas colors which, by their depressive or stimulating qualities, approach or recede in accordance with the forms I wish to approach or recede in the rhythmic scheme of the pictures.[68]

With recourse to the spatial conventions of representational art, in their ignorance or misunderstanding of Matisse's teaching, Russell and Macdonald-Wright continued to use graded color and tonal contrast to model forms in space rather than use the contrast of local color Matisse advocated. Dasburg, who shared a studio with Russell in Paris in 1909–10, had indeed summed up the essence of Synchromism, in which color was

essentially thought of as tonal gradation with chiaroscuro effects still playing their academic role. Leo Stein thought Russell brilliant; and for a brief period he seems to have been working to create space through the interaction of local color rather than through the modulation of a color through tonal gradations. But Russell was easily bored and quickly abandoned his abstract style. Only his masterpiece, the *Synchromy in Orange: To Form,* and a few related small paintings of 1914—15 such as the *Four-Part Synchromy, No. 7,* are painted with fully saturated opaque local color, and employ black and white as hues rather than tones. But quickly distracted by "cosmic" themes of whirling baroque clouds of color reminiscent of Kupka, Russell had little patience with either optics or geometry.

Bruce's Compositions, on the other hand, not only incorporate Matisse's ideas regarding the interaction of pure hue applied as local color, but also synthesize Matisse's concept of the space creating the function of color with the Delaunays' theories regarding the creation of light vibrations through the interaction of complementaries to achieve full intensity and maximum brilliance.[69] Yet another example of the clear-cut difference between Bruce's seriousness and thoroughness and Synchromist faddishness is exemplified by the manner in which Russell and Macdonald-Wright attempted to apply Sonia Delaunay's ideas regarding the creation of prismatic light: in a series of vulgar pseudo-Cubist paintings of 1912–13 they sought a shortcut to Cubist fragmentation of form, apparently by painting portraits and still lifes literally seen through prisms![70]

Although they begin in a shaky and tentative manner, with much overpainting and revision, Bruce's Compositions reveal a far more thorough understanding of the interaction of colors and of the potential of color to reflect light. Marking a radical break with his past as a disciple, first of Matisse, then of Delaunay, the

Compositions represent a new way of working for Bruce: slowly, methodically, deliberately, brushing white into his colors to create greater luminosity. Apparently his personality, too, underwent changes at this time. Helen preferred him when he painted quickly, rapidly sketching still life and landscape.[71] The increasingly intellectual, cerebral character of his paintings did not seem to her to equal the enormous effort Bruce was putting into them; and indeed their impecunious and difficult life in general began to seem not worth her sacrifices.[72]

Bruce's six extant Compositions, apparently based on photographs, are his initial attempts to create volume exclusively through color. Their allover balance is created by the interaction of the individual color planes. Although they are larger than the strokes in his earlier still lifes, these color patches once again fulfill a constructive role. Spatial tensions are carefully adjusted with deliberation, following Matisse's teaching that each subsequent addition of a color modifies the whole. The first indication of Bruce's originality as a subtle colorist, the Compositions are also proof of his deep understanding of what separates modernist painting from academic illusionism: the assertion of the integrity of the flat picture plane—the essence of Cubism that appears to have eluded virtually all the American painters of Bruce's generation, including the Synchromists. To war against that flatness and yet preserve its inviolability was to become his growing concern, as the fuzzy, painterly planes in the Compositions gradually assumed a more hard-edged geometric firmness.

By the time World War I broke out, Bruce had become as integrated into the Parisian milieu as his friends Lipchitz or Chagall. The Delaunays thought him easily the equal of the younger French Cubists; and Samuel Halpert made it clear he was the only American taken seriously in Paris. Unlike the celebrated expatriate painter Gerald Murphy, who lived the good

life on the Riveria, preferring parties to painting, Bruce was drawn into and remained at the cutting edge of the Parisian avant-garde. He saw every important show, read the current periodicals, and visited the studios of the innovators. Whenever change was in the air, he seemed the first to perceive it. In his intimacy with Picasso, Matisse, Derain, and the Delaunays and their wide circle of acquaintances, he was unique among American artists.[73] His decision to remain in Paris under siege rather than return to the safety of the United States was also singular, as was his unswerving commitment to Cubism, once he had made it. It was not in his stubborn, difficult, independent nature for Patrick Henry Bruce either to compromise or to look back. When the exiles returned, he stayed.

THE NEW SPIRIT

Three war years without touching a brush, but in contact with crude reality at its most violent.
 When I was discharged I could benefit from these hard years. I had reached a decision, without compromising in any way. I could model in pure and local color, using large volumes. I could do without backgrounds. I was no longer fumbling for the key, I had it. The war matured me, and I am not afraid to say so.
 —Fernand Léger, letter to Léonce Rosenberg, 1922
 (Published in BULLETIN DE L'EFFORT MODERNE, no. 4, 1924)

A poetry that without looking back, without pastiche, enriched by the preceding daring will disconcert the best literary milieu by seeming as little modern as possible: thus the newest of all.
 —Jean Cocteau, "Autour de De La Fresnaye,"
 L'ESPRIT NOUVEAU, no. 3, 1919

THE OUTBREAK of World War I inevitably and irrevocably altered the direction of the avant-garde. With many of its leaders absent—either to do battle or to flee from it—the Parisian avant-garde was changing its orientation, absorbing new ideas, and dropping some old allegiances. These changes understandably had a profound impact on Bruce's art, which continued to reflect the most "advanced" thought of the moment. As Paris emptied out, Apollinaire, Braque, Léger, Villon, Duchamp-Villon, and de La Fresnaye were called to the front, Matisse retired to the country, and the Delaunays fled to Spain and Portugal. Their places as leaders of the avant-garde were for the most part taken by foreigners. Among those who arrived during World War I were the Dutch neo-Plasticists Piet Mondrian and Theo van Doesburg, and the Italian ex-Futurist Gino Severini, who emerged as a leading polemicist for a classical, metaphysical art based on stasis instead of movement. The seeds of the metaphysical style had already been planted by Giorgio de Chirico, who introduced to Paris *pittura metafisica,* based on perspective, architectural vistas, and geometric symbols. In 1914, de Chirico exhibited *The Nostalgia of the Infinite,* a painting of a square surrounded by a classical portico seen in perspective, which created a stir at the Salon d'Automne. Before de Chirico left Paris at the outbreak of war, he sold dealer Paul Guillaume, Apollinaire's friend and later a close friend of both Roché and Cocteau, several metaphysical still lifes. In 1914, de Chirico's paintings began to be widely reproduced and talked about enthusiastically by Apollinaire, who had several hanging in his apartment.[74] In the group of "collapsed beam" paintings of 1924 (fig. 8), Bruce recalls the sliding objects and extreme oblique perspecive of de Chirico's *The Evil Genius of a King* (fig. 9). After de Chirico left for Italy, he and Carrà continued their patriotic efforts to establish metaphysical painting as a symbol of the future ideal world order, which was to emerge, not from French naturalism, but from Italian classicism. In their various reviews and publications such as *Voce* and *Valori Plastici,* which

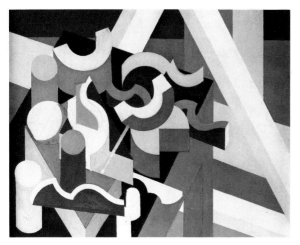

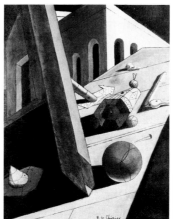

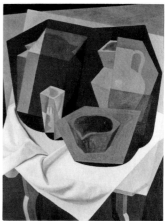

Fig. 8. Patrick Henry Bruce. *Peinture/Nature morte*, c. 1924.

Fig. 9. Girogio de Chirico. *The Evil Genius of a King*, 1914–15 *(left)*.
Fig. 10. Gino Severini. *The Blue Vase*, 1916 *(right)*.

were circulated in Paris, they preached a Pythagorean interpretation of geometry as a hermetic, mystical cult.

Since many galleries were closed during World War I (Kahnweiler's gallery, for example, was under sequestration because he was German), publications took on a new importance in disseminating new ideas. In England, the Vorticists were publishing *Blast,* which was full of reproductions of their work; in America, Stieglitz published *Camera Work* until 1917 and New York Dadaists produced a number of short-lived but influential magazines, including *291, 391, Broom, The Blind Man,* and *Rongwrong.* In 1917, the Dutch painters and architects, also seeking a *tabula rasa* through geometry, began to publish the influential neo-Plastic journal *de Stijl.* And in Paris, several important new reviews, including *SIC, Nord-Sud,* and *L'Elan,* all devoted to keeping alive avant-garde ideas, appeared during World War I. After the peace was signed, the most serious of these magazines, dedicated to innovations in politics and literature, as well as to all the visual arts, including film and photography, was founded. Its

title, *L'Esprit Nouveau*—the "new spirit"—summed up the aspirations of the generation that survived World War I: for a renewal of faith in man and his creations.

Since Apollinaire had died of a fatal head wound in 1918, the task of promulgating a new aesthetic fell to several articulate artists—most notably Gino Severini, a focal personality in Paris before his departure for America in 1917. In his autobiography, Severini provides a vivid recollection of the war years in Paris.[75] Describing the opening of the Futurist exhibition of the "Plastic Arts of War" at the Gallerie Boutet de Monvel in January 1916, Severini said the lecture he gave was concerned fundamentally with the metaphysical theme of "mystical exaltation of science." Among those who attended were Picasso, Modigliani, Gris, Metzinger, Lipchitz, Lhote, and Survage—in short, virtually all the artists of any importance left in Paris. Excited by the "plastic synthesis of ideas, the new plastic symbolism," Severini was beginning to publish influential texts stressing a mathematically based, static, transcendental, formal art, as opposed to the frag-

mented dynamism of Futurism. The death of his friend Umberto Boccioni, the leading Futurist personality, on August 16, 1916, appears to have changed Severini's orientation away from Futurist themes:

> I was discontent. At this time, I left my dancers, which by now had a lot of imitators, and began instead to paint static things, feeling it was not worthy to make my work easier by basing it on a subject.[76]

Thus in 1916, apparently sobered by Boccioni's death, Severini abandoned his dynamic dancers and volatile studies in movement, for a firm, classical style (fig. 10). This was essentially what Bruce would do in his transition from the music and dance-inspired Compositions to the static, architectural style of the Still Lifes he began painting, apparently around the time the United States entered the war. Moreover, a similar grief over the death of a friend would motivate this change.

Bruce's transition becomes more intelligible if we review the context within which it was made. In 1916, Paris, secure from invasion, began to move again. In March, Amédeé Ozenfant organized an exhibition of drawings by Derain, Marie Laurencin, Lipchitz, Picasso, Modigliani, and Jacques Villon at the salon of Bruce's friend Mme Bongard, a fashionable couturier and the sister of the eccentric designer Paul Poiret.[77]

Artists had begun to gather in Ozenfant's studio in Passy as they had once gathered at the Delaunays' or at Apollinaire's. Severini considered Ozenfant a well-intentioned, cultivated dilettante. "But his painting," he lamented, "to tell the truth didn't interest anybody. It was flat, flat like a door, and really without any profound intention in form or color. He was still publishing *L'Elan*. In the last issue, he published the *Notes on Cubism*. He wished a regenerated and purified Cubism, a new tendency, of which he would be the initiator, and he called it

'Purism.' And this was his conclusion—Cubism was a Purist movement."[78]

Severini's lectures and articles and Ozenfant's polemics were only part of a revival of the arts once Paris was safe from attack. Informal clubs like Art et Liberté, which called itself an "association for the affirmation and defense of modern art," organized concerts and theater pieces. The forward looking architect, whose theories were to influence the formulation of the International Style, Auguste Perret, was the president. One memorable event sponsored by this lively artists' club trying to keep up morale during the war was the performance at the Théâtre des Champs Elysées of Isadora Duncan dancing her "Exhortations to Victory." The programs always carried reproductions of modern drawings by artists like Severini and Matisse. Severini was also a participant in the affairs of the ultra-liberal Lyre et Palette Club—to which Picasso, Derain, Matisse, Léger, and Gris also belonged; it sponsored lectures by himself and Cocteau, among others, that called for a return to durable classical traditions.[79]

World War I destabilized European culture, and the search for a new stability was the main focus of Parisian art activity in 1917–19, the years in which Bruce evolved his monumental still-life style. The old order had clearly crumbled. The need for optimistic symbols of a new order logically found its answer in geometry, the basis of the classical ideal as well as of a neo-platonic transendence that had proved itself durable throughout the course of history. Severini recalls the mood of the day:

> I was still at the moment full of scientific mysticism; everybody was talking about space and the fourth dimension. I was in the grip of a passion for mathematics, and to understand it better and the concept of space better, I began to study the theories of Henri Poincaré, called the *Analysis Situs*.[80]

Among the first to perceive the "new spirit," Cocteau located it in Erik Satie's return to simple melodic forms in opposition to German polyphony. For Ozenfant and his fellow Purist, Charles Edouard Jeanneret, who would gain world fame as the architect Le Corbusier, the model of order was to be found in architecture, particularly in the severe, unadorned, geometrical style that Le Corbusier's mentor, Auguste Perret, was advocating as appropriate to the new materials industry was developing. In *L'Esprit Nouveau*, edited by Ozenfant and Le Corbusier beginning in 1920, architecture was presented as the incarnation of the new spirit that would supplant the decaying old order with hygienic living and engineered efficiency. Summing up the "new spirit" in their manifesto, *Le Purisme* (*L'Esprit Nouveau*, no. 4, 1920), Le Corbusier wrote:

> . . . there is no art worth having without the excitement of an intellectual order, of a mathematical order: architecture is the art which up until now has most strongly induced the states in this category. The reason is that everything in architecture is expressed by order and economy.[81]

Thus the classical revival was felt in the various arts as a step toward a new equilibrium after the disorder of war. The idea of geometry as a unifying principle, at once both metaphysical and scientific, was already implicit in the discussions of the Section d'Or as early as 1912. The displacement of painting by architecture as the most progressive art in the earliest formulations of the International Style in Paris, where Perret's personality became a powerful force in the years 1917–19, made it inevitable that geometric art would be the dominant style of the twenties. Moreover, classicism was for the victorious French a nationalistic reassertion of the superiority of French culture over Germanic "barbarism." Thus in Paris in the twenties, Plato replaced Nietzsche and Bach triumphed over Wagner as aesthetic models.

Once again Bruce's tastes changed in relation to the prevailing modes of avant-garde thought. In his library were copies of Plato and Aristotle, and the music he listened to now was the lucid fugues and sonatas of Couperin.[82]

THE CALL TO ORDER

The musician opens the cage to numbers, the draftsman emancipates geometry.

A poet always has too many words in his vocabulary, a painter too many colors in his palette, a musician too many notes on his piano.

The Impressionists were afraid of the bare canvas, the emptiness, silence. Silence is not necessarily a hole.
—Jean Cocteau, LE RAPPEL A L'ORDRE, 1923

THUS IN THE aftermath of World War I, geometry, the basis of the antique sources of Western Civilization, became the concrete manifestation of the "call to order" that would reinstate rational values after the barbarism of war. Because it coincided so perfectly with his patrician taste and ascetic, stoic temperament, Bruce was well prepared to answer this call for a classical revival. However, his intensely personal and original interpretation of a classicizing Cubism was not, like Purism, merely a simplification of still life to geometric solids. Rather, it was a fusion of elements from virtually all of the camps that shaped taste at the end of World War I: a poetic synthesis of the metaphysical still life, Léger's "new realism," and Duchamp's hermetic, alchemical formulas. Influenced by architecture, film, photography, fashion, music, and philology, Bruce's late works were so advanced and so thorough a summation of modern thought that they were literally invisible to his contemporaries and virtually unintelligible until the present. Indeed, painters like Marcelle Cahn, Florence Henri, and Gerald Murphy, who exhibited with Bruce in "Art d'Au-

jourd'hui,'' the influential avant-garde exhibition of 1925, had no recollection at all of his work![83] These works of Bruce's mature years, when at last he found his own unique and independent identity as a painter of architectonic still life were, more than anything, a continuation of pictorial problems raised by Cézanne. So complex was his synthesis of earlier pictorial traditions, however, that no one, save perhaps Roché, could comprehend these paintings. For this reason his activities between 1917, when the Compositions were exhibited at the Modern Gallery in New York, and 1936, the year of Bruce's death in New York City, are a mystery.

Fortunately, we have some clues regarding the contacts and interests that helped shape his new style. In 1918, Bruce was photographed with a group of American students in front of the Ecole des Beaux Arts (see fig. 9, p. 10). Since it is inconceivable that an abstract painter like Bruce was studying painting at the academic Ecole at this point, it is possible that he was not studying painting or sculpture, but rather that he was refreshing his interest in architecture at the progressive branch associated with the Ecole. Auguste Perret, the leading inspiration of ''l'esprit nouveau,'' had his own atelier in the Palais de Bois, which was attached officially to the Ecole.[84] Auditors passed in and out of these classes, in which Perret preached a trabeated architecture of poured concrete geometric volumes that would eventually evolve into the International Style. Given his nose for the new, it is more than likely that Patrick Henry Bruce was among them. It was in Perret's classes that Ozenfant met Le Corbusier. Here the initial program for Purism was formulated by Ozenfant and Le Corbusier, acting as polemicists in a manner not far removed from the propagandistic techniques of Morgan Russell and Stanton Macdonald-Wright. As Synchromism had its origins in Tudor-Hart's classics, so Purism was a classroom product. Once again, Bruce, who refused to

sign manifestos or to communicate his theories in writing, as if he had Matisse's ''artists should have their tongues cut out'' perpetually echoing in his ears, became associated with a movement that he in fact probably anticipated through his own independent research.

For if we can take Roché's word for it, Bruce began his architectural paintings sometime in 1917, considerably before Purism took shape as an influential style.[85] In any event, by 1919 Bruce's architectural style was fully formed. Possibly in conjunction with studies under Perret, Bruce abruptly abandoned the high-key, painterly Compositions and began to make small easel pictures, in pastel tints, of geometric objects; these were depicted using mechanical tools and techniques of engineering drawings.

Not only his paintings but also Bruce's physical appearance was radically altered at this time. From the young man Marguerite Duthuit recalled as ''gras et souple,'' he became the lean, elegant dandy in a dapper vested business suit, his arms stubbornly crossed, as if in defiance, in the photograph of the American students at the Ecole des Beaux Arts. Diet had altered his shape, but a new involvement in the world of business and a new circle of friends were reflected in his manner of dress. For the war had been exceedingly difficult for the Bruces economically. Helen had for some time been trading in jewelry and furniture, and ultimately Bruce himself was forced to take up in earnest the collecting and restoring of antiques that had been a hobby and a pleasure.

Like Gertrude Stein, Helen Bruce had driven an ambulance to aid in the war effort; in the back, she had kept Bruce's ''stovepipe'' paintings rolled up to protect them.[86] But she had begun to resent the fact that Pat appeared unwilling to support the family, by now in dire straits. For Roy the war years were a period of desperate poverty. By the end of the war, the rift between Helen and Pat was irreconcilable. No longer the charming, witty Bohemian

she had married, Bruce had become increasingly perfectionist, critical of himself as well as of others, and withdrawn to the point of having severe depressions during which he would stop painting. When he did paint, he pictured a closed, hermetic world, devoid of human life or any animation, a world of frozen forms locked in timeless stasis.

Apparently, the change in Bruce coincided with a deep personal tragedy that convinced him that the breach between the past and the present involved more than the rupture created by the war itself, and that old times could never be recaptured. In December 1917, his closest friend, his companion in art and life, his fellow traveler from the Henri school to the avant-garde of Paris, Arthur B. Frost, Jr., died of tuberculosis shortly before his thirtieth birthday. Writing to Frost's parents on May 13, 1918, Bruce lamented the loss of his beloved companion:

> Months and months we lived together in the greatest, closest intimacy and sympathy—painting, reading, walking, swimming, talking, eating together, my wife cooking the same food for us both. Never have I known such sympathy and freedom between any person as he and I had. . . . He and I had looked forward to a long life together. I have lost my life's companion and friend.[87]

Frost's death was the first of two traumatic events that changed Bruce's life after World War I. Helen Bruce, who had supported her husband, renounced her own painting and ambitions for him, and preserved his canvases at all costs, decided to take their twelve-year-old son and return to America. Thus by the end of 1919, when Helen left for good, Patrick Henry Bruce had little other than his collection of exquisite *objets* and his severe, precise art to keep him company. Bereft and suffering from the loss of his best friend, his wife, and his only child, he sought both diversion and meaning in the cold, impersonal world of aesthetics.

NATURES MORTES

The still life comes to stand then for a sober objectivity, and an artist who struggles to attain that posture after having renounced a habitual impulsiveness or fantasy, can adopt the still life as a calming or redemptive modest task, a means of self-discipline and concentration; it signifies to him the commitment to the given, the simple and dispassionate—the impersonal universe of matter. . . .

Still Life engages the painter . . . in a steady looking that discloses new and elusive aspects of the stables object. At first commonplace in appearance, it may become in the course of that contemplation a mystery, a source of metaphysical wonder. Completely secular and stripped of all conventional symbolism, the still life object, as the meeting point of boundless forces of atmosphere and light, may evoke a mystical mood like Jakob Boehme's illumination through the glint on a metal ewer.

—Meyer Schapiro, "The Apples of Cézanne: An Essay on the Meaning of Still Life"

ALONE NOW in the immaculate austerity and somber gloom of 6, rue de Furstenberg, Bruce returned to the theme of his youth, to which he dedicated himself with a single-minded sense of purpose.[88] From the end of the war until his death, he would paint no subject other than still life: a world of dead objects he could manipulate at will, arranging them in a perfection of which only he could conceive. Always wrapped in his own thought, Bruce became more inward and speculative than ever. His only joy was beauty, his only sharing the contemplation of exquisite objects with a happy few who might appreciate refinement and excellence as he did.

In these solitary philosophical and aesthetic pursuits, Bruce relied more and more on the company of "Harry" Reeves. Trained by Santayana in aesthetics, a serious student of philology, Reeves was one of Gertrude Stein's earliest admirers. In an article on American popular epics in *Soirées de Paris*, Reeves had shown considerable potential as an original critic.[89] But Harry

was as decadent and lazy as he was charming and brilliant. Having forsaken journalism for the more lucrative world of business, he now had enough money to rent a suite at the Ritz, dine on oysters, smoke opium, and enjoy the company of not only Isadora Duncan, but of an apparently endless series of ladies of the evening as well.[90] Now Reeves replaced both Helen and Frost in Bruce's life; and his tastes were for more exotic pleasures than the domestic *gemütlichkeit* of the Delaunay family. Unable to lose himself in dissipation like Reeves, Bruce, always introverted, arrogant, and withdrawn, became ever more remote, closed, and silent. His stomach was worse than ever, which meant he did not dine out, but continued to subsist mainly on a diet of almost raw vegetables prepared by his cook, Ernestine, and fresh fruits that he often selected himself.[91] Whether or not his predilection for oranges—he would often consume five or six at a sitting—aggravated his chronic colitis, it is certain that he was in constant physical discomfort.

Apparently he painted in the morning, and spent the afternoon walking, visiting the museums of Paris, and shopping for antiques. Helen had opened an antique store on Madison Avenue in New York and remitted to Pat money made on sales. The restoration of these pieces occupied a great deal of his time, as did his hypochondria. His address book and letters reflect his constant concern with his health and his finances, both of which were precarious.[92] The names in his agenda are mainly those of different kinds of doctors, his clients, and specialists in the restoration of antique furniture.[93] By now Bruce was known as a connoisseur of all categories of objects, from primitive to medieval art to all the Renaissance and post-Renaissance period styles; however, his own preference, and Helen's, was for eighteenth-century French antiques. Allowing himself now free play for his essentially aesthete's nature, Bruce frequented a milieu of private art dealers, antiquaires, and connoisseurs. To be an aesthete in Paris in the twenties was to be a dandy as well, and Bruce seemed to take considerable pleasure in giving full rein to his impeccable taste in objects, furniture, and clothes. The emergence of the Surrealist poet Jean Cocteau as a major figure, together with the considerable influence (as art patrons) of the cultivated couturiers Paul Poiret and Jacques Doucet brought fashion and art together in Paris in the twenties.

From the memoirs and unpublished journals of Henri-Pierre Roché, our main source of information regarding Bruce's activities in the twenties, we learn that Bruce was on the fringes of the artificial paradise of the aesthete and the dandy that revived *fin-de-siècle* decadence in postwar Paris, but that he did not lend himself to any of the more outré activities recorded by Roché and happily indulged in by Reeves. A poet, a painter, a womanizer, and an extraordinary connoisseur in his own right, Roché (who at the age of seventy-four published his first novel, the autobiographical *Jules and Jim*) immediately recognized the quality and originality of Bruce's work. Eventually, he was responsible for preserving what is left of Bruce's last period: the architectonic still lifes Bruce began painting at the end of World War I and whose refinement and perfection became his obsession.

Reeves had introduced Bruce to Roché in 1916; when Roché returned to Paris in 1919, he took up his friendship with Reeves, who was often with Bruce. Twice a year thereafter, Roché visited Bruce's studio. Although he found the reticent painter an inhibited bore more interested in his art theories than in a night on the town, Roché was stunned by the originality of the paintings slowly and painstakingly being created in one corner of the living room at 6, rue de Furstenberg. While in New York, Roché had become the intimate of Duchamp, who introduced him to Walter

Arensberg and Katherine Dreier. On his return to Paris, he acted as agent for American avant-garde collectors, most notably John Quinn, whose impressive collection he helped form. Back in Paris, Roché quickly became part of a fast crowd with links to both the world of fashion and the world of art. Brancusi's principal backer, he was an admirer of Man Ray, Picabia, Duchamp, and the whole circle of Paris Dada that evolved after the war from New York Dada. In the spring of 1919, Roché squired Agnes Meyer around Paris, visited his good friend Marie Laurencin, played chess with Marius de Zayas, and discussed American politics with Cendrars and Léger, who were back from the Army.[94] Soirées with collectors and fashion personalities such as Paul Poiret's sisters, Nicole Groult and Mme Bongard, fill his journals, as do dinners with Picasso, Picabia, Duchamp, Man Ray, Satie, and Reeves, who took him to Bruce's studio. On April 4, 1919, Roché notes a visit to "the painter Bruce who made much progress in his 'architectural paintings.' "[95] Apparently, by this date the studio was filled with the paintings in the new style. Roy Bruce recalls that his father had many brightly colored still lifes of geometric solids in his studio before he and his mother left Paris, late in 1919. Thus we may conclude that Bruce had painted a number of architectural still lifes before 1920, when he showed six of them in the Salon d'Automne. But we will never know how many, since he destroyed so much of his work.

In September 1919, Katherine Dreier arrived in Paris, and Roché took her to see his favorite artists: Brancusi and Bruce. The following year, Miss Dreier bought Brancusi's *The Newborn,* but Roché was not able to sell any of Bruce's still lifes—not to Mrs. Meyer, Miss Dreier, nor to Walter Arensberg, whom Roché escorted around Paris in 1920. This was not because of any lack of enthusiasm on Roché's part for Bruce's work, which he found increasingly impressive.[96] On November 15, 1920, Roché wrote

John Quinn, urging him to buy Bruce's new paintings, which Katherine Dreier, although she admired his Compositions, had not liked:

> Bruce works hard (*comme le diable*) without any recognition, without wanting (almost) recognition—his work is very strong, simple, evident, powerful, constructed—brutal, some would say (not I). I do not think it is possible that he has not an important meaning—hard to crack and discover, undiscovered yet, but quite real and certain.[97]

Quinn was not convinced. Returning the photos of Bruce's work to Roché, he expressed the common reaction to Bruce's paintings: "Bruce is trying to evolve some new architectural thing, but it seems to me that with all his hard work and with all his strength he is attempting the impossible. . . . His work seems to be very English, like furniture, [like] English Cubism."[98]

Quinn's comments, although negative, did not lack insight, for it appears that Bruce was indeed influenced by Vorticism, the English version of Cubism, as well as by the forms of the furniture he collected, restored, and photographed. In a letter denouncing Bruce's foolish pursuits, Frost's father described a painting by Bruce, no longer extant, that conforms to Vorticist imagery.[99] During the war, Wyndham Lewis, the leading propagandist for Vorticism, frequently traveled to Paris. Whether it was through him or through the illustrations in the Vorticist magazine, *Blast,* Bruce seems to have been in contact with the abstract style developed in England and based on projections of geometric solids depicting three-dimensional volumes. An example is Jessica Dismorr's *Abstract Composition,* c. 1914–15 (fig. 11).

The issue of volume became paramount at the moment that analytic Cubism began to assume the solid, hard-edge forms of synthetic Cubism. Many artists, including the Vorticists, Léger,

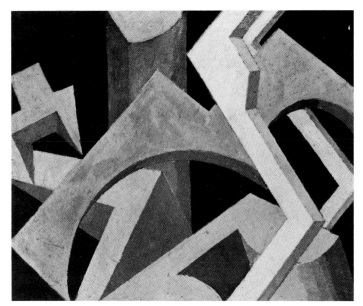

FIG. 11. Jessica Dismorr. *Abstract Composition*, c. 1914–15.

and the Purist painters influenced by Léger, began to give a sense
of three-dimensional solidity to shapes that were no longer con-
ceived as floating planes, but as fully formed, sculptural, three-
dimensional volumes. But Bruce's interpretation of volume was
peculiarly daring: instead of resorting to light-dark contrasts to
model form, he reintroduced perspective—rejected by the avant-
garde since Cézanne as academic—to create a powerful illusion
of three-dimensional objects ironically occupying a two-dimen-
sional space.

The need to give a sense of substantial "reality" to depicted
objects had been stressed by Léger in lectures and articles pub-
lished in *Montjoie!* and *Soirées de Paris* in 1913–14.[100] However,
Léger sought to assert the substantial material reality of objects
through tonal contrasts that were a direct extension of Cézanne's
conception of pictorial space as illusory bas-relief. Although

Cézanne was constantly on Bruce's mind, so was Matisse, and he
could not accept such a literally representational reformulation
of the sculptural or "real" quality of the object. In opposition to
Delaunay's contrast of colors, Léger proposed to base his "new
realism" on a contrast of forms. We see such a contrast of curves
and straight lines, of diagonals and right angles in Bruce's late
works; however, Bruce's contrasts of forms are more subtle and
various than Léger's predictable repertoire of mechanical and
architectural forms. Nor could Bruce any longer follow Léger
into the realm of the big public picture.

After 1917, Bruce conceived monumentality as an issue, not of
literal size, but of relative scale. For Bruce, monumentality was
achieved by a tightly constructed composition in which the
framing edge was defined as an architectural context, in relation
to which forms were disposed, lined up with horizontal and verti-
cal axes to express stability. In their dynamic use of the tilted
diagonal and their use of perspective instead of modulation,
Bruce's paintings differed from Léger's urban and industrial
themes.

Ironically, at the point at which Léger's works showed their
greatest debt to Cézanne, Bruce had begun to criticize the
"father of us all." In doing so, he mounted his attack against all
he believed lacking in modernism that made the ancients supe-
rior as artists to the moderns. Whereas Léger evolved a modern-
ized version of Cézanne's shallow space, Bruce sought more and
more the fully articulated sculptural projection to be found in the
masters Matisse held up as heroes: Mantegna, Botticelli, and Fra
Angelico.[101]

After the war, Bruce saw little if anything of Gertrude Stein,
who became more and more Picasso's champion. There is no
evidence of correspondence between the two after 1914, and her
name does not appear in the address book Bruce kept after

Helen's departure in 1919.[102] However, Leo Stein's Paris address is listed in Bruce's agenda, and we must count Leo Stein—the passionate admirer of Cézanne, who ranked Matisse well over Picasso—as an important and continuing influence on Bruce's thought. Although Bruce had made watercolors after reproductions by Rembrandt and Rubens as a youth in Virginia (cat. nos. A4-A7) and had copied Titian's paintings in the Louvre, by the 1920s he had rejected anything baroque or overtly painterly in favor of the severe "chaste elegance," hard edges, and local color of the Italian primitives.[103] This shift was probably stimulated by discussions with Leo Stein, whose acerbic wit and conservatism bordering on reaction were compatible with Bruce's own temperament and values.

Leo had lived in Italy before he came to Paris; after the war he spent most of his time in Fiesole, where the continued his friendship with Bernard Berenson. In 1900, Leo had written a book on Mantegna, who became for Bruce the touchstone of all that he deemed great in Old Master art and lacking in the moderns. As much a connoisseur as Bruce, Leo could exchange expertise with his fellow expatriate on this or that fine piece, or maintain a far-reaching dialogue on aesthetics that we know that Bruce enjoyed. In fact, Leo Stein was perhaps the only man in Paris, and certainly the only American, who was as arrogant, condescending, priggish, and perpetually dissatisfied as Bruce.

From Leo Stein's essays we may glean a fair picture of Bruce's views, for Leo had the distinction of being, along with Ezra Pound and Wyndham Lewis, among the first to react violently against "modernism."[104] Originally, Leo had dismissed Picasso as a gifted illustrator, long on talent but short on intellect. By the time he and Gertrude broke up their collection at the beginning of World War I, Matisse was beginning to look superficial to him, too. If Leo's criticisms of Picasso and even Matisse did not directly influence Bruce, they coincided with Bruce's own views regarding the deficiencies of the two giants of modernism. Like Leo, Bruce continued to respect Matisse, even when he no longer painted like him, but he apparently shared Leo's view that Picasso was a false prophet. Leo's major critique of modern art was that modern paintings were only composed, whereas Old Master paintings were constructed. His formula demanded both the "engineering of construction" and the "architecture of composition." He arrived at the view that "sufficient art is where construction and composition coincide."[105]

Such concerns, as we know, were central to Bruce's thought from the moment he took Cézanne as his master until he found the means to express the synthesis of construction and composition in his architectural still lifes. In his autobiographical memoir, Leo Stein maintained that these were already his critera before discovering Cézanne, and that in fact they were derived from the study of the Italian primitives, in particular his favorite painter, Mantegna.[106] Thus Bruce was probably led to his studies of the composition and coloring as well as the space of Renaissance painting through Leo Stein, who first criticized the flatness of both Picasso *and* Matisse. Bruce's genius consisted in translating Leo Stein's interest in structure and illusionism into conceptions that remained compatible with modernism, which the latter came to reject entirely.

When the Louvre was reorganized and reopened after the war, the Italian primitives had a new place of honor. Guy Pène du Bois commented on Bruce's admiration for Mantegna in 1926, and we know he spent many hours studying Fra Angelico and Botticelli as well.[107] Léger, studying Cézanne, inferred that tonal gradation—an echo of the chiaroscuro invented by the High Renaissance—was the means to depict volume. But Bruce recalled Matisse's teachings that modernist space should only be

created through the interaction of the local color preferred by
the Italian primitives.

One of the primary sources for Bruce's originality is the un-
usual palette he developed in his late still-life paintings. The idea
that black, white, and gray were to be used as colors appears to
have originated with Matisse; but the poetic pastel tints—the pale
greens, blues, pinks, lavenders, and ochres that seem peculiar to
Bruce's works—have more in common with the tempera pigments
employed by the Italian primitives than with modern painting.

Old Master painting, especially early Renaissance art, repre-
sented for Bruce a fuller conception of the world than even
Cézanne's works, because it subsumed the other arts, architec-
ture and sculpture. For Bruce understood that the architectural
contexts in which Mantegna and Fra Angelico placed their figures
gave a stronger sense of a structure to painting than just the align-
ment of forms to the framing edge that the Cubists advocated.
Emulating the pilasters that framed figures in Mantegna's paint-
ings, he introduced a vertical bar motif in a series of paintings
that gave an internal support to reinforce the framing edge,
creating an architectural frame within the painting (cat. nos.
D6-D9, D27). As it had been for the Renaissance, scale for Bruce
was based on the perception of relationships between objects of
different sizes. Thus the relationship between the small, wedged
segment cut from a sphere and the broad, beamlike structures that
connect one edge of the canvas with another creates a sense of
monumentality that is immeasurably grand because its frame of
reference is internal. The depicted objects are comparable only
to one another, and not to objects in the world. To create such
monumentality, Bruce was prohibited from painting objects that
were recognizable, because the eye would then be able to meas-
ure them against reality. He was forced to develop a repertoire
of forms that were so unspecific and generalized as to be unname-

FIG. 12. Marcel Duchamp. *Chocolate Grinder* from *The Blind Man*, 1917.

able, thus solving the problem of conveying monumentality in a
limited format.

In his youth, Bruce had admired Delaunay's friend, the
Douanier Rousseau; in his mature years, the hard, crisp edges of
Rousseau, in their similarity to the clean lines of the Italian
primitives, were once again the beacon, as was the use in primitive
painting of local color that gave a clarity and lucidity to form. We
have seen how, in his desire to appropriate sculptural volume to
painting, Bruce returned to the basis of Renaissance illusionism:
perspective. In this pursuit he had a predecessor. Roché's friend
Marcel Duchamp had been experimenting with perspective as
early as 1913–14 in his preliminary studies for *The Bride Stripped
Bare by Her Bachelors, Even,* the *Glider Containing a Water
Mill in Neighboring Metals,* and two studies for the *Chocolate
Grinder.* Bruce may have seen these works or reproductions of
them.[108] In any event, he could easily have seen the first issue of
the New York Dada publication, *The Blind Man,* with the

Chocolate Grinder in perspective on the cover (fig. 12). Edited by Duchamp, Roché, and Beatrice Wood, *The Blind Man* could have found its way to Paris via Picabia during his visit in 1917.

To insure that the illusion he was creating through perspective could not be understood as space behind the picture plane, Duchamp painted his objects on glass. The transparent background destroyed any sense of space behind the plane. Bruce contrived other means of negating the illusion provoked through the use of perspective that permitted him to continue painting on canvas. Instead of the single vanishing-point perspective of Renaissance painting, Bruce used oblique or isomorphic projections derived from engineering drawings; and such foreshortened projections appear to lie in front of the picture plane, rather than receding into space behind it.

Through the reintroduction of perspective, Duchamp was the first to find a way to depict volumes without resorting to Cézannesque modulation. This is the key to the illusion in Bruce's late paintings. For although other painters, such as Morandi, Severini, Léger, Ozenfant, Le Corbusier, and later Hélion depicted volumes, their illusions were created through tonal gradation that, like Cézanne's apples, gave a sense of convexity and concavity to space. Bruce, on the other hand, by organizing flat planes of local color into geometric volumes constructed through mechanical drawing, evoked a far stronger sense of three-dimensional sculptural projection. And paradoxically, he did so without creating convex or concave volumes. For his objects appear to project forward, in front of the picture plane and toward the viewer, as opposed to receding behind it. This was an extremely powerful, and for some, judging from the negative responses to these works, repugnant idea. By poising his objects at the edge of the table, Bruce gives a sense of dramatic imminence and precarious balance to his paintings, wherein the objects in

question are thrust aggressively forward toward the viewer. The dramatic effect is related to the projecting illusions of Caravaggio's *Deposition of Christ* or Mantegna's *The Mourning over the Dead Christ*, in which extreme foreshortening causes the figure to appear to threaten to break through the picture plane and intrude into the viewer's space.

The "reality" created by Bruce is an intense illusion; however, the world Bruce depicts has more in common with the enigmas of metaphysical painting and the irony of Surrealism than with the inexpressive, mundane studio objects in Purist still lifes. Indeed, Bruce shared many interests with the metaphysical painters. He loved the long vistas through arcades of the rue de Rivoli, and he honored the same Renaissance masters who inspired *la pittura metafisica*, although his interpretation of perspective was compatible with Cubism, as de Chirico's mannerism was not. Like the metaphysical painters' vision of a lost and ruined antiquity, Bruce's ideal classicism was not futuristic, but *passèiste*. While the Purists wished a renewed architectural classicism to symbolize the hope of the future, for Bruce and for the metaphysical painters classicism represented nostalgia for the past. In the ruins in Mantegna's paintings, he found the prototypes for his fragments of classical moldings, a reminder of the fallen grandeur of the antebellum South (fig. 13).

In the May 1919 issue of *Valori Plastici* de Chricio described the essence of the metaphysical:

> The appearance of a metaphysical work of art is serene; it gives the impression, however, that something new must happen amidst this same serenity, and that other signs apart form those already apparent are about to enter the rectangle of the canvas. Such is the revealing symptom of the *inhabited depth*.

In Bruce's series of "collapsed beam" paintings, apparently done in 1924, the tabletop is tipped up so radically that the objects

Fig. 13. Mantegna. *St. Sebastian* (detail), late 15th c *(left)*.
Fig. 14. Le Corbusier. Plan for the Villa Savoye *(right)*.

look as if they may slide, like an avalanche, into our space. Thus, with the seemingly neutral means of geometry, Bruce was able to find a full range of expression for drama, if not terror. Once again paradox plays its ironic role: fixed in a stable geometric armature that appears irrevocably locked in place, the individual pieces that fit together to create the whole look as if at any moment the force of gravity may cause them to tumble in a chaotic heap.

Like the metaphysical painters, Bruce felt himself the heir to a great tradition, a descendant of a line of heroes from the King of Scotland to the leaders of the American Revolution to the Virginia aristocracy.[109] Thus he had much in common with the disinherited Italian painters who took a lofty view of the futility of human pursuit, epitomized by Carlo Carrà's statement in the November 15, 1918 issue of *Valori Plastici*:

> *Below me I see Human Society*
> *Ethics, too, are submerged.*

This is the bird's-eye view of Bruce's metaphysical still lifes, in which the universe appears as a ghost town of signs, an uninhabited ideal city, devoid of human life or activity. And this represents Bruce's arrogant view of the artist, as an omnipotent creator who looks down on his own creations—ever critical, ever doubtful. Contemplating his efforts, making subtle adjustments in color harmonies, manipulating the miniature world of his own creation that he was free to perfect, he could agree with de Chirico that "we who know the signs of the metaphysical alphabet are more aware of the joy and the solitude enclosed by a portico, the corner of a street, or even in a room, on the surface of a table, between the sides of a box."[110]

STRAINING THE LAWS OF PHYSICS

You know exactly what I think about photography. I would like to see it make people despise painting, until something else will make photography unbearable.
—Marcel Duchamp, letter to Alfred Stieglitz, May 17, 1922
(Beinecke Library, Yale)

One can deduce and conclude that every object has two aspects: one current one which we see nearly always and which is seen by men in general, and the other which is spectral and metaphysical and seen only by rare individuals in moments of clairvoyance and metaphysical abstraction.... For some time, however, I have been inclined to believe that objects can possess other aspects apart from the two cited above; these are the third, fourth and fifth aspects, all different from the first, but closely related to the second or metaphysical aspect.
—Giorgio de Chirico, "Madness and Art," VALORI PLASTICI,
April–May, 1919

DUCHAMP'S INVOLVEMENT with engineering draftsmanship was inspired by his interests in tools and machinery as modern indus-

trial themes. Like most educated Americans of his generation, Bruce had studied engineering draftsmanship in school. With the emphasis on architectural drawings prompted by *L'Esprit Nouveau*—which often reproduced Le Corbusier's projects, such as the plan for the Villa Savoye (fig. 14)—the potential for creating a novel spatial illusion through the use of the variety of perspectives available from the vocabulary of mechanical drawing presented itself to Bruce as a means of creating a modern, streamlined image without depicting the mass-produced, mechanical objects he abhorred.[112]

We can now identify the objects Bruce chose to assemble. Based in simple geometric solids, Bruce's still lifes resemble the model villages of geometric buildings designed by the eighteenth-century visionary architects Boullée and Leduox, then experiencing a vogue in Paris as part of the neoclassical revival. All of them are intimately connected with his life as an artist, a food faddist, a dandy, and a connoisseur. Among the objects we can recognize are a drawing pad, pencil, and ruler (cat. no. D1), the orange slices Bruce was constantly eating (cat. nos. D6-D9), a boater or straw hat with a band (cat. nos. D8, D11), elements of architectural construction (cat. nos. D1-D28), a mortar and pestle (cat. no. D27), a glass of water with a straw, sometimes seen with curving elements resembling plant forms coming out of it—an echo of Bruce's earlier flowerpot still lifes—and objects resembling pieces of a jigsaw puzzle that we can recognize as standard carpentry cuts and turns (cat. nos. D3, D4, D10, D15, D28, D29), as well as other objects reminiscent of the moldings of neoclassical architecture. These classical moldings held a special interest for Bruce because of his childhood associations with the family plantation, Berry Hill, which with its Doric porticos and colonnaded vistas was considered a quintessential example of antebellum neoclassicism (see fig. 2, p. 6).

The basic format for all the late paintings is established in the first extant architectural still life (cat. no. D1). Containing shapes taken directly out of the last Composition, it appears to be the transitional painting between the 1915–16 Compositions and the late still lifes. Bruce depicts a tabletop tilted up, seen from below and at an oblique angle; it is situated in front of a checkerboard background, which recalls the decorative tapestry and fabric backgrounds of his early Cézannesque tabletop still lifes. Returning to the impersonal abstract theme and the easel format with which he is most at ease, Bruce invests still life with the monumental grandeur of classical architecture. Indeed, all of the twenty-five surviving paintings of Bruce's mature style depict architectural renderings of still lifes that become progressively more purified, refined, elegant, and tranquil.

In his initial attempt, however, Bruce is not fully in command of his new conception, and forms seem to float in space, as opposed to being firmly anchored. Here Bruce is already experimenting with depicting not only geometric solids seen from many different and conflicting points of view, but also the relationship between outside and inside, surface and volume, and other concepts of advanced mathematics and physics. Two objects seen from above appear to represent a single continuous surface winding back over itself like a Möbius strip (cat. no. D1). One of these Möbius constructions is in the lower left; the other is a twisted hoop partially obscured by a solid S-curve shape set at an oblique angle to that from which the other objects on the table are seen. Examining the painting, we realize that Bruce has depicted, in the most lucid, seemingly rational terms possible, a madhouse of contradictions in which no two objects are seen from the same point of view or lit from the same source. Moreover, in this entire painting, only the object resembling a section of a Doric molding in profile is parallel to the picture plane. The

result of all of this contradictory information is to fool the eye again and again until the eye refuses from fatigue to read the depth indicators as such, and resolves the puzzle in favor of an awareness that the manifold illusions are indeed merely illusion. On one surface, Bruce hybridizes views depicted with the four types of perspectives employed in engineering drafting: isometric, oblique, cabinet, and skewed, in addition to straight perspective.

Besides these perspectives, Bruce uses two other depth indicators: the placement of some objects above others, as if they are to be read as in the distance, as in archaic styles; and overlapping. Both devices, however, are simultaneously contradicted even as they are invoked. In the first case, the objects placed in the upper register of the canvas are the same size or larger than those in the middle and lower register. In the second case, the illusion created by overlapping one object in front of another in space is negated because the objects that overlap are not parallel to the picture plane, but are depicted at different angles contradictory to one another. Thus illusion cannot be mistaken for reality because it does not conform to our normal experience of the perception of objects in space.

What Bruce is representing is nothing less than a series of conundrums that illustrate Duchamp's proposal to "strain the laws of physics." If a depiction of the fourth dimension would presuppose the simultaneous representation of objects from different points of view in a single moment of time, then this is what Bruce has been able to resume on one continuous surface by combining the various systems evolved by different civilizations: the extreme, oblique viewpoints of the Japanese prints he collected, the archaic styles he admired, and the condensed, schematic abstractions of perspective evolved by engineers and architects to permit the simultaneous projection of elevation and ground plan.[113] The result is hallucinatory: a world that is literally "sur-realist" because it transcends reality, bending and twisting perception into accepting as rational contradictory and mutually exclusive points of view. It is one of the most powerful metaphors for the ambiguity and ambivalence of the modern condition because paradox is intrinsic to the image rather than illustrated in any literary equation that would degrade the primacy of a visual expression.

MAGISTER LUDI

A game of chess is a visual plastic thing, and if it isn't geometric in the static sense of the word, it is mechanical, since it moves; it's a drawing, it's mechanical reality . . . In chess there are some extremely important things in the domain of movement, but not in the visual domain. It is the imagining of the movement or of the gesture that makes the beauty in this case. It's completely in one's grey matter.
　　　　　　　　　　　—Marcel Duchamp to Pierre Cabanne,
　　　　　　　　　　　DIALOGUES WITH MARCEL DUCHAMP, 1971

A masterpiece is a chess game won by checkmate.
　　　　　　　　　—Jean Cocteau, LE RAPPEL A L'ORDRE, 1923

WHEN THE Delaunays returned to Paris in 1920, they were puzzled by Bruce's distance.[114] Although they maintained cordial relations, and continued to visit each other's studios occasionally, the days of warm, familial intimacy were over. Sonia Delaunay found Bruce changed after the war, and she attributed that change to the influence of Henri-Pierre Roché. In fact, Bruce saw Roché infrequently—he saw no one very often, in fact, except Reeves, his doctors, and his gym teacher—but Bruce was very attracted to the artists Roché admired. On May 27, 1919, Roché recorded a visit of the Bruces to his apartment, noting with satisfaction, "They like things I prefer."[115] Roché's affiliations and affections remained constant throughout his life. His favorite artists, besides Bruce, were Brancusi, Duchamp, and Man Ray. We know that

Roché collected Brancusi and Duchamp in depth and Bruce was sure to have seen their works—and probably those of Man Ray and Picabia as well, since Roché had a large library of avant-garde periodicals.[116] In the twenties, Bruce was probably no longer in contact with Picabia, who had begun styling himself "funnyguy." Bruce detested jokes about art, which for him was a serious matter, and loathed Dada, which he considered foolish and puerile. But he did spend time with Man Ray, who remembered him well, and he apparently was intrigued by Duchamp, who expressed admiration for Bruce's work to Roché.[117]

Through coincidence, the artists to whom Roché was closest were all involved in photography, and two of them made films. Man Ray abandoned painting for photography, Brancusi recorded his studio in a series of remarkable, large photographs, and Duchamp used photographs in his works. Indeed, it could be argued that the crisis experienced in painting in the twenties was provoked by the growing influence and creative power of cinema and photography at the moment when reproduced images, including advertising graphics, gained importance. It is in this context of a new vocabulary of popular imagery that the reaction against painterly painting in favor of styles of a mechanical precision uninflected by the brushstroke—the mark of the human hand—should be seen. For the reproductive arts have one thing in common: they reduce all images to the same substance and surface, effacing textures and material differentiation. Thus, Duchamp's advice that a Rembrandt be used as an ironing board, and Picabia's infamous assault on Cézanne, Rembrandt, and Renoir as "nature morte," summed up in the scandalous 1920 toy monkey construction, may be seen as an assault on painterly painting in general. Although Bruce did not paint mechanical images, his late works have a similar anonymity and dryness.

Duchamp, Man Ray, and Picabia could imagine no pictorial statement that could vie with film, photography, and popular graphics. Bruce, however, with the aid of photographs he had used as points of departure as early as 1914, was able to conceive of a radical synthesis of traditional pictorial values with elements borrowed from photography and film. We do not know if Bruce actually photographed any of the arrangements he painted. However, it is possible that he had a repertoire of forms, some cut out with a jigsaw in the carpentry shops he visited, or else simply a variety of moldings and pieces of furniture. And we know he had photographs of the antiques in his apartment as well as of other antique and African objects he was trading.[118]

In any event, whether he made his own photographs or not, Bruce seems to have been influenced by Brancusi's carefully composed views of his studio at 8, impasse Ronsin, where Bruce visited him.[119] Brancusi placed his geometric shapes at angles to one another and lit them to accentuate their sculptural volume. Brancusi himself was so fascinated by the transformation of form through

Fig. 15. Constantin Brancusi. *View of the Artist's Studio*, 1918.

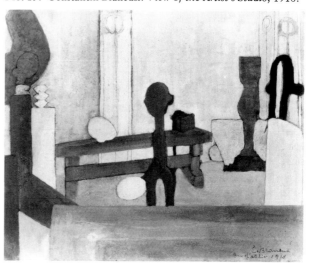

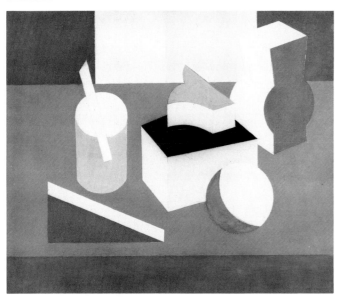

FIG. 16. Patrick Henry Bruce. *Peinture*, c. 1919.

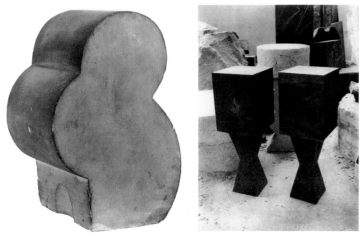

FIG. 17. Constantin Brancusi *Timidity*, 1917 *(left)*.
FIG. 18. Constantin Brancusi. Photograph of the artist's studio, c. 1923
 (right).

photography, which created new perspectives and a space that was different from the depicted illusions of painting, that he made a series of gouaches after these photographs (fig. 15). The similarity between certain of Brancusi's photographs of his sculptures (fig. 18) and Bruce's dramatically silhouetted objects, with one face always boldly illuminated, as if by studio lighting, is unmistakable (fig. 16).

There is also an undeniable similarity between *Timidity*, an early Brancusi (fig. 17) shape cut out of stone, and Bruce's shapes which seem to be cut out of wood. The tendency of photography to cause forms in the foreground to appear to loom large and project forward is also discernable in Bruce's paintings. The possibility of aerial views had already been explored by Steichen and even earlier by Malevich, and it would not be surprising if Bruce knew these photographs, for some of the objects appear to be depicted from aerial views, just as Robert Delaunay based his 1922 *Eiffel Tower* on an aerial photograph of the monument. In general, Bruce's objects do not appear enlarged. However, one painting that is substantially different from any of the others, the *Transverse Beams* (fig. 19), can be interpreted as a close-up of an architectural detail. Indeed it seems so similar to a photograph Brancusi sent Roché from Rumania in 1924 (fig. 20) that Bruce may have been inspired by this close-up of an architectural detail.[120]

It is not certain whether Bruce actually had any actual objects he moved around, and perhaps photographed, but we do know that Man Ray had such a setup in his studio. While working on his film *Emak Bakia*, he would place geometric solids in different configurations for animation effects. A still frame from this movie (fig. 21) bears an uncanny resemblance to Bruce's still lifes (fig. 22); and surely Bruce, as a friend both of Roché and Man Ray as well as a film buff, must have seen the film, if not the actual studio setups themselves.

The idea that film was the next step "beyond painting" was a popular topic in Paris in the twenties. As early as 1914, the Russian-born Cubist painter Survage published an article in *Soirées de Paris* on film as "Le Rythme Coloré." A comparison of Survage's gouache studies for an animated film intended to consist of colored visual forms analogous to music are the inspiration for Morgan Russell's experiments in light projections, if not for some of Russell's paintings themselves. Bruce, however, could not be involved with such literal-minded equivalents. On the other hand, it appears that the experiments with animating real three-dimensional objects undertaken by Man Ray in *Emak Bakia,* and by Léger in his celebrated Cubist film, *Ballet Mécanique,* affected Bruce's thinking. Both films use still-life objects we recognize in Bruce's paintings. The geometric solids in *Emak Bakia* and the straw hat with a band seen in an aerial view from *Ballet Mécanique* both appear in Bruce's still lifes.[121]

Animated film offered Bruce new ideas, such as the possibility of manipulating objects in depth, not just across a surface, but simultaneously back and forth in space. This permitted an es-

cape from the strictly frontal horizontals and verticals of the Cubist grid. In its potential for the manipulation of man-made objects that can be inverted, "flopped," reversed, or in other ways permutated, film animation suggests another kind of seriality than that proposed by Monet and Cézanne in their successive studies of the same motif at different times or from different angles. With few exceptions, Bruce's late works all appear in series; apparently drawn in pencil on identical prepared canvases at the same time, they were of similar objects differently disposed. This concept of seriality is much closer to film animation permutations than to the serial imagery of Cézanne or Monet.

Film and photography suggested to Bruce alternate conventions of perspective and composition that he could now add to his knowledge of the various systems of non-Western perspective and the schematic renderings of mechanical drawing, thus achieving a highly original imagery based on the fundamental conception of internal contradiction. By flattening forms through telescoping space, sandwiching background into foreground through visual scrambling, Bruce produces in his late paintings an adum-

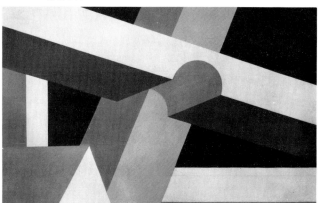

Fig. 19. Patrick Henry Bruce. *Peinture/Nature morte (Transverse Beams),* c. 1928.

Fig. 20. Constantin Brancusi. Detail of porch of wooden church, Hobitza, Rumania. n.d.

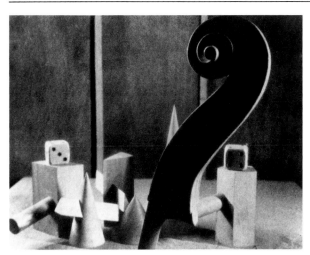

FIG. 21. Man Ray. Still from film *Emak Bakia*, 1926.

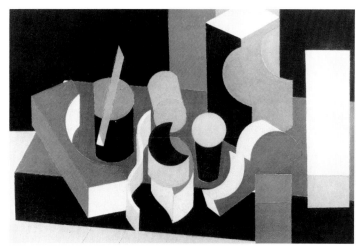

FIG. 22. Patrick Henry Bruce. *Peinture,* c. 1919.

bration of depth that is characteristic not of painting but of photography. Photography is otherwise reflected in his paintings as well: in the possibility that cast shadows will appear as solid planes, and in the variety of oblique views made possible by changing the camera angle. Photography also suggests the possibility of cropping by altering the field of vision to produce compositions that break the frame.

Earlier artists, especially Degas, had used oblique views and cropped compositions in paintings, but no artist before or after Bruce so thoroughly *translated* the novelty of the photographic vision into painting. Lesser, more literal minded artists had imitated photography and continue to do so, but Bruce was able to see how photographic imagery could be analyzed, altered, and assimilated into painting without destroying the essence of the uniquely pictorial.

Another peculiarity of Bruce's paintings that has always troubled viewers can be explained in relationship to photographs, specifically to Man Ray's Rayographs.[122] In these photographic

works, objects, losing all detail, are seen in silhouette as a reserved or negative shape on a black ground. The technique of placing objects on a sheet of developing paper and exposing it to light was simple enough, but the results were quite stunning in terms of an image that seemed simultaneously abstract and real. In Bruce's paintings, unpainted areas, reserved like the objects in a Rayograph, began to play an increasingly important role. These reserved, unpainted areas add to the degree of ambivalence. They question not only the finished state of the painting, but whether such reserved areas represent one cumulative shape or many separate forms, and whether that flat entity or combination of entities should be read as figure or ground. Conversely, in some paintings black areas, which normally read as ground, are broken up by the intrusion of volumetric shapes that may, because of overlapping and interweaving of the facets of different objects, be read as in the background. The confusion between figure and ground, positive and negative shapes achieves a dizzying multivalence far more intellectually challenging than typical synthetic Cubist inver-

sions. We are reminded of the dual function of Duchamp's two-way swinging door he built in his rue Larrey studio; but the optical sleights Bruce invokes are more complex and ambiguous than the simple flipping back and forth of a shape from figure to ground that appears in contemporary abstract illusionism. Such conceptual complexity relates Bruce's paintings not to his own time but to the art of the 1960s and '70s. So does the manner in which his unpainted, reserve areas operate to reveal the character of the woven canvas support as literally as it does in stained color abstraction relate to recent art.

His unwritten but acted out criticism of the art of his time, Bruce's architectural still lifes refute Duchamp's contention that formal innovation in painting was no longer possible, or that reproduction was capable of annihilating man's own potential as image-maker. Ironically, the same year that Duchamp painted his last canvas, the encyclopedic summary of the modes of representation in Western painting, *Tu m'* (which, like Bruce's Compositions, hung in Katherine Dreier's apartment), Bruce was answering Duchamp's challenge to postulate a future for easel painting—a future Duchamp could not envision. Inspired by Duchamp's initial reintroduction of perspective into representation, Bruce, looking at all of world art from a global point of view, as Matisse had taught him to do, evolved a synthesis of those qualities in Western painting he felt worthy of conservation. In so doing, he defined the essence of the pictorial. Bruce came to know Duchamp's work and thought, if not through Duchamp himself (who was in Paris in 1919–20), then through Roché, who kept Duchamp's works and publications always near him. Bruce was as disgusted as any Dadaist by the decadence of the Western tradition of art; but as both a profound conservative and a profound lover of art, he was more committed to its survival. To have understood Duchamp's challenge, and to have met it, was an extraor-

dinary act of intellect, will, and courage. In so doing, Bruce isolated himself totally, for Duchamp was too busy winning chess matches to engage in any dialogue. In 1925, the year Duchamp won the French chess championship, Bruce sent a still life to the "Art d'Aujourd'hui" exhibition of objects resembling chess pieces (cat. no. D20). Although he destroyed this painting, the general resemblance of the geometric solids he moved from square to square across his canvas to the pieces in Man Ray's chess set (fig. 23) seems obvious.

But the complexity of Bruce's thinking at this point was such that chess was too simple a game to occupy him. The contemplation of the abstract concepts that connected physics, mathematics, and music, the game Bruce played out on his canvases—where, as he put it, he did all his "traveling"—was a thoroughly metaphysical pursuit without any social interaction. Like the solitary Magister Ludi described by Hermann Hesse in *Das Glasperlen-*

Fig. 23. Man Ray. *Chess Set*, 1926.

spiel, Bruce doomed himself to solitude by inventing games only he could play.

Both his involvement with mutable, similar but not identical structures, as well as the gamelike feeling communicated by the seriality of his late works raises the possibility that Bruce was aware of the linguistic "games" Wittgenstein was working out at precisely the same time Bruce was painting his still lifes. Like Wittgenstein's propositions, Bruce's paintings were a process, a search, a matter of speculation, and not an end in themselves. Like the elements of grammar, Bruce's objects assume different meaning in different positions and context. It is quite possible that Bruce knew of and possibly read Wittgenstein's *Tractatus Logico-Philosophicus,* published in 1922. Both Reeves and Leo Stein remained in touch with the latest developments in philology; and Helen, who was still in contact with Bruce, visited Bertrand Russell in 1920.[123] Bruce's depiction, in visual terms, of tautologies and paradox, among the principle themes of Wittgenstein's *Tractatus,* is so explicit and self-conscious that it seems hardly accidental that it coincides with Wittenstein's preoccupations of the moment. The visual tautologies and paradoxes Bruce's work contains fulfill Wittgenstein's definition of "nonsense"; and it is as nonsensical that Bruce finally came to view both human history as well as his own life.

Bruce's late works, in the truest sense "metaphysical still lifes," are intimately connected to a strain of philosophical pessimism and scepticism that occupied the most serious minds in Europe between the two world wars. For although he might discuss primitive sculpture with Surrealists like his friend Tristan Tzara, Bruce had no patience with the literary subject matter of Surrealism. And yet, like all important painting, his art is more than merely a formal arrangement. It is based on a universal metaphor—a new metaphor that replaced the idea that life was a stage with the idea of life as a game, in which pieces were moved back and forth, preparing inevitably for the ultimate entrapment of Endgame—the checkmate of death.

In his preoccupation with still life, the narrowing of the universe to the cold, artificial light and lifeless objects in the studio, Bruce had a new understanding of the meaning of still life as a *vanitas* theme of meditation. Writing of Cézanne's involvement with still life, Meyer Schapiro observed:

> Cézanne's prolonged dwelling with still life may be viewed also as the game of an introverted personality who has found for his art of representation an objective sphere in which he feels self-sufficient, masterful, free from the disturbing impulses and anxieties aroused by other human beings, yet open to new sensation. Stable, but of endlessly shifting intense color, while offering on the small rounded forms an infinite nuancing of tones, his still life is a model world that he has carefully set up on the isolating supporting table, like the table of the strategist who mediates imaginary battles between the toy forces he has arranged on his variable terrain. Or the still life of Cézanne may be likened to a solitary pictorial chess, the artist seeking always the strong position for each of his freely selected pieces.[124]

More than ever now, in his pessimism, doubt, and isolation, Bruce felt close to Cézanne "the father" whose works were having a new influence in the twenties as part of the neoclassical revival. But unlike Cézanne, whose doubts, at least regarding the lasting significance of his works, must have been assuaged by the arrival of a younger generation of admirers who seemed to understand his deep truths, Bruce would never know his works would be admired by a generation that was not yet born. They would only come of age in the sixties, and ironically, they would be American.

Even if Roché had invited Bruce to play chess with Duchamp, Bruce would surely have refused, for he was too busy now answering on canvas Duchamp's aesthetic challenges—especially those questions regarding the relationship between represented objects

and real objects. Bruce no longer wanted or needed an opponent. For whereas chess requires two players, the Bead Game, transcending time and history, is an individual pursuit, the ultimate refuge of the disinherited, the alienated, and those deracinated from a society and culture perceived as inferior to the past and as lacking values. At the summit of civilized understanding, the master can communicate only with himself, which may answer the question of why, after 1930, Patrick Henry Bruce would not show his paintings to anyone.

NO MAN'S LAND

What you call Solid things are really superficial: what you call Space is really nothing but a great Plane. I am in Space, and look down upon the insides of the things of which you only see the outsides. You could leave this plane yourself, if you could but summon up the necessary volition. A straight upward or downward motion would enable you to see all that I can see.
 —Edwin A. Abbott, Flatland, 1884

I am doing all my traveling in the apartment on ten canvases. One visits many unknown countries that way.
 —Patrick Henry Bruce, letter to H. P. Roché, March 17, 1928

THE FURTHER elaboration of the relationship between the inside and the outside of a solid—central to the original analytic Cubist formulation of the concept of simultaneity—is an important element in Bruce's late still lifes (for example, cat. nos. D1, D4, D6-D12). The interiors of cylinders are depicted as flat circles parallel to the picture plane. However, the position of the circle above the cylinder creates an ambiguity: from one point of view, it may be interpreted as the inside of a round tube; from another, the top of a cylindrical container. In the triangular motif of the 1924 paintings Roché described as based on "collapsed beams," there is a similar confusion between interior and exterior. In the version

in the Addison Gallery of American Art (cat. no. D16 and color plate 26), a cream-colored band is adjacent to a broader mauve band in the monumental triangle of "collapsed beams" that is reminiscent of the architectural framework of trees in which Cézanne framed his late Bathers. Logically, the narrow cream "molding" should represent the outer face of the triangle. However, the broader lavender band switches positions, so that it appears on two sides as the interior faces, but on the third as the exterior face of the triangle.

By setting up such confusing and contradictory relationships, Bruce frustrates our normal tendency to resolve images in favor of coherence and consistency. The effort one must make to rationalize an image that, in its geometric rectitude pretends to a system of logic that is constantly defied and subverted, was such that Bruce's contemporaries, unconscious of the philosophical complexities of the work, could only describe them as "mistakes." Conceiving an original repertoire of images that provoke the mind to attempt to fit them together—since they often seem reversals and inversions of one another—while insuring that the similar but not identical curves can never mate in yin-yang fusion, Bruce indexes a veritable catalogue of frustrations.

Because the background and the picture plane are identical, the depicted objects placed in front of the background appear to project forward. In this respect, Bruce's late paintings are related to the peculiarly powerful illusion created by American *trompe l'oeil* still lifes, which were often also based on photographs. For paintings like Peto's *Bottle, Candlestick and Oranges* (fig. 24) create a different type of illusion—one at once fuller and more adumbrated than their seventeenth-century Dutch prototypes.

Perhaps the ultimate frustration that Bruce, as master of perverse illusionism (that is, an illusion used to contradict itself), creates is to lock his contrasting colors into an armature of oblique

FIG. 24. John F. Peto. *Bottle, Candlestick and Oranges,* n.d.

views that prohibits warm colors from advancing and cool from receding because so few planes are parallel to the picture plane. For if the planes in Bruce's paintings could give the illusion of moving in any direction, it would not be back and forth in space, but obliquely, at contradictory angles not related to the viewer's position as grounded and parallel to the picture plane and its contents.

Thus Bruce's fragmentation is more extreme than that of the Cubists, for Cubism depicts the world as literally splintered, but not the psychological condition induced by that process of disintegration. In his unique interpretation of synthetic Cubism, Bruce represents an array of presumably solid fragments that hint at a whole, which might be reconstituted, if only the pieces were slightly different so that they might fit into one another. By invoking the conditional mode of "as if," Bruce creates another powerful metaphor of frustration, dislocation, and longing for coherence—a nostalgia for the world once more whole, which

Bruce perceives to be no longer a possibility, either historically or personally.

Frustration as a psychologically charged content is exacerbated by the polarization between extreme illusion and extreme flatness, which the eye struggles to resolve. Bruce redefines the concept of simultaneity as the paradox of two or more mutually exclusive views simultaneously perceived. Bruce depicts objects in perspective. But the lack of either contour or modulation that might hint at the existence of a "back" of the object that is hidden to view and that would complete its reality, negates the sculptural illusion of representation that is carried on, albeit with decreasing conviction, through analytic Cubism. Moreover, the urge to experience the backless objects as graspable wholes is also both evoked and denied, as is the sensuality we attach to both still life as a genre relating to the senses, and to painterly painting. For not only are Bruce's arid, ascetic late still lifes deprived of all the sensual associations his ripe, rich early still lifes evoke, but Bruce also has renounced the painterliness still evident in the 1916 Compositions.

Such is the world of irony, contradiction, frustration, and visual paradox of Patrick Henry Bruce. Those who knew him complained about his preoccupation with theoretical matters. His school friend Edward Hopper recalled him as insufferable at the Henri School.[125] As a Matisse student, he refused to talk to his fellow students about their art ideas, dismissing them with his usual arrogant "çane m'interesse pas."[126] He offended Leo Stein, disagreed with Matisse, dismissed Delaunay, and bored Roché to death with his "confused art talk."[127] His serious discussions were probably his dialogues with Frost and Reeves. Frost's letters contain clues regarding Bruce's concerns and experiments in mixing glue and resin into his pigments, which gives us to understand Bruce was interested in technical experiments.[128] Yet

Reeves, whom Santayana recognized as one of the best minds of his generation, was even more silent than Bruce. In all the fragmentary information we have about Bruce, and in all of the interviews with those who knew him, the issue of his "theories" consistently recurs. But what were these theories? And how did they define Bruce's position as a disgruntled critic of the direction modern art had taken since Cézanne?

Our first indication of Bruce's preoccupation with color is contained in du Bois's description of the discussions in the garden of Bruce's studio in 1906: "One heard of the tremendous problem involved in painting a white egg on a white tablecloth or a black chunk of coal on black stuff.[129] The problem of adjusting close values and creating a sense of refinement through such minute contracts had preoccupied Bruce's hero, Whistler. Bruce never forgot the subtlety of Whistler's studies in black and white, which inspired Bruce's juxtaposition of a painted white area and an area of unpainted canvas of a slightly different white, and the contrast of a coal black with a blue-black, of a warm gray against a cool gray in his late works.

Twenty years later, du Bois remarks, Bruce "had taken painting apart and gone over it piece by piece," only to reach the conclusion that "Painting would never be put together in this machine age."[130] Assuming the analytic-critical attitude that Cézanne bequeathed to Braque and Picasso, and which they themselves abandoned in the relaxation of success, Bruce continued a line of philosophic inquiry into the relationship between the conceptual and perceptual components of vision that the most profound art of our time has had as its concern. Although he adhered to much that Matisse taught him about color and form, he dismissed Matisse's reliance on drawing as an element separate from painting. His reintroduction of perspective was a rejection both of Matisse's and Delaunay's flatness.

Although he continued to support Bruce as a friend, Delaunay jeered at Bruce's painting of the twenties.[131] In notes he wrote in 1924, it seems Delaunay was specifically attacking Bruce in his assault on those who used local colors, which he considered "primitive": the defect of such primitive work, wrote Delaunay, was "a linear and arabesque quality which was the effect of separating colors . . . This is the *cloisonné* of the primitives."[132]

As if addressing Bruce personally, he continued: "Those who follow will probably want to correct this imperfection and will fall into the error of perspective. The idea of wanting to represent space by a mechanical device—this is what has poisoned hundreds of years of painting."[133]

According to du Bois, it was at this point that Bruce has rediscovered the greatness of Mantegna, who was austere and not "mushy."[134] By "mushyness" Bruce must have meant the open, bleeding planes and soft edges of Orphism, which now seemed to him anathema, just as perspective and local color were repugnant to Delaunay. According to Roché, Bruce considered himself a "living protest" against the "chief vices of almost all painting today." This attitude undoubtedly did not increase his popularity.

In his late paintings, Bruce attempted nothing less than to synthesize painting, sculpture, and architecture in a totally personal *gesamtkunstwerk* that returned painting to the place Leonardo has assigned it, as the noblest art. The structural thrust of Bruce's late works in unmistakable. This preoccupation with structure was hinted at as early as 1913, when Leo Stein described Bruce's program as "mostly that you ought to begin at the edge of the frame and work inwards making lines and spots of color that look handsome."[135] That the frame and not the central image should be the point of departure for composition was a radical idea in 1913, as Cubism was undergoing the transition between its analytic and synthetic phrases.

These structural considerations began to dominate Bruce's thinking more and more; and to him the importance of the rectangle as an *a priori* was primary. In his memoir on Bruce, Roché wrote: "He was struggling to 'construct paintings, supported mainly by the four edges of the canvas, having a structural quality the absence of which, in all existing painting, made him suffer, rightly or wrongly'."[136] By giving priority to the image-frame relationship over the internal relationships among analogous images—the "visual rhyming" of Cubism—Bruce once more anticipated the concern of the art of the sixties, when the relationship of image to frame finally dominated over internal relationships to the point of destroying them.

The origin of Bruce's structural concerns was, once again, in Matisse's analysis of Cézanne's compositions, which had taken a great deal of class time. The reconsideration in Bruce's late works of so much material taught by Matisse, reformulated now in more abstract and conceptual terms, reveals the consistency of Bruce's thought, which evolved in a far more logical manner than the fragmentary quality of his oeuvre would indicate. For Bruce's late still lifes were not an aberration or even a sudden breakthrough: they were the culmination and synthesis of a life spent in a painstaking investigation of the same concerns that had engaged Bruce from the moment he met Matisse. The acceptance of the framing edge as the defining architecture of easel painting, which unlike mural painting has no actual architectural context, was stressed by Matisse before Mondrian based his paintings exclusively on the horizontals and verticals that echo and reinforce the axes of the frame. Both had received these ideas directly from Cézanne. To understand the importance of an architectonic structure in the creation of monumental stability, it was sufficient for Bruce to know Cézanne's late works, and such extensions of Cézannesque ideas as Matisse's *The Blue Window* (fig. 26). In

Bruce's still lifes that are framed by a vertical bar to the left, (fig. 25), there is an echo of the Matisse painting.

In *The Blue Window*, Matisse pursued Cézanne's method of linking objects lying on different planes by extending the lines of an object in the background into the contour of an object in the foreground. Bruce's originality lay in his discovery of how to link objects lying on different planes without drawing. Indeed the elimination of drawing from painting is a key issue in Bruce's late works. As early as 1921, the Belgian Constructivist Josef Peeters recognized that Bruce had the only new painting idea in Paris. During a two-month visit to the French capital in the summer of 1921, Peeters found Picasso simplistic; although he visited Mondrian, Gleizes, Archipenko, and Vantongerloo, he found that "the only one who taught me anything in all of Paris was Delaunay's friend, the American painter Bruce. He taught me that line does not exist, that it is the edge of a surface. In the same way, a colored surface defines the distance between itself and the surface in front of it."[137]

Peeters saw Bruce's views as a criticism of Mondrian, for although there was a similarity in the way the two painters worked, frequently overpainting a geometric shape in the effort to create a more perfectly balanced equilibrium, Bruce's art, with its roots in Léger's object-oriented "new realism," was philosophically at odds with the concept of nonobjectivity. Moreover, the complexity of Bruce's palette, his denial of frontality, and his frequent use of the diagonal distanced him constantly from Mondrian.[138]

The idea that drawing could be completely expunged from painting, subsumed as the edge of a colored plane, was too radical to have been widely accepted in 1921. When it finally did gain popularity, with the "hard-edge" painting of the 1960s, Matisse was thought to have originated the idea with his cutouts, in

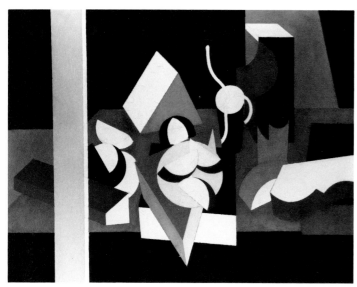

FIG. 25. Patrick Henry Bruce. *Peinture/Nature morte*, c. 1921–22.

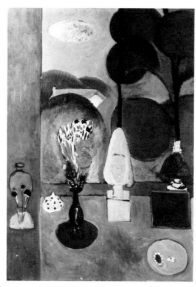

FIG. 26. Henri Matisse. *The Blue Window*, 1913.

which he claimed that he "drew" in color with a scissors. However, Bruce's still lifes antedate not only *Jazz*, but also Matisse's Barnes Foundation mural, *The Dance*, in which the figures seem cut out rather than drawn. At this point, we must question whether it was coincidental that Matisse used the same reserved shapes and a similar pink and blue palette in *The Dance* in 1932–33 as Bruce had employed in his 1928 still lifes, which appear to have been exhibited in the salons of 1928–29. The idea of using unpainted canvas as a shape and color had occurred to Matisse in *Portrait in the Moorish Chair*, c. 1929, but it had been the hallmark of Bruce's style long before. And when George L. K. Morris met Matisse in France in 1931, the one American painter Matisse mentioned was his former student, Patrick Henry Bruce.[139]

In Bruce's painting, edge subsumes the role of line in delineating contour, thus realizing the dream of synthesizing the two traditional polarities of painting, the linear and the painterly. This aspiration toward synthesis became a pressing concern for other artists only after World War II, and mainly in America, where Matisse's *découpages* were particularly valued because they seemed to have resolved this dichotomy that pitted the champions of Delacroix against those of Ingres. Bruce's arrogant ambition, which pushed him to attempt the impossible, inspired him to sum up on one canvas all that painting had ever been or ever could be. Toward this end, he turned his eyes back to the nineteenth century and to the questions that, after the battles between the ancients and the moderns, colorists and the draftsmen ended, still remained unresolved.

Since he consciously chose to live in the building that housed Delacroix's studio, which he wanted to rent for himself, it is certainly likely that Brue read Delacroix's journals.[140] Delacroix must have been on Bruce's mind when he chose to juxtapose the

complementaries of which Delacroix was fondest, the greens and violets, and especially the most basic contrast of all, the opposition of ultramarine and carmine, which appears in a number of Bruce's paintings. To expunge drawing from painting was Bruce's mission, which is surprising since he was an exceedingly talented draftsman. However, the other artist who had impressed him was Monet, who may have inspired Bruce's use of pastel colors as well as his growing distaste for line. In 1907, it appears Bruce may have met Monet during a trip to visit his friend, the American Impressionist Edmund Greacen, a Monet-follower who lived in Giverny.[141] With his love of Monet and his background of Neo-Impressionist color theory, Bruce was well prepared for the rehabilitation of Seurat that took place in Paris in the twenties. From these various sources he could have conceived a painting in which shapes were created without line, and yet expressed his fastidious concern for a clean, hard edge. In many ways, his planes of local color resemble enlargements of the Neo-Impressionist *tache* of color. But the clarity of the shapes in a Bruce still life is the opposite of the fuzzy and variable outlines of the styles derived from Impressionism. The raised ridge of paint at the boundary of a plane creates a literal, physical edge as opposed to a depicted line.

When we seek a source for Bruce's novel conception of line as the edge of a plane, we are once more involved in conjecture. However, certain facts seem to lead to the conclusion that Bruce's shapes are based on cutouts, either literally or as inspiration. As an adolescent, Bruce appears to have engaged in the popular pastime of cutting out silhouettes. Later, Sonia Delaunay involved Helen Bruce in the cutting and sewing of her simultaneous costumes, which were made up of geometric shapes cut out of brightly colored fabrics and sewn together.[142] Helen herself was

a dressmaker; a photograph of the apartment at 6, rue de Furstenberg shows the ubiquitous scissors on the floor (see fig. 15, p. 11).[143] A precocious child artist, Roy made his own toys, cutting pieces of red, green, and yellow felt into geometric shapes resembling a crocodile, a fish, and a bird.[144]

Thus the idea of cutting out shapes, especially geometric shapes, was well known to Bruce by the time he began his late still lifes. He may also have been familiar with the manner in which Marcel Duchamp created the *Nine Malic Molds*, the study for which belonged to Roché. For the "liveries," the bachelors costumes, were based on a dressmakers' patterns—two-dimensional shapes that were assembled into three dimensions.[145] Given Bruce's acquaintance with the fashion personalities of Paris as well as his intimate knowledge of dressmaking, it is possible that he used templates or even cut-out, stenciled patterns. Whether these were literal, or just a memory of how cutting could form shapes without drawing, Bruce seems to have anticipated Matisse's fusion of drawing with color in a manner Matisse later himself found useful.

Bruce chose selectively from the color theories of Matisse and Delaunay to formulate a concept of color that was relatively simple but highly sophisticated and flexible. From Matisse he learned to think of black, white, and gray as colors and to use local color rather than modulated tones. And Matisse's insistence that the addition of each color altered the whole of the composition, in depth as well as on the surface, was the basis of Bruce's conception of composition. The balancing out of the variety of relationships—and the alterations of these relationships that occurred with the addition of a new color—preoccupied Bruce from the moment he became committed to modernism. We know from x-rays that once he had penciled in a drawing he did

not alter his shapes; however, we also know that he constantly changed colors, overpainting areas with as many as four or five coats of different colors that finally built up the surface into a literal relief. These minutely calibrated alterations, which have their source in Cézanne's process of revising and criticizing his paintings, also resemble the way Mondrian worked to achieve an allover balance. These alterations are not only intrinsic to Bruce's thought processes, they are also vital to the creation of his personal style of making paintings that resemble lacquered or enameled precious objects. The juxtaposition of a variety of surfaces in a single painting—shiny, varnished, opaque oil, unpainted but primed canvas, thinly painted, transparent wash, and scumbled areas—is a singular invention of Bruce's that is without issue until the art of the sixties.

The contradiction between Bruce's concern with technical experiments (which sometimes had disastrous results) and his love of craft, particularly the medieval crafts of enamel and inlays, is expressed in these works of variable surfaces in which the paint looks as if it has been inlaid into compartments, as the twelfth-century craftsman worked his colors into the metal framework in champlevé enamels. Bruce loved the perfection and workmanship of these enamels, which he studied intently during his frequent visits to the Cluny museum. We see their echo in the clarity and brilliance of his enamellike color, as well as in the compartmentalization of color into separate chambers, and the contrast between reserved and colored areas also reminiscent of the reserved metal in champlevé objects.[146]

Here a word regarding Bruce's technique is appropriate. Throughout his life, Bruce painted with both palette knife and brush. Although some of the late still lifes are done exclusively with palette knife, one series of paintings—the ten paintings he was working on in 1928, of which we have identified two (cat. nos. D24, D25)—were apparently painted in transparent tints using just a brush.[147] These paintings have a greater clarity than the earlier still lifes and seem to signal not just a sense of resignation on Bruce's part to his solitary role, but also a renewed faith in his work, which he had once more been on the verge of renouncing. For when Michel Seuphor visited Bruce in the winter of 1926–27, he found a dejected artist moodily staring into the flames of his huge fireplace, threatening to throw the paintings Seuphor thought admirable and original works into the fire.[148] Seuphor, himself a young impoverished artist who was sent to see Bruce by the Delaunays, would willingly have bought a work to encourage Bruce, who claimed no one cared for his art; but he could do no more than try to persuade this melancholic to continue his work. The following year, however, Bruce seems to have found a revived interest in painting. Roché himself borrowed two to hang next to Braque and Picasso, where Bruce might see they could, as Roché assured him, hold their own.[149] Moreover, two very young women came into Bruce's life at this point, his niece and a young French girl he took with him to visit museums. He enjoyed pointing out to them the qualities of this or that Renaissance painting or medieval object and explaining why one thing was finer than another. (He was especially happy in the basement of the Louvre, where the Greek and Egyptian antiquities were kept, and he was among the first to praise the Mayan carvings that came to Paris.)[150]

When we turn to Bruce's color theory, we find a similar degree of originality achieved through the synthesis of traditional ideas. From Matisse, Bruce learned how to add white to bring a hue to full intensity. From Delaunay he learned how complementaries interact to produce the most dazzling optical effects.

However, Bruce rejected Delaunay's interpenetrating transparent planes in favor of separated, opaque colors. Nor did he use the graded scale of color modulation illustrated in Chevreul, which made such an impression on the Synchromists. Instead of modulating a color through its tonal gradations, Bruce split a given hue into tones and shades, which he did not connect but dispersed across the canvas, causing the eye to perceive the whole image rather than a specific colored form. In some paintings, as many as twelve or thirteen shades may be used, as in the variety hue into tints and shades, which he did not connect but dispersed of blue in the Whitney Museum painting (cat no. D8 and color plate 18). Especially in his complex paintings of the mid-twenties, Bruce uses this device of splitting and dispersing a hue to agitate and confuse the eye, forcing it to make minute color discriminations.[151]

In their respective color theories, both Matisse and Delaunay touched on the analogy between tones in color and in music. Once Chevreul revealed that color could be organized into chromatic scales, the traditional analogy with music was made concrete.[152] In *Modern Chromatics*, one of the sources of Delaunay's theories, the British color theorist Ogden Rood had made a careful study of the harmonies created through triads of color that correspond to chords in music. In Bruce's paintings, the allusion to music is unmistakable: a single color will appear in three or four places, stepped up, like the notes in a scale, by the addition of white. When the color appears in three places, the effect of a dominant chord; when there are four tones, the analogy is with the subdominant. Chords of cool colors—those based around blue—correspond to minor keys. Those with a red base correspond to major keys. Thus Bruce's "compositions" are truly that; the variations he plays on a theme are analogous to the inversions and repetitions of the classical forms of the fugue and the sonata.

THE GREAT BEYOND

We feel that even when all possible scientific questions have been answered, the problems of life remain completely untouched. Of course there are then questions left, and this itself is their answer . . . The solution of the problem of life is seen in the vanishing of the problem.

—Ludwig Wittgenstein, TRACTATUS LOGICO-PHILOSOPHICUS, 1922

AROUND 1930, Pat Bruce could be seen strolling through the Luxembourg Gardens or the Bois de Boulogne, dressed in autumnal shades of beiges and russets that complemented his auburn hair. He had shaved his beard and wore his curly hair parted and slicked down in the current fashion. His suits were tailored in the most conservative, elegant, and well-cut English style, which was popular with the Parisian aristocracy. His shoes were handmade by the finest cobbler in Paris, and his silk shirts were cut to order by Doucet. He often wore a bowler; on his arm he carried a yellow cane.[153] He had begun to see a new doctor for his continuing stomach trouble, and he seemed to be improving on a strict new diet. However, the Crash of 1929 had left customers for his antiques and *objets* either bankrupt or impoverished, and he could no longer eke out even a meager living. Helen had no money to send him; and he was forced to ask his sister, Mary, who worked for Bergdorf Goodman, for help. This was a devastating blow to his pride.

Isolated from his contemporaries and colleagues, Bruce was equally disappointed in his heroes. Only Derain seemed to him to have retained his integrity.[154] To a man of Bruce's sober and philosophical temperament, Picasso's literary classicism could only have seemed trivial. And he must have found Matisse's flat, decorative odalisques and Delaunay's repetitious soccer players even more disappointing.

In the Salon d'Automne of 1930 Bruce exhibited one painting: *Peinture*, now in the collection of The Museum of Modern Art (cat. no. D29). It was the last painting he showed. Because Roché wrote in his memoir that Bruce gave up painting in 1932, it was always presumed that Bruce produced no work after this date. We now know this is not the case. Bruce continued to paint all his life. But ruined, like so many Americans, by the Crash, he was forced to change his life-style, which pushed him into the most severe depression he had ever experienced. After Reeves's departure for America in 1931, Bruce had literally no one with whom to talk about the things that mattered to him most. Moreover, he was certain by this time that another conflict was brewing in Europe—and he had no wish to remain in Paris through another war. The demand for antiques had dwindled to a trickle, so not only was he left with no money, but also he had little to occupy him now other than visits to the Louvre. He now began to think that perhaps life was not worth living.

His social life and material circumstances more reduced than ever, Bruce dedicated himself to a single pursuit: the creation of the perfect picture, the absolute distillation of the quintessence of painting. In his repetitions and refinements of the same theme, Bruce once again emulated Brancusi, with whom he shared the ideal of the absolute created through the perfection of the same motifs. He was fascinated with Leonardo da Vinci, and the idea of the quest for an unattainable perfection in an unfinished work of art. Like the artists in Balzac's *Chef d'oeuvre inconnu* and Henry James's "Madonna of the Future," Bruce spent hours staring at his canvas, imagining the transcendent masterpiece. In The Museum of Modern Art painting, he found its format: a rectangle somewhat wider than it was tall, based on the proportions of the Golden Section, or on the shape of the train window that the Purists claimed was closest to the ideal for a painting. In this elongated rectangle he now depicted fewer objects—the glass with the straw, the section of Doric molding, the ruler or pencil, a rectangle that signified perhaps the canvas itself.

Between 1930 and 1936 (the year Bruce, desperate and suicidal, no longer able to live on the handouts his sister, Mary, was able to scrape together, sailed for New York), he painted about twenty versions of this same theme. These were not painted thinly with a brush, however, but thickly with a knife, in a reduced palette of the primary colors and green, black, white, and gray, applied directly out of the tube.

In the letters to his sister that Bruce began to write regularly when Helen was no longer able to send him any money, he complained of his bad health, and of persistent stomach trouble. On March 30, 1931, he wrote that he had been sick all winter and ordered to go to the country. He noted that he was reading Keyserling's book on America, and Gustave Le Bon's *Bases scientifiques d'une philosophie de l'histoire*.[155] Always an avid reader, Bruce had more time than ever now to devote himself to reading. He especially enjoyed the diversion of novels and biography, and he read Proust with great pleasure, sharing Proust's regret at the disintegration of a social order that had succumbed to *arrivistes*.

For Bruce identified wholeheartedly not with Léger's proletariat—although he shared Léger's contempt for the bourgeoisie—but with the fallen aristocracy.[156] He continued to paint, able to resist any negative criticism because he had never desired to sell his art. Painting, for him, was the proper pastime for a gentleman of his station. Committed to the values of a leisure class of cultivated amateurs and dilletantes as the only means of maintaining cultural standards, Bruce was devastated not because his paintings were not understood or sold, but because the Depression had robbed him of the means to sustain the life-style of a

gentleman. As involved as he was with modern art and thought, he was profoundly reactionary in his social and political attitudes. At one time or another he had expressed the opinions that slavery was a good institution, that women were inferior, and that Dreyfus was guilty.[157]

On May 28, 1933, Bruce wrote his sister:

The necessities for me are very expensive as I am undergoing this cure and a large part of what I eat is made by the man who is doing the cure and I have to pay the price. Instead of spending the money on doctors and drugs I spend it on food. I can't possibly get out for less than seventy dollars a month, and I am perfectly aware of the fact that under present conditions you cannot give me that and I do not expect it.
I still have a few belongings that I hope to sell, a few objects, negro sculpture, a Matisse drawing which I gave to Helen and which she is sending back to me. In times gone by these things were of value but at the present moment they are worth very little and one can sell nothing unless one gives it way.[158]

By this time Bruce had already decided to find a cheaper apartment outside of Paris and had moved into a new concrete, elevator building in Versailles. Since there was no further thought of commerce in the city, he could at least take his doctor's advice to get some fresh air in the country. For the first time in his life, he had no servant. This he found unbearably demeaning. His days were simpler than ever now—painting in the morning, walking in the classical gardens of the chateau and nearby woods in the afternoon.

Although his health improved and he continued to paint, and even apparently conceived of painting from the photographs of skyscrapers that he asked Mary to send, Bruce could not tolerate the diminished life he was forced to live.[159] He spoke often now of suicide, and his threats were so alarming that his sister cabled him money to return to America. On July 29, 1936, he sailed for New York on the S.S. Normandie. He planned to return to Berry

Hill, where his Virginia cousins had promised to take care of him on the plantation. On August 3, 1936, Bruce arrived in New York, which he had not seen in over thirty years. He was horrified. "C'est l'Enfer" he wrote to a friend—This is Hell. To his niece he confided, "These people have no souls."[160]

It was summer, and he was still swollen with the symptoms of dropsy that had returned from eating the ship's food. Slowly, however, he found a tolerable routine. From his sister Mary's apartment at 68th Street and Madison Avenue he would walk through Central Park to the Metropolitan Museum, where he spent his days. He began to draw large charcoal sketches of half-length figures copied from magazine advertisements, perhaps in the hope of finding a job as a commercial illustrator (cat. no. D30). But he lived from day to day, as if awaiting the long-standing appointment in Samarra friends always sensed he had. Remembering Bruce as a youth, Guy Pène du Bois described his dark pessimism: "Bruce, whose sense of humor was not easily touched, wondered whether life was worth the trouble the painter took in the effort to renew its existence on canvas."[161]

Helen's antique shop was only a few blocks away from Mary's apartment, but Bruce never visited her, although Helen Bruce recalled sometimes seeing a spectral face pressed against the window late in the evening while she worked in the back of the shop.[162] Humiliated by his dependency on his sister, incapable of imagining not living like a gentleman, Bruce grew more despondent. On November 12, 1936, Bruce was to lunch with his niece in New Jersey, but she was forced to cancel the appointment. It was the final disappointment. He wrote two notes—one to his sister, and one to the young French girl who had been virtually his only companion for the last six years of his life. He mailed the postcard with the photograph of the Waldorf Astoria to Paris. The message was: "This evening I leave for the great beyond."[163]

To his sister he wrote apologizing for burdening her with the task of disposing of a body. He swallowed the veronal he had brought with him from Paris for such an occasion.

Given his views on religion and art, his family decided that Patrick Henry Bruce be cremated and his ashes returned to France, to be scattered where he loved to stroll, in the forest of Fontainebleau.

Writing to Katharine Dreier in 1948, Roché complained he had never seen a photograph of Bruce, nor did he know anything of his background.[164] For Roché hardly knew this man he admired so much. As much as he appreciated and perhaps even understood his art, Roché could not answer the question: Who was Patrick Henry Bruce?

According to Charles Ratton, the connoisseur and champion of the Surrealists, Bruce was cold, closed but sympathetic, a distant, discreet man of impeccable manners, elegance, and refinement. Part of the intellectual milieu of St. Germain des Prés around 1930 (when several of the African bronzes he collected were published in *Cahiers d'Art*), Bruce never discussed his paintings. Indeed, few knew he painted.[165]

For John K. Page, a wealthy American expatriate who sometimes introduced Bruce to clients, there was "no one with such taste and knowledge of eighteenth-century French antiquities and who had greater integrity. It almost verged on the quixotic."[166] Page was impressed that although buying on commission, Bruce would never accept the traditional *pot de vin* from the seller. He was correct to the extreme. In words that probably would have pleased Bruce, Page lamented: "If he had had a little touch of the Semita he would have made big money, but he preferred to live up to the ideal of his state and of his ancestor whose name he carried. He loved to give but never to receive."[167]

We now know what Patrick Henry Bruce looked like. And we know enough about him to realize he was a misfit and a mass of contradictions: a dedicated, committed artist who lived out his life in his paintings, yet refused to speak of them; a dandy, an aesthete, and an aristocrat with the habits of a monk; an egomaniac who did not sign his works; a modernist who thought the twentieth-century was a mistake; an anti-Semite who admired Jewish thinkers and artists and whose few patrons were Jews; a racist who surrounded himself with the art of black Africans; a misogynist who could not live without women; a fastidious Puritan who collected erotic art. He was a critic who did not write, a connoisseur who did not sell, a classicist whose favorite opera was Wagner's *Die Meistersinger*, a story, like his own, of apprenticeship and mastery of tradition. Roché likened him to the deaf Beethoven composing the Ninth Symphony in dreadful isolation, and saw his art as the resolution of his suffering. We will never know what Bruce himself thought of his painting, since he never wrote a word about it. But his ability to communicate was so powerful and authentic that everything he had to say remains alive in his paintings.

NOTES

1. Virginia Payne Ahrens, interview with Barbara Rose, Bracciano, Italy, December 1978.
2. According to fellow Chase student, Clarence K. Chatterton (letter to William Agee, March 29, 1965), Bruce was "studious, self-confident, and talented. Under Chase he was painting attractive studies in an academic manner. Under the influence of Henri, he finally, if at first reluctantly, developed a freer style."
3. Ronald G. Pisano, *The Students of William Merritt Chase* (Exhibition Catalogue; Huntington, New York: Heckscher Museum, September 28–December 30, 1973), p. 28. Chase's advice to "make an edge without an edge in the principle of doing a thing without doing it" (Ibid., p. 6) was remembered later by Bruce.
4. See Guy Pène du Bois, *Artists Say the Silliest Things* (New York: American Artists Group, Inc.; Duell, Sloan and Pierce, Inc., 1940), p. 111. (See "Documents," p. 215.)
5. According to the chronology prepared by Helen Bruce for John I. H. Baur in 1949 (Collection Whitney Museum), Bruce went to Holland, as did she, in 1903. Since it appears he knew her well in 1904, and we know he was also a Chase student, it seems possible both Bruce and Helen went to Europe with Chase.
6. According to Céline Fildier (interview with Barbara Rose, November 1978), Bruce traveled to Spain. Since we know he did not leave Paris after 1921 (letter to Mary Bruce Payne, August 7, 1933, Collection Roy Bruce), he may have gone when Chase took his class to Madrid in 1905 and Bruce's close friend Edmund W. Greacen accompanied him.
7. Letter to Robert Henri, February 4, 1904. (Collection of American Literature, Beinecke Rare Book and Manuscript Library, Yale University hereafter, cited as Beinecke Library, Yale). I am grateful to Gail Levin for identifying Bruce in Henri 1902 class photo.
8. Ibid. Alfred H. Barr, Jr., in the exhibition catalogue *Edward Hopper* (New York: Museum of Modern Art, 1933), p. 10, states that Hopper was introduced to the work of the Impressionists, especially Sisley, Renoir, and Pissaro by Bruce in Paris in 1906–07.
9. See *James Wilson Morrice* (Exhibition Catalogue; Bordeaux: Musée des Beaux Arts, 1968).
10. Letter to Robert Henri, March 23, 1904 (Beinecke Library, Yale). (See "Documents," p. 214.)
11. Ibid.
12. Letter to Robert Henri, February 23, 1905 (Beinecke Library, Yale).
13. For a full description of Henri as an art teacher see William Innes Homer, *Robert Henri and His Circle* (Ithaca: Cornell University Press, 1969).
14. Letter to Robert Henri, February 23, 1905 (Beinecke Library, Yale). Bruce refers to a portrait painted by Helen of her little sister that Henri liked. Helen was an extremely talented artist who showed in the salons along with Bruce until the birth of their son, when she apparently gave up painting. A 1906 painting of a *fête* in the Luxembourg Gardens by Helen Bruce is in the collection of Virginia Payne Ahrens.
15. Du Bois, *Artists*, p. 111. (See "Documents," p. 215.)
16. Homer, *Robert Henri*, p. 149. Henri was in Paris for the month of September 1908, when he visited the Salon d'Automne. By this time Morrice had become a close friend of Matisse. As Homer points out, Henri rejected "the strange freaks" at the Salon d'Automne, claiming "The Eight exhibition was much more notable."
17. Helen Bruce told B. F. Garber that she and Pat were already good friends of Gertrude's before Toklas arrived.
18. At 27, rue de Fleurus, about 1907, there was Matisse's *Woman with the Hat*, 1905, and a number of smaller landscapes and still lifes. Michael and Sarah Stein, in 1907, owned *The Gypsy*, 1906; *Joy of Life*, 1905; *Mme Matisse ("The Green Line")*, 1905; *The Young Sailor, I*, 1906; *Blue Still Life*, 1907; *Self-Portrait*, 1906; and various other Matisse works of the Fauve period. See Alfred H. Barr, Jr. *Matisse: His Art and His Public* (New York: Museum of Modern Art, 1951), pp. 20–21.
19. Alice B. Toklas, *What is Remembered* (New York: Holt, Reinhart and Winston, 1963), p. 28. Toklas implies Bruce met Roché in 1907, but Roché remembers meeting Bruce only in 1916.
20. Helen Bruce to B. F. Garber. Jacques Lipchitz, in interview with William C. Agee, May 16, 1964, recalls Bruce giving him an African ivory at a very early date. Lipchitz remembered Bruce as a man of exquisite and fastidious taste who talked mostly about his bad stomach.
21. Charles Ratton, interview with Barbara Rose, Paris, April 1978. Ratton recalls that around 1930 Bruce owned one of the finest bronze gold weights he had ever seen. The piece is now on loan to The University of Pennsylvania Museum.
22. Helen Bruce to B. F. Garber.
23. Bruce to Gertrude Stein, postcard postmark "Boussac," apparently summer 1911: "Oh joy! Oh rupture ! (sic) Marvelous of wonderful— I got 400 francs from Feldmann . . . I feel so wicked" (Beinecke Library, Yale). These may have been the paintings loaned by Feldmann to the Armory Show.
24. Helen Bruce to B. F. Garber.
25. Toklas, *What is Remembered*, pp. 38–39.
26. Céline Fildier, interview with Barbara Rose, December 1978.
27. Helen Bruce to B. F. Garber.
28. "Matisse Speaks to His Students," 1908: Notes by Sarah Stein in Barr, *Matisse* p. 550. Additional insights into the material Matisse taught is contained in the lecture given at Wayne State University, October 1954, by Greta Moll, a member of the original Matisse class. According to Bruce's classmate, Matisse was aware of the shape of the canvas, and always tried to organize his shapes in reference to it. He used color abstractly, working in color planes—which he said expressed a greater tranquility than pointillist dots and patches. He told the students that they were free to distribute the colors of the spectrum

over the whole canvas, and to use cold colors for objects as well as shadows. Greta Moll (interview with William Agee, November 1964) recalls Bruce as quiet and charming, with a ginger beard. She commented on Matisse's visits with the class to the Louvre to study the Old Masters, and on the fact that his dining room walls were covered with watercolors by Cézanne, which we must assume Bruce saw during his visits to the Matisse apartment.

29. Bruce to the Steins (Beinecke Library, Yale, n.d.).

30. The drawing was purchased from Helen Bruce in Los Angeles by Vincent Price.

31. Marguerite Duthuit, interview with Barbara Rose, April 1978.

32. Ibid.

33. Pierre Matisse, interview with Barbara Rose and William C. Agee, November 1978.

34. Ibid.

35. Marguerite Duthuit, interview with Barbara Rose, April 1978.

36. Edward Steichen to Alfred Stieglitz, n.d. but apparently early 1911 (Beinecke Library, Yale): "Bruce's wife is over in New York now with his stuff. You will hear from her. I think he wants something of a chance. In spite of his limitations his stuff is genuine and only differs from Weber's in so far that he only follows one man, that Matisse–in fact they are really the only thing strictly speaking that are à la Matisse. Mrs. Bruce has her own stuff which is good enough but ordinary. She hopes to place them some place so as to make money while her dear husband pursues his serious ideals!!"

37. Helen to Stein and Toklas (Beinecke Library, Yale, date illegible, apparently summer of 1912). Helen's description of the house mentions: "5 rooms on the ground floor. Besides the kitchen and the bedrooms on second, a garden that must have once been beautiful with three terraces and all enclosed with a wall–and just on the side of the garden a perfect park of wonderful trees–
 "There are red geraniums in the garden–almost to my shoulders–great bushes of them." (This is the motif of Bruce's 1912 "leaf" paintings.)

38. Helen Bruce to Gertrude Stein, spring 1912 (Beinecke Library, Yale). Apparently echoing her husband's sentiments: "We have also seen the Matisses but nothing much doing save that Mme must be lonely as she was most cordial. Matisse came yesterday to see Pat's things and it sounded like the Beaux-Arts. The chèr maître is evidently getting old."

39. Sonia Delaunay, interview with Barbara Rose, April 1978. The Greek sandal was popularized by Isadora's brother, Raymond Duncan, who made them in Florence for Gertrude and Leo Stein. It continued to be the trademark of the American Bohemian expatriate.

40. Reeves to Gertrude Stein, April 1913 (Beinecke Library, Yale). A letter of A. B. Frost, Sr., April 19, 1912 (Collection Henry M. Reed), notes that Arthur is returning to Paris from the Swiss sanitorium and has taken an apartment adjoining the Bruces. Reeves may have shared this apartment or borrowed it from Frost.

41. For the theories of Robert Delaunay see Arthur A. Cohen, ed., *The New Art of Color* (New York: The Viking Press, 1978).

42. Bruce to Stein and Toklas (Beinecke Library, Yale), n.d.

43. Bruce to Robert Delaunay (Collection Sonia Delaunay), n.d.

44. Back from Belle-Ile in the fall of 1912, the Bruces picked up their friendship with the Delaunays. This is apparently the time that Bruce was most intensely involved with Robert Delaunay's color theory. Bruce's last portrait was *Femme assise* (cat. no. B37), a portrait of Helen in the pose and hairstyle of *Mme Cézanne* owned by Leo Stein. A note to Gertrude Stein, February 22, 1912 (Beinecke Library, Yale) mentions a portrait Bruce is painting of Gertrude, of which there is no record. Apparently he must have had rivaling Picasso's portrait of Gertrude Stein in mind.

45. Andrew Dasburg does not recall much, if any, contact between Russell and Bruce when he was in Paris in 1909–10 (Dasburg, interview with Barbara Rose, November 1977). Russell's name appears in Bruce's address book, but with an address in Aigremont, where he lived in the twenties. The hostility between the Synchromists and Bruce is clear. For Bruce was accepted as a member of the School of Paris, a full-fledged "simultaneist" as far as Apollinaire was concerned. The hostility toward Bruce is clear from Macdonald-Wright's brother, Willard Huntington Wright's dismissal of Bruce as "once an imitator of Matisse and later of Cézanne" who "has joined the Simultaneist camp." W. H. Wright, *Modern Painting* (New York: John Lane Company, 1915), p. 262. Nor was Bruce invited to exhibit in the Forum exhibition, organized principally by Macdonald-Wright and Stieglitz.

46. Gail Levin, "The Tradition of the Heroic Figure in Synchromist Abstractions," *Arts* (June 1977), pp. 138–42.

47. Bruce to Delaunay, September 20, 1913 (Collection Sonia Delaunay).

48. Succession Apollinaire.

49. Originally Bruce collected large, standing wooden African sculptures that appear to have influenced the geometric, sculptural volumes of his late paintings. On his return to America in 1936, he traded all the wooden sculptures in for small bronze pieces (fig. 17, p. 12) that he could take with him to sell. After his death, Mary Bruce Payne loaned these to The University of Pennsylvania Museum of Art.

50. Guillaume Apollinaire, review of the Salon des Indépendants, *L'Intransigéant*, March 15, 1914 (see "Documents," p. 219). André Salmon's review, *Montjoie!*, March 1914 (see "Documents," p. 219) mentions that the Delaunays, Picabia, and Bruce are all exhibiting in the entrance of the Quai d'Orsay, thus Bruce could not have missed seeing *Negro Song*. See note 62.

51. Gabrielle Buffet-Picabia, interview with Monique Nonne, Paris, February 1979.

52. Leo Stein to Lee Simonson (Beinecke Library, Yale).

53. The drawing is reproduced in *Sonia and Robert Delaunay* (Paris: Bibliothèque Nationale, 1977), p. 44. A date of 1922 is given for this drawing, apparently because Man Ray signed that year; however, Frost

was dead in 1918 and Helen left Paris in 1919, although both signed the drawing, which must be earlier, and therefore an inspiration for Picabia's *L'oeil cacodyle*, the 1921 souvenir signature painting.

54. Steichen to Stieglitz, August 19, 1913 (Beinecke Library, Yale): "Pat Bruce must have had a row with Matisse. He has certainly gone everyone better in cubes and he has thown in to boot all the shrieking colors of Maurer."

55. See description by Katherine Dreier, *Western Art and the New Era: An Introduction to Modern Art*, (New York: Brentano's, 1923), pp. 95–97. (See "Documents," p. 220.)

56. Ibid.

57. Letter from Henri-Pierre Roché to Michel Seuphor, March 3, 1956 (Collection Michel Seuphor, Paris).

58. Michel Seuphor in *Dictionary of Abstract Painting* (Paris: Paris Book Center, 1957), p. 25, noted that Bruce was indebted to Picabia as well as to Delaunay.

59. It should be noted here that *no* American painter achieved a genuinely analytic Cubist style. Leo Steinberg in "Resisting Cézanne: Picasso's 'Three Women,'" *Art in America*, vol. 56, no. 6 (November-December 1978), points out that Gertrude Stein owned the 1908 early Cubist picture and that Morgan Russell copied it. Steinberg agrees with Gail Levin's suggestion that this drawing was an important source for Russell's abstract synchromies. It is important to realize that while formulating their abstract styles in 1913–14, Russell was abstracting forms from sculpture, whereas Bruce's motif source was photographs. Helen Bruce (to B. F. Garber) dated the "stovepipe" paintings 1913, but it seems more likely they postdated Bruce's "simultaneist" compositions. The term "stovepipe" was apparently a reference to Cézanne's advice on how to abstract from reality. According to Theodore F. Reff: "When asked by the young painter Francis Jourdain for guidance, Cézanne advised him to copy his stovepipe, a cylindrical form, by distinguishing the planes of light, shadow, and halftone" ("Cézanne on Solids and Spaces," *Artforum*, 16 [October 1977], p. 35).

60. Helen Bruce to B. F. Garber and Sonia Delaunay, interview with Barbara Rose, April 1978.

61. Leon Kroll, interview with William C. Agee, March 1964 and Helen Bruce to B. F. Garber.

62. In a letter of September 18, 1914, A. B. Frost, Jr., asks for photos from magazines—especially animals, tigers, and lions: "Bruce wants dance halls like Bullier. Lots of women in modern clothes." In a letter to his father (October 22, 1914), Frost mentions that he and Bruce have enjoyed receiving the New York *Times* Fashion Supplement, and that he is painting from photographs. He requests "bundles of photo reproductions" (Collection Henry M. Reed). Thus apparently in the fall of 1914, both Bruce and Frost were painting from photographs that had replaced nature as the source of the motif.

63. In the exhibition catalogue of the Picabia retrospective (Paris: Musée National d'Art Moderne, Centre National d'Art et de Culture Georges Pompidou, 1976), the watercolor of *Negro Song* is published. Although it is noted that the painting was exhibited in the 1914 Salon des Indépendants there is no record of the painting. William Camfield in *Francis Picabia: His Art, Life and Times* (Princeton: Princeton University Press, 1979), fig. 73, 74, also reproduces the watercolors *Negro Song, I* and *Negro Song, II*, which were exhibited and purchased by Stieglitz. Apparently the oil is lost, as were *Danses à la source* and *La Source*, until recently.

64. Harrison Reeves, "Les Epopées Populaires Americaines," *Soirées de Paris*, March 1914.

65. See William Innes Homer, *Alfred Stieglitz and the American Avant-Garde* (Boston: The New York Graphic Society, 1977).

66. Henry McBride reviewed the exhibit in the Sunday New York *Sun*, March 25, 1917 issue: "Earlier in the winter we considered Mr. Bruce, a banana painter à la Cézanne, but calmer, much calmer than the master from Aix. Now he is a Dynamist, but still calm . . . Mr. Bruce's dynamics, in fact, are as monotonous as his former bananas." Another review of the exhibit, *American Art News*, vol. 15, no. 22 (March 10, 1917), p. 6, claimed: "An exhibition of the latest paintings by Patrick Henry Bruce is now on at the Modern Gallery, 500 Fifth Ave., to March 28, and will doubtless be of absorbing interest to the initiated, albeit somewhat difficult of comprehension to those who are not followers and students of the futurist cult."

67. James P. Daugherty, letter to Katherine Dreier, February 12, 1949 (Collection Société Anonyme).

68. Andrew Dasburg, catalogue for the Forum exhibition, 1916.

69. See Robert Delaunay, *The New Art of Color*, pp. 4–38 and Sonia Delaunay, pp. 200–02.

70. Reproduced in Gail Levin, *Synchromism and American Color Abstraction 1910–1925* (New York: George Braziller; The Whitney Museum of American Art, 1978), plates 2, 3, 5, and 7.

71. Helen Bruce to John I. H. Baur (Whitney Museum Archives).

72. Roy Bruce, interview with Barbara Rose, March 1978.

73. Milton Brown, *The Story of the Armory Show* (The Joseph H. Hirshhorn Foundation, 1963). Bruce was selected to be added to the French contingent by Pach (p. 50). Bruce caused a scandal when he asked to have his paintings removed because of the refusal to hang Delaunay's *City of Paris* (p. 120). "Halpert told the press that 'Bruce was the only American painter at all considered by French artists'" (p. 121).

74. Giorgio de Chirico, *De Chirico by de Chirico* (Exhibition Catalogue: New York: The New York Cultural Center, January 19-April 2, 1972), pp. 30–32. De Chirico's memoir documents his intimacy with Apollinaire and the Saturday evening soirées held by Apollinaire for poets, painters, and literati in his Saint-Germain des Prés apartment, where Brancusi and Derain, both friends whose names were found in Bruce's address book, went regularly. Apollinaire, the major conduit between Italian and French painters before and during World War I, served an important role as go-between.

75. Gino Severini, *Tutta la vita di un pittore* (Milan: Garzanti, 1946), pp. 240–74.
76. Ibid, p. 251. All translations by the author, unless otherwise indicated.
77. Ibid, p. 249. In his correspondence with the Delaunays, Bruce asked them to remember him to Mme Bongard.
78. Severini, *Tutta la vita*, p. 261. In his influential 1921 text *Du Cubisme au classicisme*, Severini demanded a new monumental classical form of Cubism. Even before Purism called for architectural paintings, Severini was preaching on architectonic still-life style.
79. Severini, *Tutta la vita*, p. 259. Severini's article "La Peinture de l'avant-garde," published in *Mercure de France*, April 1917, was the opening salvo of the "call to order" and was widely circulated.
80. Severini, *Tutta la vita*, p. 263.
81. *L'Esprit Nouveau*, no. 4 (1920), p. 369.
82. Virginia Payne Ahrens, interview with Barbara Rose, December 1978. When she visited her uncle in 1928, Couperin was his favorite composer.
83. Marcelle Cahn and Florence Henri, interview with Barbara Rose, November 1978. When Calvin Tomkins asked Murphy if he knew Bruce, Murphy had no memory for either Bruce or his work (Calvin Tomkins, interview with Barbara Rose, March 1978).
84. For a discussion of Perret and his influence, see Reyner Banham, *Theory and Design in the First Machine Age* (New York: Praeger Publishers, 1960), especially chapters 16 and 17, which document the relationship of architecture and painting in Paris between 1918 and 1928.
85. In his memoir (see "Documents," p. 223), Roché says that Bruce stopped painting in 1932 and that he had worked in his late style for fifteen years. Based on this information, we deduce that Bruce began the architectural paintings in 1917. When Virginia Ahrens visited her uncle in 1928, he took her on a tour of the new concrete buildings in the geometric modern style outside of Paris (Virginia Ahrens, interview with Barbara Rose, December 1978).
86. See note 59.
87. Collection Henry M. Reed.
88. Michel Seuphor, interview with Barbara Rose, November 1978. Seuphor recalls the darkness and gloominess of Bruce's apartment. Roché in his memoirs comments on the austerity and cleanliness of Bruce's home (see Roché memoir in "Documents," p. 223, for a description of Bruce's apartment-atelier). In *Dictionary of Abstract Painters*, p. 25, Seuphor recalls: "He himself was dispirited and disinclined to talk, and yet his painting radiated happiness and reasonableness."
89. Harrison Reeves, "Les Epopées Populaires Americaines," *Soirées de Paris*, March 1914. This was perhaps the first article to take American popular culture seriously. Reeves cites his Harvard philosophy professors, Childs, Kittredge, Schofield, Neilson, and Weiner, as being ignorant of popular language.
90. Journals of Henri-Pierre Roché, 1919–22 (Collection François Truf-

faut, Paris). Roché was an intimate of Reeves, who is sometimes referred to with the code name "Kousin," indicating their intimacy.
91. On December 16, 1925, Bruce wrote to his sister, Mary Payne, about a severe intestinal infection: "I am still sick and lead the life of an invalid, am generally in a bad humor and even less given to letter writing than formally" (Collection Roy Bruce).
92. In his address book, among the many pages of doctors was the name of Bruce's dentist, Dr. Tzanck, for whose services Duchamp had paid with the famous *Tzanck Check*.
93. Among the subcategories were specialists in stonework, leather for chairs, mantles in marble, mirrors, glass work—in short, every manner of craftsman.
94. Roché Journals, entries for 1919 (Collection François Truffaut, Paris).
95. Ibid.
96. Ibid.
97. John Quinn Memorial Collection, New York Public Library. On October 22, 1920, Roché records a lunch with Reeves at Bruce's and remarks, "La peinture de ce dernier montera." On November 20, 1920, Roché notes a lunch at Bruce's, where he found Reeves: "I stayed alone with Bruce who showed me his paintings. I find them very impressive—his importance in painting will show up one of these days. I would buy if I had any money!" Roché Journals (Collection François Truffaut, Paris).
98. John Quinn Memorial Collection, New York Public Library.
99. Letter of A. B. Frost, Jr., to Augustus Daggy, September 6, 1914, describes a Bruce painting as "patches of crude color getting smaller toward the center, no 'form' whatever and generally straight lines, no curves." The sketch of the lost painting with a "Vorticist" image of whirling vortex is reproduced as fig. 17 in Gail Levin, "Patrick Henry Bruce and Arthur Burdett Frost, Jr.: from the Henri Class to the Avant-Garde," *Arts* (April 1979), pp. 102-06. (Letter Collection Henry M. Reed).
100. Fernand Léger, published as "The Origins of Painting and its Representational Value," and "Contemporary Achievements in Painting," *Functions of Painting*, The Documents of 20th-Century Art (New York: The Viking Press, 1973).
101. When Virginia Ahrens visited, he lectured her at length on Fra Angelico and Botticelli (Virginia Ahrens, interview with Barbara Rose, December 1978).
102. By the time Virgil Thomson began seeing Stein in 1924–25, she no longer spoke of Bruce, nor was there any communication between the two (Virgil Thomson, interview with Barbara Rose, March 1979).
103. These were the words Bruce used to describe Botticelli to his niece when showing her the Louvre (Virginia Ahrens, interview with Barbara Rose, December 1978).
104. Irene Gordon, "A World Beyond the World: The Discovery of Leo Stein," *Four Americans in Paris* (Exhibition Catalogue: New York: The Museum of Modern Art, 1970), pp. 13–33. The similarity be-

tween Bruce and Leo Stein in personality, taste, and intellectual sources is remarkable; we may assume Leo's disgust with Picasso's intellectual limitations was shared by Bruce. In an interview with William C. Agee (March 1964), Steichen maintained that Leo Stein was "a good influence on Bruce."

105. Leo Stein, *Appreciation* (New York: Random House, 1947). Leo Stein reminisces about the early years, when he and Gertrude discovered modern art. In the chapter "Personal Adventures," he explains how Mantegna's Crucifixion prepared him for Cézanne. A considerable amount of the book is dedicated to mocking Picasso and to fulminating against the limitations of modernism, especially as exemplified in the writing of his sister, Gertrude, who finally achieved the artistic eminence that eluded Leo.

106. Ibid, p. 121. He found the intersecting planes of Cubism particularly repugnant and confusing, as did Bruce, who sought a maximum clarity of contour. Bruce's frequent use of diagonals may derive from Jay Hambidge's *The Elements of Dynamic Symmetry*, a treatise on composition cited by Leo Stein in *Appreciation*. Bruce could easily have seen copies of Hambidge's *The Diagonal*, a monthly magazine the American theorist published while he was in Europe in the winter of 1919–20.

107. Du Bois, *Artists*, p. 111.

108. He could also have seen the drawing Duchamp made on the wall of his studio of *The Bride Stripped Bare by her Bachelors, Even* (the *Large Glass*). See Ulf Linde, "La perspective dans les neuf moules maliques," *Marcel Duchamp abécédaire* (Paris: Musée National d'Art Moderne, Centre National d'Art et de Culture Georges Pompidou, 1977), pp. 160–65. In Pierre Cabanne, *Dialogues With Marcel Duchamp* (New York: The Viking Press, 1971), p. 38, Duchamp commented: "In addition perspective was very important. The *Large Glass* constitutes a rehabilitation of perspective which had been completely ignored and disparaged."

109. He liked to claim that he was descended not only from Patrick Henry, but also directly from the first King of Scotland (Céline Fildier, interview with Barbara Rose, November 1978).

110. Giorgio de Chirico, "On Metaphysical Art," reprinted in Massimo Carrà, *Metaphysical Art* (New York: Praeger Publishers, 1971), p. 90.

111. Translated in Carrà, *Metaphysical Art*, p. 97. The metaphysical painters were the first to focus on architecture as a theme for painting.

112. Under construction in 1928, the Villa Savoye was probably one of the new concrete buildings Bruce showed his niece (Virginia Ahrens, interview with Barbara Rose, December 1978). Members of the Bruce family, including Bruce's great grandfather, his grandfather, and his son, were amateur architects. Berry Hill, the seat of the Bruce family, has been described as the purest surviving Greek Revival mansion in Virginia, the grandest house in the state aside from the Governor's Mansion. Built in 1841–44 by Bruce slaves and craftsmen, Berry Hill, according to Virginia historian Kenneth Cook, is noted for its massive octastyle Doric portico and two smaller Doric pavillions, the plantation

office, and schoolroom. Tarover, the Victorian Gothic villa where Patrick Henry Bruce was born, had many Greek Revival details, including moldings of the type that inspired Bruce's still life forms, identical to those at Berry Hill.

113. Madame X has one of Bruce's Japanese prints that depicts such an oblique viewpoint.

114. Sonia Delaunay, interview with Barbara Rose, April 1978.

115. Roché Journals (Collection University of Texas, Austin, Texas).

116. Part of Roché's library was acquired in 1966 by the Moderna Museet. Among the periodicals were most of the major avant-garde reviews, including the New York Dada publications such as the issue of *The Blind Man* with Duchamp's *Chocolate Grinder* on the cover.

117. Man Ray, interview with William C. Agee, January 31, 1964: Man Ray met Bruce at Roché's in the twenties. He thought he had the personality and dress of an American businessman, but that "Bruce was to American painting what Gris was to Picasso and Braque." Duchamp (interview with William C. Agee, November 29, 1963) also met Bruce at Roché's studio. He recalled Bruce as a man with a keen mind and high intelligence. He apparently did not see Bruce's paintings until after his death, when he encouraged Roché to write about them (Roché letter to Katherine Dreier, February 14, 1948, Collection Société Anonyme).

118. One of the entries in the address book is for a photographer of art objects.

119. Brancusi's address is listed in Bruce's address book at 8, impasse Ronsin, and it is not changed to 11, impasse Ronsin. Thus Bruce must have known Brancusi between 1916 and 1928, when he lived at 8 impasse Ronsin.

120. Published by Sidney Geist in *Brancusi: A Study of the Sculpture* (New York: Grossman Publishers, 1967), p. 193. Carola Giedion-Welcker, *Constatin Brancusi* (New York: George Braziller, Inc., 1959), was the first to publish Brancusi's own photographs of his work, now in the Centre Nationale d'Art Moderne, Beaubourg. See *Brancusi Photographe* (Paris: Musée National d'Art et de Culture Georges Pompidou, 1977).

121. See Standish Lawder, *The Cubist Cinema* (New York: New York University Press, 1975).

122. In his Journals of 1923, Roché mentions having Man Ray's photographs in his possession. Bruce's involvement with photography started early. Arthur B. Frost, Jr., in a letter to his father requested photographs for them to work from in 1914 (see note 62). In a letter to his sister, Mary, May 28, 1933, Bruce mentions awaiting the arrival of photographs of skyscrapers (Collection Roy Bruce). Bruce's last drawing also appears to be based on a reproduction.

123. Letter from Russell to Helen Bruce giving instructions to his house, August 4, 1920 (Collection B. F. Garber).

124. Meyer Schapiro, "The Apples of Cézanne: An Essay on the Meaning of Still-Life," *Modern Art 19th and 20th Centuries* (New York: George Braziller, 1978).

125. Hopper to Henri, September 24, 1906. Hopper is complaining to Henri that Bruce is a little better than when he was at school.
126. Greta Moll, interview with William C. Agee, November 29, 1964.
127. A number of Roché's Journal entries in 1919–20 reveal Roche's impatience with Bruce's theorizing.
128. For some time, apparently under the influence of Delaunay's technical experiments (see Delaunay, *New Art*, p. 71 for a discussion of painting with wax, gum, oil and varieties of pigment), Bruce used mixed media. A technical analysis of the *Compositions* reveals the presence of gesso. In a letter to his father (August 25, 1914, Collection Henry Reed) Frost described the technique of painting *à la colle*, which he and Bruce presumably both used: "Painting *à la colle* is no such terrible business. We keep the paint powder mixed into water, in tumblers labelled. The powder sinks to the bottom of the water and we stir it up with a stick. . . . We mix some gelatine in warm water in a bowl over an alcohol lamp. . . . It is a clean pure way of painting. Of course it dries out much lighter than it is when it was wet but that can be allowed for." In the pursuit of maximum color brilliance and intensity, these experiments were undertaken. There is no doubt that Bruce had technical difficulties as a result of such experiments. In his review of the 1914 Salon des Indépendants. Apollinaire berated Bruce for painting like a "Renaissance artist," for he apparently had difficulty mastering the transparency Delaunay preached. "In our kind of painting," Frost continued, "we mix the colors with water and the gelatine into the water. All the water evaporates and all that remains on the canvas is a thin coat of gelatine which contains color." This mixture of powdered pigment, gelatine, and water is apparently what Frost meant when speaking of the technique of painting "*à la colle*." The presence of different types of pigments in Bruce's paintings has resulted in preservation problems and shifting paint areas, and technical problems that plagued him until the last paintings he made, which are painted with traditional techniques of brush, knife, or a combination of the two.
129. Du Bois, *Artists*, p. 111.
130. Ibid.
131. Leon Kroll recalls Delaunay mocking Bruce's paintings in his studio when Kroll visited Bruce in 1923. Leon Kroll, interview with William C. Agee, March 1964.
132. Robert Delaunay, *New Art*, p. 6.
133. Ibid.
134. Du Bois, *Artists*, p. 111.
135. Leo Stein to Lee Simonson (Beinecke Library, Yale).
136. Roché, "Memories of P. H. Bruce" (Collection of Société Anonyme). (See "Documents," p. 223.)
137. Florent Bex, *Jozef Peeters* (Exhibition Catalogue; Antwerp: Antwerp International Culture Center, July 1–September 3, 1978), p. 26.
138. According to Seuphor, Peeters understood Bruce's paintings as a criticism of Mondrian's use of black line, his restricted palette and refusal to use the diagonal. "From Bruce he learned that there is no other line in painting except the edge of a flat surface." *Seuphor* (Exhibition Catalogue; Antwerp: Fonds Mercator, S.A., 1978), p. 305.
 Roché offered to give the Guggenheim Museum a Bruce painting in 1948, but Hilla Rebay refused the gift because Bruce was not a nonobjective painter. On April 30, 1948, Roché wrote the Baroness that he wished her to choose a painting from the "12-15 canvases in my home of Patrick Bruce, who has worked 15 years alone on his personal Cubism. . . . He was a proud and lonesome character, a precursor then, *nobody knows his serious and passionate works of his last 15 year period*" (Hilda Rebay Archives, Guggenheim Museum).
139. George L. K. Morris, "A Brief Encounter With Matisse," *Life*, vol. 69 (August 28, 1970), p. 44.
140. Bruce's tendency was always to go back to the original source—to Cézanne for his ideas about structure and to Delacroix for his color theory. These were the patriarchs of the modern movement to whom he constantly returned. Thus his conception of color is almost identical with the color theory described by Paul Signac in his seminal *D'Eugene Delacroix au neo-impressionnisme*, first published in 1899, which informed both Matisse and Delaunay.
141. Mrs. Edmund Greacen, interview with William C. Agee, March 1964.
142. Helen Bruce to B. F. Garber.
143. Collection B. F. Garber.
144. Roché's description of these toys in his memoirs is erroneous. The author has seen them, and they are simple cut-out felt pieces sewn together. The fish resembles the elliptical objects in the center of *Forms* (Lane Collection).
145. Olivier Micha, "Duchamp et la couture," *Marcel Duchamp abécédaire* (Paris: Musée National d'Art Moderne, Centre National d'Art et de Culture Georges Pompidou, 1977), pp. 33–34.
146. Both Virginia Ahrens and Céline Fildier recalled (interviews with Barbara Rose) Bruce lecturing them on such objects.
147. In a letter to Roché of March 12, 1928, Bruce mentions he has all the elements for ten paintings.
148. Michel Seuphor, interview with Barbara Rose, November 1978.
149. Roché memoir. See note 136.
150. Madame X, interview with Barbara Rose, November 1978.
151. Helen Bruce (to John I. H. Baur) and Roché (to Katherine Dreier, February 14, 1948, Collection Société Anonyme) both described the slow, methodical, painstaking manner in which Bruce worked. The growth of industrial manufacture produced a crisis of craft—epitomized in the *art decoratif* exhibitions of the twenties—to which Bruce was also acutely sensitive. Bruce's unwillingness to sign his paintings indicates his solidarity with a tradition of anonymous craftsman as much as it expresses his characteristic self-effacement.
152. Harrison Reeves had a great interest in and knowledge of classical music, which Bruce may have discussed with him. (Harvard University, Records of the Class of 1910 contains a detailed obituary of Reeves, who died penniless in New York in 1944).

153. Description based on information provided by Madame X, on whose memories this chapter is largely based.

154. Madame X, interview with Barbara Rose, November 1978.

155. Bruce to Mary Payne. On December 16, 1931, Bruce wrote to his sister: "I have been sick and lost ten pounds in weight. This chemist who is treating me says I am in bad condition, that my intestines are in rubbans (sic) and that it will take ten years to cure me, but that he can do it. I believe he can do it if anybody can" (Collection Roy Bruce).

156. All those interviewed about Bruce stressed his belief that he was an aristocrat. As it was not an accident he moved into the building that housed Delacroix's studio, nor was it chance he chose to live in Versailles, seat of the *ancien régime*.

157. One of the postcards he sent to the Delaunays has a picture of Dreyfus being taken to Devil's Island on it (Collection Sonia Delaunay).

158. Letter from Bruce to Mary Payne, May 28, 1933 (Collection Roy Bruce).

159. Virginia Ahrens, interview with Barbara Rose, December 1978.

160. Ibid.

161. Du Bois, *Artists*, p. 111.

162. Helen Bruce to B. F. Garber.

163. Bruce to Madame X: "Mon cher petit lapin—Ce soir je pars pour au-de-là."

164. Roché to Dreier, February 14, 1948 (Collection Société Anonyme).

165. Charles Ratton, interview with Barbara Rose, April 1978.

166. John K. Page to Mary Payne, November 29, 1936 (Collection Charles W. Porter, III).

167. Ibid.

COLOR PLATES

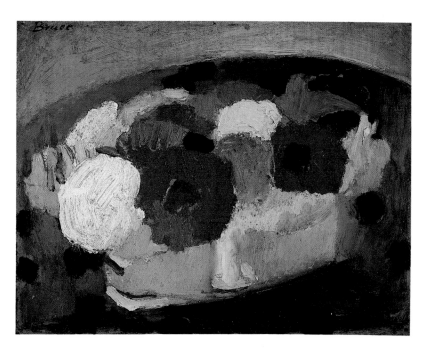

1. STILL LIFE (WITH FLOWERS). c. fall 1912

Oil on panel, 7⅜ x 9½ in (18.7 x 24.1 cm)
Collection B. F. Garber, Marigot, St. Martin
Cat. no. B69

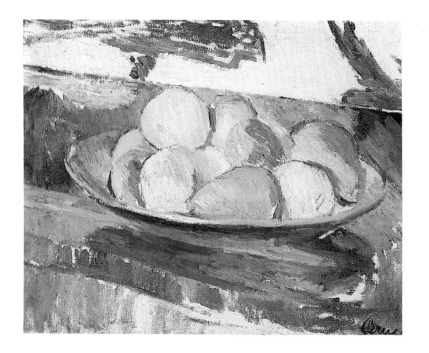

2. STILL LIFE (WITH DISH OF FRUIT). 1911

Oil on canvas, 12½ x 16 in (31.8 x 40.6 cm)
Collection B. F. Garber, Marigot, St. Martin
Cat. no. B42

3. LEAVES c. summer 1912

Oil on canvas, 21½ x 17¼ in (54.6 x 43.8 cm)
Collection William Kennedy, Marigot, St. Martin
Cat. no. B64

4. STILL LIFE (WITH TAPESTRY). c. fall 1912

Oil on canvas, 19½ x 28 in (49.5 x 71.1 cm)
Collection Mr. and Mrs. Henry M. Reed, Montclair, New Jersey
Cat. no. B73

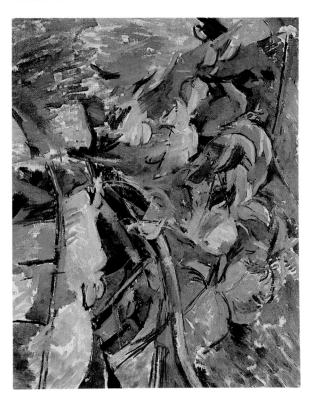

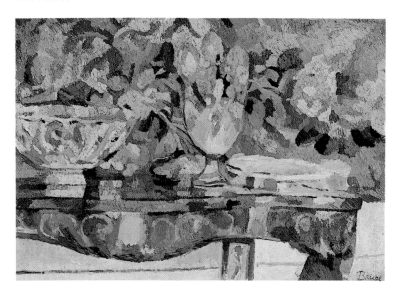

5. COMPOSITION III. 1916

Oil on canvas, 63¼ x 38 in (160.6 x 96.5 cm)
Yale University Art Gallery, gift of Collection Société Anonyme
Cat. no. C7

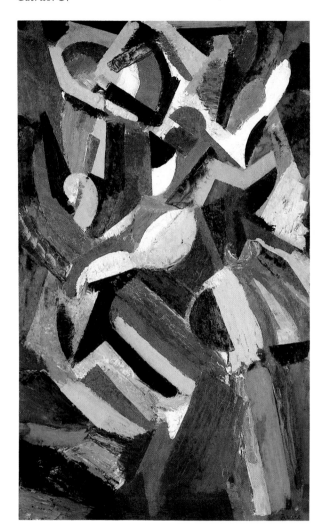

6. COMPOSITION VI. 1916

Oil on canvas, 64¼ x 51¼ in (163.2 x 130.2 cm)
The Museum of Fine Arts, Houston, The Agnes Cullen Arnold Endowment Fund
Cat. no. C8

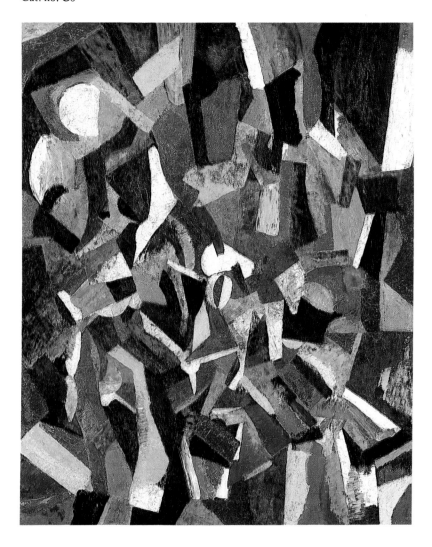

7. COMPOSITION V. 1916

Oil on canvas, 51⅜ x 63⅝ in (130.5 x 161.6 cm)
Yale University Art Gallery, gift of Collection Société Anonyme
Cat. no. C9

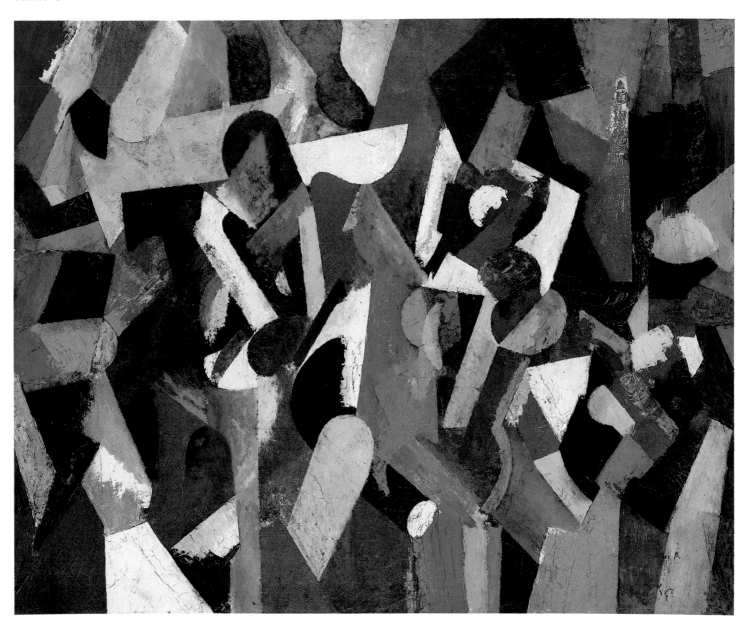

8. COMPOSITION IV. 1916

Oil on Canvas, 50¾ x 76½ in (128.9 x 194.3 cm)
Yale University Art Gallery, gift of Collection Société Anonyme
Cat. no. C10

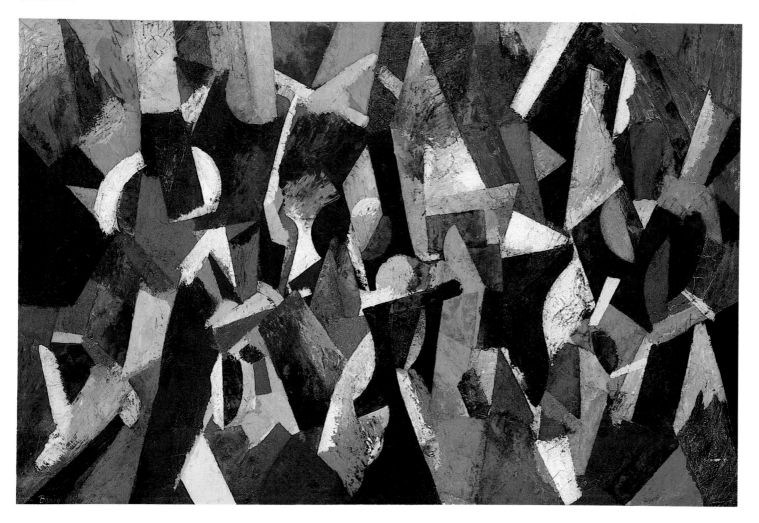

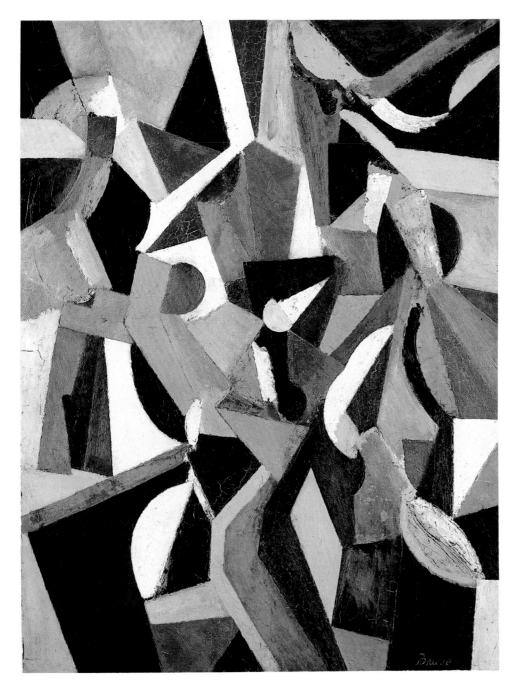

9. COMPOSITION I. 1916

Oil on canvas, 45½ x 34¾ in (115.6 x 88.3 cm)
Yale University Art Gallery, gift of Collection
Société Anonyme
Cat. no. C11

10. COMPOSITION II. 1916

Oil on canvas, 38¼ x 51 in (97.2 x 129.5 cm)
Yale University Art Gallery, gift of Collection Société Anonyme
Cat. no. C12

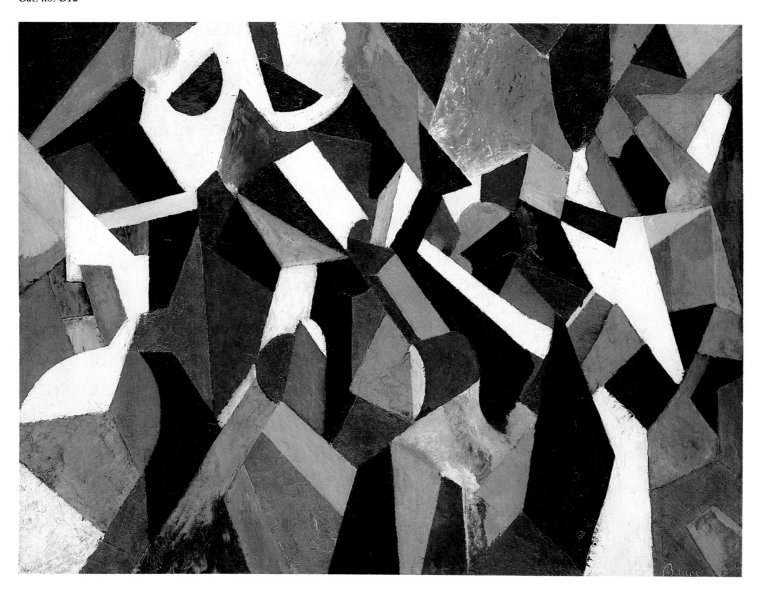

11. PEINTURE. c. 1917-18

Oil and pencil on canvas, 26⅛ x 32½ in (66.4 x 82.6 cm)
Collection Rolf Weinberg, Zurich
Cat. no. D1

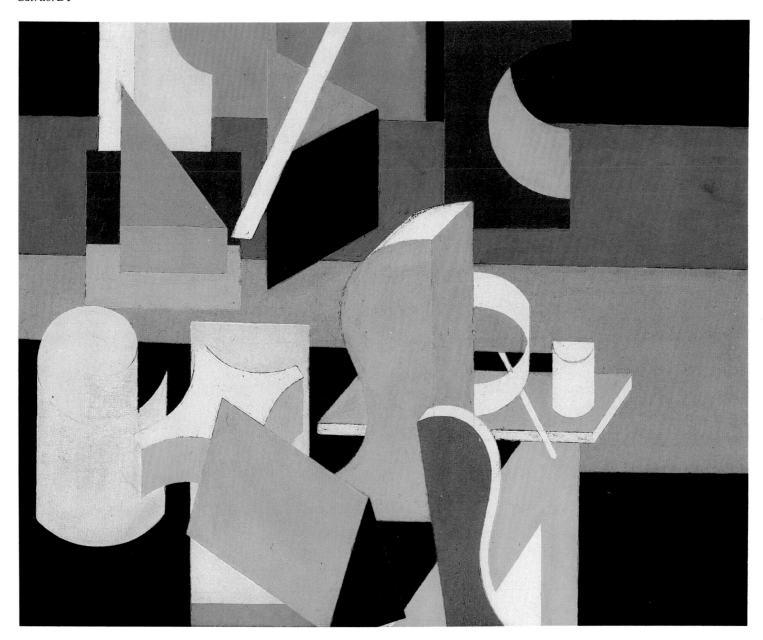

12. PEINTURE. c. 1918-19

Oil on canvas, 23½ x 28¾ in (59.7 x 73 cm)
Sheldon Memorial Art Gallery, University of Nebraska, Lincoln, Howard S. Wilson Memorial Collection
Cat. no. D2

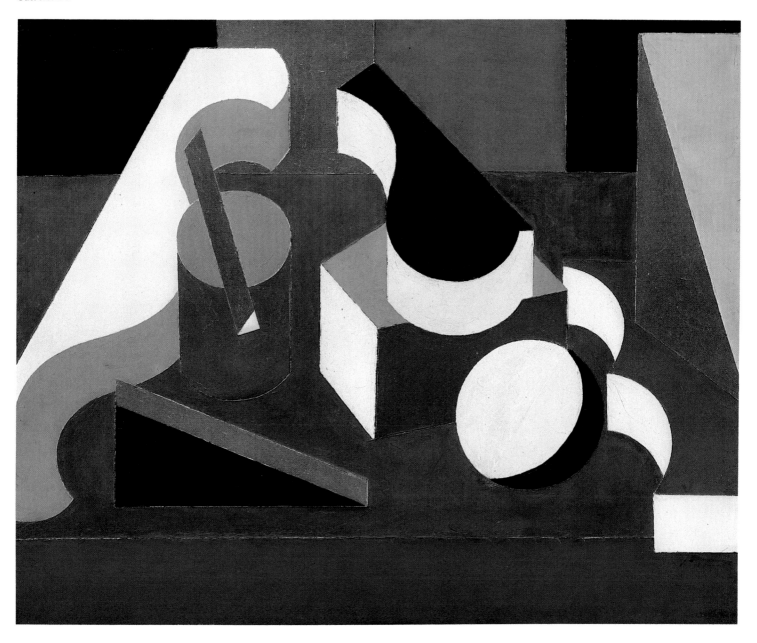

13. PEINTURE. c. 1919

Oil and pencil on canvas, 23½ x 28⅜ in (59.7 x 72 cm)
Collection Roy R. Neuberger, New York
Cat. no. D3

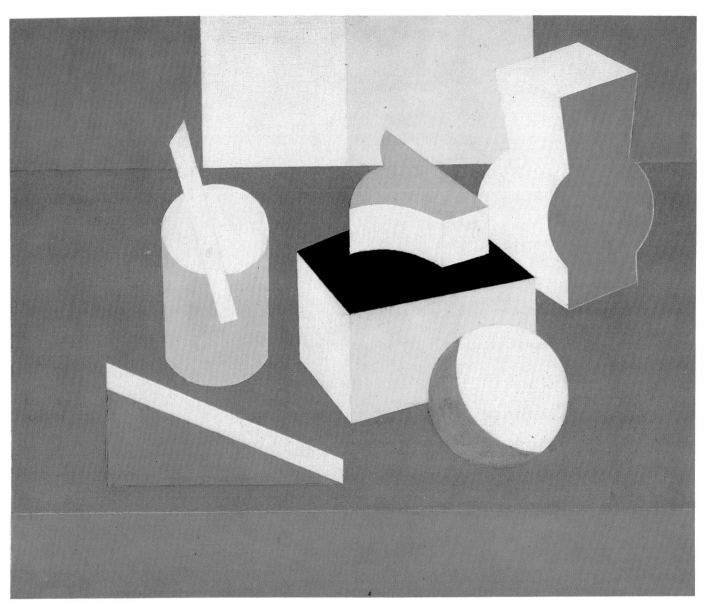

14. PEINTURE. c. 1919

Oil and pencil on canvas, 23½ x 36 in (59.7 x 91.4 cm)
Private collection, New York
Cat. no. D4

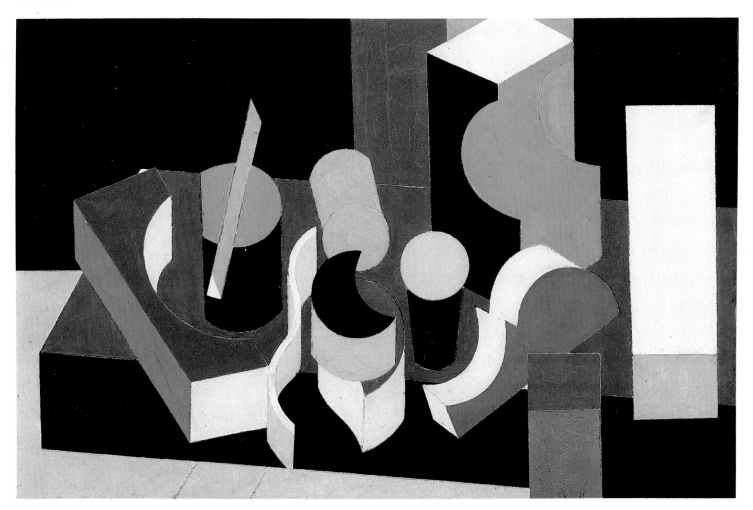

15. PEINTURE. c. 1919-20

Oil and pencil on canvas, 23¾ x 36¼ in (60.3 x 92.1 cm)
William H. Lane Foundation, Leominster, Massachusetts
Cat. no. D5

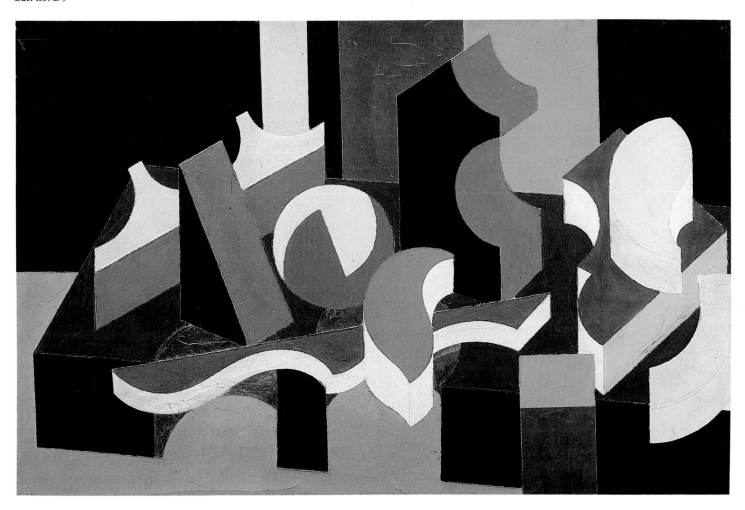

16. PEINTURE/NATURE MORTE. c. 1920-21

Oil and pencil on canvas, 35 x 46 in (88.9 x 116.8 cm)
The Museum of Fine Arts, Houston, gift of the Brown Foundation
Cat. no. D6

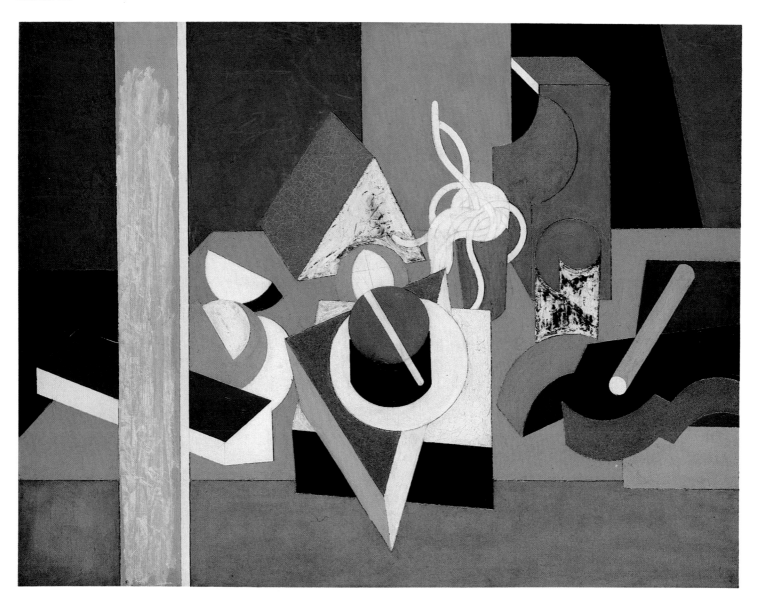

17. PEINTURE / NATURE MORTE. c. 1920-21

Oil and pencil on canvas, 35 x 45¾ in (88.9 x 116.2 cm)
Metropolitan Museum of Art, George A. Hearn Fund
Cat no. D7

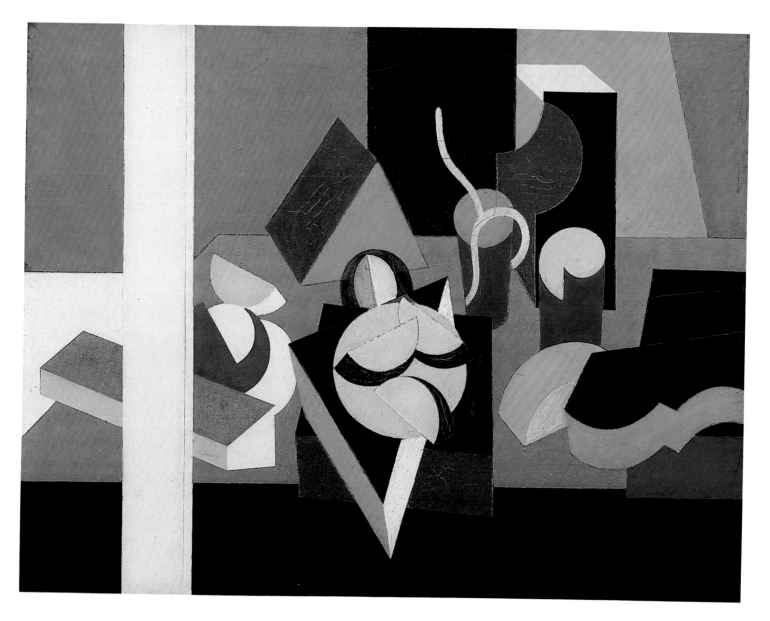

18. PEINTURE/NATURE MORTE. c. 1921-22

Oil and pencil on canvas, 35 x 45¾ in 88.9 x 116.2 cm)
Whitney Museum of American Art, New York, anonymous gift
Cat. no. D8

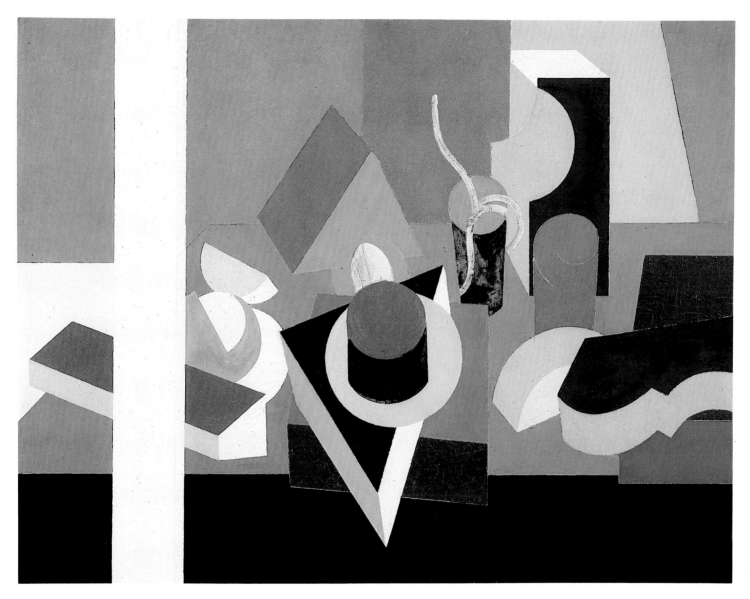

19. PEINTURE/NATURE MORTE. c. 1921-22

Oil and pencil on canvas, 34⅜ x 45 in (87.3 x 114 cm)
Philadelphia Museum of Art, gift of the Woodward Foundation
Cat. no. D9

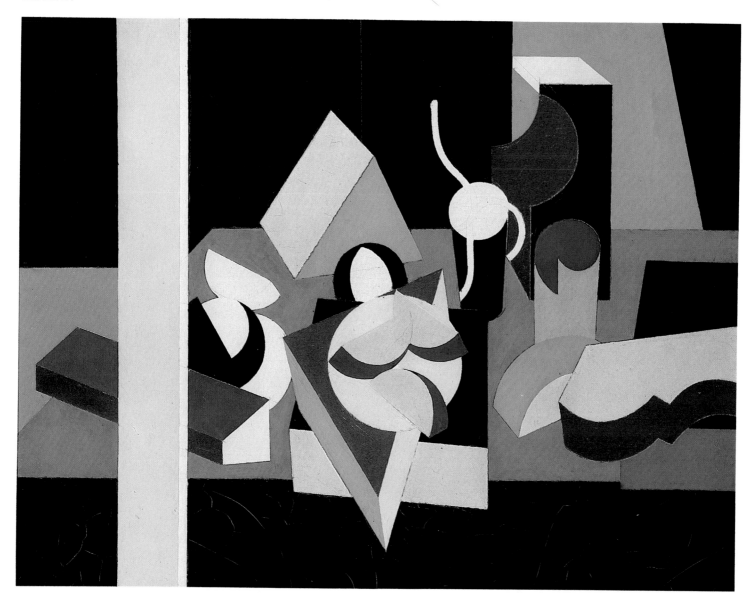

20. PEINTURE/NATURE MORTE. c. 1922-23

Oil and pencil on canvas, 25½ x 31¾ in (64.8 x 80.5 cm)
Hirshhorn Museum and Sculpture Garden, Smithsonian Institution, Washington, D.C.
Cat. no. D10

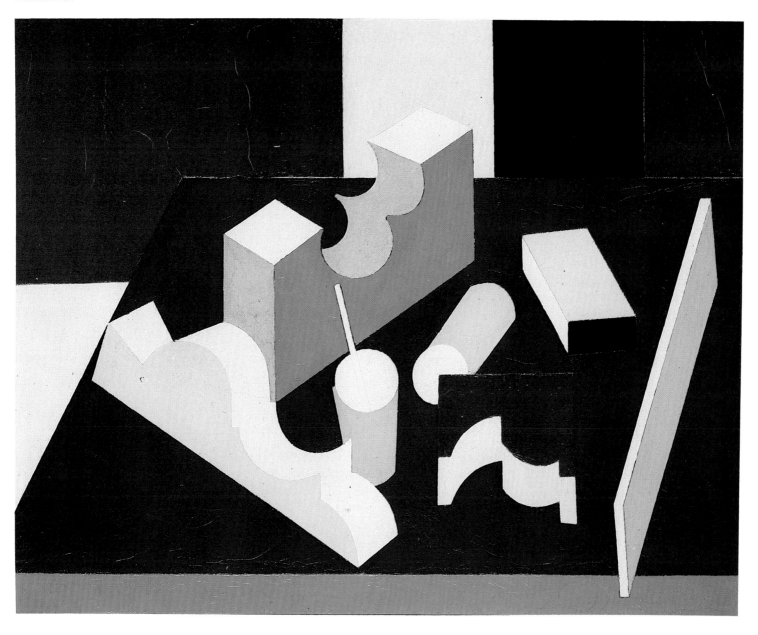

21. PEINTURE/NATURE MORTE. c. 1922-23

Oil and pencil on canvas, 28¾ x 36¼ in (73 x 92.1 cm)
Private collection, New York
Cat. no. D11

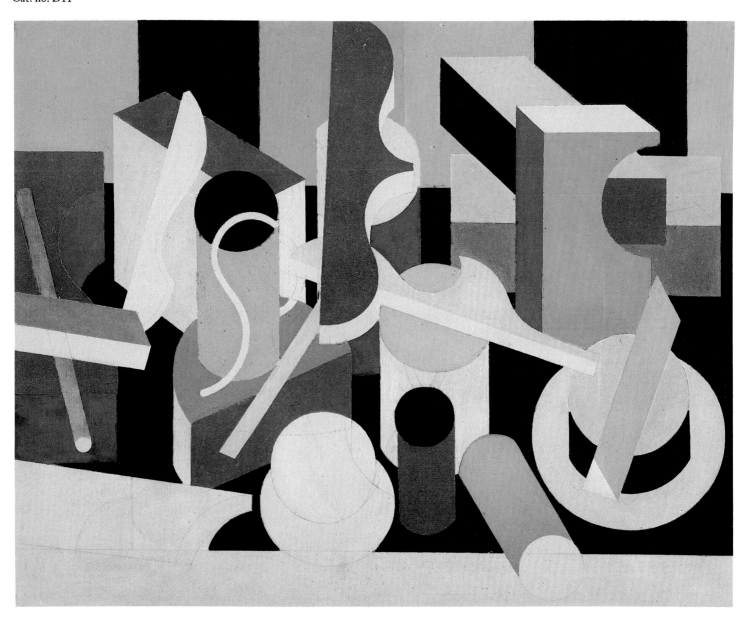

22. Peinture/Nature morte. c.1923 or c.1926

Oil and pencil on canvas, 25⅜ x 31⅞ in (64.5 x 81 cm)
Musée National d'Art Moderne, Centre Georges Pompidou, Paris, gift of Michel Seuphor
Cat. no. D12

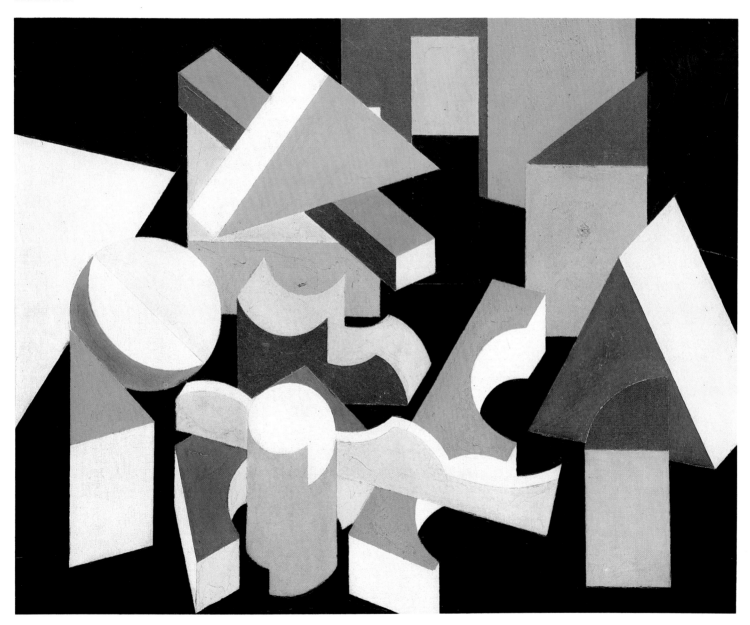

23. PEINTURE/NATURE MORTE. c. 1923-24

Oil and pencil on canvas, 25 x 32 in (63.5 x 81.3 cm)
Collection Mr. and Mrs. Henry M. Reed, Montclair, New Jersey
Cat. no. D13

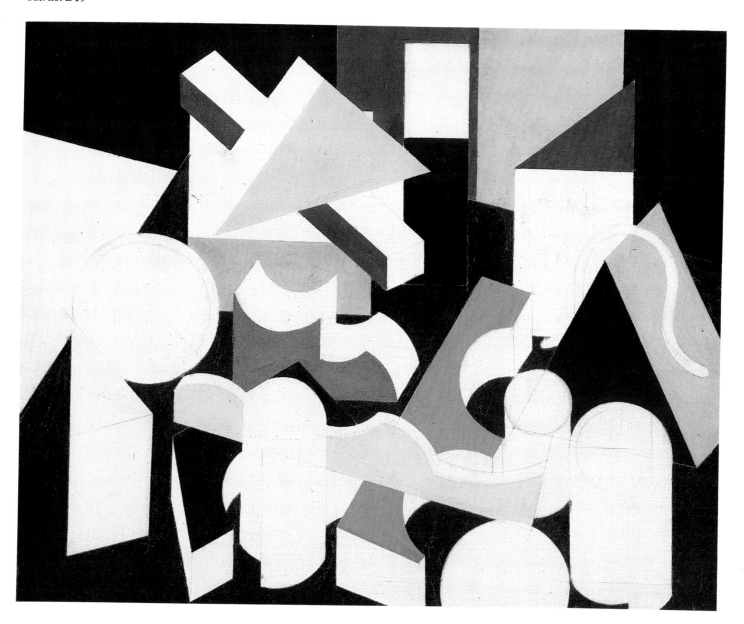

24. PEINTURE/NATURE MORTE. c. 1923-24

Oil and pencil on canvas, 31⅞ x 38¾ in (81 x 98.4 cm)
Museum of Art, Rhode Island School of Design, Albert Pilavin Collection
Cat. no. D14

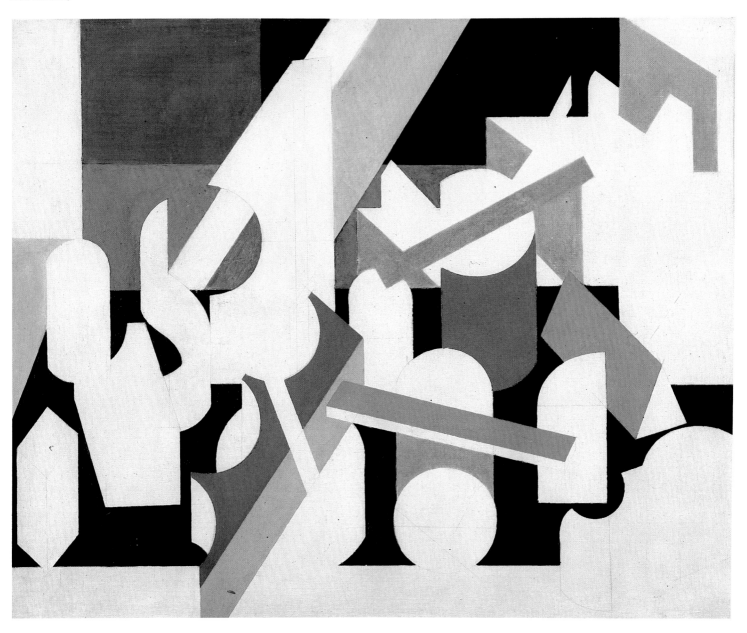

25. PEINTURE/NATURE MORTE. c. 1923-24

Oil and pencil on canvas, 31¼ x 38½ in (79.4 x 97.8 cm)
Private collection, New York
Cat. no. D15

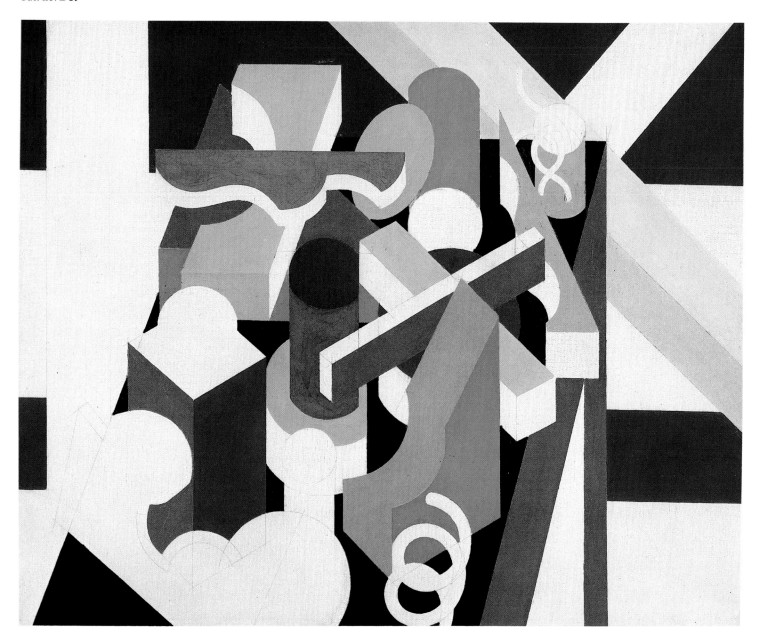

26. PEINTURE/NATURE MORTE. c. 1924

Oil and pencil on canvas, 28¾ x 36¼ in (73 x 92.1 cm)
Addison Gallery of American Art, Phillips Academy, Andover, Massachusetts, gift of Mr. and Mrs. William Lane
Cat. no. D16

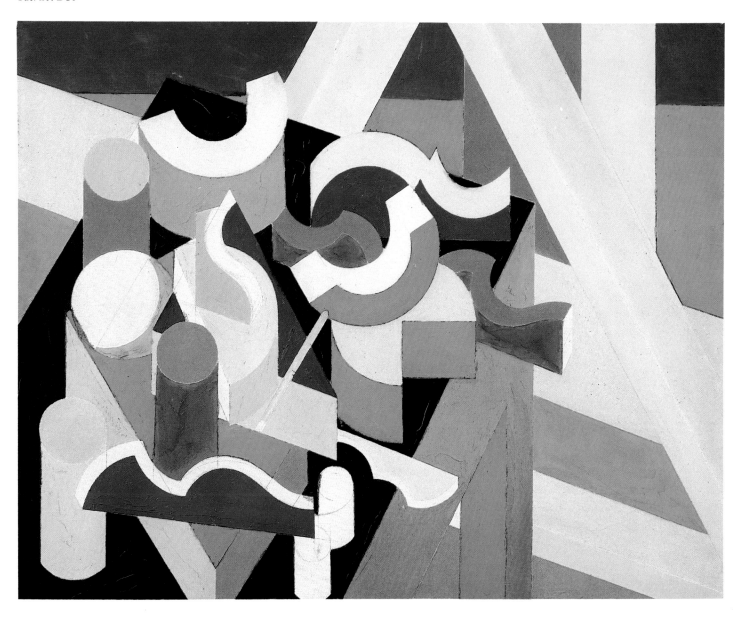

27. PEINTURE/NATURE MORTE. c. 1924

Oil and pencil on canvas, 28¼ x 35¾ in (71.8 x 90.8 cm)
Collection B. F. Garber, Marigot, St. Martin
Cat. no. D17

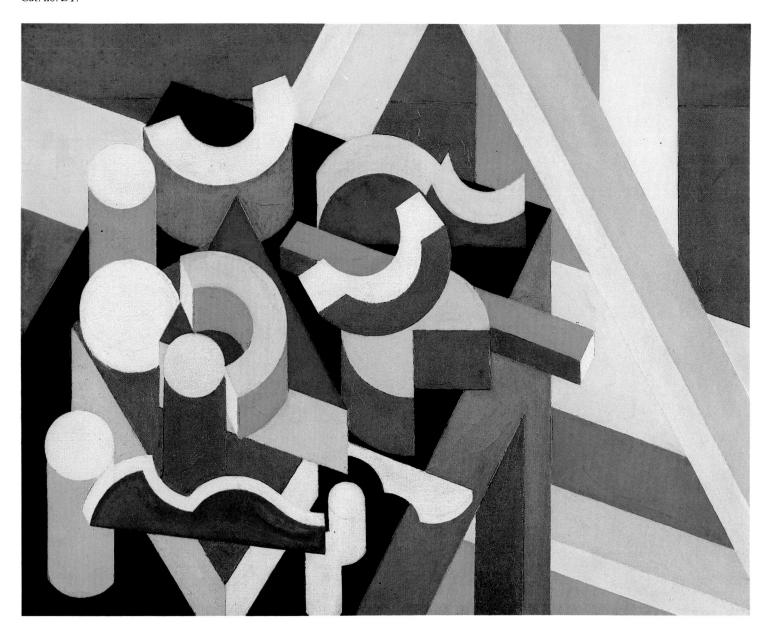

28. PEINTURE/NATURE MORTE. c. 1924

Oil and pencil on canvas, 28¾ x 35¾ in (73 x 90.8 cm)
Corcoran Gallery of Art, Washington, D.C.
Cat. no. D18

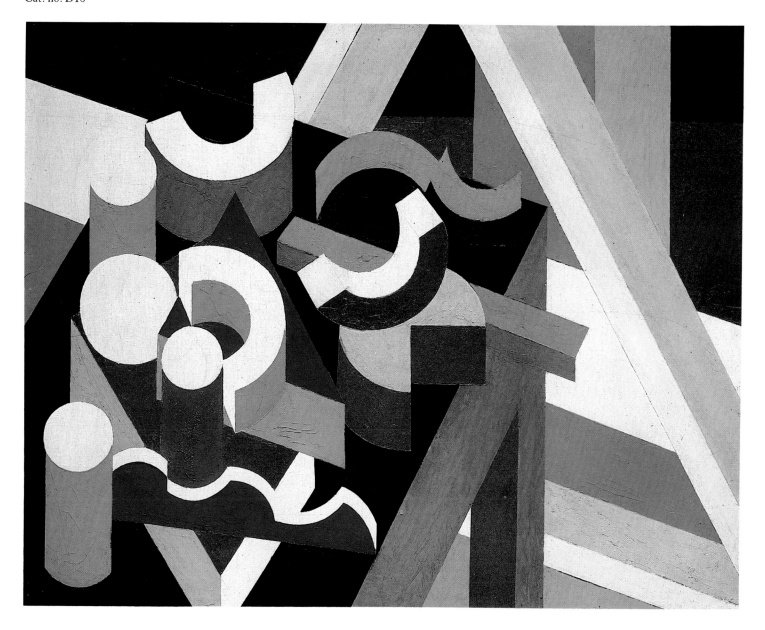

29. PEINTURE/NATURE MORTE (TRANSVERSE BEAMS). c. 1928

Oil and pencil on canvas, 32 x 51¼ in (81.3 x 130.2 cm)
Hirshhorn Museum and Sculpture Garden, Smithsonian Institution, Washington, D.C.
Cat. no. D23

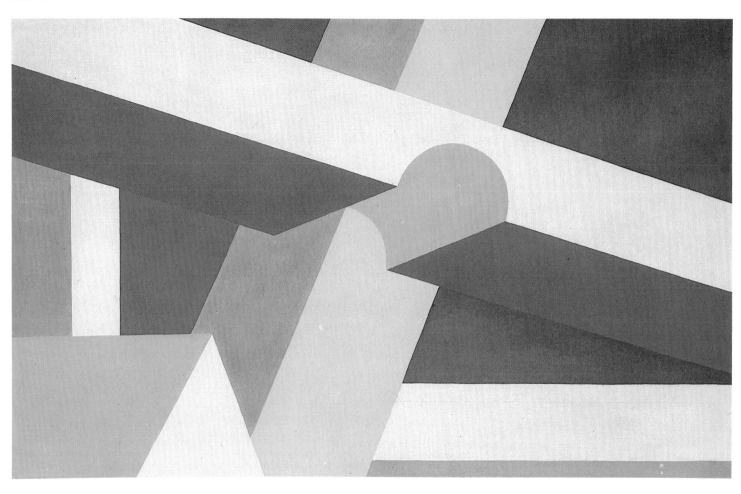

30. Peinture / Nature morte. c. 1925-26 or c. 1928

Oil and pencil on canvas, 35⅛ x 45¾ in (89.2 x 116.2 cm)
Hirshhorn Museum and Sculpture Garden, Smithsonian Institution, Washington, D.C.
Cat. no. D24

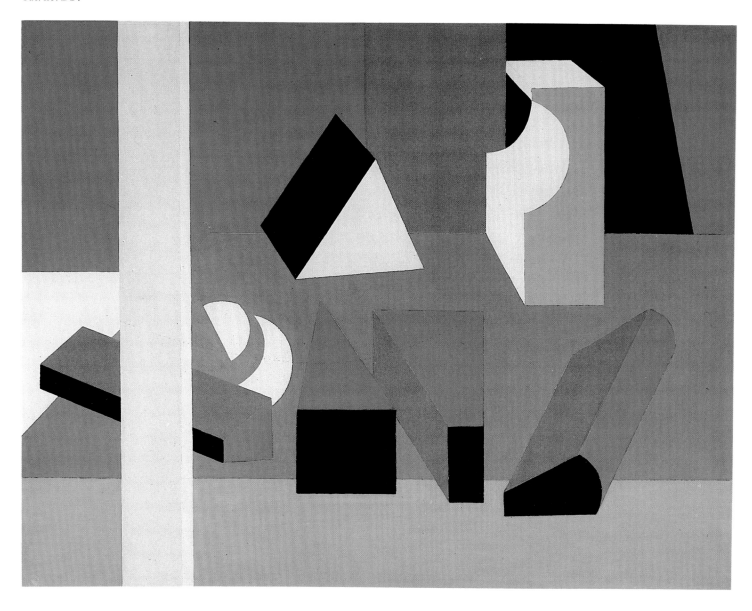

31. PEINTURE/NATURE MORTE. c. 1928
Oil and pencil on canvas, 34½ x 45 in (87.6 x 114.3 cm)
Collection Mr. and Mrs. Ahmet Ertegun, New York
Cat. no. D25

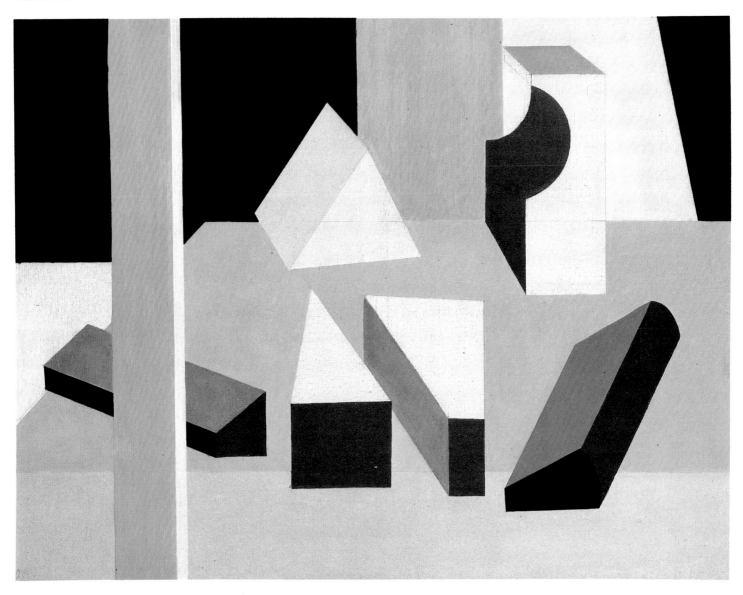

32. PEINTURE/NATURE MORTE. c. 1928

Oil and pencil on canvas, 35 x 46 in (88.9 x 116.8 cm)
Museum of Art, Carnegie Institute, Pittsburgh, gift of G. David Thompson
Cat. no. D26

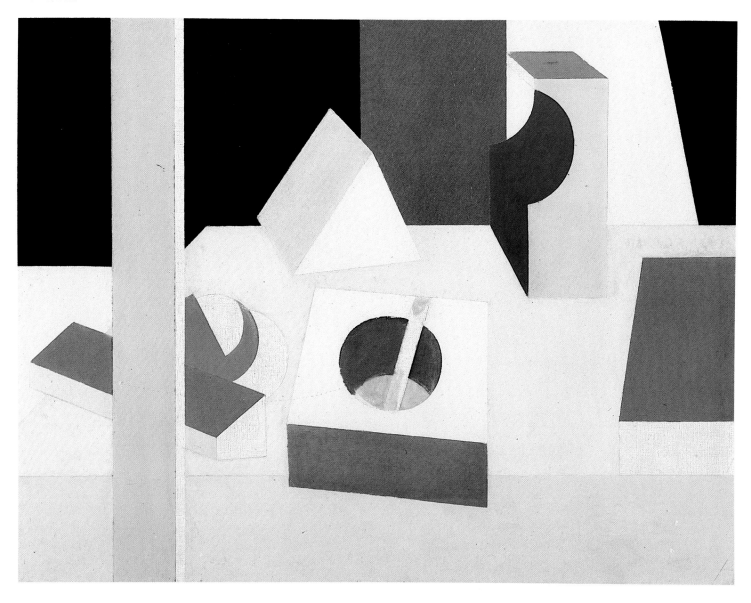

33. PEINTURE/NATURE MORTE. C. 1928

Oil and pencil on canvas, 35 x 45½ in (88.9 x 115.6 cm)
Allen Memorial Art Museum, Oberlin College, gift of Mr. and Mrs. Bruce Swift and Mrs. Ruth Roush
Cat. no. D27

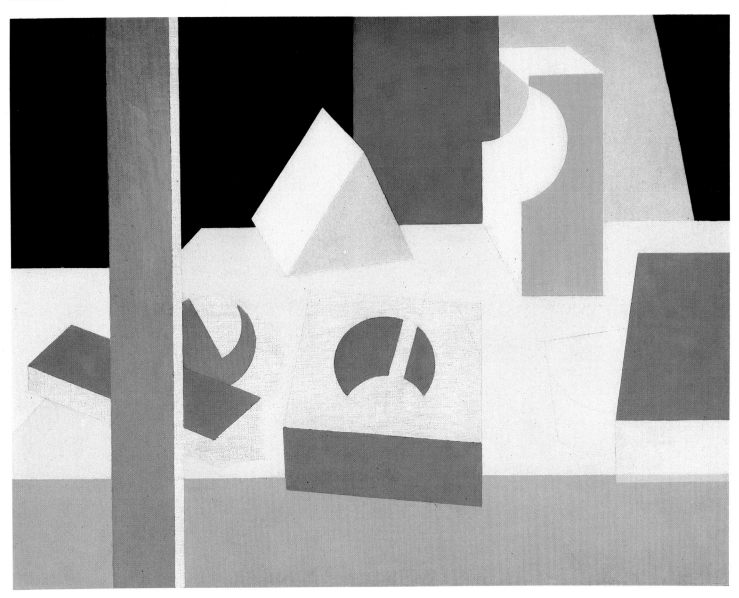

34. PEINTURE / NATURE MORTE. c. 1928

Oil and pencil on canvas, 23½ x 36¼ in (59.7 x 92.1 cm)
Collection Josephine Cockrell Thornton, Washington, D.C.
Cat. no. D28

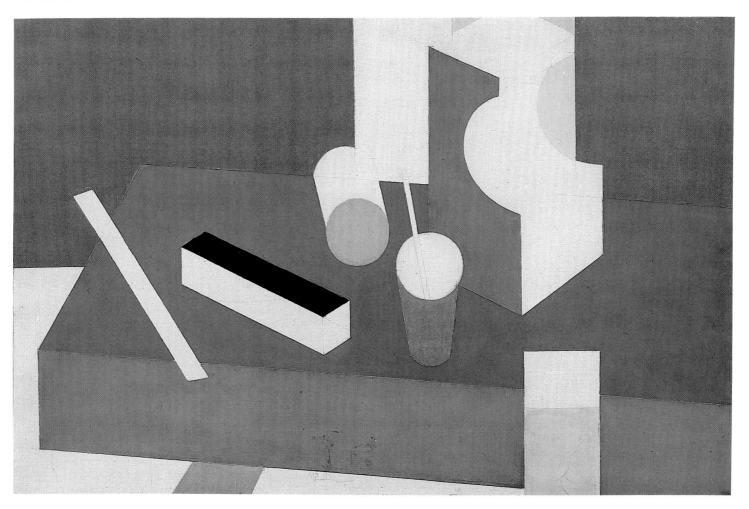

35. PEINTURE. c. 1929-30
Oil and pencil on canvas, 23¼ x 36 in (59.1 x 91.4 cm)
The Museum of Modern Art, New York, gift of G. David Thompson, Mrs. Herbert
M. Dreyfus, Harry J. Rudick, Willy Baumeister, Edward James, and Mr. and Mrs. Gerald Murphy Fund
Cat. no. D29

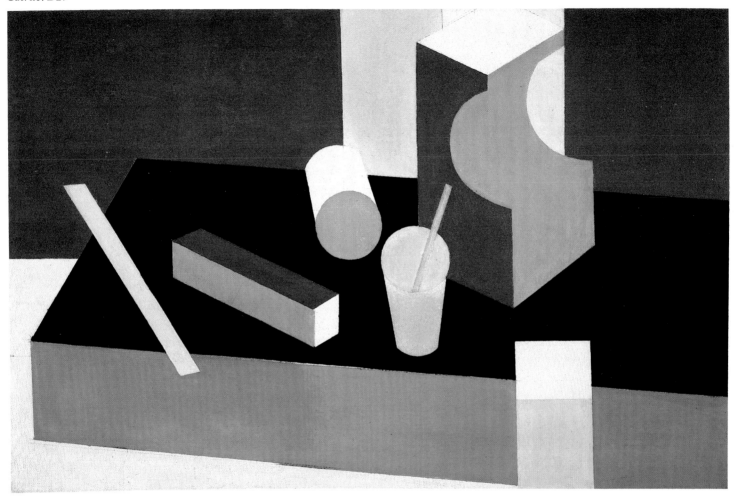

CHRONOLOGY

The chronology records most of the little we know at this time of Bruce's life; it also includes pertinent references to his career and development as a painter.

Primary sources are listed within the text; full sources are given when first cited and are thereafter abbreviated or shortened. Other names and sources are abbreviated as follows:

W. C. A. = William C. Agee (abbreviated throughout chronology).

B. R. = Barbara Rose (abbreviated throughout chronology).

S. D. = Sonia Delaunay (full name used in first references, then abbreviated to initials).

du Bois = Guy Pène du Bois, *Artists Say the Silliest Things,* New York, 1940.

Société Anonyme = Catalogue of the *Collection of the Société Anonyme,* Yale University, 1950, pp. 143-44.

Roché journal = Humanities Research Center, The University of Texas at Austin.

1. The Henri and Stein correspondence is in The Collection of American Literature, Beinecke Rare Book and Manuscript Library, Yale University.
2. Bruce to Mary Bruce Payne letters courtesy of Roy Bruce.
3. Bruce to Henri-Pierre Roché letters, originals in possession of William C. Agee.
4. Helen Bruce to B. F. Garber, conversations, c. 1958-60.

EARLY YEARS: 1881–1901

MARCH 25, 1881

Patrick Henry Bruce, the great-great-great grandson of Patrick Henry, born at Long Island, a house in Campbell County, Virginia (South Central Virginia), according to birth certificate. However, family lists birthplace as March 21, 1881, at Tarover, one of the Bruce family homes. A large, prosperous, stone Gothic Revival house, Tarover was built in 1854–55 to replace a frame house that burned in 1854. It is located about one-half milë from Berry Hill (built 1851–54), the primary and largest of the Bruce homes, an important Greek Revival house close to South Boston, Halifax County, Virginia (letter, Virginia Ahrens to B. F. Garber, August 6, 1962; letters and conversations, Kenneth Cook to W. C. A., 1978–79).

FAMILY BACKGROUND

A wealthy, distinguished, aristocratic Virginia family that once owned 3,000 slaves and the largest plantation (5,000 acres) in that part of the country. Fortunes were vastly diminished by Civil War; at time of Bruce's birth, family living off sale of land and other assets, in greatly reduced circumstances (Kenneth Cook).
Father: James Cole Bruce III, born July 29, 1857, died 1899.
Mother: Susan Seddon Brooks, from a prosperous Richmond family, whose home is now the Valentine Museum; born 185? (exact year uncertain), died c. 1897–98.
Married: January 16, 1878.
Bruce was second of four children. Marion Roy Bruce, the eldest, died at three months. James Cole Bruce IV, the third child, died in infancy. Mary Louise Bruce, the youngest, born July 29, 1884; later married (1905) and divorced (1912) George Henry Payne. She and her daughter, Virginia Ahrens, remained the relatives closest to Bruce.

c. 1885–86

Family moves to Richmond, Virginia, where father was employed by the Chesapeake & Ohio Railroad for $100 a week. "The family with their background of wealth considered this dire poverty" (V. Ahrens to B. F. Garber, 1962).

1896–97

Bruce close to Wickham family of Woodside, a prosperous home in Richmond. His sister later stays with them for extended periods after death of parents.

JULY 30, 1896

First known letter, written from South Boston to Mr. Ashby (Judge Thomas Ashby Wickham), who was one of the Wickhams at Woodside in Richmond. Letter speaks of mother's continuing bad health. (Exact date of mother's death unknown; previously thought to be about 1894, but probably c. 1897–98, of dropsy, after extended illness.)

AUGUST 15, 1896

Letter to Mr. Ashby. Again mentions mother's bad health (letters in possession of Dr. and Mrs. Charles W. Porter III, Richmond).

1897

Graduates from public school at age sixteen, then attends McCabe's, School, Richmond (V. Ahrens to B. F. Garber, 1962).

c. 1898 to c. MID-1902

Attends evening classes at Art Club of Richmond (founded in 1895) on Belvedere and Grace streets. Works during the day for a Mr. Carneal in the real estate business. Edward Valentine is a teacher and close friend during this period. Valentine was a well-known neoclassic sculptor who had a studio on Lee Street (interview, W. C. A. with Adele Clark, Richmond, October 1978).

1899

Father dies of tuberculosis. According to Mrs. Mary Bruce Payne, Carneal wanted Bruce to enter real estate business permanently, but "all he lived for was to study art and go to Paris" (V. Ahrens to B. F. Garber, 1962).

1900–01

Bruce continues studying art at night at Art Club of Richmond. Also taking some day classes at Virginia Mechanics Institute, where he studied mechanical drawing and drafting. Adele Clark (b. 1882) and Bruce study and paint together, take life drawing from Edward Valentine; William L. Shepherd taught sculpture; Harriet Talifero also a teacher there (interview, W. C. A. with Adele Clark).

c. 1900

First known extant oil painting, *Portrait of Littleton Waller Tazewell Wickham* (Cat. no. A1).

DECEMBER 9, 1901

Earliest known extant work that can be precisely dated: a highly accomplished charcoal drawing, signed and dated, of Miss Clark's father, who posed one evening at the Art Club of Richmond. Miss Clark remembers Bruce as being a very serious and hard-working art student. Pattern continues throughout life. Miss Clark fairly certain Bruce knew work of William Merritt Chase and John Singer Sargent; this is why he wanted to go to New York to study with Chase (interview, W. C. A. with Adele Clark).

NEW YORK: 1902–03

1902

Goes to New York sometime after his twenty-first birthday (March), perhaps in late spring, to study with William Merritt Chase and Robert Henri (letter from Helen Bruce to John I. H. Baur, June 7, 1949).

In New York at least a year (correspondence from Paris to Henri in 1904–05 indicates a stay of that length). Studies with Chase, Henri, and Kenneth Hayes Miller at the New York School of Art. Chase's example as a still-life painter influences Bruce, who prefers still-life format throughout his career. Becomes friends with Hopper and Guy Pène du Bois, among others. Miller felt Bruce was one of his most brilliant pupils, and even liked his later work (interview, W. C. A. with Edmund Archer, October 10, 1978, Richmond; Archer studied with Kenneth Hayes Miller in New York in early twenties).

1903

Works with George Bellows, Charles Coleman, Arnold Friedman, Walter Pach, Vachel Lindsay, and Homer Boss at the New York School of Art. Meets Helen Frances Kibbey at the School.

EARLY YEARS IN PARIS: 1903–07

EARLY OCTOBER 1903

Known to be at Woodside in Richmond (see cat. no. A7).

NOVEMBER-DECEMBER 1903 or JANUARY 1904

In Paris probably by late 1903 or January 1904, but definitely by February 1904, since date of first known letter back to United States (to Robert Henri) is February 4, 1904. This and subsequent letters to Henri establish that between 1904 and 1905 he is largely immune to newer French painting and still belongs to the Chase, Henri, Whistler tradition. Lives at American Art Association on rue Notre Dames des Champs.

JANUARY 1904

First known exhibition, at National Academy of Design in New York; painting is *War Portrait of W. T. Hedges* (now lost). His address is listed as c/o Henri, in New York.

FEBRUARY 4, 1 9 0 4

"When I look back on my stay in New York, I realized how much I enjoyed it and I sincerely miss the fellow."

Has visited James Morrice, a Canadian Post-Impressionist painter; this is perhaps his first introduction to modernist art. Writes to Henri that he is impressed by Morrice's work after seeing the "pink and blue" paintings that compose exhibitions in Paris.

Two portraits exhibited by the American Art Association in Paris (letter, Bruce to Henri). Morgan Russell also part of Association.

MARCH 23, 1 9 0 4

Has seen Morrice again. Three-quarter-length portrait, *Man with Blue Cape*, exhibited at Salon de Société Nationale des Beaux Arts. Has found man with "deep sunken eyes that pierced" in the street and painted him, an old Henri practice, using strong silhouette. Is still aligned with old teacher (letter, Bruce to Henri).

APRIL 1 9 0 4

Exhibits three works in Salon de Société Nationale des Beaux Arts. Full-length, Whistler-style portraits.

1 9 0 4

By April has moved to 3, rue Vercingétorix (XIVᵉ), where he lives until 1905 or early 1906.

1 9 0 4

Again meets Helen Kibbey, whom he had first met in New York, while she is traveling in Europe with Chase and his other students.

MAY 3, 1 9 0 4

Sees Morrice again and thinks that his paintings are the best landscapes in the Beaux Arts Salon. They are in a strong Post-Impressionist style. Sees and likes Whistler's work. Mentions that he has been in touch with Kenneth Hayes Miller and says that he is homesick for New York. Says "Artists are born, not made" (letter, Bruce to Henri).

JULY 5, 1 9 0 4

Missed Hopper when visited Paris. Says he would have liked to have seen him. Considers himself making good progress. Still admires Morrice's painting, but has not seen him for some time (letter, Bruce to Henri).

FEBRUARY 23, 1 9 0 5

Henri's letter "made me wish for the old days. I don't think I have had such good times again as I enjoyed at the New York School of Art." In this letter Bruce concedes that Henri's criticism of his work —"human emotions are presented uninterestingly and foolishly"—is correct and says he will continue to try to do better. First of many rejections and rebuffs Bruce suffered from people he esteemed. Hopes to go to London to see Whistler exhibition to give him new ideas. Has seen Morrice again (letter, Bruce to Henri).

1 9 0 5

Maurice Sterne's studio opposite Bruce's on rue Vercingétorix.

JULY 1 9 0 5

Returns to United States. Goes to Richmond to settle his father's estate, after his sister's twenty-first birthday on July 29 (V. Ahrens to B. F. Garber, 1962). This is when he paints *Portrait of Helen Johnston Skinner* (cat. no. A8).

AUGUST 24, 1 9 0 5

Marries Helen Frances Kibbey in Marshfield Hills, Massachusetts; witnessed by Helen's stepsister, Ruth Rose.

DECEMBER 1 9 0 5

Known to be back in Paris, but probably had returned in September.

DECEMBER 2, 1 9 0 5

Sees du Bois, enjoys talking to him; says du Bois is doing good work. No longer a member of the American Art Association (letter, Bruce to Henri).

DECEMBER 7, 1 9 0 5

Three copies of Titian, done in the Louvre that summer, are now in Bruce's studio for study (letter, Bruce to Henri).

1 9 0 5 – 0 6

By late 1905 or early 1906 has moved to 65, boulevard Arago

(XIV^e). Bruce's apartment a rendezvous for Americans. No "funny business" talk; is always serious. Discusses problem of painting white egg on white tablecloth, problems of still life. (du Bois, pp. 110-111).

JUNE 13, 1 9 0 6

Plans to leave Paris to go to the country for some time (letter, Bruce to Henri).

OCTOBER 1 9 0 6

Meets Arthur B. Frost, Jr., through Walter Pach (letter, Frost to Henri, September 24, 1906, in which Frost says he will see Bruce as soon as he arrives in Paris. Frost known to be in Paris by October). Edward Hopper is in Paris by this time. Sees the Bruces on several occasions. Hopper remains in Paris until August 1907; later credits Bruce with introducing him to the Impressionists, especially Sisley, Renoir, and Pissarro (Alfred H. Barr, Jr., *Edward Hopper Retrospective Exhibition*, The Museum of Modern Art, New York, 1933, p. 10).

1 9 0 6

By mid or late 1906, meets Gertrude and Leo Stein; begins to frequent Stein salons before Alice Toklas moves in. More friendly with Leo than with Gertrude (Helen Bruce to B. F. Garber).

TOWARD A MODERNIST ART: PARIS 1 9 0 7 – 1 2

APRIL 29, 1 9 0 7

Son, Marion Roy Bruce, born in Berlin; they felt that Germany was the most advanced place for knowledge of childbirth. Frequent trips to Germany. May have met dealer Maurice Feldmann at this time. Continues traveling intermittently to Germany 1907–14 (Helen Bruce to B. F. Garber).

C. MID-1 9 0 7

Missed Hopper when he came to visit Bruce (letter to Henri, month and day uncertain). By fall 1907, Hopper has returned to United States.

1 9 0 7

Is seeing the Steins regularly; close friendship develops with both Gertrude and Leo. Frequents circle of people involved with Steins.

SUMMER-FALL 1 9 0 7

Paints first-known landscapes. Thinks Whistler an advanced painter. Two Landscapes shown at Salon d'Automne. Painting now showing modernist influences and orientation.

SEPTEMBER 30, 1 9 0 7

Receives first-known published mention in Paris: Louis Vauxcelles, in review of Salon d'Automne, notes his three paintings as "des pseudo-Manquin signés Bruce" (*Gil Blas*, p. 3).

1 9 0 7

Meets Matisse at the Steins (Helen Bruce to John Baur, 1949). Last known letter to Robert Henri in New York (month and day uncertain). Late in year, Sarah Stein and Bruce look for a studio for Matisse School (Alfred H. Barr, Jr., *Matisse: His Art and His Public*, New York, 1951, p. 116).

JANUARY 10, 1 9 0 8

Matisse School opens. Bruce an original member, along with Hans Purrmann, Sarah Stein, and Max Weber (Barr, *Matisse*, p. 116).

FEBRUARY 25, 1 9 0 8

Steichen calls meeting to establish "The New Society of American Artists in Paris." Steichen on Advisory Board; charter members include John Marin and Bruce; among other members are Alfred Maurer and Weber (William Innes Homer, *Alfred Stieglitz and the American Avant-Garde*, Boston, 1977, p. 87).

1 9 0 8

His painting begins to undergo enormous changes as a result of contact with Matisse; therefore he does not exhibit again until fall 1910.

1 9 0 8

Continues to be intimate with Steins, Leo, Michael, and Gertrude (recalled by Gertrude in *Autobiography of Alice B. Toklas*; also letter, Helen Bruce to John I. H. Baur, 1949).

FALL 1 9 0 8

Matisse School moves to Couvent du Sacré Coeur, 33, boulevard des Invalides; Matisse studio, apartment, and school all in the same place. Studying sculpture with Matisse at this time. The Bruces live in apartment above Matisse family. "When Matisse went to live in the school building of the Convent of the Sacré Coeur on boulevard des Invalides, he [Bruce] moved into the same building and became *massier* for the Matisse School which was in the refectory in the convent garden. At this time [1908–09] he was slightly influenced by Matisse but far more by Renoir and Cézanne and it is from then on he painted still lifes of fruits and flowers—a few landscapes and heads." (Helen Bruce to John I. H. Baur, 1949.)

Daily contact with Matisse and his work; in following years his work shows increasing influence of Renoir and Cézanne as seen through Matisse's eyes.

c. 1 9 0 8 – 0 9

Bruce meets Guillaume Apollinaire at Café du Dome (interviews, W. C. A. with Sonia Delaunay, Paris, January 1964). Remains good friends with Matisse (interviews, W. C. A. with Mme Duthuit, Matisse's daughter, Paris, February 1964).

APRIL 1 9 0 9

Address listed as 33, boulevard des Invalides, site of the Matisse School.

1 9 0 9

Louis Vauxcelles, noted critic, has unrealized idea for exhibition of American painters. In preparing notes, puts Bruce first (unpublished manuscript, Fond Vauxcelles, Fondation Doucet, Institut de l'Art et Archéologie, Paris).

1 9 0 9

Working in sculpture class at Matisse School. (See fig. 5, p. 8).

SUMMER 1 9 0 9

Summer at Boussac, about 170 miles south of Paris. "We went the summer of 1909 to Boussac near Bordeaux where we lived in a peasant house and Pat painted landscapes and still lifes" (Helen Bruce to B. F. Garber).

c. MARCH 1 9 1 0

Frost leaves Matisse School "late in the winter" (letter, Frost to A. Daggy, August 17, 1910, in possession of Henry M. Reed, Montclair, New Jersey).

SUMMER 1 9 1 0

Summer in Boussac (Helen Bruce to B. F. Garber).

1 9 1 0

By September at latest, the Bruces move to 6, rue de Furstenberg (VIe), where he lives until late spring 1933.

1 9 1 0

Salon d'Automne includes *Flowers*, his first still life to be exhibited. It is Bruce's first exhibition in three years.

c. 1 9 1 0

By this time, if not earlier, is collecting African art (Helen Bruce to B. F. Garber; also interview, B. R. and Roy Bruce, Oxnard, California, October 1978).

1 9 1 0 – 1 2

Intense interest in Cézanne.

1 9 1 0 – 1 2

Bruce and wife supporting themselves selling antiques, as they were to do the rest of their lives.

JANUARY 1 9 1 1

Helen goes to New York and Boston showing Bruce's work (letter, Bruce to Gertrude Stein, day uncertain; also Edward Steichen letter to Alfred Stieglitz, month and day uncertain). Reason many of 1908–10 paintings are still extant is that Bruces had no money to send them back to Paris.

SUMMER 1 9 1 1

Spends summer with family at Boussac. They plan to stay until October 15 (Helen Bruce to B. F. Garber; letter to Steins, 1911, month and day uncertain).

1911

Bruce exhibits two still lifes in Salon d'Automne.

1912

Meets Harrison Sprague Reeves (1888–1944), an American correspondent. They develop close friendship, and Reeves moves for periods into the Bruces' apartment.

FEBRUARY 22, 1912

Is apparently painting Gertrude Stein's portrait (letter, Bruce to Gertrude Stein).

1912

Exhibits at Salon des Indépendants and at Salon d'Automne.

FIRST MATURITY: PARIS 1912–16

SPRING 1912

Meets Sonia and Robert Delaunay while out walking with Helen and Roy. Introduced by Frost (interview, B. R. with S. D., Paris, April 1978).

SUMMER 1912

Spends summer at Belle-Île-en-mer, island off Brittany coast.

LATE 1912–MID-1914

Delaunays and Bruces became so close that they "lived a life together" (interview, B. R. with S. D., Paris, April 1978).

LATE 1912–EARLY 1914

Paintings show influence of the Delaunays.

1912

Sells at least two paintings to Maurice Feldmann, a dealer in Berlin.

FEBRUARY 1913

Exhibits four paintings of 1910 and 1911 at the Armory Show in New York. Involved in controversy over withdrawal of Delaunay's

City of Paris from the Armory Show; finally, picture not removed.

SPRING 1913

Exhibits with Delaunays in Salon des Indépendants, along with Francis Picabia. Exhibits *Landscape* (cat no. C1). Reviews of Salon des Indépendants are favorable; Reeves writes a favorable one, as do Apollinaire and André Salmon. Gaining recognition. Reeves living with the Bruces at 6, rue de Furstenberg.

SUMMER 1913

Again spends summer in Belle-Île; Frost stays with them.

FALL 1913

Exhibits two paintings at "Erster Deutscher Herbstsalon" held at Herwarth Walden's Der Sturm Gallery in Berlin. Bruce and Marsden Hartley are only Americans in show. (Sends postcard to Sonia Delaunay that has stickers of Herbstsalon on it.) Exhibits *Composition* (cat. no. C2) at Salon d'Automne; painting now lost, presumed destroyed; published in *Soirées de Paris* (Dec. 15, 1913). Apollinaire described it and Picabia's as being the most striking (*L'Intransigéant*, Nov. 19, 1913).

1913–14

Regularly attends, with the Delaunays and others, the Bal Bullier, a fashionable dance hall at 31–39, avenue de L'Observatoire, across the street from the Closerie de Lilas (interviews, W. C. A.–S. D., 1964, B. R.–S. D., 1978).

MARCH–APRIL 1914

Exhibits large painting, *Mouvement, couleur, l'espace: Simultané* (cat. no. C4, now lost), at the Salon des Indépendants; his most purely Orphic painting. Apollinaire, in *L'Intransigéant*, March 5, 1914, describes subject as being "so vast that I am not at all surprised if the painter has been unable to take it all in," and in *Soirées de Paris*, March 15, 1914, says it is more "personal" than the *Composition* exhibited at the 1913 Salon d'Automne.

SUMMER 1914

Is in Belle-Île with Frost when war breaks out. Stays there well into fall, probably painting from photographs, working closely with Frost.

LATE NOVEMBER 1914

Bruce returns to Paris (letter, A. B. Frost, Jr., to father, Nov. 23, 1914, collection Henry M. Reed, Montclair, N.J.).

JANUARY 1915

Frost, Bruce's closest friend at the time, returns to New York.

1915

Helen Bruce leaves to drive in the ambulance corps for duration of the war (Helen Bruce to B. F. Garber). She takes the large *Simultané* painting with her. Between 1912 and 1914 Bruce had worked on large, abstract paintings based on urban landscapes and on figures in urban settings. These she carried around in ambulance through the war and returned to Bruce after war. Presumably destroyed by Bruce in 1933. Sonia Delaunay recalls seeing, before her departure for Portugal in 1915, at least a dozen very large abstract paintings of the type lost (interview, B. R. with S. D., October 1978).

1916

Meets Henri-Pierre Roché through Reeves (letter, Roché to Katherine Dreier, Dec. 21, 1918; also Roché's statement in Société Anonyme catalogue).

NOVEMBER 21–DECEMBER 9, 1916

Exhibits thirty-three paintings, primarily landscapes and still lifes, at the Montross Gallery in New York; exhibition organized through the efforts of Frost and Harrison Reeves.

LATE 1916

Sends six large abstract paintings, the Compositions (cat. nos. C7–C12), to Frost in New York. Frost, stunned by color innovation in new use of black and white, changes his own style (letter, James Daugherty to Katherine Dreier, Feb. 12, 1949; interviews, W. C. A. with Daugherty, 1964–65). Frost teaches new color ideas to James Daugherty, who passes them on to Jay Van Everen and others.

MARCH 12–MARCH 28, 1917

Exhibits Compositions at Modern Gallery, New York. This and

1916 Montross exhibition first and only one-man shows he has until 1979.

DECEMBER 7, 1917

Frost dies in New York, four days before his thirtieth birthday.

THE LATE STYLE: PARIS 1917–33

1917–18

Bruce begins work on late geometric still lifes, a subject that will occupy him for the rest of his life. Roché, in statement for Société Anonyme catalogue, says Bruce painted these works, in Roché's possession in 1933, during the next fifteen years. Since Roché believed that Bruce gave up painting in 1932, the first painting of late style probably dates from 1917, not 1918-19 as previously thought.

1918

Katherine Dreier, in New York, purchases *Composition I* and *Composition II* from Bruce. Involved with Comité des Etudiants Americains de l'Ecole des Beaux Arts, apparently in an exhibition.

1919–20

The Bruces separate. Helen takes Roy, who is now twelve years old, to London and then to New York. She opens an antique store at 725 Madison Avenue. Bruce sends her antiques that he locates in Paris, and she sends him money; this arrangement continues throughout his years in Paris.

JANUARY 2, 1919

Roché visits Reeves with Bruce, Nicole Groult (Roché journal entry).

APRIL 4, 1919

Roché goes with Reeves to see Bruce, "who made much progress: architectural painting" (Roché journal entry). Roché sees Bruce frequently in these years; becomes avid supporter of his work.

SEPTEMBER 8, 1919

Katherine Dreier, in Paris, visits Bruce's studio with Roché (Roché journal entry).

November 1919

Exhibits two geometric still lifes, which he calls *Peintures*, at the Salon d'Automne; first known exhibition of these paintings.

JANUARY–FEBRUARY 1920

Exhibits six works at Salon des Indépendants, the largest number of these works ever shown in his lifetime. (Also exhibits at Indépendants in 1921, 1922, 1923. Represents the peak of his activity.) All post-1917 work termed either *Peinture* or *Nature morte*, although most works have come to be known by titles such as *Formes*.

JUNE 17–AUGUST 1, 1920

Katherine Dreier exhibits Bruce with James Daugherty, Jan Matulka, and Jay Van Everen at galleries of Société Anonyme, in New York. It is his last important show in America until 1950.

OCTOBER–DECEMBER 1920

Exhibits *Peintures* at Salon d'Automne. (Also exhibits at Salon d'Automne in 1921, 1922, 1923, 1928, 1929, 1930.)

NOVEMBER 20, 1920

"I stay alone with Bruce. He shows me his paintings, I find them very impressive. Their importance as paintings will burst forth (éclater) one of these days. I would buy if I had money" (Roché journal entry).

NOVEMBER–DECEMBER 1920

Roché tries to persuade John Quinn, American collector, to buy Bruce paintings; Quinn refuses (John Quinn Memorial Collection, New York Public Library; Roché Archives, Humanities Research Center, The University of Texas at Austin).

Early 1920s

Meets Duchamp in Roché's studio.

1920s

Bruce an integral part of Parisian café life, frequenting Café du Dome and the Flore; often seen in company of Surrealists, especially Tristan Tzara. At the time and throughout Bruce's life Roché is his greatest supporter and friend. However, Bruce becomes increasingly reclusive.

1921

Belgian artist Jozef Peeters (1895–1970) goes to Paris, meets Bruce through Delaunay; finds Bruce's work the most impressive he has seen in Paris.

JANUARY 27, 1922

Bruce's paintings at Salon des Indépendants termed "three incontestable errors" by Maurice Raynal (*L'Intransigéant*, p. 2).

c. 1923–33

Bruce gives up painting for periods of months at a time. Work receives less and less reception; he becomes more and more depressed and discouraged. Continues trade in antiques by sending objects to Helen, and she sends him money in return.

DECEMBER, 1925

In "L'Art d'Aujourd'hui" exhibition in Paris, Bruce exhibits four paintings. Organized by Polish Cubist Victor Poznanski, who calls exhibition a show of "neo-plastic" work. Also included are Picasso, Gris, Léger, Masson, Miró, Mondrian, Murphy, and others. Charles Ratton places him in milieu of Surrealists Paris at this time (interview, B. R. with C. Ratton, Paris, October 1978).

Fall 1926

Michel Seuphor meets Bruce through Delaunay. Finds Bruce "completely alone and retired, a taciturn pessimist, morose and neurasthenic." He remembers Bruce talking about burning all his work (interview, B. R. with M. Seuphor, Paris, October 1978).

Winter 1927

Seuphor's second visit to Bruce.

1928

Dreier buys *Composition III, IV,* and *V* in New York, probably through Duchamp.

March 17, 1928

Working on ten paintings (letter, Bruce to Roché).

1928

Bruce writes Roché regarding framing of paintings in possession of Helen Hessel, a friend of Roché's (letter, Bruce to Roché, month and day uncertain, Roché archives; also recalled by Helen Hessel, interview with W. C. A., Paris, January 1964).

November 1930

Shows one painting at Salon d'Automne; last time his post-1916 work is exhibited for twenty years.

March 30, 1931

Has been very ill all winter, after suffering severe stomach ailments for several years (letter, Bruce to his sister, Mary Bruce Payne).

October 8, 1931

Puts himself in hands of a new doctor, who prescribes a primarily raw vegetable diet (letter, Bruce to Mary Bruce Payne).

December 16, 1931

Has again been very sick, and has lost ten pounds (letter, Bruce to Mary Bruce Payne).

VERSAILLES: 1933–36

May 1933

By this time, Bruce has moved to 18, rue de la Bonne Aventure, Versailles, on advice of doctor and because it is less expensive. He has sold everything he possibly could to raise money in midst of worldwide Depression.

July 3, 1933

Writes to Roché from Versailles that he has destroyed "all his

paintings with the exception of twenty-one canvases," which are stored in Paris. He offers them to Roché.

July 30, 1933

Roché has taken the paintings. Most remain in his possession until his death in 1959. Fourteen remain with Madame Roché until 1967-68, when they are sold by the Noah Goldowsky Gallery in New York.

1933–36

Continues to live in Versailles. Previously thought to have given up painting entirely; recently discovered that in fact he did continue to paint. Paintings of this time are lost; now thought either to have been destroyed by Bruce just prior to his death or subsequently lost.

July 29, 1936

Sails for New York, apparently taking the Versailles paintings with him. Moves in with his sister, Mary Bruce Payne.

November 12, 1936

Takes his life by his own hand in New York. Until 1965, and frequently thereafter, date of death incorrectly listed as 1937 (Department of Health Death Certificate #24627, City of New York, Borough of Manhattan).

1941

Société Anonyme Collection, which includes five Compositions, and a still life of c. 1912, given to Yale University by Katherine Dreier.

1950

The catalogue *Collection of the Société Anonyme* is published, with amended version of Roché's statement on Bruce. This is the first serious published attention given to Bruce since Katherine Dreier's book *Western Art and the New Era,* New York, 1923.

November–December 1950

Rose Fried Gallery shows five of the *Peinture/Nature morte* works, the first time any of them have been exhibited for twenty years.

October 1965

Fourteen Bruce paintings are included in the exhibition "Synchro-

mism and Color Principles in American Paintings, 1910–1930,"
organized by William C. Agee and shown at M. Knoedler and Co.,
Inc., New York.

MARCH 1976

Parsons-Bruce Art Association, a chapter of the Virginia Museum of
Fine Arts, Richmond, is founded in South Boston, Halifax County,
Virginia. Named in memory of Bruce and the sculptor Edith Stevens
Parsons (1878–1956), who was born in Halifax County, Virginia.

MAY 1977

Publication of William C. Agee's article "Patrick Henry Bruce:
A Major American Artist of Early Modernism" in *Arts in Virginia*
(Virginia Museum, Richmond, vol. 17, no. 3), pp. 12-32.

MAY 1979

Bruce's first retrospective exhibition, as well as first one-man show,
organized by The Museum of Fine Arts, Houston.

AUGUST 1979

Bruce retrospective opens at The Museum of Modern Art, New York.

NOVEMBER 1979

Bruce retrospective opens at the Virginia Museum, Richmond.

Every known exhibition in which Bruce was included during his lifetime, and thereafter until 1952, is listed here. Major group exhibitions from that time until the present are also included. With a few exceptions, which are noted in the *catalogue raisonné*, it has been impossible to determine which of the surviving paintings were in which exhibition. Entries are listed exactly as they appeared in the exhibition catalogues, including known errors; where appropriate, these are noted by [sic]. At certain points, where precise documentation is lacking but where the evidence is strong enough to warrant doing so, the authors have added in brackets interpretive or explanatory notes.

1904

New York. NATIONAL ACADEMY OF DESIGN. CATALOGUE OF THE 79TH ANNUAL EXHIBITION. January 2-30
c/o Robert Henri, 58 West 57th Street
41. *War Portrait of W. T. Hedges*

Paris. AMERICAN ART ASSOCIATION. February. Also included other artists; names unknown. Two portraits. Titles unknown. [Referred to in letter from Bruce to Robert Henri, February 4, 1904. Collection of American Literature, Beinecke Rare Book and Manuscript Library, Yale University.]

Paris. SALON DE SOCIÉTÉ NATIONALE DES BEAUX-ARTS. April 17–June 30
3, rue Vercingétorix (XIVe)
203. *Portrait de Mlle K.*
204. *Homme à la cape bleue*
205. *Enfant qui rit*

St. Louis. UNIVERSAL EXPOSITION. OFFICIAL CATALOGUE OF EXHIBITORS.
April 30–December 1
89. *Portrait of W. T. Hedges, Esq.*

1905

Philadelphia. PENNSYLVANIA ACADEMY OF THE FINE ARTS.

CATALOGUE OF THE 100TH ANNIVERSARY EXHIBITION. January 23–March 4
382. *Italian in Blue Cape*

New York. SOCIETY OF AMERICAN ARTISTS. CATALOGUE OF THE TWENTY-SEVENTH EXHIBITION. March 25–April 30
3, rue Vercingétorix, Paris
394. *Italian in Blue Cape*

Paris. SALON DE SOCIÉTÉ NATIONALE DES BEAUX-ARTS. April 15–June 30
3, rue Vercingétorix (XIVe)
216. *Portrait de Mme. F.*
217. *Portrait de M. M.*

Portland, Oregon. LEWIS AND CLARK CENTENNIAL EXPOSITION. June 1–October 1
240. *Italian in Blue Cape*
549. *Portrait of W. L. [sic] Hedges*

Paris. SALON D'AUTOMNE. October 18–November 25
Bruce (Patrick Newy [sic]), né à Virginia, U.S. Americain—
65, boulevard Arago
245. *Petite fille en rouge*, p.
246. *Petite fille en gris*, p.

Chicago. THE ART INSTITUTE OF CHICAGO. 18TH ANNUAL EXHIBITION OF OIL PAINTINGS AND SCULPTURE OF AMERICAN ARTISTS. October 19–November 26
47. *Portrait of Madame F.*

London. Place unknown. December 1905 or January 1906. Shows one of the two portraits exhibited at the 1905 Salon d'Automne. Other exhibitors unknown. [Referred to in letter from Bruce to Robert Henri, December 2, 1905. Collection of American Literature, Beinecke Rare Book and Manuscript Library, Yale University.]

1906

Philadelphia. PENNSYLVANIA ACADEMY OF FINE ARTS. CATALOGUE OF THE 101ST ANNUAL EXHIBITION. January 22–March 3
65, boulevard Arago
555. *Man in Black*

Paris. Salon d'Automne. October 6–November 15
 65, boulevard Arago
 253. *"Jane,"* p.
 254. *Madame S.,* p.
 255. *La Robe rayée,* p.

Chicago. The Art Institute of Chicago. 19th Annual Exhibition of Oil Paintings and Sculpture of American Artists. October 16–November 29
 63. *Young Woman*
 64. *A Boy*
 65. *Little Girl*

1907

Philadelphia. Pennsylvania Academy of Fine Arts. Catalogue of the 102nd Annual Exhibition. January 21–February 24
 65, boulevard Arago, Paris
 33. *A Boy*

Paris. Salon d'Automne. October 1–22
 65, boulevard Arago
 213. *Jeune fille,* p.
 214. *Paysage,* p.
 215. *Paysage,* p.

1910

Paris. Salon d'Automne. October 1–November 8
 6, rue Furstenberg
 162. *Fleurs,* p.

1911

Paris. Salon d'Automne. October 1–November 8
 6, rue Furstenberg
 211. *Nature morte,* p.
 212. *Nature morte,* p.

1912

Paris. Salon des Indépendants. March 20–May 16

 6, rue Furstenberg
 524. *Femme assise*
 525. *Fleurs*
 526. *Nature morte*

Cologne. Stadtische Ausstellungshalle. Sonderbund Internationale Kunstausstellung. May 25–September 30. Also included works by Cézanne, Gauguin, Munch, Picasso, van Gogh, and many others.
 234. *Blumen*

Paris. Salon d'Automne. October 1–November 8
 6, rue Furstenberg
 Now listed as a member of Société du Salon d'Automne
 221. *Pommier,* p. (Appartient à M.F.) [Maurice Feldmann]
 222. *Fruits,* p. (Appartient à M.F.) [Maurice Feldmann]
 223. *Nature morte,* p.
 224. *Nature morte,* p.

1913

Baltimore. Peabody Institute Galleries. The Charcoal Club of Baltimore. Fourth Annual Exhibition of Contemporary American Art. Febraury 11–March 9. Also included other artists such as William Glackens, Hugh L. Breckenridge, Alice Worthington, W. L. Neilson Ford, Putnam Brinley, and Arthur B. Davies.
 19. *Nature morte*
 Lent by Dr. Claribel Cone

New York. Association of American Painters and Sculptors. International Exhibition of Modern Art. February 17–March 15
 160. *Nature morte*
 Oil [dated on entry blank 1910]
 Lent by M. F. [Maurice Feldmann]
 [Price listed: $190]
 161. *Nature morte*
 Oil [dated on entry blank 1911], 12 x 15"
 Lent by the artist
 [Price listed: $135]

162. *Nature morte*
 Oil [dated on entry blank 1910]
 Lent by the artist
 [Price listed: $135]

163. *Nature morte*
 Oil [dated on entry blank 1910]
 Lent by the artist
 [Price listed: $135]

Paris. SALON DES INDÉPENDANTS. March 19–May 18
 6, rue Furstenberg
 459. *Paysage*
 460. *Paysage*
 461. *Harmonie*

Budapest. MUVESZHAZ. NEMZETKOZI POSTIMPRESSZIONISTA KIALLITAS. April–May. Also included works by Archipenko, R. Delaunay, Kandinsky, Marc, and others.
 22. *Tájkép* (kicsiny) [Landscape (small)]
 23. *Csendelet* [Still life]
 24. *Harmonia* [Harmony]
 25. *Tájkép* (nagy) [Landscape (large)]

Berlin. DER STURM. ERSTER DEUTSCHER HERBSTSALON. Catalogue with foreword by Herwarth Walden. September 30–December 1
 56. *Landschaft* (illustrated)
 57. *Landschaft*

Berlin. NEUE GALERIE. ERSTE AUSSTELLUNG. October–November. Also included works by Arp, Braque, Matisse, Pascin, Picasso, and others.
 11. *Blumen*
 12. *Blumen*
 13. *Blumen*
 14. *Blumenvase*

Paris. SALON D'AUTOMNE. November 15, 1913–January 5, 1914
 6, rue Furstenberg
 271. *Composition*, p.
 272. *Composition*, p.

1914

Prague. MANES. MODERNI UMENI, XXXXV. February–March. Also included works by R. Delaunay, Duchamp-Villon, Dufy, Gleizes, Metzinger, and others.
 11. *Komposice.* Olej
 12. *Komposice.* Olej

Paris. SALON DES INDÉPENDANTS. March 1–April 30
 6, rue Furstenberg
 502. *Mouvement, couleur, l'espace: Simultané*

Brussels. GALERIE GEORGES GIROUX. *Salon des Artistes Indépendants de Paris.* May 16–June 7. Also included works by Chagall, Laurens, Picabia, and others; a partial recreation of 1914 Paris Salon des Indépendants.
 33. *Mouvement, couleur, l'espace: Simultané*

1916

New York. MONTROSS GALLERY. November 21–December 9 [Included 33 paintings, referred to in letter from Arthur B. Frost, Jr., to his mother, 1916, month and day uncertain]
 2. *Wood Interior* [numbers taken from English labels on back of paintings]
 5. *Red Cheeked Pears*
 6. *Old Gate Near Saintes*
 8. *Fruit & Green Pot*
 10. *Green Jug*
 11. (21?) *Landscape Near Saintes*
 22. *Portrait*
 27. *Leaves*
 30. *Landscape*
 Italian Faience and Tapestry [Caffin*]
 Fruit and Italian Faience [Caffin]
 Quinces, Bananas and Ginger Jar [Caffin]
 Still Life with Red Apple [Caffin]
 Still Life (with Ecorché) [Caffin]. Illustrated
 "Two heads in a Renoir vein" [*Globe*, December 4, 1916]
 [Possibly the two portraits of son, Roy]

*Charles H. Caffin, "Significant Still-Lifes by Bruce," *New York American*, November 27, 1916

1917

New York, Modern Gallery. March 12–28
[Compositions I–VI]

New York. Grand Central Palace. Society of Independent Artists. April 10–May 6
c/o A. B. Frost, Jr., 6 East 14th St., N.Y.; 6, Place Furstenberg, Paris
211. Composition [IV] (illustrated)

New York. Penguin Club. October 27–November 9. Also included other artists.
73a. Still Life

1918

New York. Penguin Club. Contemporary Art. March 16–?
13. Still Life

1919

Paris. Salon d'Automne. November 1–December 10
6, rue Furstenberg
241. Peinture
242. Peinture

1920

Paris. Salon des Indépendants. January 28–February 29
6, rue Furstenberg
607. Peinture
608. Peinture
609. Peinture
610. Peinture
611. Peinture
612. Peinture

New York. Galleries of the Société Anonyme. April 30–June 15.
With Brancusi, Daugherty, Duchamp, Gris, Man Ray, Picabia, Ribemont-Dessaignes, Schamberg, Stella, Villon, van Gogh, Vogeler.
[Presumably one or more of the six Compositions]

New York. Galleries of the Société Anonyme. June 17–August 1.
With James Daugherty, Jan Matulka, Jay Van Everen.
[Presumably one or more of the six Compositions]

Paris. Salon d'Automne. October 15–December 12
6, rue Furstenberg
313. Peinture
314. Peinture

1921

Paris. Salon des Indépendants. January 23–February 28
6, rue Furstenberg
462. Peinture
463. Peinture
464. Peinture

Paris. Salon d'Automne. November 1–December 20
6, rue Furstenberg
298. Peinture
299. Peinture

Worcester. Société Anonyme. Worcester Art Museum. November 3–December 5. With 31 other artists.
[Presumably one or more of the Compositions. No records kept by Société Anonyme as to which paintings were exhibited in this or following exhibitions of the Société Anonyme]

1922

Paris. Salon des Indépendants. January 28–Febraury 28
6, rue Furstenberg
514. Peinture
515. Peinture
516. Peinture

New York. Société Anonyme. MacDowell Club. April 24–May 8
With 30 other artists.
[Presumably one or more of the Compositions]

Paris. Salon d'Automne. November 1–December 17
6, rue Furstenberg
319. Nature morte, p.
320. Nature morte, p.

1923

Paris. SALON DES INDÉPENDANTS. February 10–March 11
 6, rue Furstenberg
 668. *Nature morte*
 669. *Nature morte*
 670. *Nature morte*

Poughkeepsie, New York. SOCIÉTÉ ANONYME. VASSAR COLLEGE.
April 4–May 12. With 23 other artists.
[Presumably one or more of the Compositions]

Paris. SALON D'AUTOMNE. November 1–December 16
 6, rue Furstenberg
 243. *Nature morte*
 244. *Nature morte*

1925

Paris. L'ART D'AUJOURD'HUI. *Salles du Syndicat des Négociants en Objets d'Art*, rue de la Ville L'Eveque.* December. Organized by Victor Poznanski. Also included Arp, Baumeister, Brancusi, Marcelle Cahn, Sonia and Robert Delaunay, van Doesburg, Ernst, Gleizes, Gris, Florence Henri, Jeanneret, Léger, Klee, Larionov, Laurens, Masson, Miró, Mondrian, Murphy, Ozenfant, Picasso, Vantongerloo, and Villon.
 13. *Nature morte*
 14. *Nature morte*
 15. *Nature morte*
 16. *Nature morte*

1926

New York. ART CENTER. MEMORIAL EXHIBITION OF REPRESENTATIVE WORKS SELECTED FROM THE JOHN QUINN COLLECTION. January 7–30.
Still Life–Fruit and Michel Angelo Statuette . . . Painting
[Painting not listed in catalogue, but is mentioned in *Art News*, January 1926 summary of exhibition]

[*Not at the Musée Galleria, as stated in the catalogue]

Chicago. ARTS CLUB EXHIBITIONS AT THE ART INSTITUTE OF CHICAGO. CATALOGUE OF AN EXHIBITION OF A GROUP OF PAINTINGS BY VARIOUS MODERN ARTISTS. Loaned by the American painter Arthur B. Davies. March 19–April 25
 2. *Still Life*

1927

New York. AMERICAN ART ASSOCIATION. PAINTINGS AND SCULPTURES: THE RENOWNED COLLECTION OF MODERN AND ULTRA-MODERN ART FORMED BY THE LATE JOHN QUINN. February 5–11, 1927
339. *Still Life*

1928

Paris. SALON D'AUTOMNE. November 4–December 16
 6, rue Furstenberg
 285. *Peinture*
 286. *Peinture*

1929

New York. AMERICAN ART ASSOCIATION. THE ARTHUR B. DAVIES ART COLLECTION. April 13–17
 62. *Peppers and Fruit*
 69. *Fruit*
 394. *Bowl of Fruit*
 421. *Nature morte*
 423. *Books and Fruit*

Paris. SALON D'AUTOMNE. November 3–December 22
 6, rue Furstenberg
 197. *Nature morte*
 198. *Nature morte*

1930

Paris. SALON D'AUTOMNE. November 1–December 14
 6, rue Furstenberg
 352. *Peinture*

1942

New Haven. Yale University Art Gallery. INAUGURAL EXHIBITION OF THE COLLECTION SOCIÉTÉ ANONYME. January 13–February 23
Composition I–V
Plums

1950

New York. Rose Fried Gallery. THREE AMERICAN PIONEERS OF ABSTRACT ART. November 20–December 30. Also included paintings by Morgan Russell and Stanton Macdonald-Wright.
Five untitled and undated *Peinture/Nature morte*

1951

New York. ROSE FRIED GALLERY. January 4–20
Exhibition also included works by Arp, Delaunay, Diller, Gallatin, Gildewart, Glarner, Picabia, Russell, van Doesburg, Vantongerloo.
3. Untitled Oil (192?)

New York. ABSTRACT PAINTING AND SCULPTURE IN AMERICA, THE MUSEUM OF MODERN ART. CATALOGUE BY ANDREW CARDNUFF RITCHIE. January 23–March 25
5. *Composition II*. Before 1918
 Oil, 38¼ x 51"
 Lent by the Yale University Art Gallery, New Haven, Société Anonyme Collection. Illus. p. 53.

1952

New York. ROSE FRIED GALLERY. *10 American Abstract Painters.* March 24–April 11. Also included works by Diller, Dove, Feininger, Glarner, Knaths, Loew, Macdonald-Wright, Russell, Tobey.
Exact paintings shown unknown.

New York. ROSE FRIED GALLERY. December 15-?
Exhibition also included works by Diller, Domela, Fleischmann, Glarner, Huszar, El Lissitzky, Malevich, Mondrian, Picabia, Russell, Richter, Vantongerloo, Xceron.
Exact paintings shown unknown.

1957

New York. ROSE FRIED GALLERY. PIONEERS OF AMERICAN ABSTRACT ART. Circulated by the American Federation of Arts. December 19–January 9. Also included work by Macdonald-Wright, Russell, and others.
1. *Still Life*, 1922
 The Metropolitan Museum of Art, George A. Hearn Fund
 Oil on canvas, 23½ x 28⅜
 Written on back of canvas: *Ceci est un Patrick Henry Bruce/ H. P. Roché*
 Collection: Rose Fried Gallery
2. Untitled and undated composition
 Herbert and Nannette Rothschild
 Oil on canvas, 23½ x 36
 Unsigned
 Collection: Pierre Roché, Paris, France

1965

New York. M. KNOEDLER & CO., INC. SYNCHROMISM AND COLOR PRINCIPLES IN AMERICAN PAINTING, 1910-1930. October 12–November 6. Catalogue by William C. Agee. Included works by Morgan Russell, Stanton Macdonald-Wright, Bruce, Arthur B. Frost, Jr., Thomas H. Benton, Arthur B. Davies, James Daugherty, Jay Van Everen, and others.
2. *Portrait of a Child*, 1903
 Oil on canvas, 22¼ x 18
 Collection Mrs. James B. Skinner, Middleburg, Virginia
3. *Still Life with Pears*, c. 1908
 Oil on canvas, 10½ x 13
 Private Collection, California
4. *Still Life with Flowers*, c. 1908–09
 Oil on canvas, 7½ x 9½
 Private Collection, California
5. *Landscape with Gate*, 1911
 Oil on canvas, 25¾ x 19
 Collection Mr. William C. Kennedy, New York
6. *Still Life*, 1911–12
 Oil on canvas, 19¼ x 27
 Collection Mr. Benjamin F. Garber, New York

7. *Composition I*, 1916–17
Oil on canvas, 45½ x 34¾
Yale University Art Gallery, New Haven:
Collection Société Anonyme

8. *Composition II*, 1916–17
Oil on canvas, 38¼ x 51
Yale University Art Gallery, New Haven:
Collection Société Anonyme

9. *Composition III*, 1916–17
Oil on canvas, 63¼ x 38
Yale University Art Gallery, New Haven:
Collection Société Anonyme

10. *Composition IV*, 1916–17
Oil on canvas, 50¾ x 76½
Yale University Art Gallery, New Haven:
Collection Société Anonyme

11. *Composition V*, 1916–17
Oil on canvas, 51⅜ x 63⅝
Yale University Art Gallery, New Haven:
Collection Société Anonyme

12. *Forms*, c. 1920–21
Oil on canvas, 23¾ x 36¼
W. H. Lane Foundation, Leominster, Massachusetts

13. *Formes sur la table*, c. 1925–26
Oil on canvas, 28¾ x 36¼
Addison Gallery of American Art, Phillips Academy,
Andover, Massachusetts

14. *Forms*, c. 1929–30
Oil on canvas, 23¼ x 36
Collection B. F. Garber, New York

15. *Vertical Beams*, 1932
Oil on canvas, 32 x 51¼
Collection Mme Henri-Pierre Roché, Paris

1 9 6 7

Albuquerque, New Mexico. UNIVERSITY OF NEW MEXICO ART
MUSEUM. CUBISM: ITS IMPACT IN THE USA 1910–1930.
February 10–March 19. Traveled to Marion Koogler McNay Art

Institute, San Antonio; San Francisco Museum of Art; and
Los Angeles Municipal Art Gallery.

4. *Formes*, c. 1920–21
Oil on canvas, 23½ x 28¾
Howard S. Wilson Memorial Collection, University of
Nebraska, Lincoln. Illus. p. 16

New York. NOAH GOLDOWSKY GALLERY. Thirteen *Peinture/Nature
morte*, from Collection of Mme Henri-Pierre Roché, Paris.

1 9 6 7 - 6 8

New York. Circulated by The Museum of Modern Art. SYNCHROM-
ISM AND RELATED AMERICAN COLOR PAINTING, 1910–1930.
February 4, 1967–June 17, 1968. Organized by William C. Agee.
Traveled to State University at Oswego, New York; Santa Barbara
Museum of Art; California Institute of Arts, Los Angeles; Allen
Memorial Art Museum, Oberlin, Ohio; Rose Art Museum,
Brandeis University, Waltham, Massachusetts; The Museum of
Art, Rhode Island School of Design, Providence; Goucher College,
Towson, Maryland; Cummer Gallery of Art, Jacksonville, Florida;
San Francisco Museum of Art.

3. *Still Life*, 1911–12
Oil on canvas, 19⅝ x 28¼
Collection Messrs. Kennedy-Garber, New York

4. *Composition II*, 1916–17
Oil on canvas, 38¼ x 51¼
Yale University Art Gallery, Collection Société Anonyme

5. *Composition III*, 1916–17
Oil on canvas, 63½ x 28⅛
Yale University Art Gallery, Collection Société Anonyme

6. *Composition V*, 1916–17
Oil on canvas, 51⅝ x 63⅞
Yale University Art Gallery, Collection Société Anonyme

7. *Forms*, c. 1920–21
Oil on canvas, 24 x 36½
William H. Lane Foundation, Leominster, Massachusetts

8. *Formes sur la table*, c. 1925–26
Oil on canvas, 28¾ x 36¼
Addison Gallery of American Art,Phillips Academy,
Andover, Massachusetts, gift of Mr. William Lane

9. *Vertical Beams*, 1932
 Oil on canvas, 31⅞ x 51¼
 Collection Mme Henri-Pierre Roché, Paris

1978-79

New York. THE WHITNEY MUSEUM OF AMERICAN ART. SYN-
CHROMISM AND AMERICAN COLOR ABSTRACTION, 1910–1925.
January 24–March 26. Traveled to The Museum of Fine Arts,
Houston; Des Moines Art Center; San Francisco Museum of
Modern Art; Everson Museum of Art, Syracuse; and Columbus
Gallery of Fine Arts, Columbus, Ohio.

Still Life, c. 1911
Oil on canvas, 10⅝ x 13¾
Collection of Mr. and Mrs. Henry M. Reed
Still Life with Tapestry, 1911–12
Oil on canvas, 19¼ x 27
Collection of Mr. and Mrs. Henry M. Reed
Composition I, 1916
Oil on canvas, 45½ x 34¾
Yale University Art Gallery, New Haven, Conn., gift of
Collection Société Anonyme
Composition II, 1916
Oil on canvas, 38¼ x 51
Yale University Art Gallery, New Haven, Conn., gift of
Collection Société Anonyme
Composition III, 1916
Oil on canvas, 63¼ x 38
Yale University Art Gallery, New Haven, Conn., gift of
Collection Société Anonyme
Composition V, 1916
Oil on canvas, 51⅜ x 63⅝
Yale University Art Gallery, New Haven, Conn., gift of
Collection Société Anonyme
Forms, 1920–21
Oil on canvas, 23½ x 28¾
Howard S. Wilson Memorial Collection, University of Nebraska-
Lincoln Art Galleries

Untitled (Forms), 1920–21
Oil on canvas, 23¾ x 36¼
William H. Lane Foundation, Leominster, Mass.
Still Life, c. 1922–25
Oil on canvas, 23½ x 28⅜
Collection of Roy R. Neuberger

1979

PATRICK HENRY BRUCE: AMERICAN MODERNIST
 The Museum of Fine Arts, Houston, May 31–July 29
 The Museum of Modern Art, New York, August 22–October 21
 Virginia Museum of Fine Arts, Richmond, November 26–
 January 6, 1980

Included are all extant works, as well as photographs of works now lost and presumed destroyed; in addition, lost works for which there are records but no photographs are also listed.

In order to allow for possible future expansion, should new works come to light, the catalogue is divided into four sections:

A) c. 1900–c. mid-1907
B) c. mid-1907–c. early fall 1912
C) c. late fall 1912–16
D) 1917–36

Because with two early exceptions Bruce never dated his work, and because there exists very little significant documentation pertaining to specific extant works done after 1905, the bulk of this chronology is based primarily on intensive examination and stylistic analysis of the paintings themselves.

In cases where the owners wished to remain anonymous, "Private Collection" and the location are given.

Measurements are given in both inches and centimeters, with height preceding width. Centimeters are carried to the nearest tenth.

A box (□) preceding a title indicates the work is also reproduced in color.

In the Exhibitions and Literature sections in the entries, a distinction is made between "mentioned" and "discussed," the first indicating a brief citation, the second a longer passage on the work. Where a painting is discussed in an exhibition catalogue, the reference is included under Exhibitions; otherwise it is listed under Literature.

Under Provenance, dates of ownership are given when they are known, either exactly or approximately; otherwise no date is listed.

The comments were written by William C. Agee, except where noted, although the dating and chronology are the authors' joint conclusions.

Abbreviations of frequently mentioned bibliography are used as follows:

Agee, "Bruce": William C. Agee, "Patrick Henry Bruce: A Major American Artist of Early Modernism," *Arts in Virginia* 17 (Spring 1977): 12-32.

Agee, *Synchromism:* William C. Agee, *Synchromism and Color Principles in American Painting, 1910-1930* (New York: M. Knoedler & Co., Inc., 1965). Published on the occasion of the exhibition "Synchromism" at M. Knoedler & Co., Inc., New York, October 1965.

Judson, *Bruce:* William D. Judson III, "Patrick Henry Bruce: 1881-1936" (unpublished master's thesis, Oberlin College, 1968).

Levin, *Synchromism:* Gail Levin, *Synchromism and American Color Abstraction, 1910-1925* (New York: George Braziller, 1978). Published on the occasion of the exhibition "Synchromism and American Color Abstraction, 1910-1925" at the Whitney Museum of American Art, New York, 1978.

Wolf, "Bruce": Tom M. Wolf. "Patrick Henry Bruce." *Marsyas* 15 (1970-71): 73-85.

SECTION A

A1. PORTRAIT OF LITTLETON WALLER TAZEWELL WICKHAM (1821–1909). c. 1900
Oil on canvas, 19½ x 15¾ in (49.5 x 40 cm)
Collection:
 Virginia Wickham Hayes, Ann Arbor, Mich.
Inscribed on back:
 Littleton Waller Tazewell Wickham, painted at Woodside, 1900
Provenance:
 Littleton Waller Tazewell Wickham, Woodside, until 1909
 Judge Thomas Ashby Wickham, Woodside, 1909–39
 Jointly owned by Julia Wickham Porter, Ashby Porcher Wickham, and Littleton Maclurg Wickham, kept at Woodside with Littleton Maclurg Wickham, 1939–73
 Ashby Porcher Wickham, Kilmarnock, Va.
 Virginia Wickham Hayes

The Wickhams are an old and distinguished family still residing at their large estate, Woodside, just outside Richmond (Henrico County). They were very close to the

A1

A2

A3

Bruces, who frequently visited there. Littleton Wickham began construction of the present mansion in 1854 with the architect Albert L. West and completed it in 1859.*

The inscription on the back is not Bruce's handwriting. It is thought by the family to be in Mrs. Littleton Waller Tazewell Wickham's hand; it is not known when the inscription was added. The portrait was certainly done at Woodside, but it could well have been done as late as mid-1902, when Bruce left for New York.

A2. PORTRAIT OF MR. ROBERT CLARK. December 9, 1901
Charcoal on paper, mat 29⅜ x 23¾ in (74.6 x 60.3 cm),
 image 24 x 18 in (61 x 45.7 cm)
Signed in pencil lower left: P. H. Bruce,
 December 9, 1901
Collection:
 Miss Adele Clark, Richmond, Va.

Robert Clark was the father of Adele Clark (b. 1882), a fellow student of Bruce at the Art Club of Richmond. Mr. Clark would sometimes pose at night for the sketch class, and on December 9, 1901, Bruce and Miss Clark exchanged their drawings. Bruce's portrait has remained in her possession since then.

A3. Copy of Ruben's DAUGHTERS OF LEUCIPPUS. c. 1901–02
Watercolor, 14¹/₁₆ x 11⁷/₁₆ in (35.7 x 29.1 cm)
Collection:
 Julia Wickham Porter (Mrs. Charles W. Porter III),
 Woodside, Richmond, Henrico Co., Va.

This and the Rembrandt copies (A4, A5a, A5b) were recently discovered by Dr. Charles W. Porter III (his wife is Julia Wickham Porter) at Woodside. They are not signed, but there is no question that they are by Bruce. With the watercolors Dr. Porter also discovered forty-eight issues of *Masters of Art*, a series published from January 1900 through 1904, inscribed with the name Anne Allston Porcher, an aunt of Littleton Wickham who often visited Woodside. In addition, a children's record book of the Wickhams, still kept at Woodside, has an entry of 1901 stating that Bruce "sent a stack of art books" to Mrs. Porcher. The *Daughters of Leucippus* was reproduced as Plate VII of the January 1901 issue, which was devoted to Rubens, and in all likelihood was the source for this copy. As proof that they are by Bruce, these watercolors show the same assurance and accomplishment of Bruce's work of these early years; moreover, neither the oral nor written history of the Bruces or Wickhams mentions any friend or relative other than Bruce as a serious artist.

Bruce is known to have copied Old Master paintings at least as late as summer 1905, when he did three copies from

*We are indebted to Dr. and Mrs. Charles W. Porter III (Mrs. Porter is a Wickham) who now live at Woodside for the family history and records cited in this and the following entries.

A4 A5 A6

Titian in the Louvre and then brought them to his studio for study (letter to Henri, December 7, 1905). Later, during the 1920s and 1930s, Bruce haunted the Louvre, and after returning to New York, the Metropolitan Museum of Art.

The paper used for this and the other copies was Strathmore Drawing Bristol, Grade 235, which had been produced since 1896.*

A4. Copy of Rembrandt's Self-Portrait. c. 1901-02
Watercolor, 14⁷⁄₁₆ x 11⅛ in (36.7 x 28.3 cm)
Collection:
 Julia Wickham Porter (Mrs. Charles W. Porter III),
 Woodside, Richmond, Henrico Co., Va.

Neither this nor the two other Rembrandt copies (A5a, A5b) are to be found in the *Masters of Art* series; where Bruce found the reproductions has not been determined.

The handling is loose and open, and the lucid color is an early, sophisticated hint of his later predilection for refined pastel harmonies.

A5. Copies after Rembrandt. c. 1901-02
Watercolor, 14⁵⁄₁₆ x 11 in (36.4 x 27.9 cm)
Collection:

*Wynn Phelan, paper conservator for The Museum of Fine Arts, Houston, identified the paper and verified the information with the manufacturer.

Julia Wickham Porter (Mrs. Charles W. Porter III),
 Woodside, Richmond, Henrico Co., Va.
A5a *(top)*. The source is Rembrandt's portrait of his son Titus, now in Vienna.

A5b. Done after the *Portrait of Hendrickje Stoffels* (Louvre), this and A5a are free and inventive in their interpretations and coloration, clearly indicating that Bruce was working from black-and-white reproductions.

A6. Portrait of Judge Thomas Ashby Wickham (1857–1939). c. 1903
Pencil on paper, 4¼ x 4¼ in (5.7 x 5.7 cm)
Collection:
 Julia Wickham Porter (Mrs. Charles W. Porter III),
 Woodside, Richmond, Henrico Co., Va.
Inscribed on back of frame:
 c. 1903
Provenance:
 Judge Thomas Ashby Wickham, Woodside, until 1939
 Jointly owned by Julia Wickham Porter, Ashby Porcher Wickham, and Littleton Maclurg Wickham, kept at Woodside with Littleton Maclurg Wickham, 1939–73
 Julia Wickham Porter, 1973

The inscription "c. 1903" is not in Bruce's handwriting; it is thought to be in Mrs. Wickham's hand, but when the

A7

A8

inscription was added is not known.

After the death of Bruce's father in 1899, Judge Wickham* became the legal guardian of Mary Bruce, the artist's younger sister, who went to live at Woodside for several years. Bruce visited Woodside frequently to see his sister and the Wickhams, and the Wickham family records show that Bruce was there in early October of 1903. Since Bruce went to Europe at the end of 1903, the date would appear to be secure.

A7. PORTRAIT OF LITTLETON MACLURG WICKHAM (1898–1973). Early fall 1903
Oil on canvas. 20 x 16 in (50.8 x 40.6 cm)
Collection:
 Julia Wickham Porter (Mrs. Charles W. Porter III)
 Woodside, Richmond, Henrico Co., Va.
Inscribed on back:
 painted when he was about 5 years old—1903–04
Provenance:
 Littleton Maclurg Wickham
 Julia Wickham Porter, 1973

Littleton Maclurg Wickham was the son of Judge Thomas Ashby Wickham and was born on September 27, 1898. The Wickham family records show that Bruce was at Woodside when young Wickham's birthday party was held in the first

week of October 1903; the family oral history is certain that the party was the occasion for the portrait. Since Bruce was in Europe in the summer of 1904, the inscription (not in Bruce's handwriting) must have been added later by someone who was not certain of Wickham's year of birth.

The portrait shows the effects of a year's study with Henri. By virtue of the absolute frontality and boldness of execution, the portrait embodies Henri's dictum to record the immediacy of life as directly as possible. The spots at the sides of the painting are the child's thumbprints, adding a freshness and spontaneity that would not have displeased either Bruce or Henri.

A8. PORTRAIT OF HELEN JOHNSTON SKINNER. July 1905
Oil on canvas, 22¼ x 18 in (56.5 x 45.7 cm)
Signed in pencil on back:
 PH Bruce–July 1905
Collection:
 Helen Johnston Skinner, Middleburg, Va.
Exhibitions:
 Agee, *Synchromism.* No. 2. Mentioned in catalogue p. 12.
 Heckscher Museum, Huntington, N.Y.
 "The Students of William Merritt Chase." November 18–December 30, 1973. No. 54. Illustrated and discussed p. 28.
Literature:
 Agee, "Bruce," illustrated p. 15, mentioned p. 14.

*Also called Mr. Ashby by the family, it was to Judge Wickham that Bruce wrote, in July and August 1896, the first extant letters of Bruce that we have.

Although this portrait has been previously dated as 1903 (Agee, *Synchromism*) and c. 1903 (Agee, "Bruce"), recent examination shows, very faintly, Bruce's signature and the date July 1905. Mrs. Skinner (b. 1899) has confirmed this date.* Bruce returned to the United States in the summer of 1905 in order to settle his father's estate in Richmond, which could only be done after his sister Mary's birthday (July 29, 1905). He then married Helen Kibbey on August 24, 1905, in Marshfield Hills, Massachusetts.

Bruce came to visit Mrs. Skinner's family, who were distant relatives, at Rock Castle, in Rutherford, Virginia, about forty miles west of Richmond on the James River. She recalls that Bruce took about two hours to do it, and termed the painting a "portrait sketch" because it did not have a background.* This is significant because it demonstrates that Bruce was well aware of the entire question—and history—of the "finished" vs. the "unfinished" painting, a matter crucial to his art for the rest of his life.

Mrs. Skinner later visited Bruce in Paris in about 1928, but he would not show his work to her, saying, as she recalls, that "she didn't know enough about painting."*

SECTON A: LOST PAINTINGS

WAR PORTRAIT OF W. T. HEDGES. c. 1903
New York. National Academy of Design. Catalogue of the 79th Annual Exhibition. January 2–30, 1904.

St. Louis. Universal Exposition. Official Catalogue of Exhibitors. April 30–December 1, 1904.
Portland, Oregon. "Lewis and Clark Centennial Exposition." June 1–October 15, 1905.

PORTRAIT DE MLLE K. c. 1904
Paris. Salon de Société Nationale des Beaux-Arts. April 17–June 30, 1904.

HOMME A LA CAPE BLEUE. c. 1904
Paris. Salon de Société Nationale des Beaux-Arts. April 17–June 30, 1904.

ENFANT QUI RIT. c. 1904
Paris. Salon de Société Nationale des Beaux-Arts. April 17–June 30, 1904.

ITALIAN IN BLUE CAPE. c. 1904
Philadelphia. Pennsylvania Academy of the Fine Arts. Catalogue of the 100th Anniversary Exhibition. January 23–March 4, 1905.
New York. Society of American Artists. Catalogue of the Twenty-seventh Exhibition. March 25–April 30, 1905.
Portland, Oregon. "Lewis and Clark Centennial Exposition." June 1–October 15, 1905.

PORTRAIT DE MME. F. c. 1904–05
Paris. Salon de Société Nationale des Beaux-Arts. April 15–June 30, 1905.
Chicago. The Art Institute of Chicago. "18th Annual Exhibition of Oil Paintings and Sculpture of American Artists." October 19–November 26, 1905.

*Interview with William C. Agee, December 11, 1978.

PORTRAIT DE M. M. c. 1904–05
 Paris. Salon de Société Nationale des Beaux-Arts. April 15–June 30, 1905.
PETITE FILLE EN ROUGE. c. 1905
 Paris. Salon d'Automne. October 18–November 25, 1905.
PETITE FILLE EN GRIS. c. 1905
 Paris. Salon d'Automne. October 18–November 25, 1905.
MAN IN BLACK. c. 1905
 Philadelphia. Pennsylvania Academy of Fine Arts. Catalogue of the 101st Annual Exhibition. January 22–March 3, 1906.
JANE. c. 1906
 Paris. Salon d'Automne. October 6–November 15, 1906.
MADAME S. c. 1906
 Paris. Salon d'Automne. October 6–November 15, 1906.
LA ROBE RAYÉE. c. 1906
 Paris. Salon d'Automne. October 6–November 15, 1906.
YOUNG WOMAN. c. 1906
 Chicago. The Art Institute of Chicago. "19th Annual Exhibition of Oil Paintings and Sculpture of American Artists." October 16–November 29, 1906.
A BOY. c. 1906
 Chicago. The Art Institute of Chicago. "19th Annual Exhibition of Oil Paintings and Sculpture of American Artists." October 16–November 29, 1906.
 Philadelphia. Pennsylvania Academy of Fine Arts. Catalogue of the 102nd Annual Exhibition. January 21–February 24, 1907.
LITTLE GIRL. c. 1906
 Chicago. The Art Institute of Chicago. "19th Annual Exhibition of Oil Paintings and Sculpture of American Artists." October 16–November 29, 1906.
JEUNE FILLE. c. 1907
 Paris. Salon d'Automne. October 1–22, 1907.
PAYSAGE. c. 1907
 Paris. Salon d'Automne. October 1–22, 1907.
PAYSAGE. c. 1907
 Paris. Salon d'Automne. October 1–22, 1907.

SECTION B

Only one painting from this period, *Still Life* (B42), known to be from 1911 because of its Armory Show label, carries a firm date. After 1905 Bruce dated none of his paintings, and the chronology proposed here is made all the more difficult because he did not exhibit from the fall of 1907 to the fall of 1910, leaving a three-year period with no exhibition records at a time when his art was undergoing radical changes.

At points, prevailing motifs, especially that of the single vase of flowers (B6–B20), are arranged by theme and are not integrated with other paintings in a purely chronological manner. This method will show Bruce's habit, established at an early date, of reexamining and extending the same motif, the pattern that was to dominate his later work. It should also be remembered that, like Cézanne, Bruce was working simultaneously in different modes and techniques, another complicating factor in dating these paintings.

The provenance for most works in this section is listed as "the artist, to Mrs. Bruce." Some were brought to New York by her in early 1911; others were brought to this country by A. B. Frost, Jr., Bruce's close friend, when he returned to the United States in early 1915. After Frost's death in November 1917, they were held by James Daugherty, who had been working closely with Frost in New York. He then turned them over to Frost's brother, Jack.* They were returned to Mrs. Bruce sometime after she moved to New York (c. 1920). With a few exceptions, which are so noted, it is impossible to determine the exact sequence of their possession, and thus we have entered them as "the artist, to Mrs. Bruce."

From existing exhibition records of these years, Bruce entitled his works *Nature morte, Fleurs,* or *Pommier,* etc., which in this section are translated. The flower paintings are here assigned that title. In certain cases, for purposes of clarity, we have elaborated on *Still Life* by adding a descriptive phrase, which is indicated by parentheses. The titles of paintings exhibited at the 1916 Montross Gallery show are taken from their labels. They are probably descriptive and are either used in their entirety or added here because in all probability they were assigned by Arthur B. Frost, Jr., and Harrison Reeves.

*Letter from James Daugherty to Katherine Dreier, 1949 (Collection Société Anonyme, Yale University).

 B1

 B2

 B3

Bruce's two closest friends, they knew his work intimately and arranged the exhibition.

B1. STILL LIFE. c. mid–1907
 Oil on canvas, 21¾ x 18 in (55.1 x 45.7 cm)
 Signed lower left: Bruce
 Collection:
 B. F. Garber, Marigot, St. Martin
 Provenance:
 Artist
 Mrs. Helen Kibbey Bruce
 B. F. Garber, c. 1960

The painting and the following portrait (B2) are the first extant examples of Bruce's shift from his old allegiance to Henri and Chase to a more modernist art. Although a rough Fauvelike color is applied, the format and distinct light-dark shading recall the work of his old teacher Chase. The painting is also his first known still life and established a passion for the genre that was to dominate his art for the rest of his life.

B2. PORTRAIT (HELEN KIBBEY BRUCE). c. mid–1907
 Oil on canvas, 20⅞ x 16⅞ in (53 x 42.9 cm)
 Signed upper right: Bruce
 Collection:
 William Kennedy, Marigot, St. Martin
 Label on stretcher:
 "Portrait"

 by P. H. Bruce
 Catalogue #22
 Provenance:
 Artist
 Mrs. Helen Kibbey Bruce
 William Kennedy, c. 1960
 Exhibition:
 Montross Gallery, New York. November 21–December
 9, 1916. No. 22.

The sitter is identifiable from photographs as Helen Kibbey Bruce, the artist's wife. Although the label on the back does not carry the gallery's name, without doubt it was put on for Bruce's 1916 show at the Montross Gallery. Other paintings of this period with identically typed labels are from the same show, the only exhibition of any size to show his work until now. The Montross catalogue, however, has not been found, as is the case with most of the Montross records.

B3. PORTRAIT OF ROY BRUCE. c. mid–1909
 Oil on canvas, 11½ x 11½ in (29.2 x 29.2 cm)
 Signed upper right: Bruce
 Collection:
 Mr. and Mrs. Henry M. Reed, Montclair, N. J.
 Provenance:
 Artist
 Mrs. Helen Kibbey Bruce
 William Kennedy, c. 1960

B4

B5

B6

Mr. and Mrs. Henry M. Reed, c. 1969
Exhibitions:
 Montclair Art Museum, Montclair, N.J. "Synchro-
 mism from the Henry M. Reed Collection." April 6–27.
 1969. No. 2.
 Montross Gallery, New York. November 21–December
 9, 1916. Possibly one of "two heads in a Renoir vein,"
 mentioned in New York *Globe,* December 4, 1916.

Photographs identify this and B4 as portraits of Bruce's son,
Roy, who was born on April 29, 1907. In both portraits, the
child appears to be about two-and-a-half years old, indicat-
ing a date of c. mid–1909 (see figs. 6, 7, p. 9). At this time
we also know Bruce was influenced by Renoir, whose
feathery touch and color pervade both paintings.

B4. PORTRAIT OF ROY BRUCE. c. mid–1909
 Oil on canvas, 18 x 15¼ in (45.7 x 38.2 cm) (unstretched)
 Probable size of stretcher: 15 x 12½ in (38.1 x 31.8 cm)
 Signed lower right: Bruce
 Collection:
 B. F. Garber, Marigot, St. Martin
 Provenance:
 Artist
 Mrs. Helen Kibbey Bruce
 B. F. Garber, c. 1960
 Exhibition:
 Montross Gallery, New York. November 21–December 9,

1916. Possibly one of "two heads in a Renoir vein,"
mentioned in New York *Globe,* December 4, 1916.

B5. LANDSCAPE. c. summer 1909
 Oil on canvas, 18 x 21⅜ in (45.7 x 54.3 cm)
 Collection:
 William Kennedy, Marigot, St. Martin
 Provenance:
 Artist
 Mrs. Helen Kibbey Bruce
 William Kennedy, c. 1960

The rural setting indicates that the painting was done in
the summer of 1909, in Boussac, the first year the Bruces
are known to have spent the summer away from Paris. They
were also in Boussac (a small town about 170 miles due
south of Paris and about the same distance northwest of
Bordeaux) in the summers of 1910 and 1911. The decided
Renoiresque feel of the painting, although now less delicate,
relates it to the portraits of Roy Bruce (B3, B4).

B6. FLOWERS. c. late 1909
 Oil on canvas, 15 x 18¾ in (38.1 x 47.4 cm) (unstretched)
 Probable size of stretcher: 12⅝ x 16 in (32.1 x 40.6 cm)
 Collection:
 William Kennedy, Marigot, St. Martin
 Provenance:
 Artist

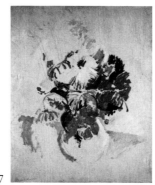
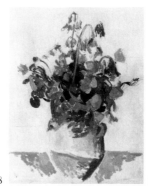

B7 B8 B9

Mrs. Helen Kibbey Bruce
William Kennedy, c. 1960

By its awkward, tentative quality, the painting is Bruce's
initial extant work in which he began to assimilate Cézanne.
The disposition of the cloth diagonally across the surface,
with flowers resting on it, bears some resemblance to the
center portion of a Cézanne of c. 1886–90 (Venturi 510),
although Cézanne used apples rather than flowers and
included another element in the left background. The paint-
ing is also significant because it marks Bruce's first true
attempt to engage the problems of the modernist still life.
In addition, it is here that Bruce begins concentrating on a
single object, such as a vase of flowers or a dish of fruit on
a table, motifs central to his work of these years.

B7. FLOWERS. c. late 1909–early 1910
 Oil on canvas, 14¾ x 18 in (37.3 x 45.7 cm)
 Signed lower left: Bruce
 Collection:
 B. F. Garber, Marigot, St. Martin
 Provenance:
 Artist
 Mrs. Helen Kibbey Bruce
 B. F. Garber, c. 1960

B8. FLOWERS. c. early to mid–1910
 Oil and pencil on canvas, 21½ x 17¾ in (54.6 x 44.9 cm)

Signed lower left: Bruce
Collection:
 B. F. Garber, Marigot, St. Martin
Provenance:
 Artist
 Mrs. Helen Kibbey Bruce
 B. F. Garber, c. 1960

The painting is the first of fifteen extant paintings, done
probably from c. early 1910 to c. late 1911, in which Bruce
focuses on a single vase of flowers set on a table, a motif
that preoccupied Cézanne from the mid–1870s until at
least c. 1900, and less frequently until 1904 (c.f. Venturi
179–184, 748, 752, and 757). It was also used by Matisse
in certain paintings of 1907–09, the period when Bruce
was closest to him.

B9. FLOWERS. c. early to mid–1910
 Oil and charcoal on canvas, 22⅞ x 18 in (58.1 x 45.7 cm)
 Collection:
 William Kennedy, Marigot, St. Martin
 Provenance:
 Artist
 Mrs. Helen Kibbey Bruce
 William Kennedy, c. 1960

The painting marks Bruce's full engagement with Cézanne,
a fascination that grew unabated until late 1912 and that

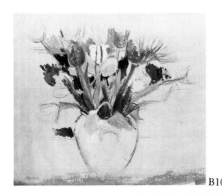
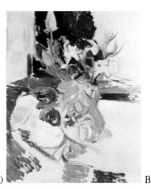
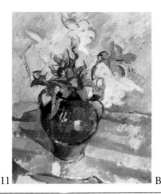
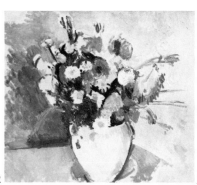

B10 B11 B12 B13

in the most profound sense lay at the heart of his late geometric still lifes. Bruce chose to exhibit a painting of this type in the 1910 Salon d'Automne, the first work he had exhibited since the fall of 1907. A specific Cézanne prototype can be found in *Fleurs dans un vase vert*, c. 1883–87 (Venturi 511).

B10. FLOWERS. c. early to mid–1910
Oil and charcoal on canvas, 21¾ x 26 in (55.1 x 66 cm) (unstretched)
Probable size of stretcher: 19½ x 24 in (49.5 x 61 cm)
Collection:
William Kennedy, Marigot, St. Martin
Provenance:
Artist
Mrs. Helen Kibbey Bruce
William Kennedy, c. 1960

The placement of the vase directly at the front surface, the expansive fullness of the flowers, and the large areas of bare canvas closely parallel Cézanne's *Bouquet of Peonies in a Green Jar* (private collection, Paris; Venturi 748) of c. 1895–98.

B11. FLOWERS. c. mid–1910
Oil and charcoal on canvas, 23⅞ x 20⅜ in (60.6 x 51.8 cm) (unstretched)
Probable size of stretcher: 21⅝ x 18 in (54.9 x 45.7 cm)

Collection:
William Kennedy, Marigot, St. Martin
Provenance:
Artist
Mrs. Helen Kibbey Bruce
William Kennedy, c. 1960

This and the following paintings in this series (B12–B20) take on an increasing amplitude and richness, as did Cézanne's paintings of the same motif after 1895.

B12. FLOWERS. c. mid–1910
Oil on canvas, 21½ x 18¼ in (54.6 x 46.4 cm)
Signed lower right: Bruce
Collection:
William Kennedy, Marigot, St. Martin
Provenance:
Artist
Mrs. Helen Kibbey Bruce
William Kennedy, c. 1960

B13. FLOWERS. c. mid- to late 1910
Oil on canvas, 19 x 22 in (47.5 x 55.9 cm)
Collection:
B. F. Garber, Marigot, St. Martin
Provenance:
Artist
Mrs. Helen Kibbey Bruce
B. F. Garber, c. 1960

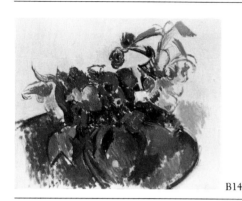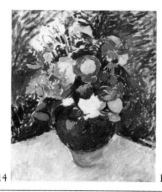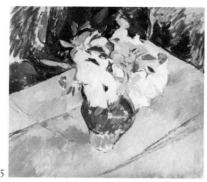

B14 B15 B16

B14. FLOWERS. c. late 1910–early 1911
 Oil on canvas, 19 x 23¾ in (48.3 x 60.3 cm)
 Signed lower right: Bruce
 Collection:
 Private collection, Mt. Kisco, N.Y.
 Provenance:
 Artist
 Mrs. Helen Kibbey Bruce
 William Kennedy
 Private Collection ,1959

B15. FLOWERS. c. early to mid–1911
 Oil on canvas, 23 x 20 in (58.4 x 50. 8 cm)
 Signed lower right: Bruce
 Collection:
 Reader's Digest
 Provenance:
 Artist
 Mrs. Helen Kibbey Bruce
 B. F. Garber
 Reader's Digest Collection, 1959
 Exhibition:
 M. Knoedler & Co., Inc., New York. "Reader's Digest
 Collection." May 15–June 8, 1963. Illustrated p. 11.

B16. FLOWERS. c. mid–1911
 Oil on canvas, 21¼ x 25½ in (54 x 64.8 cm)
 Signed upper right: Bruce

Collection:
 B. F. Garber, Marigot, St. Martin
Provenance:
 Artist
 Mrs. Helen Kibbey Bruce
 B. F. Garber

B17. FLOWERS. c. mid to late 1911
 Oil on canvas, 21¼ x 25¼ in (54 x 64.1 cm)
 Collection:
 B. F. Garber, Marigot, St. Martin
 Provenance:
 Artist
 Mrs. Helen Kibbey Bruce
 B. F. Garber, c. 1960

B18. STILL LIFE (FLOWERS IN A GREEN VASE). c. late 1911
 Oil on canvas, 25 x 21 in (63.5 x 53.3 cm)
 Signed upper right: Bruce
 Collection:
 Mr. and Mrs. Henry M. Reed, Montclair,
 Provenance:
 Artist
 Mrs. Helen Kibbey Bruce
 William Kennedy, c. 1960
 Mr. and Mrs. Henry M. Reed, c. 1968
 Exhibitions:
 Montclair Art Museum, Montclair, N. J. "Synchromism

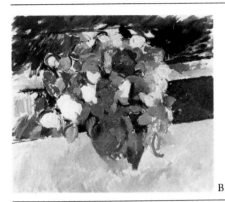 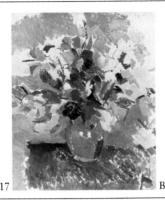 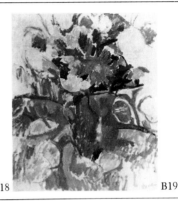 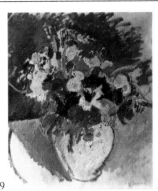

B17 B18 B19 B20

from the Henry M. Reed Collection." April 6–27, 1969.
No. 4.
Montclair Art Museum, Montclair, N. J. "American
Still-Life in New Jersey Collections." October 25–
December 13, 1970. No. 7.
Whitney Museum of American Art, New York. "20th-
Century American Art from Friends' Collections."
July 27–September 27, 1977.

B19. FLOWERS. c. late 1911
Oil on canvas, 21½ x 18 in (54.6 x 45.7 cm)
Signed lower right: Bruce
Collection:
Private collection, New York
Provenance:
Artist
Ferargil Galleries, New York
Frederick King
Rose Fried Gallery, New York
Coe Kerr Gallery, New York
Private collection

B20. STILL LIFE. c. late 1911
Oil on canvas, 22 x 18 in (55.9 x 45.7 cm)
Signed lower right: P. H. Bruce
Collection:
The Baltimore Museum of Art, bequest of Miss Etta

and Dr. Claribel Cone. 50.316
Provenance:
Artist
Miss Etta and Dr. Claribel Cone, at least by 1913
The Baltimore Museum of Art, 1950
Exhibitions:
Peabody Institute Galleries, Baltimore. "The Charcoal
Club of Baltimore Fourth Annual Exhibition of
Contemporary American Art." February 11–March 9,
1913. No. 19.
Washington County Museum of Fine Arts, Hagerstown,
Md. "Still Lifes." November 6–27, 1966.
"Still Life and Flowers." Circulated by the Maryland
Arts Council. May–November 1967. No. 5.
The Baltimore Museum of Art. "New Dimensions in the
Cone Collection." August 9–September 29, 1974.
Literature:
J. O. L., "Show of Paintings at Peabody Fine,"
The Evening Sun, Baltimore, March 5, 1913.
Kenneth H. Cook, "Patrick Henry Bruce," *News &
Record,* South Boston, Va., October 31, 1974, illus-
trated p. 2D.

Since Bruce exhibited a *Fleurs* in March 1912 at the Salon
des Indépendants, and as late as May in the Cologne
"Sonderbund" exhibition the same year, it is possible that
a few flower paintings of this type were done in early 1912.

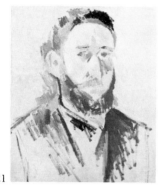

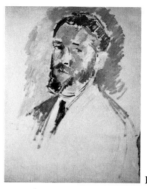

B21.

B22.

B23.

B21. STILL LIFE. c. mid–1910
Oil and charcoal on canvas, 24⅜ x 20½ in (61.9 x 52.1 cm)
 (unstretched)
Probable size of stretcher: 21½ x 18 in (54.6 x 45.7 cm)
Signed in pencil upper left: Bruce
Collection:
 B. F. Garber, Marigot, St. Martin
Provenance:
 Artist
 Mrs. Helen Kibbey Bruce
 B. F. Garber, c. 1960

This work combines the touch and openness, as well as a
motif, of Cézanne's late watercolors (e.g., Venturi 853)
with Matisse's palette and translates them into an oil
painting of remarkable subtlety. Even at this early date,
however, the color is Bruce's own; it consists of a wide
array of modulated pastel hues—lemon, lemon-green, and
raspberry, and pale grays, gray-blues, and gray-greens—
contrasted with sharp orange and acid green areas that
foretell the unique color usage of his late work. Such is its
refinement of color that a somewhat later date might well
be indicated.

B22. SELF-PORTRAIT. c. summer 1910
Oil and charcoal on canvas, 20¼ x 16⅞ in (51.4 x 42.9 cm)
 (unstretched)

Probable size of stretcher: 18 x 14⅞ in (45.7 x 37.8 cm)
Signed in pencil upper right: Bruce
Collection:
 William Kennedy, Marigot, St. Martin
Provenance:
 Artist
 Mrs. Helen Kibbey Bruce
 William Kennedy, c. 1960

From contemporary photographs (fig. 6, p. 9) and
descriptions (see p. 217) of Bruce with an auburn beard, this
painting is clearly a self-portrait. The style is similar to that
of the open, loose landscapes (B24-B26), which we have
assigned to the summer of 1910.

B23. PORTRAIT. c. summer 1910
Oil and charcoal on canvas, 23⅝ x 19⅞ in (60 x 50.5 cm)
 (unstretched)
Probable size of stretcher: 21½ x 18 in (54.6 x 45.7 cm)
Signed in pencil lower right: Bruce
Collection:
 B. F. Garber, Marigot, St. Martin
Provenance:
 Artist
 Mrs. Helen Kibbey Bruce
 B. F. Garber, c. 1960

At first glance, the painting may appear to be another

B24 B25 B26

self-portrait. However, despite the similar facture and arbitrary color modeling, it is probably a portrait of Arthur B. Frost, Jr. (1887–1917), Bruce's closest friend during these years (fig. 8, p. 9).

B24. LANDSCAPE. c. summer 1910
Oil and charcoal on canvas, 22½ x 27¾ in (57.2 x 70.3 cm) (unstretched)
Probable size of stretcher: 20⅞ x 25¼ in (53 x 64.1 cm)
Signed in pencil lower left: Bruce
Collection:
 B. F. Garber, Marigot, St. Martin
Provenance:
 Artist
 Mrs. Helen Kibbey Bruce
 B. F. Garber, c. 1960

In all probability this painting and B25, B26, and B27 were done in the summer of 1910, at Boussac.

B25. LANDSCAPE. c. summer 1910
Oil and charcoal on canvas, 20¼ x 26⅜ in (51.4 x 67 cm) (unstretched)
Probable size of stretcher: 18 x 23⅞ in (45.7 x 60.6 cm)
Signed in pencil lower right: Bruce
Collection:
 William Kennedy, Marigot, St. Martin
Provenance:
 Artist

Mrs. Helen Kibbey Bruce
William Kennedy, c. 1960

By its lateral frontality and emphasis on distant landscape elements that are brought to the front of the picture, Bruce recalls the example of Cézanne's late open landscapes such as *Mont Sainte-Victoire*, 1904–06. Reproduced in William Rubin, ed., *Cézanne: The Late Work* (New York: The Museum of Modern Art, 1977), p. 320. It is not in Venturi.

B26. LANDSCAPE. c. summer 1910
Oil and pencil on canvas, 20 x 23¾ in (50.8 x 60.1 cm) (unstretched)
Probable size of stretcher, 18 x 21½ in (45.7 x 54.6 cm)
Collection:
 B. F. Garber, Marigot, St. Martin
Provenance:
 Artist
 Mrs. Helen Kibbey Bruce
 B. F. Garber, c. 1960

The painting is most likely of the "peasant house," described by Helen Bruce, that the family rented in Boussac.*

B27. LANDSCAPE. c. summer 1910
Oil on canvas, 24 x 18⅛ in (61 x 46 cm)

*Helen Bruce to John I. H. Baur, 1949.

B27

B28

B29

Signed lower left: Bruce
Collection:
 William Kennedy, Marigot, St. Martin
Provenance:
 Artist
 Mrs. Helen Kibbey Bruce
 William Kennedy, c. 1960
Literature:
 Grace Glueck, "Peace Plus: New York Gallery Notes,"
 Art in America, vol. 58, no. 5 (September–October
 1970), illustrated p. 38.

The motif, the planar divisions of the winding road fusing
foreground and distant space, and the contrasting verticals
of the architecture are reminiscent of Cézanne's *Route
tournante*, 1900–06, and *Route tournante en sous-bois*,
1902–06. (Venturi 790 and 789; reproduced in color in
Rubin, *Cézanne*, pp. 278 and 283.)

B28. STILL LIFE (PEARS). c. early to mid–1911
 Oil on canvas, 10⅝ x 8⅝ in (27 x 21.9 cm)
 Signed lower left: Bruce
 Collection:
 William Kennedy, Marigot, St. Martin
 Provenance:
 Artist
 Mrs. Helen Kibbey Bruce
 William Kennedy, c. 1960

The painting can be compared to Cézanne's studies of fruit
of 1873–77 (e.g., Venturi 201, 202), 1879–82 (e.g.
Venturi 350, 355), and 1883–87 (e.g., Venturi 505, 506,
and 509). Cézanne's *Deux Pommes et demie* (Venturi
202) is also a parallel, but the drastically close focus is really
Bruce's own, as is the precipitous tilt of the surface, which
goes beyond even the almost vertical disposition of the plate
in Cézanne's late *Nature morte*, c. 1900 (Venturi 742).
Bruce's picture also calls to mind Picasso's Cézannesque
Fruit and Glass, summer 1908 (The Museum of Modern
Art, New York). In addition, the radical angle forecasts the
gravity-defying geometric still lifes such as D14 and D15 of
c. 1923–24.

B29. STILL LIFE. c. mid–1911
 Oil on canvas, 16 x 13 in (40.6 x 33 cm)
 Signed upper right in pencil: Bruce
 Also signed in paint on back of canvas
 Collection:
 Mr. and Mrs. Henry M. Reed, Montclair, N. J.
 Provenance:
 Artist
 Mrs. Helen Kibbey Bruce
 B. F. Garber, c. 1960
 Mr. and Mrs. Henry M. Reed, c. 1969
 Exhibition:
 Montclair Art Museum, Montclair, N. J. "American Still

B30

B31

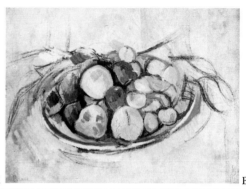

B32

Life in New Jersey Collections." October 25–
December 13, 1970. No. 11.

B30. FRUIT AND GREEN POT. c. mid–1911
Oil on canvas, 12½ x 10¾ in (31.8 x 27.1 cm)
Signed lower right: Bruce
Collection:
 B. F. Garber, Marigot, St. Martin
Label on stretcher:
 "Fruit and Green Pot"
 by P. H. Bruce
 Catalogue #8
Provenance:
 Artist
 Mrs. Helen Kibbey Bruce
 B. F. Garber, c. 1960
Exhibition:
 Montross Gallery, New York. November 21–December 9,
 1916. No. 8.

B31. STILL LIFE. c. mid–1911
Oil on canvas, 9½ x 16¼ in (24.1 x 41.3 cm)
Signed lower right: Bruce
Collection:
 William Kennedy, Marigot, St. Martin
Provenance:
 Artist
 Mrs. Helen Kibbey Bruce

William Kennedy, c. 1960

B32. STILL LIFE. c. mid–1911
Oil and charcoal on canvas, 13⅛ x 18 in (33.3 x 45.7 cm)
Signed in pencil lower left: Bruce
Collection:
 William Kennedy, Marigot, St. Martin
Provenance:
 Artist
 Mrs. Helen Kibbey Bruce
 William Kennedy, c. 1960

B33. STILL LIFE (WITH ECORCHÉ). c. mid-to late 1911
Oil on canvas, 21½ x 18 in (54.6 x 45.7 cm)
Collection:
 B. F. Garber, Marigot, St. Martin
Provenance:
 Artist
 Mrs. Helen Kibbey Bruce
 B. F. Garber, c. 1960
The painting is a "study" for the fuller, more "finished"
version (B34). The focus here is much closer and concen-
trates primarily on the plate of fruit.

B34. STILL LIFE (WITH ECORCHÉ). c. mid-to late 1911
Oil on canvas. 21½ x 18½ in (54.6 x 47 cm)
Signed lower left: Bruce
Collection:

B33 B34

Mrs. Malcolm G. Chace, Providence, R. I.

Provenance:

Artist

John Quinn, 1916–1924 (probably acquired from Bruce
exhibition, Montross Gallery, New York, 1916)

Quinn Estate, 1924–27

Frederick King, 1927 (?)—as late as 1966

Rose Fried Gallery, New York

Coe Kerr Gallery, New York

Mrs. Malcolm G. Chace

Exhibitions:

Montross Gallery, New York. November 21–December 9,
1916.

Art Center, New York. "Memorial Exhibition of Repre-
sentative Works Selected from the John Quinn
Collection." January 7–30, 1926.

American Art Association, Inc., New York. "The John
Quinn Collection: Paintings and Sculpture of the
Moderns." February 9–11, 1927. No. 339 (Auction—
paintings exhibited at auction).

Literature:

Charles H. Caffin, "Significant Still-Lifes by Bruce,"
New York American, November 27, 1916, illustrated.

"Whole of John Quinn Collection Announced for Sale
Piece Meal," *Art News*, vol. 24, no. 13 (January 2,
1926), mentioned p. 1.

John Quinn: Collection of Paintings, Water Colors,

Drawings and Sculpture (Huntington, N. Y.: Pidgeon
Hill Press, 1926), illustrated p. 186, mentioned p. 23.

Wolf, "Bruce," illustrated fig. 2, discussed pp. 77–78.

William H. Gerdts and Russell Burke, *American Still-
Life Painting* (New York: Praeger, 1971), illustrated
plate 28.

Judith Zilczer, *"The Noble Buyer": John Quinn, Patron
of the Avant-Garde* (Washington, D.C.: Smithsonian
Institution Press for the Hirshhorn Museum and
Sculpture Garden, 1978), mentioned p. 152.

Cézanne had made studies of the *ecorché*, then believed to
be by Michelangelo (Venturi 709, 1317, and 1453), as a
single object and had incorporated the lower half of it in the
background of the famous Courtauld painting *Nature morte
avec l'amour en platre* of c. 1895 (Venturi 706). However,
Bruce would have found a more immediate example in
Matisse, first in a copy done in 1903, and more especially
in Matisse's *Still Life with Auberqines* (The Museum of
Modern Art, New York), painted in the summer of 1911.
Like Matisse, Bruce fuses the *ecorché* with the patterning
of the tapestry on the rear wall. There the similarity ends;
Bruce uses a single plate of fruit set on a table that runs
laterally across the entire surface as a single plane that ex-
tends beyond the edges of the canvas. If the proposed date
is correct, the painting is Bruce's first extant work using this
pictorial device favored by Cézanne, and one that Bruce
came to incorporate with increasing frequency.

B35 B36 B36a

B35. LANDSCAPE NEAR SAINTES. c. summer 1911
 Oil on canvas, 21⅝ x 18 in (55 x 45.7 cm)
 Signed lower right: Bruce
 Collection:
 B. F. Garber, Marigot, St. Martin
 Label on stretcher:
 "Landscape near Saintes"
 by P. H. Bruce
 Catalogue #11 (or 21?)
 Provenance:
 Artist
 Mrs. Helen Kibbey Bruce
 B. F. Garber, c. 1960
 Exhibition:
 Montross Gallery, New York. November 21–December 9,
 1916. No. 11 (or 21?).

Saintes is a small, historic town about 145 miles southwest
of Boussac, fifty miles due north of Bordeaux, not far from
the ocean; the Bruces probably visited there while spending
the summer in Boussac. The new density and closely
parallel strokes, which begin to occur with greater fre-
quency in Bruce's painting from this point until the fall of
1912, indicate a date of summer 1911, the last year the
Bruces spent in Boussac.

B36. OLD GATE NEAR SAINTES. c. summer 1911.
 Oil on canvas, 24 x 18⅛ in (61 x 46 cm)

 Signed lower left: Bruce
 Collection:
 William Kennedy, Marigot, St. Martin
 Label on stretcher:
 "Old Gate Near Saintes"
 by P. H. Bruce
 Catalogue #6
 Provenance:
 Artist
 Mrs. Helen Kibbey Bruce
 William Kennedy, c. 1960
 Exhibitions:
 Montross Gallery, New York. November 21–December 9,
 1916. No. 6.
 Agee, Synchromism. No. 5. Illustrated in catalogue
 p. 13, mentioned p. 16.
 Literature:
 Judson, Bruce, mentioned pp. 22, 30.
 Wolf, "Bruce," illustrated fig. 4, discussed p. 78.

The scene is the same as that found in B35, although the
artist has painted it from a somewhat more distant vantage
point. Here Bruce also strives for a new fullness and density,
achieving it, however, not through heavily impastoed,
parallel touches, but rather through the flattened and
"scrubbed" bleeding of contours.

 In Agee, Synchromism, the date was given as 1911, a date
that can now probably be refined to the summer of that year.

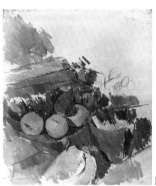

B37 B38 B39

B36a. LANDSCAPE, c. summer 1911
Oil on canvas, dimensions unknown
Present whereabouts unknown; presumed destroyed

In the photograph of Bruce's apartment-atelier at 6, rue de Furstenberg, hanging in the center wall, to the left of the *Old Gate Near Saintes* (B36), there is visible the lower portion of a landscape that is at least twice the size of *Old Gate Near Saintes.* The facture is pure Cézanne and appears to be more sophisticated than that in either B35 or B36. We would assign a date of c. late summer 1911. Even with such fragmentary evidence, the large painting can be considered as his culminating landscape of that year and is another instance of Bruce's lifelong habit of searching for the "absolute," for the "perfect" picture, be it of a series, a period, or, finally, of a lifetime.

B37. PORTRAIT OF HELEN KIBBEY BRUCE. c. fall 1911
Oil on canvas, 28 x 20 in (approximate) (71 x 50.8 cm)
Whereabouts unknown; presumed destroyed
Exhibition:
 Probably the *Femme assise* exhibited at 1912 Salon des
 Indépendants.

From the photograph, the facture is close to that of *Old Gate Near Saintes* (B36), and because it is probably the *Femme assise* exhibited in early 1912, a date of c. fall 1911 is appropriate. We know from photographs that the sitter is Helen Bruce. It is modeled after the many portraits of

Madame Cézanne, most particularly *Madame Cézanne au fauteuil jaune,* 1890–94 (Venturi 572); both show the sitters in a high-backed chair, with hands folded, looking slightly to the left. The painting is Bruce's last-known, and culminating, portrait.

B38. STILL LIFE (WITH PITCHER AND FRUIT). c. summer 1911
Oil on canvas, 12⅞ x 16 in (32.7 x 40.6 cm)
Signed lower left: Bruce
Collection:
 B. F. Garber, Marigot, St. Martin
Provenance:
 Artist
 Mrs. Helen Kibbey Bruce
 B. F. Garber, c. 1960

The concentration of color and shape in the lower center and central portions of the canvas, surrounded by large areas of bare canvas, strongly suggests the similar motif and handling of Cézanne's *Nature morte,* 1895–1900 (Venturi 750). The Cézanne is also the prototype for Picasso's *Still Life with Carafe and Candlestick,* of 1909 (formerly Collection of Mr. and Mrs. Walter Bareiss, New York).

B39. STILL LIFE (WITH FLOWER POT AND FRUIT). c. summer 1911
Oil and charcoal on canvas, 23¼ x 19½ in (59.1 x 49.5 cm)
Signed on stretcher
Collection:

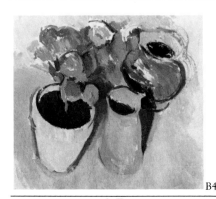

B40

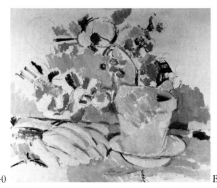

B41

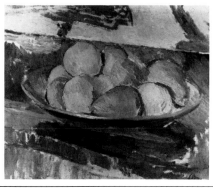

B42

Mr. and Mrs. Henry M. Reed, Montclair, N. J.
Provenance:
 Artist
 Mrs. Helen Kibbey Bruce
 William Kennedy, c. 1960
 Mr. and Mrs. Henry M. Reed, c. 1970

A similar handling as that in B38 is used here, except that more elements are included and are moved to the left and left-center, against the edges of the surface.

B40. STILL LIFE (WITH FLOWER POT AND VASES). c. summer 1911
Oil on canvas, 18 x 19⅝ in (45.7 x 49.8 cm)
Signed in pencil lower left: Bruce
Collection:
 William Kennedy, Marigot, St. Martin
Provenance:
 Artist
 Mrs. Helen Kibbey Bruce
 William Kennedy, c. 1960

The clay flower pots and intense light in this painting, as well as in B39 and B41, suggest a rural summer atmosphere, rather than the formal austerity of Bruce's apartment-atelier in Paris; thus a date of summer 1911, in Boussac, is indicated.

B41. STILL LIFE (WITH FLOWER POT AND BANANAS). c. summer 1911

Oil and charcoal on canvas, 18 x 21¼ in (45.7 x 54 cm)
Signed in pencil lower left: Bruce
Collection:
 Mr. and Mrs. Henry M. Reed, Montclair, N. J.
Provenance:
 Artist
 Mrs. Helen Kibbey Bruce
 B. F. Garber, c. 1960
 Mr. and Mrs. Henry M. Reed, c. 1968
Exhibition:
 Montclair Art Museum, Montclair, N. J. "Synchromism from the Henry M. Reed Collection." April 6–27, 1969. No. 1.

B42. ☐ STILL LIFE (WITH DISH OF FRUIT). 1911 (fall?)
Oil on canvas, 12½ x 16 in (31.8 x 40.6 cm)
Signed lower right: Bruce
Collection:
 B. F. Garber, Marigot, St. Martin
Provenance:
 Artist
 Mrs. Helen Kibbey Bruce
 B. F. Garber, c. 1960
Exhibitions:
 Armory of the Sixty-ninth Infantry, New York. "International Exhibition of Modern Art." February 17–March 15, 1913. No. 161.

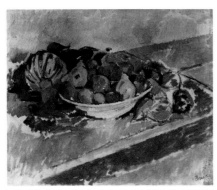

B43

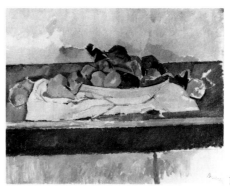

B44

Munson-Williams-Proctor Institute, Utica, N.Y. "1913
Armory Show: 50th Anniversary Exhibition, 1963."
February 17–March 31, 1963. No. 161.

From the date given on the entry blank for the Armory
show, we know the painting was done in 1911, the one
firm date we have for Bruce's work of this period. Unfortu-
nately, we do not know when in 1911 it was done;
however, given its density, an indication of Bruce's now
total absorption in Cézanne, the fall of 1911 is appropriate.
From this point until the early fall of 1912, Bruce was
striving to achieve a new fullness and richness in his
approach to Cézanne. The table and patterned background
indicate that the painting was done in Paris, in Bruce's
apartment-atelier.

B43. STILL LIFE (FRUITS AND VEGETABLES). c. fall 1911
Oil on canvas, 19½ x 24 in (49.5 x 61 cm)
Signed lower right: Bruce
Collection:
 Mr. and Mrs. Henry M. Reed, Montclair, N. J.
Provenance:
 Artist
 Mrs. Helen Kibbey Bruce
 William Kennedy, c. 1960
 Mr. and Mrs. Henry M. Reed, c. 1970
Exhibitions:
 Montclair Art Museum, Montclair, N. J. "American

Still Life in New Jersey Collections." October 25–
 December 13, 1970. No. 9.
Robert Schoelkopf Gallery, New York. "Four Ameri-
 cans." January 7–31, 1975. No. 1.
Literature:
 Hilton Kramer, "Art: Sensual, Serene Sculpture," The
 New York Times, January 25, 1975, mentioned p. 23.
 Judith Tannenbaum, "Four Americans," *Arts Magazine*
 vol. 49, no. 7 (March 1975), mentioned p. 10.
 Agee, "Bruce," illustrated p. 15, mentioned p. 17.

Although the painting has been dated c. 1910 (Agee,
"Bruce"), the intense study and refined handling of
Cézanne indicates c. fall 1911 is more accurate.

B44. STILL LIFE. c. fall 1911
Oil and charcoal on canvas, 18 x 23⅞ in (45.7 x 60.6 cm)
Signed in pencil lower right: Bruce
Collection:
 William Kennedy, Marigot, St. Martin
Provenance:
 Artist
 Mrs. Helen Kibbey Bruce
 William Kennedy, c. 1960
After experimenting with diagonal table planes in B42 and
B43, Bruce incorporates here and in B45 and B46 the
laterally extended frontal plane that he had first used in
B34. In this series Bruce strives for a painting that would

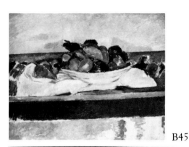 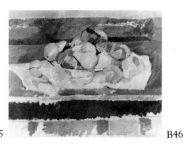 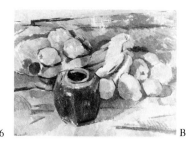 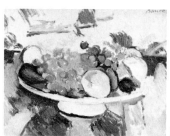

B45 B46 B47 B48

embody the monumentality of Cézanne's late still lifes. Specific prototypes for the motif of this and B45 and B46 can be found in Cézanne's *Assiette de pêches* (Venturi 743) and *Nature morte: assiette de poires* (Venturi 744), both of 1895–1900. Paintings B42 through B47 can also be grouped together through their common use of modulated lavenders, especially in the table and table front.

B45. STILL LIFE. c. fall 1911
Oil on canvas, 18 x 23¾ in (45.7 x 60.1 cm)
Signed in pencil lower right: Bruce
Collection:
 B. F. Garber, Marigot, St. Martin
Provenance:
 Artist
 Mrs. Helen Kibbey Bruce
 B. F. Garber, c. 1960
Working within the same format, Bruce here and in B46, as well as in B44, subtly varies the vantage point, color, and density of the paint surface.

B46. STILL LIFE. c. late 1911
Oil and charcoal on canvas, 19 x 23¾ in (48.2 x 60.3 cm)
Signed in pencil lower right: Bruce
Collection:
 B. F. Garber, Marigot, St. Martin
Provenance:
 Artist

 Mrs. Helen Kibbey Bruce
 B. F. Garber, c. 1960

B47. STILL LIFE (QUINCES, BANANAS, AND GINGER JAR).
 c. late 1911–early 1912
Oil on canvas, 18¼ x 24¼ in (46.4 x 61.6 cm)
Signed lower left: Bruce
Collection:
 Santa Barbara Museum of Art, Santa Barbara, Calif.,
 Donald Bear Memorial Collection. 63.37
Provenance:
 Artist
 Mrs. Helen Kibbey Bruce
 William Kennedy, c. 1960
 Santa Barbara Museum of Art, 1963
Exhibition:
 Montross Gallery, New York. November 21–December 9,
 1916.
Literature:
 Santa Barbara Museum of Art, *Donald Bear Memorial*
 Collection (Santa Barbara: Santa Barbara Museum
 of Art, 1964), no. 6.

Although the vantage point is closer, and the facture tighter, the painting is nevertheless related to B42–B46, a kinship reinforced by the variations of lavender hues.

B48. STILL LIFE (WITH COMPOTIER). c. late 1911–early 1912

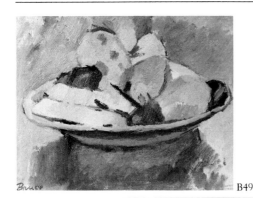
B49

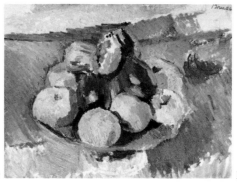
B50

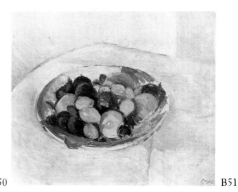
B51

Oil on canvas, 10⅝ x 13⅞ in (27 x 35.2 cm)
Signed upper right: Bruce
Collection:
 William Kennedy, Marigot, St. Martin
Provenance:
 Artist
 Mrs. Helen Kibbey Bruce
 William Kennedy, c. 1960

The painting is part of a series that extends through B55, in which Bruce explores a single plate of fruit, placed at differing viewpoints, while concentrating on achieving a fullness and amplitude of color and form.

B49. STILL LIFE (WITH PLATE OF FRUIT). c. late 1911–early 1912
 Oil on canvas, 10½ x 13½ in (26.7 x 34.3 cm)
 Signed lower left: Bruce
 Collection:
 William Kennedy, Marigot, St. Martin
 Provenance:
 Artist
 Mrs. Helen Kibbey Bruce
 William Kennedy, c. 1960

B50. STILL LIFE (WITH COMPOTIER). c. late 1911–early 1912
 Oil on canvas, 13⅝ x 18 in (34.6 x 45.7 cm)
 Signed upper right: Bruce
 Collection:

 B. F. Garber, Marigot, St. Martin
 Provenance:
 Artist
 Mrs. Helen Kibbey Bruce
 B. F. Garber, c. 1960

B51. STILL LIFE (WITH PLATE OF FRUIT). c. early 1912
 Oil on canvas, 15 x 18 in (38.1 x 45.7 cm)
 Signed lower right: Bruce
 Collection:
 William Kennedy, Marigot, St. Martin
 Provenance:
 Artist
 Mrs. Helen Kibbey Bruce
 William Kennedy, c. 1960
 Literature:
 Wolf, "Bruce," illustrated fig. 1, discussed p. 77.

B52. STILL LIFE (WITH PLATE OF FRUIT). c. early 1912
 Oil on canvas, 14½ x 17⅝ in (36.8 x 44.8 cm)
 Signed upper right: Bruce
 Collection:
 B. F. Garber, Marigot, St. Martin
 Provenance:
 Artist
 Mrs. Helen Kibbey Bruce
 B. F. Garber, c. 1960

B53. STILL LIFE (RED CHEEKED PEARS). c. spring 1912

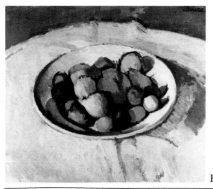

B52

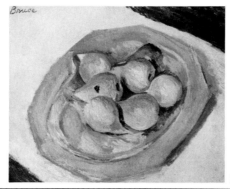

B53

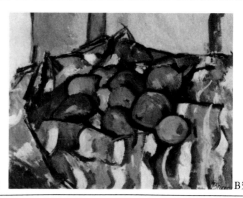

B54

Oil on canvas, 10¾ x 13⅞ in (27.3 x 35.2 cm)
Signed upper left: Bruce
Collection:
 B. F. Garber, Marigot, St. Martin
Label on stretcher:
 "Red Cheeked Pears"
 by P. H. Bruce
 Catalogue #5
Provenance:
 Artist
 Mrs. Helen Kibbey Bruce
 B. F. Garber, c. 1960
Exhibitions:
 Montross Gallery, New York. November 21–December
 9, 1916. No. 5.
 Agee, *Synchromism.* No. 3. Mentioned in catalogue p. 12.

The painting previously has been dated as 1908 (Agee,
Synchromism). However, the extraordinary irridescense of
the painting is far too accomplished to warrant the earlier
date. The drastic angle of the table and the almost bird's-
eye view of the plate can be traced ultimately to a Cézanne
of 1890–94, *Quatre Pêches sur une assiette* (Venturi 614),
and more immediately to paintings by Matisse such as *Still
Life in Venetian Red*, 1908 (Museum of Modern Western
Art, Moscow). Another parallel for the motif and angle of
the table is van Gogh's *Still Life with Apples in a Basket*
of 1887 (Rijksmuseum Kroller-Müller, Otterlo).

B54. STILL LIFE (PEARS ON BLUE AND WHITE CLOTH). c. late
 spring 1912
Oil on canvas, 13¾ x 17¾ in (34.9 x 45.1 cm)
Signed lower right: Bruce
Collection:
 Mrs. Shirley Barbee, Honolulu, Hawaii
Provenance:
 Artist
 Mrs. Helen Kibbey Bruce
 Stanley Barbee, 1959
 Mrs. Shirley Barbee, c. 1971

Here Bruce is specifically emulating the format and mood
of Cézanne's monumental still lifes of 1900–04, the one
extant work of the time to do so.

B55. STILL LIFE (FRUIT ON A CLOTH). c. late spring 1912
Oil on canvas, 12¾ x 16 in (32.4 x 40.6 cm)
Signed lower left: Bruce
Collection:
 Yale University Art Gallery, New Haven, Conn.,
 gift of Collection Société Anonyme. 1941.371
Provenance:
 Artist
 James Daugherty
 Société Anonyme, 1928
 Yale University Art Gallery, 1941
Exhibitions:

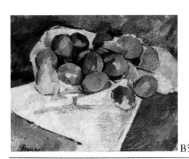

B55 B56 B57 B58

Yale University Art Gallery, New Haven, Conn. "Inaugural
Exhibition of the Collection Société Anonyme."
January 13–February 23, 1942.
Slater Memorial Museum, Norwich, Conn.
"Trends in 20th-Century American Painting."
November 8–29, 1953.
Centre National d'Art et de Culture Georges Pompidou,
Paris. "Paris-New York." June 1–September 19, 1977.
Illustrated p. 209.

Literature:
"Many Visitors See Modern Show in Converse,"
Norwich Bulletin, November 14, 1953.
Judson, *Bruce*, discussed pp. 13, 22, 25–26.
Kenneth H. Cook, "Patrick Henry Bruce," *News &
Record*, South Boston, Va. (October 31, 1974),
illustrated p. 1D.

Although the painting has come to be known as *Plums*, it
actually displays a mixture of fruit, much of which, as with
Cézanne, is not readily identifiable.

B56. STILL LIFE (FOLIAGE IN CLAY POTS). c. summer 1912
Charcoal on canvas, 19½ x 24 in (49.5 x 61 cm)
Collection:
B. F. Garber, Marigot, St. Martin
Provenance:
Artist
Mrs. Helen Kibbey Bruce

B. F. Garber, c. 1960

After 1905, Bruce apparently did not draw, with this one
exception. It inaugurates the following series of foliage
paintings, all done in the summer of 1912 at Belle-Île-en-
Mer, an island off the Brittany coast, where the Bruces also
spent the summers of 1913 and 1914.

B57. STILL LIFE (FLOWERS IN CLAY VASE). c. summer 1912
Oil on canvas, 17½ x 14¾ in (44.5 x 37 cm)
Collection:
Roy Bruce, Oxnard, Calif.
Provenance:
Artist
Mrs. Helen Kibbey Bruce
Roy Bruce

Prototypes for the painting are found in Cézanne's *Les
Petunias* and *Pot de fleurs*, both of 1875–76 (Venturi 198
and 199). These works should be considered as extensions
of Bruce's flower paintings of c. late 1909–c. late 1911
(B7–B20), although the format and handling are quite
different.

B58. STILL LIFE (FLOWERS IN VASE). c. summer 1912
Oil and charcoal on canvas, 19½ x 23⅝ in (49.5 x 60 cm)
Signed lower right: Bruce
Collection:
William Kennedy, Marigot, St. Martin
Provenance:

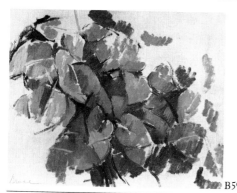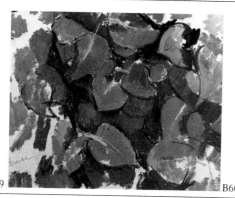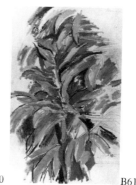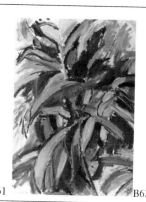

B59 B60 B61 B62

Artist
Mrs. Helen Kibbey Bruce
William Kennedy, c. 1960

B59. LEAVES. c. summer 1912
Oil on canvas, 13 x 17⅛ in (33 x 43.5 cm)
Signed lower left: Bruce
Collection:
William Kennedy, Marigot, St. Martin
Provenance:
Artist
Mrs. Helen Kibbey Bruce
William Kennedy, c. 1960

As was his habit throughout his life, Bruce intensely observed, and painted, his immediate surroundings. The "foliage" paintings and two extant landscapes (B66, B67) from the summer of 1912 are no exception. From a photograph we know the house was surrounded by heavy foliage, and in a letter of 1912 from Belle-Île (month and day uncertain) to Gertrude Stein, Helen Bruce mentioned "great bushes of geraniums—almost to my shoulders."*

B60. LEAVES. c. summer 1912
Oil on canvas, 10½ x 13¾ in (26.7 x 34.9 cm)

Signed lower left: Bruce
Collection:
B. F. Garber, Marigot, St. Martin
Provenance:
Artist
Mrs. Helen Kibbey Bruce
B. F. Garber, c. 1960
Literature:
Wolf, "Bruce," illustrated fig. 5, discussed p. 79

A specific prototype for this and the other foliage pictures of this time, in addition to Cézanne's later watercolors, is a small Cézanne, *Fruits et feuillages* of 1890–94 (Venturi 613), which was owned by Matisse.

B61. LEAVES. c. summer 1912
Oil and charcoal on canvas, 20¼ x 13⅛ in (51.4 x 33.3 cm)
Signed in pencil upper right: Bruce
Collection:
B. F. Garber, Marigot, St. Martin
Provenance:
Artist
Mrs. Helen Kibbey Bruce
B. F. Garber, c. 1960

B62. LEAVES. c. summer 1912
Oil on canvas, 18¼ x 14¼ in (46.4 x 36.2 cm)
Signed lower left: Bruce
Collection:

*Collection of American Literature, Beinecke Manuscript and Rare Book Library, Yale University.

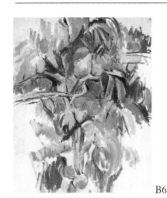

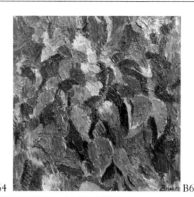

B63 B64 B65 B66

B. F. Garber, Marigot, St. Martin
Provenance:
 Artist
 Mrs. Helen Kibbey Bruce
 B. F. Garber, c. 1960
Exhibition:
 Whitney Museum of American Art, New York. "The
 Decade of the Armory Show: New Directions in
 American Art, 1910–1920." February 27–April 14,
 1963. By Lloyd Goodrich. No. 6.

B63. Leaves. c. summer 1912
 Oil on canvas, 16 x 13 in (40.6 x 33 cm)
Collection:
 William Kennedy, Marigot, St. Martin
Provenance:
 Artist
 Mrs. Helen Kibbey Bruce
 William Kennedy, c. 1960
The accent created by the red-lavender flower at top center
serves much the same effect as in B64, and thus the painting
can be seen as a final "preparation" for that masterful work.

B64. ☐ Leaves. c. summer 1912
 Oil on canvas, 21½ x 17¼ in (54.6 x 43.8 cm)
 Signed on back of canvas: Bruce
Collection:
 William Kennedy, Marigot, St. Martin

Provenance:
 Artist
 Mrs. Helen Kibbey Bruce
 William Kennedy, c. 1960

B65. Leaves. c. summer 1912
 Oil on canvas, 12¼ x 12¼ in (31.1 x 31.1 cm)
 Signed lower right: Bruce
Collection:
 B. F. Garber, Marigot, St. Martin
Label on stretcher:
 "Leaves"
 by P. H. Bruce
 Catalogue #27
Provenance:
 Artist
 Mrs. Helen Kibbey Bruce
 B. F. Garber, c. 1960
Exhibition:
 Montross Gallery, New York. November 21–December
 9, 1916. No. 27.
Literature:
 Agee, "Bruce," illustrated p. 16, discussed p. 17.
An earlier date of c. 1910–11 (Agee, "Bruce") must be
revised to c. summer 1912, as given here.

B66. Wood Interior. c. summer 1912
 Oil on canvas, 17½ x 21⅜ in (44.5 x 54.3 cm)

B67

B68

Signed lower right: Bruce
Collection:
 William Kennedy, Marigot, St. Martin
Label on stretcher:
 "Wood Interior"
 by P. H. Bruce
 Catalogue #2
Provenance:
 Artist
 Mrs. Helen Kibbey Bruce
 William Kennedy, c. 1960
Exhibition:
 Montross Gallery, New York. November 21–December
 9, 1916. No. 2.

The setting for this and B67 fits Helen Bruce's description
of their house on Belle-Île, ". . . on the side of the garden
a perfect park of wonderful trees."*

B67. LANDSCAPE. c. summer 1912
 Oil on canvas. 25⅝ x 18⅛ in (65.1 x 46 cm)
 Signed lower left: Bruce
 Collection:
 William Kennedy, Marigot, St. Martin
 Label on stretcher:
 "Landscape"

────────────
*Letter to Gertrude Stein, op. cit.

by P. H. Bruce
Catalogue #30
Provenance:
 Artist
 Mrs. Helen Kibbey Bruce
 William Kennedy, c. 1960
Exhibition:
 Montross Gallery, New York. November 21–December
 9, 1916. No. 30.

B68. GREEN JUG. c. early fall 1912
 Oil on canvas, 10⅝ x 8⅝ in (27 x 21.9 cm)
 Signed lower right: Bruce
 Collection:
 William Kennedy, Marigot, St. Martin
 Label on stretcher:
 "Green Jug"
 by . . . H. Bruce
 . . . #10
 Provenance:
 Artist
 Mrs. Helen Kibbey Bruce
 William Kennedy, c. 1960
 Exhibition:
 Montross Gallery, New York. November 21–December
 9, 1916. No. 10.

The painting is difficult to date, but the heavy impasto and

B69

B70a, B70b, B70c

tightly knit facture correspond to B71, B72, and B73, thus indicating the date given here. Support for the date is also lent by the myriad gradations of dark and pastel greens in the upper portion of the jug and of lavenders and light blue-purples in the table, the mark of an artist who at this time was mastering color usage.

B69.☐ STILL LIFE (WITH FLOWERS). c. early fall 1912
Oil on panel. 7⅜ x 9½ in (18.7 x 24.1 cm)
Signed upper left: Bruce
Collection:
　B. F. Garber, Marigot, St. Martin
Provenance:
　Artist
　Mrs. Helen Kibbey Bruce
　B. F. Garber, c. 1960
Exhibition:
　Agee, *Synchromism*. No. 4. Mentioned in catalogue
　　p. 16.

A previous date of 1908–09 (Agee, *Synchromism*) is far too early; that date was assigned primarily because of the painting's seeming naiveté. On the contrary, closer study reveals that it is a highly sophisticated color study of pure and gradated hues that are juxtaposed and interwoven like a tapestry, and in fact the central area of flowers could almost be a study for a detail in the background of Bruce's culminating *Still Life (with Tapestry)* (B73).

B70a, B70b, B70c

In this detail of a photograph of Bruce's apartment-atelier at 6, rue de Furstenberg, taken about 1917–18, there are five still lifes hanging on the wall. The two on the far right are extant: *Flowers* (B9), c. early–mid 1910, and *Still Life (with Ecorché)* (B34), c. mid–1911. The other three are lost and are presumed destroyed; they are herein summarized insofar as they can be. The titles are not known and those assigned here are descriptive.

B70a (third in from right, on top): *Still Life (Fruit and Vegetable on Table).* This may well be the painting owned by Arthur B. Davies and sold in 1929 after his death (see "Exhibitions," p. 147). In the catalogue of the Davies sale the painting was described as follows: "*Peppers and Fruit.* Portrayed on a modeling stand are brilliantly colored peppers, bananas, plums, and other fruit. 9½ x 16"."

Based on its size relative to *Flowers* on the right, which measures 22⅞ x 18 inches, the dimensions are in accord with those given in the sale's catalogue. The description of the array of fruits and vegetables is accurate, as is the mention of a "modeling stand," as distinct from a table. The "brilliant" colors in the description suggest Matisse and fauvism, and the "modeling stand" hints at Matisse's sculpture class. A date of c. 1910–11 might thus be appropriate.

B70b (third in from right, on bottom): *Still Life (with Compotier).* Of particular importance is the placement of the

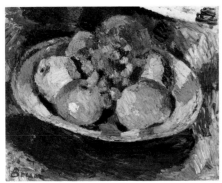

B71

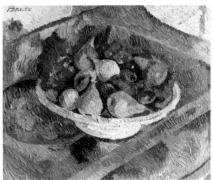

B72

table and still life against, and interwoven with, a tapestry immediately behind it. As such, the painting can be considered a prototype for Bruce's culminating *Still Life (with Compotier)*, c. fall 1912 (B73).

The pattern of the tapestry in the lost painting closely corresponds to sections in the actual tapestry at the far left of the photograph, which we know was the model for the c. 1912 *Still Life (with Tapestry)* (B73). The photograph is difficult to read, but the paint handling in the lost work appears to be looser and more open than the final painting and thus probably did not immediately precede it. On this basis, a date of c. late 1911–early 1912 may be appropriate.

B70c (far left): *Still Life (with Compotier)*. The painting is related to similar motifs of a single plate of fruit found in B71 and B72; especially important is the singularly drastic tilt of the plate and table, which forms a kinship with *Still Life (Red Cheeked Pears)* (B53) as well. Since all three of these works appear to date from the spring to early fall of 1912, this painting can be assigned to the same period.

B71. STILL LIFE (PLATE OF FRUIT). c. early fall 1912
Oil on canvas, 10⅝ x 13¾ in (27 x 35 cm)
Signed lower left: Bruce
Collection:
 Mr. and Mrs. Henry M. Reed, Montclair, N. J.
Provenance:
 Artist
 Mrs. Helen Kibbey Bruce

B. F. Garber, c. 1960
Mr. and Mrs. Henry M. Reed, c. 1968
Exhibitions:
 Montclair Art Museum, Montclair, N. J. "Synchromism
 from the Henry M. Reed Collection." April 6–27,
 1969. No. 3.
 Montclair Art Museum, Montclair, N. J. "American
 Still Life in New Jersey Collections." October 25–
 December 13, 1970. No. 6.
 Levin, *Synchromism.* Illustrated fig. 130, mentioned. p. 39

An earlier date of c.1911 (Levin, *Synchromism*) is here revised, in keeping with the heavy paint surface and intense color.

B72. STILL LIFE (WITH COMPOTIER). c. early fall 1912
Oil on canvas. 13 x 17 in (33 x 43.2 cm)
Signed upper left: Bruce
Collection:
 Mr. and Mrs. Charles M. Daugherty, Weston,
 Conn.
Provenance:
 Artist
 Arthur Burdett Frost, Jr.
 James Daugherty, c. 1917
 Mr. and Mrs. Charles Daugherty, 1973

The motif of the plate on a table, jutting out at a sharp angle to the wall, recalls Cézanne's *Le Plat de pommes,* c. 1877 (Venturi 210), as does the density of stroke, touch, and color.

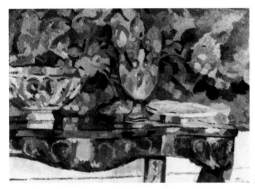

B73

B73. □ STILL LIFE (WITH TAPESTRY). c. fall 1912
Oil on canvas, 19½ x 28 in (49.5 x 71.1 cm)
Signed lower right: Bruce
Collection:
Mr. and Mrs. Henry M. Reed, Montclair, N. J.

Provenance:
Artist
Mrs. Helen Kibbey Bruce
B. F. Garber, c. 1960
Mr. and Mrs. Henry M. Reed, c. 1969

Exhibitions:
Montross Gallery, New York. November 21–December 9, 1916.
Agee, *Synchromism.* No. 6. Illustrated in catalogue plate I, mentioned p. 20.
"Synchromism and Related American Color Painting, 1910–1930." Circulated by The Museum of Modern Art. February 4, 1967–June 17, 1968. Organized by William C. Agee. No. 3.
Montclair Art Museum, Montclair, N. J. "Synchromism from the Henry M. Reed Collection." April 6–27, 1969. No. 5.
Montclair Art Museum, Montclair, N. J. "American Still Life in New Jersey Collections." October 25–December 13, 1970. No. 10.
Robert Schoelkopf Gallery, New York. "Four Americans." January 7–31, 1975. No. 2.

Centre National d'Art et de Culture Georges Pompidou, Paris. "Paris–New York." June 1–September 19, 1977. Illustrated p. 218.
Levin, *Synchromism.* Illustrated in catalogue fig. 131, discussed p. 39.

Literature:
Judson, *Bruce,* mentioned p. 34.
Wolf, "Bruce", illustrated fig. 3, discussed p. 78.
Hilton Kramer, "Art: Sensual, Serene Sculpture," The New York *Times,* January 25, 1975, mentioned p. 23.
Agee, "Bruce," illustrated p. 16, discussed p. 17.

Dates of 1911–12 (Agee, *Synchromism* and Levin, *Synchromism*) and c. 1911–12 (Agee, "Bruce") can now be revised to read as 1912, and probably the fall. It is Bruce's most ambitious and concluding still life and shows the first influences of the Delaunays. As such, it leads to Bruce's first abstract paintings of c. late 1912–early 1913.

SECTION B. LOST PAINTINGS
(Titles are given as listed in catalogues. No photographs known to exist)

POMMIER (purchased from the artist by Maurice Feldmann, a German dealer in Berlin, by 1912).
Exhibited Salon d'Automne, 1912.
FRUITS (purchased from the artist by Maurice Feldmann by 1912).

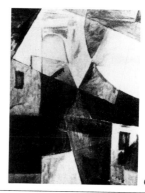

C1

Exhibited Salon d'Automne, Paris, 1912.

NATURE MORTE. Oil, 1910 (owned by Maurice Feldmann). Possibly no. 1 or no. 2, as listed above.
Exhibited Armory Show, New York, 1913. no. 160.

STILL LIFE. c. 1911. Purchased from the artist by Mrs. A. B. Frost, mother of A. B. Frost, Jr., Bruce's close friend. Referred to in letter from A. B. Frost, Jr., to his father, date uncertain. Letter in collection of Mr. and Mrs. Henry M. Reed, Montclair, N.J.

Five paintings owned by Arthur B. Davies. Sold in April, 1929, at the American Art Association, New York. Described in catalogue of the sale as follows:

62. PEPPERS AND FRUIT
Portrayed on a modeling stand are brilliantly colored peppers, bananas, plums, and other fruit.
9½ x 16 in [Perhaps B70a]

69. FRUIT
A bowl of fruit with brilliant bloom.
Signed at lower right: Bruce
13 x 16 in

394. BOWL OF FRUIT
A bowl heaped with brilliantly colored fruits, standing upon a shaded mauve fabric.
Signed at lower left: Bruce
13 x 16 in

421. NATURE MORTE
A bowl of fruit and a faience ewer depicted in brilliant colors.

Signed at lower right: Bruce
21½ x 18 in

423. BOOKS AND FRUIT
A table with a compotier heaped with bananas and other fruit, and two books nearby.
Signed at lower right: Bruce
18 x 24 in
From the Ferargil Gallery, New York.

STILL LIFE. c. 1911–12. Given to McAllister College, St. Paul, Minnesota, c. 1961, by B. F. Garber. McAllister is unable to locate the painting.

SECTION C

C1. LANDSCAPE. late 1912–early 1913
Dimensions unknown
Whereabouts unknown; presumed destroyed

Exhibitions:
Salon des Indépendants, Paris. March 19–May 18, 1913.
Der Sturm, Berlin. "Erster Deutscher Herbstsalon." September 30–December 1, 1913. Catalogue foreword by Herwarth Walden. Illustrated.

Literature:
Judson, *Bruce*, discussed pp. 39–40, 42.
Donald E. Gordon, *Modern Art Exhibitions, 1900–1916: Selected Catalogue Documentation* (Munich: Prestel, 1974), illustrated vol. 1, p. 269.

C2

C3

Agee, "Bruce," illustrated p. 18, discussed pp. 17, 19.
Levin, *Synchromism*, illustrated p. 40, mentioned p. 39.

Although previously dated c. mid–1912 (Agee, *Synchromism*, p. 20), 1913 (Agee, "Bruce"), and c. 1913 (Levin, *Synchromism*), a firm date of late 1912–early 1913 can now be established. This and C2, C3, and C4, were probably among the paintings later destroyed by Bruce. At least one other painting of the same title and date is known to have been done.

C2. COMPOSITION. 1913
Dimensions unknown
Whereabouts unknown; presumed destroyed
Exhibition:
 Salon d'Automne, Paris. November 15, 1913–
 January 5, 1914.
 Manes Society, Prague. February–March 1914.
Literature:
 Guillaume Apollinaire, "A travers le Salon d'Automne,"
 L'Intransigéant, November 19, 1913, discussed p. 2.
 Reprinted in translation in *Apollinaire on Art: Essays
 and Reviews 1902–1918* (New York: Viking, 1972),
 p. 329.
 Guillaume Apollinaire, "Le Salon d'Automne," *Les
 Soirées de Paris*, no. 19 (December 15, 1913),
 illustrated p. 48.
 Agee, *Synchromism*, discussed p. 20.

Judson, *Bruce*, discussed pp. 40–42.
Agee, "Bruce," discussed pp. 19–20.
Centre National d'Art et de Culture Georges Pompidou,
 Paris. *Paris–New York*. (Paris: Musée National d'Art
 Moderne, 1977), illustrated p. 304, mentioned p. 301.
Levin, *Synchromism*, illustrated p. 40, discussed p. 39.

It is another terrible irony of Bruce's life that these four paintings—C1, C2, C3, C4—all destroyed by the artist, are among the few that can be securely dated. The *Composition* is clearly 1913, not c. 1913 (Levin, *Synchromism*), since stylistically it follows *Landscape* and was both exhibited and published that fall.

C3. LE BAL BULLIER. c. mid- to late 1913–early 1914
Dimensions unknown
Whereabouts unknown; presumed destroyed
Literature:
 Comoedia, June 2, 1914. Illustrated.
 Agee, *Synchromism*, mentioned p. 20.
 Judson, *Bruce*, mentioned p. 42.
 Agee, "Bruce," discussed p. 19.
 Centre National d'Art et de Culture Georges Pompidou,
 Paris. *Paris–New York*. (Paris: Musée National d'Art
 Moderne, 1977), illustrated p. 304, mentioned p. 302.
 Levin, *Synchromism*, illustrated and mentioned p. 42.

Although a firm date of 1914 has been given (Agee, "Bruce," and Levin, *Synchromism*), the painting could well have

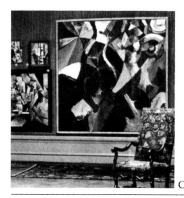

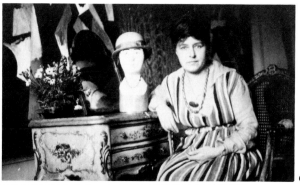

C4

C5

C5

been started in 1913. However, the *terminus post quem* is late spring 1914.

C4. MOUVEMENT, COULEUR, L'ESPACE: SIMULTANÉ.
late 1913–14
Dimensions unknown
Whereabouts unknown; presumed destroyed
Exhibitions:
Salon des Indépendants, Paris. March 1–April 30, 1914. No. 502.
Galerie Georges Giroux, Brussels. "Salon des Artistes Indépendants de Paris." May 16–June 7. No. 33.
Literature:
Montjoie!, vol. 2, no. 3 (March 1914), illustrated on its side p. 22.
Guillaume Apollinaire, "Au Salon des Indépendants," *L'Intransigéant*, March 5, 1914, mentioned p. 2. Reprinted in translation in *Apollinaire on Art: Essays and Reviews 1902–1918* (New York: Viking, 1972), p. 359.
Guillaume Apollinaire, "Le 30ᵉ Salon des Indépendants," *Les Soirées de Paris*, March 15, 1914, mentioned p. 185. Reprinted in translation in *Apollinaire on Art: Essays and Reviews 1902–1918* (New York: Viking, 1972), p. 366.
Agee, *Synchromism*, discussed p. 23.
Judson, *Bruce*, discussed pp. 41–42.

Donald H. Karshan, *Archipenko: the Sculpture and Graphic Art* (Tubingen: Wasmuth, 1974), illustrated p. 10.
Agee, "Bruce," discussed p. 19.
Centre National d'Art et de Culture Georges Pompidou. Paris. *Paris–New York*. (Paris: Musée National d'Art Moderne, 1977), illustrated p. 304, mentioned p. 302.
Levin, *Synchromism*, illustrated and discussed p. 41.
Barbara Rose, "Synchromism: the Balance Sheet," *Arts Magazine*, vol. 52, no. 7 (March 1978), illustrated p. 105.

A date of 1914 has been used previously (Agee, "Bruce"), but given the size and ambition of the painting and the fact that it was exhibited in March 1914, it was almost certainly begun in late 1913.

C5. COMPOSITION A. c. late 1914–15
Dimensions unknown
Whereabouts unknown; presumed destroyed

The only record we have of this and C6 are from the background of three photographs of Helen and Roy Bruce. We do not know what titles these paintings actually carried, but we are assigning them the titles of *Composition A* and *Composition B* for purposes of clarity and continuity in the discussion of this period in Bruce's career.

However, *Composition A* does not properly belong to the series of 1916 (C7–C12) that we know were entitled by that

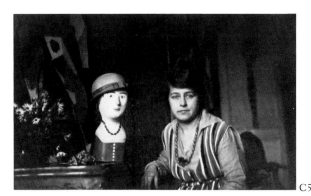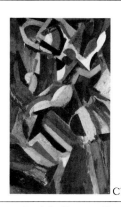

C5 C6 C7

name. It is most likely one of a group of paintings that Helen Bruce termed as the "stovepipe" paintings and which she remembered as consisting of hooked and angular forms,* precisely the kind of shapes that are apparent in the photographs. She later recalled that they were done in 1913,† but since they are a clear departure from the purely Orphic work such as *Mouvement, couleur, l'espace: Simultané* that had culminated in the spring of 1914, the painting must date from mid-or late 1914 into 1915.

C6. COMPOSITION B. c. 1915
Dimensions unknown
Whereabouts unknown; presumed destroyed

The painting can be taken as the true beginning of the Compositions, and was probably done sometime in 1915, although a date of c. 1915–16 is also possible. The downward movement of the forms is a prototype for the format of *Composition III*.

C7.□ COMPOSITION III. 1916
Oil on canvas, 63¼ x 38 in (160.6 x 96.5 cm)
Signed lower right: Bruce
Collection:
 Yale University Art Gallery, New Haven, Conn.,

*In conversation with B. F. Garber, c. 1958–60.
†Handwritten notes to B. F. Garber, c. 1959.

gift of Collection Société Anonyme. 1941. 370
Provenance:
 Artist
 Arthur Burdett Frost, Jr. in New York, late 1916 or early 1917
 Katherine S. Dreier
 Purchased by Katherine S. Dreier for the Société Anonyme, 1928
 Yale University Art Gallery, 1941

Exhibitions:
 Modern Gallery, New York. March 12–28, 1917.
 Probably Galleries of the Société Anonyme, New York. April 30–June 15, 1920.
 Probably Galleries of the Société Anonyme, New York. June 17–August 1, 1920.
 Perhaps Worcester Art Museum, Worcester, Mass. "Société Anonyme." November 3–December 5, 1921.
 Perhaps MacDowell Club, New York. "Société Anonyme." April 24–May 8, 1922.
 Perhaps Vassar College, Poughkeepsie, N.Y. "Société Anonyme." April 4–May 12, 1923.
 Yale University Art Gallery, New Haven, Conn. "Inaugural Exhibition of the Collection Société Anonyme." January 13–February 23, 1942.
 Agee, "Synchromism." No. 9. Illustrated in catalogue, plate 2.
 National Collection of Fine Arts, Washington, D.C.

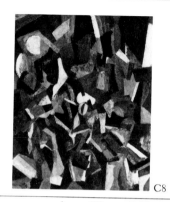

C8

"Roots of Abstract Art in America, 1910–30." December 2, 1965–January 9, 1966. Catalogue by Adelyn Breeskin. No. 11. Illustrated on cover.

"Synchromism and Related American Color Painting, 1910–30." Circulated by The Museum of Modern Art. February 4, 1967–June 17, 1968. Organized by William C. Agee. No. 5.

"The Modern Spirit: American Painting, 1908–35." Organized and circulated by the Arts Council of Great Britain. August 20–November 20, 1977. Catalogue by Milton W. Brown. No. 64. Illustrated p. 46.

Levin, *Synchromism*. Illustrated plate 28, mentioned p. 42.

Literature:

H. H. Arnason, *History of Modern Art: Painting, Sculpture, Architecture* (New York: Abrams, 1968), illustrated p. 419, mentioned p. 413.

Judson, *Bruce*, discussed pp. 43–44.

Wolf, "Bruce," mentioned p. 80.

Sam Hunter, *American Art of the 20th Century* (New York: Abrams, 1972), illustrated p. 112.

Kenneth H. Cook, "Patrick Henry Bruce," *News & Record*, South Boston, Va. October 31, 1974, illustrated p. 2D.

Kenneth H. Cook, "Bruce: One of Greatest of Early Modern Painters," *News & Record*, South Boston, Va., May 13, 1976, illustrated p. 2B.

Agee, "Bruce," illustrated on cover, discussed pp. 19–20, 22, 25.

" 'AIV' Features 'Pat' Bruce," *News & Record*, South Boston, Va., June 23, 1977, mentioned p. 2.

Konstantin Bazarov, "The Modern Spirit," *Art and Artists*, vol. 12 (December 1977), illustrated p. 10.

Compositions I-V were numbered by the order in which they were purchased by Katherine Dreier, not the order in which they were painted. *Composition VI* (C8), now in the collection of The Museum of Fine Arts, Houston, was traded by Miss Dreier to James Daugherty, and the number has been assigned by the authors.

The date of 1916 for the six paintings is fairly certain since we know they were sent to Frost in New York in late 1916 or very early 1917, in time for him to arrange the exhibition held at the Modern Gallery in March, 1917. However, the first one or two of these paintings may have been started in late 1915. With the exception of the lost *Composition B*, we do not know if Bruce did any other Compositions.

C8.☐ COMPOSITION VI. 1916

Oil on canvas, 64¼ x 51¼ in (163.2 x 130.2 cm)

The Museum of Fine Arts, Houston, Agnes Cullen Arnold Endowment Fund. 79.69

Provenance:

Artist

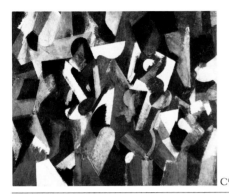

C9

Arthur Burdett Frost, Jr. in New York, late 1916 or early
 1917
Katherine S. Dreier, 1918
James Daugherty, c. 1922–23
B. F. Garber
The Museum of Fine Arts, Houston, 1979
Exhibitions:
 Modern Gallery, New York. March 12–28, 1917.
 Probably Galleries of the Société Anonyme, New York.
 April 30–June 15, 1920.
 Probably Galleries of the Société Anonyme, N.Y.
 June 17–August 1, 1920.
 Perhaps Worcester Art Museum, Worcester, Mass.
 "Société Anonyme." November 3–December 5, 1921.
 Perhaps MacDowell Club, New York. "Société
 Anonyme." April 24–May 8, 1922.
 Perhaps Vassar College, Poughkeepsie, N.Y.
 "Société Anonyme." April 4–May 12, 1923.
Literature:
 Judson, *Bruce*, mentioned p. 48 and footnote no. 51.
 Agee, "Bruce," footnote no. 39.

C9. □ COMPOSITION V. 1916
 Oil on canvas, 51⅜ x 63⅝ in (130.5 x 161.6 cm)
 Signed lower left: Bruce
Collection:
 Yale University Art Gallery, New Haven, Conn., gift of
 Collection Société Anonyme. 1941. 373

Provenance:
 Artist
 Arthur Burdett Frost, Jr. in New York, late 1916 or
 early 1917
 Katherine S. Dreier
 Purchased by Katherine S. Dreier for the Société
 Anonyme, 1928
 Yale University Art Gallery, 1941

Exhibitions:
 Modern Gallery, New York. March 12–28, 1917.
 Probably Galleries of the Société Anonyme, New York.
 April 30–June 15, 1920.
 Probably Galleries of the Société Anonyme, New York.
 June 17–August 1, 1920.
 Perhaps Worcester Art Museum, Worcester, Mass.
 "Société Anonyme." November 3–December 5, 1921.
 Perhaps MacDowell Club, New York. "Société
 Anonyme." April 24–May 8, 1922.
 Perhaps Vassar College, Poughkeepsie, N.Y.
 "Société Anonyme." April 4–May 12, 1923.
 Yale University Art Gallery, New Haven, Conn.
 "Inaugural Exhibition of the Collection Société
 Anonyme." January 13–February 23, 1942.
 Agee, *Synchromism.* No. 11.
 "Synchromism and Related American Color Painting,
 1910–1930." Circulated by The Museum of Modern Art.
 February 4, 1967–June 17, 1968. Organized by

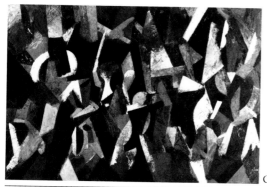

C10

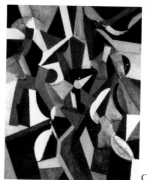

C11

William C. Agee. No. 6.
Levin, *Synchromism*. Illustrated in catalogue fig. 132.
Literature:
 Wolf, "Bruce," mentioned p. 80.
 Agee, "Bruce," discussed pp. 19–20.

C10.☐ COMPOSITION IV. 1916
 Oil an canvas, 50¾ x 76½ in (128.9 x 194.3 cm)
 Collection:
 Yale University Art Gallery, New Haven, Conn., gift of
 Collection Société Anonyme. 1941.372
 Provenance:
 Artist
 Arthur Burdett Frost, Jr. in New York, late 1916 or
 early 1917
 Katherine S. Dreier
 Purchased by Katherine S. Dreier for the Société
 Anonyme, 1928
 Yale University Art Gallery, 1941
 Exhibitions:
 Modern Gallery, New York. March 12–28, 1917.
 Grand Central Palace, New York. "First Annual Exhibi-
 tion of the Society of Independent Artists." April 10–
 May 6, 1917. No. 211. Illustrated.
 Probably Galleries of the Société Anonyme, New York.
 April 30–June 15, 1920.
 Probably Galleries of the Société Anonyme, New York.
 June 17–August 1, 1920.

Perhaps Worcester Art Museum, Worcester, Mass.
 "Société Anonyme." November 3–December 5, 1921.
Perhaps MacDowell Club, New York. "Société
 Anonyme." April 24–May 8, 1922.
Perhaps Vassar College, Poughkeepsie, N. Y.
 "Société Anonyme." April 4–May 12, 1923.
Yale University Art Gallery, New Haven, Conn.
 "Inaugural Exhibition of the Collection Société
 Anonyme." January 13–February 23, 1942.
Agee, *Synchromism*. No. 10
Literature:
 Wolf, "Bruce," illustrated fig. 6, discussed p. 80.
 Agee, "Bruce," discussed pp. 19-20.

C11.☐ COMPOSITION I. 1916
 Oil on canvas, 45½ x 34¾ in (115.6 x 88.3 cm)
 Signed lower right: Bruce
 Collection:
 Yale University Art Gallery, New Haven, Conn., gift of
 Collection Société Anonyme. 1941.368
 Provenance:
 Artist
 Arthur Burdett Frost, Jr. in New York, late 1916 or
 early 1917
 Katherine S. Dreier, 1918
 Société Anonyme
 Yale University Art Gallery, 1941
 Exhibitions:

C12

Modern Gallery, New York. March 12–28, 1917.
Probably Galleries of the Société Anonyme, New York.
 April 30–June 15, 1920.
Probably Galleries of the Société Anonyme, New York.
 June 17–August 1, 1920.
Perhaps Worcester Art Museum, Worcester, Mass.
 "Société Anonyme." November 3–December 5, 1921.
Perhaps MacDowell Club, New York. "Société
 Anonyme." April 24–May 8, 1922.
Perhaps Vassar College, Poughkeepsie, N.Y.
 "Société Anonyme." April 4–May 12, 1923.
Yale University Art Gallery, New Haven, Conn.
 "Inaugural Exhibition of the Collection Société
 Anonyme." January 13–February 23, 1942.
Agee, *Synchromism*. No. 7.
Fogg Art Museum, Cambridge, Mass. "Paintings,
 Drawings, and Sculpture from the Yale University Art
 Gallery." October 5–November 14, 1967.
Fine Arts Gallery of San Diego, San Diego, Calif. "Color
 and Form, 1909–1914." November 20, 1971–
 January 2, 1972. Catalogue by Henry G. Gardiner.
 No. 4. Illustrated p. 47.
Centre National d'Art et de Culture Georges Pompidou,
 Paris. "Paris-New York." June 1–September 19, 1977.
 Illustrated upside down p. 305, mentioned p. 302.
Levin, *Synchromism*. Illustrated in catalogue plate 27,
 mentioned p. 42.

Literature:
 Société Anonyme, Inc. Museum of Modern Art. *Report,
 1920–1921* (New York: Société Anonyme, 1921;
 reprinted by Arno Press, 1972), illustrated p. 50.
 Katherine S. Dreier, *Western Art and the New Era*
 (New York: Brentano's, 1923), illustrated p. 96,
 discussed p. 95.
 Lloyd Goodrich, *Pioneers of Modern Art in America: the
 Decade of the Armory Show, 1910–1920.* (New York:
 Praeger for the Whitney Museum of American Art,
 1963), illustrated p. 85.
 Judson, *Bruce*, mentioned pp. 43, 48-49.
 Wolf, "Bruce," illustrated on its side fig. 7, discussed
 pp. 80-81.
 Agee, "Bruce," discussed pp. 19-20, 25.
 Barbara Rose, "Synchromism: the Balance Sheet," *Arts
 Magazine*, vol. 52, no. 7 (March 1978), illustrated
 on cover.

C12. ☐ COMPOSITION *II*, 1916
 Oil on canvas, 38¼ x 51 in (97.2 x 129.5 cm)
 Signed lower right: Bruce
 Collection:
 Yale University Art Gallery, New Haven, Conn., gift of
 Collection Société Anonyme c. 1941. 369
 Provenance:
 Artist
 Arthur Burdett Frost, Jr., in New York, late 1916 or early 1917

Katherine S. Dreier, 1918
Société Anonyme
Yale University Art Gallery, 1941

Exhibitions:

Modern Gallery, New York. March 12–28, 1917.

Probably Galleries of the Société Anonyme, New York. April 30–June 15, 1920.

Probably Galleries of the Société Anonyme, New York. June 17–August 1, 1920.

Perhaps Worcester Art Museum, Worcester, Mass. "Société Anonyme." November 3–December 5, 1921.

Perhaps MacDowell Club, New York. "Société Anonyme." April 24–May 8, 1922.

Perhaps Vassar College, Poughkeepsie, N. Y. "Société Anonyme." April 4–May 12, 1923.

Yale University Art Gallery, New Haven, Conn. "Inaugural Exhibition of the Collection Société Anonyme." January 13–February 23, 1942.

The Museum of Modern Art, New York. "Abstract Painting and Sculpture in America." January 23–March 25, 1951. By Andrew Carnduff Ritchie. No. 5. Illustrated p. 53.

Walker Art Center, Minneapolis. "The Classic Tradition in Contemporary Art." April 24–June 28, 1953. No. 11.

Wadsworth Atheneum, Hartford, Conn. "Twentieth Century Painting from Three Cities: New York, New Haven, Hartford." October 19–December 4, 1955.

No. 8. Illustrated plate 5.

Galerie Chalette, New York. "Construction and Geometry in Painting from Malevitch to 'Tomorrow'" March 31–June 4, 1960. No. 19. Illustrated.

Whitney Museum of American Art, New York. "The Decade of the Armory Show: New Directions in American Art, 1910–1920." February 27–April 14, 1963. By Lloyd Goodrich. No. 7.

Agee, *Synchromism*. No. 8.

"Synchromism and Related American Color Painting, 1910–1930." Circulated by The Museum of Modern Art. February 4, 1967–June 17, 1968. Organized by William C. Agee. No. 4. Illustrated in leaflet.

Danenberg Galleries, New York. "The Second Decade." March 24–April 12, 1969.

Fine Arts Gallery of San Diego, San Diego, Calif. "Color and Form, 1909–1914." November 20,1971–January 2, 1972. Catalogue by Henry G. Gardiner. No. 5. Illustrated p. 47.

Robert Schoelkopf Gallery, New York. "Four Americans." January 7–31, 1975. No. 3.

Delaware Art Museum, Wilmington. "Avant-Garde Painting and Sculpture in America, 1910–25." April 4–May 18, 1975. Illustrated p. 39.

Levin, *Synchromism*. Illustrated in catalogue fig. 133, mentioned p. 42.

Literature:

Yale University Art Gallery, *Collection of the Société*

Anonyme: Museum of Modern Art, 1920. (New Haven, Conn.: Yale University Art Gallery, 1950), illustrated p. 142.

John I. H. Baur, *Revolution and Tradition in Modern American Art* (Cambridge: Harvard University Press, 1951), illustrated fig. 57.

Milton W. Brown, *American Painting from the Armory Show to the Depression* (Princeton, N.J.: Princeton University Press, 1955), illustrated on its side p. 105.

Charles McCurdy, ed., *Modern Art, A Pictorial Anthology* (New York: Macmillan, 1958), illustrated p. 160.

William H. Pierson and Martha Davidson, eds., *Arts of the United States, A Pictorial Survey* (Athens, Ga., University of Georgia Press, 1960, reprint 1966), illustrated p. 334.

William C. Agee, "Synchromism: the First American Movement," *Art News*, vol. 64, no. 6 (October 1965), illustrated p. 30.

Judson, *Bruce*, mentioned pp. 48-49.

George Heard Hamilton, *19th and 20th Century Art: Painting, Sculpture, Architecture* (New York: Abrams, 1970), illustrated p. 294.

Wolf, "Bruce," discussed pp. 80-81.

Katharine B. Neilson, *Selected Paintings and Sculpture from the Yale University Art Gallery* (New Haven, Conn.: Yale University Press, 1972), illustrated and discussed no. 89.

Kenneth H. Cook, "Patrick Henry Bruce," *News &*
Record, South Boston, Va., October 31, 1974, illustrated p. 1D.

John Russell, *The Meanings of Modern Art*, volume 6: "An Alternative Art" (New York: The Museum of Modern Art, 1975), illustrated p. 4.

Hilton Kramer, "Art: Sensual, Serene Sculpture," *The New York Times*, January 25, 1975, mentioned, p. 23.

Judith Tannenbaum, "Four Americans," *Arts Magazine*, vol. 49, no. 7 (March 1975), mentioned p. 10.

Agee, "Bruce," illustrated p. 21, discussed pp. 19-20, 25.

Charlotte Moser, "In Pursuit of the Elusive," Houston *Chronicle*, December 10, 1978, illustrated.

SECTION C: LOST PAINTINGS
(No photographs known to exist; for all entries see Exhibition List)

PAYSAGE (LANDSCAPE). c. late 1912–early 1913. c. f. to C1
 Exhibited with C1, Salon des Indépendants, Paris, 1913.
 Exhibited with C1, Der Sturm, September–December, 1913.
 Probably exhibited at Müvészhav, Budapest, April–May, 1913.

HARMONIE. c. late 1912–early 1913.
 Exhibited: Salon des Indépendants, Paris, March–May 1912.

Harmonie. c. late 1912–early 1913.
 Exhibited: Müvészhav, Budapest, April–May, 1913.
Composition. 1913. c. f.C2
 Exhibited with C2, Salon d'Automne, Paris, 1913.
 Exhibited with C2, Manes Society, Prague, 1914.

SECTION D

We now know of twenty-five extant geometric still lifes; in addition, we can partially reconstruct four others from an installation photograph of "L'Art d'aujourd'hui" exhibition held in Paris in December 1925. New evidence has led us to revise the sequence of these paintings so that almost all are now assigned earlier dates than those previously given in the literature or by the owners. However, with the few exceptions noted here and in the essays, the dates proposed are still far from being completely secure.

Bruce entitled all of his late work as either *Peinture* or *Nature morte*, but many continue to carry titles such as *Forms*, which are listed here in parentheses. From the fall of 1919, when the late work was first exhibited at the Salon d'Automne, through the 1922 Salon des Indépendants, which opened in January, the works were called *Peinture*. Beginning with the 1922 Salon d'Automne (which opened November 1), and continuing through "L'Art d'aujourd'hui" exhibition, he used *Nature morte*. Bruce did not exhibit again until the Salon d'Automne in 1928, when he reverted to *Peinture*. At the 1929 Salon d'Automne, however, he shifted back to *Nature morte*, only to use *Peinture* once again at the 1930 Salon d'Automne, the last time he was to exhibit in his life. Thus, we have here used *Peinture* when

we are certain the work is either very early (D1, D2, D3, D4, D5) or much later (D29, c. 1929–30). In all other cases, because we cannot be sure of the exact dates, we have used the combined title of *Peinture/Nature morte*.

The inscriptions given here are those of Henri-Pierre Roché who, at one time or another, had all of what is now Bruce's extant late work. In some cases, he simply stated "this is a Patrick Henry Bruce." In others, which are so noted, he attached his own inventory number, and the dimensions in centimeters. The inventory number corresponds to the entries in a handwritten document* in which Roché noted brief—but often revealing—descriptions of the paintings. These notes are included under "inscriptions" since they were in the past sometimes also affixed to the stretcher. Over the years, however, relining and restretching have now made it difficult to determine exactly which paintings actually carried the full inscriptions.

What little Bruce himself did not destroy has fared badly in the years since his death—first through neglect, and more recently through unwarranted and irresponsible alterations. Sometime between January 1964 and September 1965,† before they were sold, twelve paintings (almost fifty percent of the extant late work) suffered

*Now in possession of William C. Agee. The inventory lists the fourteen paintings still in his possession, and thus was probably done in about 1957 or 1958, shortly before Roché's death.

†In January 1964, Agee saw the paintings at Madame Roché's and had photographs made; the changes were made sometime between that time and September 1965, when the fourteen paintings then still in Madame Roché's possession were sent to New York.

D1

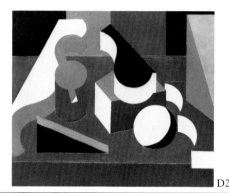

D2

deliberate erasures and alterations to the pencil drawing that is an intrinsic part of the late canvases. The motive was apparently to make them appear more "polished" or "finished," but the result is that we now are left with significant changes from the original state of the paintings that rob them of essential qualities. The erasures range from subtle, almost imperceptible losses or changes in single lines, to gross distortions and full loss of entire shapes and contours that radically disrupt the fluency of the picture surface. In one case (D25) drawn areas were painted in. Fortunately, we have photographs taken in early 1964, which are published here with photographs of the paintings in their present condition, so that we can reconstruct Bruce's original intentions. The color plates are of the works in their present state.

D1.□ Peinture. c. 1917–18
Oil and pencil on canvas, 26⅛ x 32½ in (66.4 x 82.6 cm)
Collection:
Rolf Weinberg, Zurich
Inscribed on back of canvas:
Ceci est un Patrik [sic] *Bruce. H. P. Roché*
Provenance:
Artist
Henri-Pierre Roché, 1933
Rose Fried Gallery, New York
Charles Simon, New York, c. 1949–1950
Rolf Weinberg, 1978
Exhibition:
Whitney Museum of American Art, New York.

"20th-Century American Art from Friends' Collections." July 27–September 27, 1977.

Although it had been in a New York collection for over twenty-five years and its existence known, the painting came to light only after Agee, "Bruce" had been published. Its discovery makes a radical difference in dating the late work since it is clearly a bridge between the last *Composition* and the other geometric still lifes that were known. We date this first still life c. 1917 because of Roché's statement that Bruce stopped painting in 1932, and that he had been making the architectural still lifes for fifteen years (see Roché memoir, p. 223).

D2.□ Peinture (presently entitled *Forms*). c. 1918–19
Oil on canvas, 23½ x 28¾ in (59.7 x 73 cm)
Collection:
Sheldon Memorial Art Gallery, University of Nebraska, Lincoln, Howard S. Wilson Memorial Collection. U-510
Inscription:
73 x 60 20 F (*Les noirs craquelés*) #1
(*1 boule entre autres objets*)
Provenance:
Artist
Henri-Pierre Roché, 1933
Mme. Henri-Pierre Roché, 1959
M. Knoedler & Co., Inc., New York, 1965
Mrs. Howard S. Wilson, 1965
Sheldon Memorial Art Gallery, University of Nebraska, 1966

D3

Exhibitions:

Sheldon Memorial Art Gallery, University of Nebraska, Lincoln. "The Howard S. Wilson Memorial Collection." October 11–November 13, 1966. No. 7. Illustrated.

University of New Mexico Art Museum, Albuquerque. "Cubism: Its Impact in the USA, 1910–30." February 10–March 19, 1967. No. 4. Illustrated p. 16.

Pennsylvania Academy of the Fine Arts, Philadelphia. "Early Moderns." January 31–March 3, 1968. No. 2.

Joslyn Art Museum, Omaha. "The Chosen Object: European and American Still Life." April 23–June 5, 1977. Illustrated p. 29.

Levin. "Synchromism," illustrated in catalogue fig. 134, mentioned p. 42.

Literature:

"College Museum Notes: Acqusitions," *Art Journal,* vol. 25, no. 4 (summer 1966), illustrated p. 398, mentioned p. 396.

Betje Howell, "Perspective on Art," *Evening Outlook,* Santa Monica, Calif., August 12, 1967, illustrated p. 16A.

Judson, *Bruce,* discussed pp. 60–61, 74, 80

Agee, "Bruce," discussed pp. 25, 29

Roy Bruce recalls seeing this painting in his father's studio in 1919.*

*Roy Bruce, interview with Barbara Rose.

D3. ☐ PEINTURE (presently entitled *Still Life*). c. 1919
Oil and pencil on canvas, 23½ x 28⅜ in (59.7 x 72 cm)

Collection:

Roy R. Neuberger, New York

Inscribed on back of canvas: Ceci est un Patrick Henry Bruce. H. P. Roché

Provenance:

Artist

Henri-Pierre Roché, 1933

Rose Fried Gallery, New York

Metropolitan Museum of Art, 1953

Graham Gallery, New York

Roy R. Neuberger, 1961

Exhibitions:

"Pioneers of American Abstract Art." Circulated by the American Federation of Arts. December 1955–January 1957. No. 1.

University of Michigan Museum of Art, Ann Arbor. "Contemporary American Painting: Selections from the Collection of Mr. and Mrs. Roy R. Neuberger." October 21–November 18, 1962. No. 6.

Whitney Museum of American Art, New York. "The Decade of the Armory Show: New Directions in American Art, 1910–20." February 27–April 14, 1963. By Lloyd Goodrich. No. 8.

Museum of Art, Rhode Island School of Design, Providence. "The Neuberger Collection: an American Collection, Paintings, Drawings, and Sculpture." May 8–

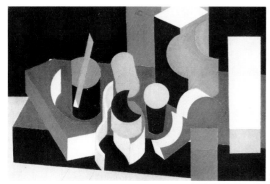

D4

June 30, 1968. No. 81. Illustrated p. 87.

Delaware Art Museum, Wilmington. "Avant-Garde
Painting and Sculpture in America, 1910–25." April 4–
May 18, 1975. Illustrated p. 39.

Levin, *Synchromism*.

Neuberger Museum, State University of New York, Col-
lege at Purchase. "In Celebration: Selections from the
Private Collection of Roy R. and Marie S. Neuberger."
September 24–November 26, 1978. No. 9. Illustrated.

Literature:

Albert Ten Eyck Gardner, *A Concise Catalogue of the
American Paintings in the Metropolitan Museum of
Art* (New York: Metropolitan Museum of Art, 1957),
mentioned p. 6.

Lloyd Goodrich, *Pioneers of Modern Art in America: the
Decade of the Armory Show, 1910–20* (New York:
Praeger for the Whitney Museum of American Art,
1963), illustrated p. 85.

Judson, *Bruce*, mentioned p. 59.

D4. ☐ Peinture (presently entitled *Still Life*). c. 1919
Oil and pencil on canvas, 23½ x 36 in (59.7 x 91.4 cm)
Collection:

Private collection, New York

Provenance:

Artist

Henri-Pierre Roché, 1933

Rose Fried Gallery, New York

Herbert and Nannette Rothschild, c. 1950

Private Collection, New York

Exhibitions:

Rose Fried Gallery, New York. "Three American
Pioneers of Abstract Art." November 20–December 30,
1950.

"Pioneers of American Abstract Art." Circulated by the
American Federation of Arts. December 1955–January
1957. No. 2.

Whitney Museum of American Art, New York. "The
Museum and Its Friends: Twentieth-Century Ameri-
can Art from Collections of the Friends of the Whitney
Museum." April 30–June 15, 1958. No. 14.

Galerie Chalette, New York. "Construction and Geom-
etry in Painting from Malevitch to 'Tomorrow.' "
March 31–June 4, 1960. No. 20.

Museum of Art, Rhode Island School of Design, Provi-
dence. "Herbert and Nannette Rothschild Collection."
October 7–November 6, 1966. No. 21. Illustrated,
mistakenly marked no. 20.

Tate Gallery, London. "Léger and Purist Paris." Novem-
ber 18, 1970–January 24, 1971. No. 77. Illustrated p. 72.

Dallas Museum of Fine Arts. "Geometric Abstraction,
1926–1942." October 7–November 19, 1972. No. 9.
Illustrated.

Literature:

"The Museum and Its Friends," *Art News*, vol. 57, no. 4
(summer 1958), illustrated p. 15.

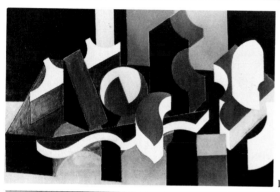

D5

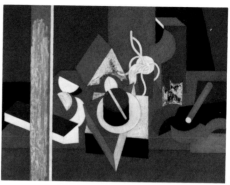

D6

D5. □ PEINTURE (presently entitled *Forms*). c. 1919–20
Oil and pencil on canvas, 23¾ x 36¼ in (60.3 x 92 cm)
Collection:
 William H. Lane Foundation, Leominster, Mass.
Inscribed on back of canvas: *Ceci est un Patrick Bruce. H. P. Roché*
Inscribed on stretcher: *Bruce* (not in his handwriting)
Provenance:
 Artist
 Henri-Pierre Roché, 1933
 New Gallery, New York, 1955
 Private Collection, 1955–57
 William H. Lane Foundation, 1957
Exhibitions:
 Agee, *Synchromism.* No. 12. Illustrated in catalogue
 p. 14, mentioned p. 36.
 "Synchromism and Related American Color Painting,
 1910–30." Circulated by The Museum of Modern Art.
 February 4, 1967–June 17, 1968. Organized by
 William C. Agee. No. 7.
 William Benton Museum of Art, Storrs, Conn. "Selec-
 tions from the William H. Lane Foundation." March
 17–May 25, 1975. No. 9.
 Levin, *Synchromism.* Illustrated fig. 135, mentioned p. 42.
Literature:
 Dore Ashton, "Life and Movement without Recession,"
 Studio International, vol. 170 (December 1965),
 illustrated p. 250.

Judson, *Bruce,* discussed pp. 53, 55–56, 59.
Wolf, "Bruce," illustrated fig. 10, discussed p. 82.
Agee, "Bruce," illustrated p. 23, discussed pp. 25, 29.

D6. PEINTURE/NATURE MORTE. c. 1920–21
Oil and pencil on canvas, 35 x 46 in (88.9 x 116.8 cm)
Collection:
 The Museum of Fine Arts, Houston, gift of the Brown
 Foundation. 78. 182
Inscribed on back of canvas: *Ceci est un Patrick Henry
 Bruce. H. P. Roché*
Provenance:
 Artist
 Henri-Pierre Roché, 1933
 Galerie Chalette, New York
 B. F. Garber, c. 1960
 The Museum of Fine Arts, Houston, 1978
Exhibition:
 "Seven Decades, 1895–1965: Crosscurrents in Modern
 Art." April 26–May 21, 1966. By Peter Selz for the
 Public Education Association. Bruce painting exhibited
 at the Perls Galleries. Illustrated p. 84.
Literature:
 Judson, *Bruce,* mentioned pp. 58–59, 63, 78.

D7. □ PEINTURE/NATURE MORTE (presently entitled *Still Life*).
 c. 1920–21
Oil and pencil on canvas, 35 x 45¾ in (88.9 x 116.2 cm)

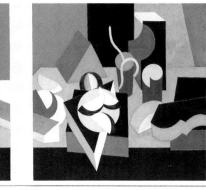

D7

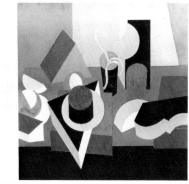

D8

Collection:
 Metropolitan Museum of Art, New York,
 George A. Hearn Fund
Inscribed on back of canvas: *Ceci est un Patrick Bruce.*
 H. P. Roché
Provenance:
 Artist
 Henri-Pierre Roché, 1933
 Rose Fried Gallery, New York
 Graham Gallery, New York
 Metropolitan Museum of Art (by exchange), 1961
Exhibitions:
 Metropolitan Museum of Art, New York. "Three Cen-
 turies of American Painting." April 9–October 17, 1965.
 National Collection of Fine Arts, Washington, D.C.
 "Roots of Abstract Art in America, 1910–30."
 December 2, 1965–January 9, 1966. By Adelyn D.
 Breeskin. No. 12.
Literature:
 John I. H. Baur, "Rediscovery," *Art in America,* vol. 48,
 no. 3 (1960), illustrated and discussed p. 87.
 Henry Geldzahler, *American Painting in the 20th
 Century* (New York: Metropolitan Museum of Art,
 1965), illustrated and discussed p. 144.
 Judson, *Bruce,* discussed pp. 55, 56A, 58–59, 79.
 Wolf, "Bruce," illustrated fig. 11, discussed p. 82.
 Michel Seuphor, *L'Art Abstrait* (Paris: Maeght, 1971–
 74), illustrated v. 2, p. 102.

Kenneth H. Cook, "Patrick Henry Bruce," *News & Record,*
 South Boston, Va., October 31, 1974, illustrated p. 3D.

D8.☐ Peinture/Nature morte (presently entitled *Paint-
 ing*). c. 1921–22
Oil and pencil on canvas, 35 x 45¾ in (88.9 x 116.2 cm)
Collection:
 Whitney Museum of American Art, New York,
 anonymous gift. 54.20
Provenance:
 Artist
 Henri-Pierre Roché, 1933
 Rose Fried Gallery, New York
 Herbert and Nannette Rothschild, c. 1950
 Whitney Museum of American Art, 1954
Exhibitions:
 Rose Fried Gallery, New York. "Three American
 Pioneers of Abstract Art." November 20–
 December 30, 1950.
 Whitney Museum of American Art, New York. "Geo-
 metric Abstraction in America." March–May 1962.
 By John Gordon. No. 10. Illustrated p. 21.
 Whitney Museum of American Art, New York. "60 Years
 of American Art." September 17–October 20, 1963.
 National Collection of Fine Arts, Washington, D.C.
 "Roots of Abstract Art in America, 1910–1930."
 December 2, 1965–January 9, 1966. By Adelyn D.
 Breeskin. No. 13.

PRE-ALTERATION

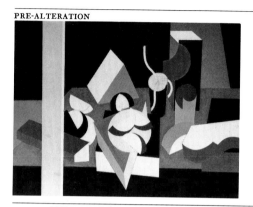
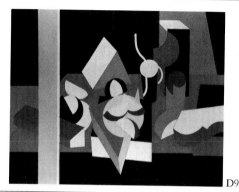

D9

Whitney Museum of American Art, New York. "Art of the United States, 1670–1966." September 28–November 27, 1966. By Lloyd Goodrich. No. 31.

Museum of Art, Rhode Island School of Design, Providence. "Herbert and Nannette Rothschild Collection." October 7–November 6, 1966. No. 20.

New York University Art Collection, New York. "The New York Painter: a Century of Teaching: Morse to Hofmann." September 27–October 14,1967. Illustrated p. 42.

Coe Kerr Gallery, New York. "150 Years of American Still-Life Painting." April 27–May 16, 1970. Illustrated p. 36.

University of Texas Art Museum, Austin. "Not So Long Ago: Art of the 1920's in Europe and America." October 15–December 17, 1972. Illustrated p. 28.

Whitney Museum of American Art, New York. "The Whitney Studio Club and American Art, 1900-1932." May 23–September 3, 1975. By Lloyd Goodrich. Illustrated p. 13.

Montgomery Museum of Fine Arts, Montgomery, Ala. "American Painting, 1900–1939: Selections from the Whitney Museum of American Art." June 29–August 8, 1976. By Diane J. Gingold. No. 20. Illustrated p. 40.

Whitney Museum of American Art, New York. "Introduction to 20th Century American Art: Selections from the Permanent Collection." October 10, 1978–September 23, 1979. By Patterson Sims. Illustrated and discussed in leaflet.

Literature:

William H. Pierson and Martha Davidson, eds., *Arts of the United States, A Pictorial Survey* (Athens, Ga., University of Georgia Press, 1960, reprint 1966), illustrated p. 334.

Lloyd Goodrich and John I. H. Baur, *American Art of Our Century* (New York: Praeger for the Whitney Museum of American Art, 1961), illustrated p. 47.

Max Kozloff, "Geometric Abstraction in America," *Art International*, vol. 6, no. 5–6 (summer 1962), illustrated p. 99.

H. H. Arnason, *History of Modern Art: Painting, Sculpture, Architecture* (New York: Abrams, 1968), illustrated and mentioned p. 413.

Judson, *Bruce*, discussed pp. 55, 56A, 58–59, 79.

William H. Gerdts and Russell Burke, *American Still-Life Painting* (New York: Praeger, 1971), illustrated p. 222.

Marshall B. Davidson, *The American Heritage History of the Artists' America* (New York: American Heritage, 1973), illustrated p. 332.

Whitney Museum of American Art, *Catalogue of the Collection* (New York: Whitney Museum of American Art, 1975), illustrated p. 39.

Jules David Prown and Barbara Rose, *American Painting from the Colonial Period to the Present*, new edition

PRE-ALTERATION

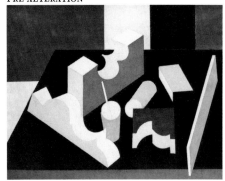 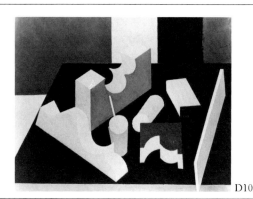

D10

(New York: Rizzoli, 1977), illustrated p. 153.
Agee, "Bruce," illustrated p. 24, discussed pp. 26, 28.

D9.☐ Peinture/Nature morte (presently entitled
 Still Life). c. 1921–22
Oil and pencil on canvas, 34⅜ x 45 in (87.3 x 114 cm)
Collection:
 Philadelphia Museum of Art, gift of the Woodward
 Foundation. 75-81-2
Inscription:
 116 x 89 50 F grande barre bleu verticale #13
 fond sombre
Provenance:
 Artist
 Henri-Pierre Roché, 1933
 Mme Henri-Pierre Roché, 1959
 Jon Streep
 Woodward Foundation, 1965
 Philadelphia Museum of Art, 1975
Exhibitions:
 National Collection of Fine Arts, Washington, D.C.
 "Roots of Abstract Art in America," 1910–1930.
 December 2, 1965–January 9, 1966. By Adelyn Bree-
 skin. No. 14. Illustrated.
 United States Embassy Residence, Moscow. 1967–68.
 United States Embassy Residence, Mexico. October
 1970–December 1974.
 Philadelphia Museum of Art. "Selections from the

Woodward Foundation Collection." June 19–July 29,
 1973.
Philadelphia Museum of Art. "Gifts to Mark a Century."
 February 18–March 20, 1977. No. 203.
Literature:
Judson, *Bruce*, mentioned pp. 58–59.
Robert Korengold, "Diplomacy with Art," *Vogue*,
 vol. 151, no. 9 (May 1968), illustrated p. 265.
Erasures were made in the abstracted "vase and foliage"
at center, including a line that defined the rear edge of the
vertical concave shape at the rear; another was made in the
sphere at the center.

D10.☐ Peinture/Nature morte (presently entitled
 Forms No. 4). c. 1922–23
Oil and pencil on canvas, 25½ x 31¾ in (64.8 x 80.5 cm)
Collection:
 Hirshhorn Museum and Sculpture Garden, Smithsonian
 Institution, Washington, D.C.
Inscription:
 81 x 65 25 F Objets découpés sur table bleu (fini) #4
Provenance:
 Artist
 Henri-Pierre Roché, 1933
 Mme Henri-Pierre Roché, 1959
 M. Knoedler & Co., Inc., New York (on consignment),
 1965–67
 Noah Goldowsky Gallery, New York, 1967

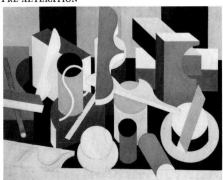 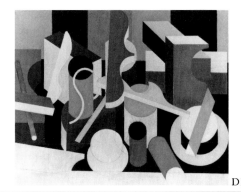 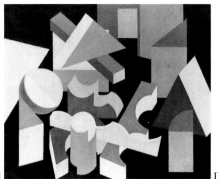

D11 D12

Jon Streep
Joseph H. Hirshhorn, 1968
Hirshhorn Museum and Sculpture Garden, 1972
Exhibitions:
Noah Goldowsky Gallery, New York. 1967.
"Synchromism and Related American Color Painting,
1910–1930." Circulated by The Museum of Modern
Art. February 4, 1967–June 17, 1968. Organized by
William C. Agee.
Literature:
Judson, *Bruce*, discussed pp. 60, 89.

Although they are difficult to see, erasures were made in the
lines of the nearer filigree element, first at left center, where
it joins with the related shape behind it, and at front center
where it intersects with the "glass and staw."

D11.☐ Peinture/Nature morte (presently entitled
Formes 1921 No. 7). c. 1922–23
Oil and pencil on canvas, 28¾ x 36¼ in (73 x 92.1 cm)
Collection:
Private collection, New York
Inscription:
92 x 73 30 F *Canotier bleu et rose—pas fini—* #7
beaucoup d'objets
Provenance:
Artist
Henri-Pierre Roché, 1933

Mme Henri-Pierre Roché, 1959
M. Knoedler & Co., Inc., New York (on consignment),
1965–67
Noah Goldowsky Gallery, 1967
Private Collection, 1968
Exhibitions:
Noah Goldowsky Gallery, New York. 1967.
Fort Worth Art Museum, Fort Worth, Tex.
"Twentieth Century Art from Fort Worth, Dallas
Collections." September 8–October 15, 1974.

The beautifully fluent and sweeping drawing at the lower
left was erased, thus eliminating the partial filigree shape
that played against and echoed the three other similar
shapes at the left, center, and center right, and robbing the
picture of its original fullness.

D12. Peinture/Nature morte (presently entitled
Composition). c. 1923 or c. 1926*
Oil and pencil on canvas, 25⅜ x 31⅞ in (64.5 x 81 cm)
Collection:
Centre National d'Art et de Culture Georges Pompidou,

*Barbara Rose believes this painting and the related motifs (plate D13,
D14) were painted just after the "collapsed beam" series of 1924, rather
than just before. In a letter of July 1, 1959, to Mme Roché, Michel Seuphor
recalled seeing this painting and "five or six" related works in Bruce's studio
during his 1926 visit. In a subsequent interview (with Barbara Rose,
October 1978), Seuphor once again described this as the painting Bruce

PRE-ALTERATION

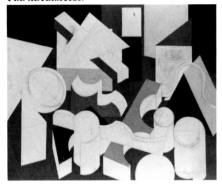 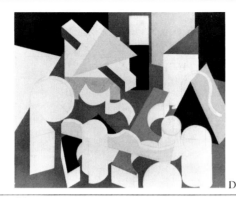

D13

Paris, gift of Michel Seuphor. 1977–609.

Provenance:

Artist

Henri-Pierre Roché, 1933

Michel Seuphor, c. 1957–58

Centre National d'Art et de Culture Georges Pompidou,
1977

Literature:

Michel Seuphor, *La Peinture Abstraite: Sa Genèse. Son
Expansion.* (Paris: Flammarion, 1962), illustrated p. 234.

Michel Seuphor, *Abstract Painting: Fifty Years of
Accomplishment from Kandinsky to the Present*
(New York: Abrams, 1962), illustrated p. 234.

Judson, *Bruce*, mentioned p. 59.

Michel Seuphor, *L'Art Abstrait* (Paris: Maeght, 1971–
1974), illustrated v. 2, p. 107.

Robert Maillard, *Dictionnaire Universel de la Peinture*
(Paris: Robert, 1975), illustrated v. 1, p. 347.

D13.□ Peinture/Nature morte (presently entitled
Formes). c. 1923–24
Oil and pencil on canvas, 25 x 32 in (63.5 x 81.3 cm)

showed him. He also recalled five or six other pictures stacked against the
wall. Whether these three related paintings (D12, D13, D14) precede the
"collapsed beam" paintings, as Barbara Rose believes, or whether they im-
mediately postdate them, these paintings were probably part of a more
extensive series, the rest presumably destroyed.

Collection:

Mr. and Mrs. Henry M. Reed, Montclair, N. J.

Provenance:

Artist

Henri-Pierre Roché, 1933

Mme Henri-Pierre Roché, 1959

M. Knoedler & Co., Inc., New York (on consignment),
1965–67

Jon Streep

Noah Goldowsky Gallery, New York, 1967

Mr. and Mrs. Henry M. Reed, 1967

Exhibitions:

Noah Goldowsky Gallery, New York. 1967.

"From Synchromism Forward: a View of Abstract Art
in America." Circulated by the American Federation
of Arts. November 12, 1967–November 17, 1968.
No. 10.

Montclair Art Museum, Montclair, N. J. "Synchromism
from the Henry M. Reed Collection." April 6–27,
1969. No. 7

Montclair Art Museum, Montclair, N. J. "American
Still Life in New Jersey Collections." October 25–
December 13, 1970. No. 8.

Heckscher Museum, Huntington, N.Y. "The Students
of William Merritt Chase." November 18–
December 30, 1973. No. 55. Illustrated p. 29.

Katonah Gallery, Katonah, N.Y. "American Painting,

PRE-ALTERATION

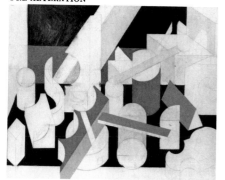
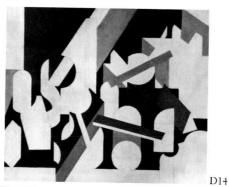

D14

1900–1976. Pt. 1, 'The Beginning of Modernism, 1900–1934.'" November 1, 1975–January 4, 1976. By John I. H. Baur. No. 4. Illustrated.

The Museum of Fine Arts, Houston. "Modern American Painting, 1910–1940: Toward a New Perspective." July 1–September 25, 1977. By William C. Agee. No. 10. Illustrated p. 15.

Literature:

Hilton Kramer, "Rediscovering the Art of Patrick Henry Bruce," The New York *Times*, July 17, 1977, illustrated p. D21.

Mimi Crossley, "Bruce's Reputation Salvaged," *The Houston Post*, April 30, 1978, illustrated.

Extensive erasures were made in the sphere at left center, the cylinder at the lower left center, and the cylinder in the lower right corner; also in the long rectangular block at the center, most especially a line that also served to define the lower left edge of the "vertical bar" at the center rear. The effect has been to make the picture thinner, less full, and less "finished" than the artist intended.

D14.□ PEINTURE/ NATURE MORTE (presently entitled *Forms*). c. 1923–24
Oil and pencil on canvas, 31⅞ x 38¾ in (81 x 98.4 cm)
Collection:

Museum of Art, Rhode Island School of Design, Albert Pilavin Collection: Twentieth Century American Art. 68.048

Inscription:
100 x 81 40 F Tres peu peint—dessin fini #9

Provenance:

Artist

Henri-Pierre Roché, 1933

Mme Henri-Pierre Roché, 1959

M. Knoedler & Co., Inc., New York (on consignment), 1965–67

Noah Goldowsky Gallery, New York, 1967

Museum of Art, Rhode Island School of Design, Albert Pilavin Collection, 1968

Exhibitions:

Noah Goldowsky Gallery, New York. 1967.

Museum of Art, Rhode Island School of Design, Providence. "The Albert Pilavin Collection: Twentieth-Century American Art." October 7–November 23, 1969. No. 3. Illustrated p. 13. Discussed p. 14.

Museum of Art, Rhode Island School of Design, Providence "The Albert Pilavin Collection: Twentieth-Century American Art, Part II." October 23–November 25, 1973.

Lyman Allyn Museum, New London, Conn. "Selections from the Albert Pilavin Collection." April 7–May 12, 1974.

Literature:

Judson, *Bruce*, discussed pp. 57, 59–60, 62, 79.

Agee, "Bruce," illustrated p. 23, discussed p. 28.

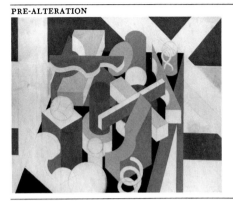 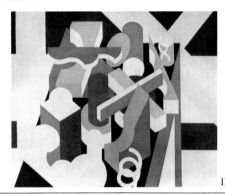 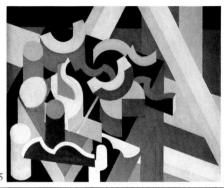

D15 D16

The same type and extent of alterations were made here as in the Reed picture.

D15.☐PEINTURE/NATURE MORTE. c. 1923–24
Oil and pencil on canvas, 31¼ x 38½ in (79.4 x 97.8 cm)
Collection:
Private collection, New York
Inscription:
100 x 81 40 F *Beaucoup d'objets sur table* #8
 rouge, dessus noir—(pas fini)
 (+ orbillon pas fini)
Provenance:
Artist
Henri-Pierre Roché, 1933
Mme Henri-Pierre Roché, 1959
M. Knoedler & Co., Inc., New York, 1965–67
Noah Goldowsky Gallery, New York, 1967
Private Collection, 1968
Exhibition:
Noah Goldowsky Gallery, New York. 1967.

Extensive erasures were made in the vertical plane in the left rear, the scroll shape in the lower left and the vertical block at lower left center; the drawing in the sphere on top of this block was completely obliterated. Curved lines in the sphere at the bottom left, which completed the filigree shape at the lower left, were also removed. In addition, erasures were made in the helix shape at the bottom center right, the cylinder at the upper right on the edge of the

table, and in the front edge of the horizontal rectangular block protruding over the table edge at center right.

D16.☐ PEINTURE/NATURE MORTE (presently entitled
 Forms on Table). c. 1924
Oil and pencil on canvas, 28¾ x 36¼ in (73 x 92.1 cm)
Inscribed on back of canvas:
 Ceci est un Patrick Bruce. H. P. Roché
Collection:
Addison Gallery of American Art, Phillips Academy,
 Andover, Mass., gift of Mr. and Mrs. William H. Lane
 1958.38
Provenance:
Artist
Henri-Pierre Roché, 1933
New Gallery, New York
William H. Lane, c. 1955
Addison Gallery of American Art, 1957
Exhibitions:
American Academy of Arts and Letters, New York.
 "A Change of Sky: Paintings by Americans Who Have
 Worked Abroad." March 4–April 3, 1960. No. 37.
Flint Institute of Arts, Flint, Michigan. "The Coming
 of Color." April 2–30, 1964. No. 4.
Agee, *Synchromism*, No. 13
"Synchromism and Related American Color Painting,
 1910–1930." Circulated by The Museum of Modern
 Art. February 4, 1967–June 17, 1968. Organized by
 William C. Agee. No. 8. Illustrated in leaflet.

PRE-ALTERATION

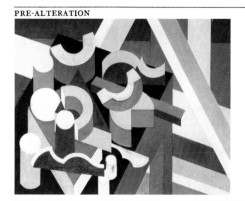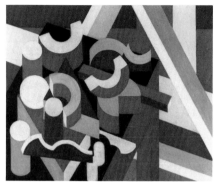

D17

Literature:
 Dorothy Adlow, "Forms on Table," *The Christian
 Science Monitor*, October 6, 1960, illustrated and dis-
 cussed p 12.
 Judson, *Bruce*, discussed pp. 57, 59–60.
 Wolf, "Bruce," illustrated fig. 13, mentioned p. 82.
 John Wilmerding, *The Genius of American Painting*
 (New York: Morrow, 1973), illustrated p. 237.

D17. ☐ PEINTURE/ NATURE MORTE (presently entitled
 Forms No. 5). c. 1924
Oil and pencil on canvas, 28¼ x 35¾ in (71.8 x 90.8 cm)
Collection:
 B. F. Garber, Marigot, St. Martin
Inscription:
 *92 x 73 30 F Amas d'objets sans point d'appui #5
 Rose Friend [sic]Gallery, N.Y.
 (pas tout à fait fini)*
Provenance:
 Artist
 Henri-Pierre Roché, 1933
 Mme Henri-Pierre Roché, 1959
 M. Knoedler & Co., Inc., New York (on consignment),
 1965–67
 Noah Goldowsky Gallery, New York, 1967
 Mr. and Mrs. Henry M. Reed, c. 1967–70
 B. F. Garber, c. 1970
Exhibitions:

 Rose Fried Gallery, New York, 1950
 Noah Goldowsky Gallery, New York. 1967.
 Montclair Art Museum, Montclair, N. J. "Synchromism
 from the Henry M. Reed Collection." April 6–27,
 1969. No. 6.
Literature:
 Michel Seuphor, "Peintures Construites," *L'Oeil*, No. 58
 (October 1959), illustrated p. 37.
 Michel Seuphor, *L'Art Abstrait* (Paris: Maeght,
 1971–74), illustrated, v. 2, p. 102.

As in the Corcoran picture (D18), the drawing in the
sphere at the left was removed, with the same unfortunate
results. In addition, erasures were made in the two cylinders
at bottom center and in the curving shape just above them
on the table. The cylinders in the original were conceived
as two well-defined shapes that, typical of Bruce's
wonderful simultaneous clarity and ambiguity, were at once
separate but joined together, a unique effect now muted,
if not altogether lost.

D18. ☐ PEINTURE/ NATURE MORTE (presently entitled
 Forms). c. 1924
Oil and pencil on canvas. 28¾ x 35¾ in (73 x 90.8 cm)
Collection:
 Corcoran Gallery of Art, Washington, D.C. 68.2
Inscription:
 92 x 73 30 F identique comme dernier *#6*

PRE-ALTERATION

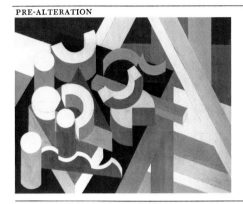 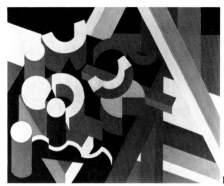

D18 D19, D20, D21, D22

qqs couleurs différentes
(pas tout à fait fini)
Provenance:
 Artist
 Henri-Pierre Roché, 1933
 Mme Henri-Pierre Roché, 1959
 M. Knoedler & Co., Inc., New York (on consignment),
 1965–1967
 Noah Goldowsky Gallery, New York, 1967
 Corcoran Gallery of Art, 1968
Exhibitions:
 Noah Goldowsky Gallery, New York. 1967.
 "The Modern Spirit: American Painting, 1908–1935."
 Organized and circulated by the Arts Council of Great
 Britain. August 20–November 20, 1977. Catalogue by
 Milton W. Brown. No. 65.
Literature:
 Wolf, "Bruce," illustrated fig. 12, discussed pp. 82–83.
 Sam Hunter, *American Art of the 20th Century*
 (New York: Abrams, 1972) illustrated p. 86.
 Dorothy W. Phillips, *A Catalogue of the Collection of
 American Paintings in the Corcoran Gallery of Art*,
 Vol. 2: "Painters Born from 1850 to 1910" (Wash-
 ington, D.C.: Corcoran Gallery of Art, 1973), men-
 tioned p. 109, illustrated.
 Kenneth H. Cook, "Patrick Henry Bruce," *News &
 Record*, South Boston, Va., October 31, 1974, illus-
 trated p. 3D.

Agee, "Bruce," illustrated p. 27, discussed p. 28.

The drawing in the sphere at the left has been completely
removed, as has a line defining the upper left edge of the
table that extended partly into the top of the cylinder. As a
result, the sphere now reads as a flat circle rather than as
the ambiguous, contradictory shape that, originally, was at
once part sphere, part semicircle, and that contrasted with
and echoed the other three-dimensional crescent shapes
and curved forms on the table. Lines in the upright half
circle at the center, that defined the lower edge of the
curved shape behind it and the top edge of the long rec-
tangular block under it, were also removed. The lines that
defined the contour of the front and lower edges of this
rectangle as it jutted off the table into the background at
center right were also erased.

D19, D20, D21, D22

 All *Nature morte*, before December 1925
 Oil on canvas, dimensions unknown.
 Now destroyed (probably by the artist in 1933).
 From photograph of "L'Art d'aujourd'hui" exhibition,
 Paris, December 1925; reproduced in *Bulletin de la vie
 artistique*, Paris. 7e année, no. 1, Janvier 1926, page 5.

These four paintings, almost certainly among those de-
stoyed by Bruce in 1933, were all listed as *Nature morte* in
the exhibition catalogue. Bruce entitled his late work
Peinture until the Salon des Indépendants of 1922, which

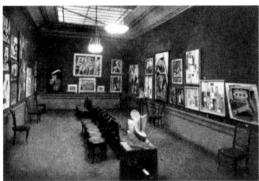

D19, D20, D21, D22

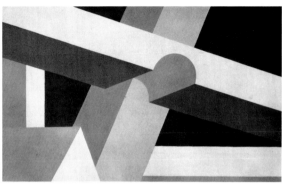

D23

opened in January. He then began using *Nature morte* later in the same year at the Salon d'Automne. He had shifted back to *Peinture* by the fall of 1928. Thus, a *terminus ante quem* of early 1922 is suggested, with a *terminus post quem* of late 1925, for all four paintings. None of these paintings can be clearly or fully read from the photograph, but certain primary elements can be deciphered.

D19. (*top, far left*) The plane and angle of the table are similar to D4 (c. 1919) and D5 (c. 1919–20), as is the shortened "vertical bar" at right. Of particular note are what appear to be chess figures at the front edge of the table, objects whose significance Barbara Rose discusses in her essay.

D20. (*middle, far left*) The angle of the table, its placement and the shortened "vertical bar" again recalls D4 and D5, as well as the painting hanging above. On the table at the right one can see the clear outline of a bottle.

D21. (*bottom, far left*) The full length "vertical bar" at the left and the placement of two reversed triangles on the table is close to the format of the Hirshhorn painting (D24), which we have dated c. 1925–26. On this basis, although they are not the same paintings, it is possible that the Hirshhorn picture may have been completed by the end of 1925.

D22. (*top, second row in on left*) Although it is the least legible work of all in the photograph, there appears to be a table-top that fills a sizable portion of the surface and pushes

against the lower edge at a radical angle, elements that are vaguely reminiscent of another Hirshhorn painting of c. 1922–23 (D10). In addition, the "background" appears to be divided solely into two distinct planes.

D23.☐ PEINTURE/NATURE MORTE (TRANSVERSE BEAMS) (formerly entitled *Vertical Beams*). c. 1928
Oil and pencil on canvas, 32 x 51¼ in (81.3 x 130.2 cm)
Collection:
 Hirshhorn Museum and Sculpture Garden, Smithsonian Institution, Washington, D.C. 1972.47
Inscriptions:
 When the painting was relined sometime before 1972, the restorer recorded the following inscription, which he copied onto the new lining: *ce tableau est de Patrick Bruce/vers 1932. H. P. Roché*
 130 x 81 60 M trés simples poutres transversales #10
Provenance:
 Artist
 Henri-Pierre Roché, 1933
 Mme Henri-Pierre Roché, 1959
 M. Knoedler & Co., Inc., New York (on consignment), 1965–1967
 Noah Goldowsky Gallery, New York, 1967
 Jon Streep
 Joseph H. Hirshhorn, 1968
 Hirshhorn Museum and Sculpture Garden, 1972
Exhibitions:

PRE-ALTERATION

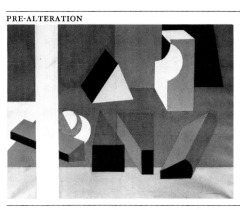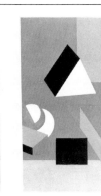

D24

Agee, *Synchromism*. No. 15. Illustrated in catalogue
 p. 15, discussed p. 36.
Noah Goldowsky Gallery, New York. 1967.
"Synchromism and Related American Color Painting,
 1910–1930." Circulated by The Museum of Modern
 Art. February 4, 1967–June 17, 1968. Organized by
 William C. Agee. No. 9.
Hirshhorn Museum and Sculpture Garden, Washington,
 D.C. "Inaugural Exhibition." October 1, 1974–
 September 15, 1975.
"The Modern Spirit: American Painting, 1908–1935."
 Organized and circulated by the Arts Council of Great
 Britain. August 20–November 20, 1977. Catalogue by
 Milton W. Brown. No. 122.

Literature:
Judson, *Bruce*, discussed pp. 57, 86–87.
Jay Jacobs, "Collector: Joseph H. Hirshhorn," *Art in
 America*, vol. 57, no. 4 (July–August 1969), illustrated
 p. 63, on its side.
William C. Agee, "Letters: Patrick Henry Bruce," *Art in
 America*, vol. 57, no. 6 (November–December 1969),
 discussed p. 38.
Abram Lerner, "Letters: Patrick Henry Bruce," *Art in
 America*, vol. 57, no. 6 (November–December 1969),
 discussed p. 38.
William C. Agee, "Letters: Patrick Henry Bruce," *Art in
 America*, vol. 58, no. 1 (January–February 1970),

discussed p. 15.
Jean Lipman, *The Collector in America* (New York:
 Viking, 1970), illustrated p. 85.
*The Hirshhorn Museum and Sculpture Garden, Smith-
 sonian Institution* (New York: Abrams, 1974), illus-
 trated p. 351.
Jean Lipman and Helen M. Franc, *Bright Stars:
 American Painting and Sculpture Since 1776* (New
 York: Dutton, 1976), illustrated and discussed p. 109.
Agee, "Bruce," illustrated p. 28, discussed pp. 29–30.

The painting was previously thought to be Bruce's last
work, done in 1932 (Agee, *Synchromism* and Agee,
"Bruce"). New information, however, has disclosed that
Bruce kept painting steadily until his return to America in
the summer of 1936. The work was dated 1932 by virtue of
Roché's inscription, which we now know was inaccurate.
Because the painting is unique in Bruce's extant oeuvre it is
difficult to date; we have now assigned it as c. 1928 for
reasons discussed in the essays. The picture formerly carried
the descriptive title *Vertical Beams*, which was based on a
misreading of Roché's inventory notes, which actually read
"transverse beams" (see Agee, "Bruce").

D24. ☐ PEINTURE/NATURE MORTE (presently entitled
 Forms No. 12). c. 1925–26 or c. 1928
 Oil and pencil on canvas, 35⅛ x 45¾ in (89.2 x 116.2 cm)
 Collection:

PRE-ALTERATION

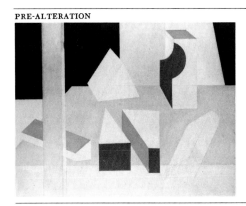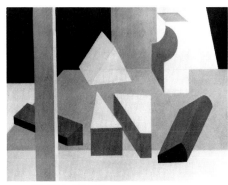

D25

Hirshhorn Museum and Sculpture Garden, Smithsonian
Institution, Washington, D.C. 1972.46
Inscriptions:
116 x 89 50 F *Grande barre rose verticale* #12
(*+ encadrement baguette mince*)
Provenance:
Artist
Henri-Pierre Roché, 1933
Mme Henri-Pierre Roché, 1959
M. Knoedler & Co., Inc., New York (on consignment),
1965–67
Noah Goldowsky Gallery, New York, 1967
Jon Streep
Joseph H. Hirshhorn, 1968
Hirshhorn Museum and Sculpture Garden, 1972
Exhibitions:
Noah Goldowsky Gallery, New York. 1967.
"Synchromism and Related American Color Painting,
1910–1930." Circulated by The Museum of Modern
Art. February 4, 1967–June 17, 1968. Organized by
William C. Agee (not listed in leaflet).
Hirshhorn Museum and Sculpture Garden, Washington,
D.C. "Inaugural Exhibition." October 1, 1974–
September 15, 1975.
Literature:
Judson, *Bruce*, discussed pp. 58, 60, 64–65.
Wolf, "Bruce," illustrated fig. 8 (mistakenly identified
as belonging to the Carnegie Institute),

discussed pp. 81, 83.
*The Hirshhorn Museum and Sculpture Garden, Smith-
sonian Institution* (New York: Abrams, 1974), illus-
trated p. 270.

Two erasures and one alteration were made in the painting.
First, the originally strong line that ran the full height of
the "vertical bar" at its right side was weakened, thus con-
siderably diluting Bruce's division of the bar into two
planes, one frontal, the other a side view. The erasures are
both in the vertical concave element at the right rear; one,
the line defining both the back of the table and the far side
of the vertical shape, the other the line completing the top
front edge of the vertical element. Although this is similar
to a destroyed painting shown in "L'Art d'aujourd'hui"
exhibition of 1925 (D21), this painting has the same
format and facture of Bruce's 1928 paintings. There is a
possibility it is a refinement of the painting Bruce exhibited
in 1925 and destroyed, and thus would date c. 1925–26.

D25. ☐ Peinture/Nature morte, c. 1928
Oil and pencil on canvas, 34½ x 45 in (87.6 x 114.3 cm)
Collection:
Mr. and Mrs. Ahmet Ertegun, New York
Inscription:
116 x 89 50F *Grande barre bleu rose verticale* #14
(*tableau plus clair pas fini du tout*)
Provenance:
Artist

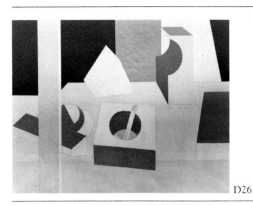
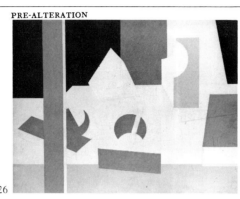
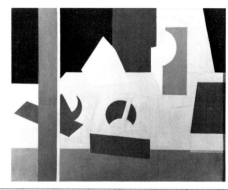

D26

D27

Henri-Pierre Roché, 1933
Mme Henri-Pierre Roché, 1959
M. Knoedler & Co., Inc., New York (on consignment)
 1965–67
Noah Goldowsky Gallery, New York, 1967
Charles Byron
Mr. and Mrs. Ahmet Ertegun
Exhibitions:
 Noah Goldowsky Gallery, New York. 1967.
 Davis and Long Co., New York. "The Designer
 Collects." September 23–October 9, 1975.

This is the most extensively altered of the many late Bruce
still lifes that were changed before they arrived in the
United States. A comparison of the 1964 photograph with
the painting reveals that the vertical bar has been entirely
repainted, and both the lower portion of the "book"-shaped
object at the left as well as the entire analogous shape at the
right, left unpainted by Bruce, have been filled in with
colors Bruce did not choose. In addition, areas of the draw-
ing have been erased, so that the painting diverges signifi-
cantly from the state in which the artist left it.

D26. ☐ Peinture/Nature morte (presently entitled
 Abstract). c. 1928
 Oil and pencil on canvas, 35 x 46 in (88.9 x 116.8 cm)
 Collection:
 Museum of Art, Carnegie Institute, Pittsburgh, gift of
 G. David Thompson. 56.47

Inscribed on back of canvas:
 Ceci est un Patrick Bruce. H. P. Roché
Provenance:
 Artist
 Henri-Pierre Roché, 1933
 Rose Fried Gallery, New York
 Museum of Art, Carnegie Institute, 1956
Exhibitions:
 "From Synchromism Forward: a View of Abstract Art
 in America." Circulated by the American Federation
 of Arts. November 12, 1967–November 17, 1968.
 No. 9.
 Albright-Knox Art Gallery, Buffalo, N.Y. "Plus by
 Minus: Today's Half-Century." March 3–April 14,
 1968. By Douglas MacAgy. No. 22. The painting was
 released from the American Federation of Arts exhibi-
 tion for this show.
 Dallas Museum of Fine Arts, Dallas. "Geometric
 Abstraction, 1926–1942." October 7–November 19,
 1972. No. 10. Illustrated.
Literature:
 Judson, *Bruce*, discussed pp. 56–58, 60, 62–64, 78–79, 86.
 Museum of Art, Carnegie Institute, *Catalogue of Paint-
 ing Collection* (Pittsburgh: Museum of Art, Carnegie
 Institute, 1973), illustrated plate 74, mentioned p. 30.

D27. ☐ Peinture/Nature morte (presently entitled
 Formes). c. 1928

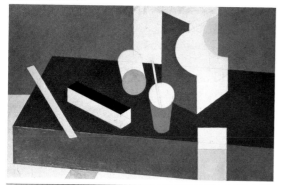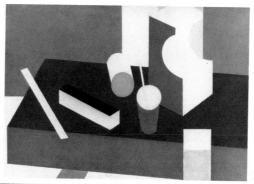

D28

Oil and pencil on canvas, 35 x 45½ in (88.9 x 115.6 cm)
Collection:
 Allen Memorial Art Museum, Oberlin College, gift of
 Mr. and Mrs. Bruce Swift and Mrs. Ruth Roush. 70.61
Inscription:
 116 x 89 50 F grande barre grise verticale #11
 pas tout à fait fini
Provenance:
 Artist
 Henri-Pierre Roché, 1933
 Mme Henri-Pierre Roché, 1959
 M. Knoedler & Co., Inc., New York (on consignment),
 1965–67
 Jon Streep
 Noah Goldowsky Gallery, New York, 1967
 Allen Memorial Art Museum, 1970
Exhibition:
 Noah Goldowsky Gallery, New York. 1967.
Literature:
 Michel Seuphor, *Dictionary of Abstract Painting with a
 History of Abstract Painting* (New York: Tudor,
 1957), illustrated p. 139.
 "Accessions," *Allen Memorial Art Museum Bulletin,*
 vol. 28, no. 3 (spring 1971), p. 237.
 "Acquisitions," *Art Journal,* vol. 30, no. 4 (summer
 1971), illustrated p. 394.
 "Recent Accessions of American and Canadian
 Museums, January–March 1971," *Art Quarterly,*

vol. 34, no. 3 (autumn 1971), illustrated p. 383.

The major alteration was the erasure of almost the entire
curvilinear shape juxtaposed over the irregular rectangle, at
center right, which cuts the edge of the canvas. All that
remains is the left section on the table plane, eliminating
the original fusion of the two elements. Erasures were also
made in the mortar and pestle at the center; the line of the
lower arc of the mortar has been removed, as has the exten-
sion of the pestle that originally intersected that arc. In its
original state, the pestle appeared as being simultaneously
both *in* the mortar and lying *on top* of it, another of Bruce's
myriad formal complexities. As it is now, the pestle appears
to have been placed directly into the container at a sharp
angle.
 Lines that defined the back, front, and bottom edges of
the trapezoid on the side near the front of the table
(between the "vertical bar" and mortar) have been erased,
and thus weaken the structure of that element. Lastly, the
pencil line that extended the left edge of the table through
the full unpainted area of the trapezoid has been thinned
and reduced by approximately half its original length.

D28.□ PEINTURE/NATURE MORTE. c. 1928
 Oil and pencil on canvas, 23½ x 36¼ in (59.7 x 92.1 cm)
 Collection:
 Josephine Cockrell Thornton, Washington, D.C.
 Inscription:

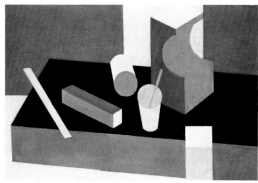

D29

92 x 60 30 M *Verre avec paille pas fini* #2
(peu d'objets)

Provenance:
Artist
Henri-Pierre Roché, 1933
Mme Henri-Pierre Roché, 1959
M. Knoedler & Co., Inc., New York (on consignment),
 1965–67
Noah Goldowsky Gallery, New York, 1967
Josephine Cockrell Thornton, 1967

Exhibition:
Noah Goldowsky Gallery, New York. 1967.

From the left, the following alterations were made: the lines
at the back and front edges of the table that ran through
the flat "ruler" have been erased; those defining the front
top plane of the vertical concave element have been short-
ened and weakened, as has the line extending the back edge
of the tabletop through the vertical shape. Finally, the line
of the front edge of the table, which was drawn through the
upper portion of the shortened "vertical bar" at the lower
right, has been completely removed.

In an interview with William C. Agee in Paris on Feb-
ruary 12, 1964, Helen Hessel, a close friend of Roché's,
identified this painting as the one Bruce lent her in 1928.
It hung in the apartment she had just moved into that year,
until 1932, when she vacated the flat. We learned later, from
a letter of 1928 from Bruce to Roché (month and day
uncertain*), that in fact Bruce had lent her two paintings
that year.

D29. □ PEINTURE. c. 1929–30
Oil and pencil on canvas, 23¼ x 36 in (59.1 x 91.4 cm)
Collection:
The Museum of Modern Art, New York. Gift of G.
 David Thompson, Mrs. Herbert M. Dreyfus, Harry J.
 Rudick, Willy Baumeister, Edward James, and
 Mr. and Mrs. Gerald Murphy Fund, 1978
Provenance:
Artist
Henri-Pierre Roché, 1933
Jon Streep
B. F. Garber
The Museum of Modern Art, 1978
Exhibitions:
Salon d'Automne, Paris. November 1–December 14, 1930.
 No. 352.
Agee, *Synchromism*. No. 14. Illustrated in catalogue,
 plate 3, discussed p. 36.
Whitney Museum of American Art, New York. "The 1930's:
 Painting and Sculpture in America." October 15–Decem-
 ber 1, 1968. By William C. Agee. No. 12. Illustrated.
The Museum of Modern Art, New York. "Recent Acquisi-

*Letter in the Roché Archives, Humanities Research Center, University of
Texas at Austin.

D30

tions: Painting and Sculpture." September 12–November 26, 1978.

Literature:

William C. Agee, "Synchromism and Color Principles in American Painting, 1910–1930," *Art in America*, vol. 53. (October–November 1965), illustrated p. 77.

Barbara Rose, *American Art Since 1900: A Critical History* (New York: Praeger, 1967), illustrated p. 96, mentioned p. 95.

Judson, *Bruce*, discussed pp. 57, 60, 89, 91, 93.

Barbara Rose, *American Art Since 1900* (New York: Holt, Rinehart & Winston, 1975), revised and expanded edition, illustrated p. 76, mentioned p. 75.

Agee, "Bruce," illustrated p. 24, discussed p. 29.

The painting has always been dated c. 1929–30 (Agee, *Synchromism* and Agee, "Bruce"). Recently, Céline Fildier* has reported that she is positive this was the painting she saw at the 1930 Salon d'Automne, providing a *terminus post quem* of October, 1930.

D30. PORTRAIT OF A WOMAN. 1936
Charcoal on paper, 24 x 18 in (61 x 45.7 cm)
Collection:
Virginia Payne Ahrens, Bracciano, Italy
Provenance:
Artist

Mary Bruce Payne, 1936
Virginia Payne Ahrens

The drawing was done sometime after Bruce returned to the United States, in August 1936. Virginia Ahrens also owns another, a half-length portrait of a boy, but has not been able to locate it. Mrs. Ahrens remembers that Bruce probably based the drawing on a photograph from a current magazine.* At the end of his life, Bruce thus recalled the years 1913–14, when he and Frost had worked from photographs, and even earlier, when he had made free copies of Old Masters from reproductions, some thirty-five years before when he was a young art student.

LOST WORKS: 1917–36
(No photographs known to exist)

1. Twenty paintings done between 1933 and 1936, in Versailles.
2. Charcoal drawing, similar in technique to D31, done in New York between August and November 1936. Collection of Virginia Ahrens, but work has not been located.

*Interview with Barbara Rose, February 1979.

*Interview with Barbara Rose, October 1978.

DOCUMENTS

THIS SECTION contains biographical and critical documents extending from early 1904 to 1950. Published documents are not always arranged in the order in which they appeared, but rather according to the period of Bruce's life and career to which they refer.

In the earliest, we can see Bruce as an earnest young artist, trying to find his way in Paris, and looking to his old teacher Robert Henri for advice and guidance. The two letters to Henri establish that for his first two years in Paris (he had arrived in either late 1903 or January 1904) he was largely immune to newer French art and was still working in the bravura style of Henri, Chase, and Sargent.

The du Bois account refers first to late 1905 and 1906, when Bruce was gradually becoming surer of himself and his painting. It is particularly valuable because it reveals Bruce's absolute, uncompromising seriousness as an artist, a trait that marked his entire career, as well as the profound changes he underwent over a period of twenty years. The Toklas and Stein memoirs impart a sense of Bruce's increasing participation by 1908–09 in the Paris avant-garde; his letter to Gertrude Stein, probably written in the late spring of 1912, is amusing in that he is trying to imitate or playfully mock Gertrude's style. Charles Caffin's article on Bruce's exhibition in New York at the Montross Gallery in 1916 is a sensitive illumination of his work from 1908 to 1912. The Apollinaire and Salmon reviews of the 1913 and 1914 Salons incisively demonstrate the high esteem with which Bruce was held in these years.

In her description of the 1916 Compositions, which was published in 1923, Katherine Dreier shows a rare critical perceptiveness for the period, and provides confirmation that the source of these paintings resided in the colorful atmosphere of The Bal Bullier, the fashionable Parisian dance hall that Bruce, Frost, the Delaunays, and other artists frequented prior to World War I. Hers was the last favorable published recognition Bruce received, not only during his lifetime, but until 1950, when Henri-Pierre Roché's statement on Bruce appeared in Yale University's *Catalogue of The Collection of the Société Anonyme*. After an exhaustive search, only four references to Bruce's late work of 1917–36 have been found in the serious magazines and and newspapers of the period. Two, from *L'Esprit Nouveau*, merely list Bruce as an exhibitor in two Salons of the early twenties. The others, both of which are included here, are by Maurice Raynal, and although brief, they must surely rank among the most devastating rebuffs in the criticism of modern art. An even more stinging rejection of Bruce's work had come earlier from John Quinn, in his letter to Roché of 1920. Small wonder that in the twenties Bruce became more and more withdrawn and finally stopped exhibiting, convinced that his work would never be understood in his lifetime.

The letters to Roché of the late twenties and early thirties show Bruce at his most taciturn, a far cry from the eager young man and enthusiastic participant in the prewar Stein and Apollinaire circles. By this time, we can understand why Bruce was painting only for himself, reluctant even to show his work except to a few admirers, of whom Roché was the most ardent and dedicated.

The last section includes the most important document on Bruce that we have, Henri-Pierre Roché's "Memories of P. Bruce." Roché's notes, done from memory and without the aid of documents, were originally written and typed out in French, in two versions, both of which were dated March 10, 1938. One version (Text I) was "corrected," according to Roché's handwritten notes on the manuscript, on November 10, 1947. The other version (Text II) was also corrected with handwritten additions and deletions and sent, again according to Roché's notes on the manuscript, to Katherine Dreier on December 21, 1948, for publication in the Yale University *Catalogue of the Collection of the Société Anonyme*. However, certain sections of Roché's text were entirely omitted and still other key phrases omitted or changed in the English translation that was published by Yale in 1950.

Using Text II as the basis, we are incorporating here a synthesis of the complete Text I and Text II, which has been translated from the French. Roché made his "corrections" in ink, leaving the typewritten words clearly visible in the original manuscript of Text II; these are retained in brackets. The significant phrases from Text I that did not appear in Text II are inserted in italic type. Thus the synthesis contains all of Roché's original observations made in 1938. The document, unpublished until now, sheds new light on Bruce. In order to transmit Roché's original thoughts as fully and accurately as possible, the translation is kept quite literal, including the structure of sentences and paragraphs.

List of Documents

BRUCE TO ROBERT HENRI, MARCH 23, 1 9 0 4

Your last in which you kindly agree to frame picture & send to Ex.— was received and fully appreciated, and I am sincerely sorry I have naught but words to thank you.

You must know that to a fellow in my position, young in the game, and with few friends and no influence, such kindness as you have extended to me makes me truly glad and grateful. . . . I hope and trust that I may be able some day to show some substantial gratitude

and in the meantime profit by your encouragement and live up to your hopes—

Of course I am delighted for you to have the picture and send it wherever you like and price it accordingly—I should have enjoyed seeing the show at the school. . . .

I have seen your friend Mr. Morrice again. He is always very kind . . . He advised me to send to the New Salon, in preference to the Old, as the New, he assured me, was the best show by far—I did so, and heard from them yesterday. Had three pictures accepted—A full-length portrait of Miss Kibbey (a student at N.Y. School last year), three-quarters of Man in Blue cape, and head of child laughing—I wish you might have seen them, as I think they are the best things I have done, and show improvement—I send you inclosed [sic], very indifferent photos of the Man in Cape & head of boy—taken by a friend, but very poor—The man I picked up off the street & painted. He was extremely interesting; deep sunken eyes that peered forth questioningly—The photo does not give it, but I treated the blue cape & black hat in the silhouette, and the face & hand as the only light spots & these modelled only by the silhouette (on the edge). The boy too struck my acquaintances here as having much character, and I thought it was very human— . . .

Agihora (you remember the Jap!) comes around to see me quite often and I enjoy him thoroughly . . . and 'tis good to see someone I knew in N.Y. He is quite disgusted with Parisian Schools and longs to be back in N.Y. under your instruction . . .

I have invited him round to my studio to paint, thinking he might enjoy working from my model . . .

. . . I often miss the fellows and the old times.

Glad Cedrequist won prize— . . .

I hear nothing of America here, & nothing of American exhibitions—. . . .

Collection of American Literature, Beinecke Rare Book and Manuscript Library, Yale University

BRUCE TO ROBERT HENRI, FEBRUARY 23, 1 9 0 5

I received your fine letter of Dec. 25th, telling me all about the good times of the School, the controversy. . . . the Simple Palette . . . & it

made me wish for the old days again when I was there—I don't think I have had such good times again as I enjoyed at the N.Y. School of Art & I often wish that they had not ended—

I regret that you are so undecided about coming over now, as I had hoped to see you & have you see some more of my stuff—but I am glad you are so well pleased in the Spanish Model—I should think she would be quite a treat—

I have just received your second letter today—All about the Phila. Academy show . . .

I am glad you are frank in letting me know your exact opinion of my picture & I appreciate it—I agree with you entirely as to how most of the human creatures are presented foolishly & uninterestingly & in a character they do not possess—and one longs for a bit of real appreciative & really truthful painting, all of which I thought mine had— (you will pardon my stubbornness) but I trust to be able to express myself better in my next—Have done lots of things since I painted that—for 'twas a year ago now, & hope these later ones are much better—I wish you could see them—

I also appreciated your extreme kindness in offering to send the Picture to the Society Show. . . . Mr. Mora wrote me some two months ago that if I had anything that was to go to N.Y. he would look after it for me—& when I rec'd your first letter telling me of how I could send the Picture from the Phil. Show to the Society N.Y. . . . I wrote Mora—to attend to it for me. . . .

You had put yourself to so much trouble with the portrait of Hedges that I did not have the heart to ask more of you— . . .

I read excitedly the news you wrote me of the Pa. Academy Ex. & longed to see it—We have such poor shows in Paris, with the Exception of the Salon, for most of the local shows—as you will remember— are too sweet for words—that when I hear of the Exhibits at home I feel that I am losing a great deal not to be able to see them—Wish heartily I could see the portrait of Fitzgerald by Glackens that you like so . . .

Well, I've worked pretty hard since I've been here though I've done little, but trust it may come out later, and just finishing up somethings now which I intend sending to the Salon—one is the full-length Portrait of a Frenchwoman--which I should like especially for you to see. If things turn out well I hope to have some good things at the Phila. show next year & in N.Y. also. After sending-in-day for the Salon I hope to go to London for a stay of two or three weeks in the Galleries there & to see the Whisler [sic] Ex.—all of which I hope will rest me up & may the change produce some new ideas & new work—

Mr. Morrice was kind enough to come up to see me some time ago, & I trust I profitted by it—I think he does some wonderful stuff—

I presume you have heard of my engagement to Miss Kibbey?—Do you remember her in the School? She painted a portrait of her little sister while there that you liked—I consider myself very lucky & only hope that art may some day permit me to marry—

Maurice Sterne is in Paris with a studio opposite mine & he has asked me to present his regards to you. . . .

And for the Hedges—I am delighted that you should send it any where you should think best, but if there are any changes let me know —& please believe me very grateful for your interest. . . .

Collection of American Literature, Beinecke Rare Book and Manuscript Library, Yale University

Guy Pène du Bois, 1940

Among those in the Henri class who have since made names for themselves are George Bellows, Gifford Beal, Homer Boss, Patrick Henry Bruce, Glenn O. Coleman, Arnold Friedman, Edward Hopper, Rockwell Kent, Walter Pach and Vachel Lindsay, who was advised to desert painting for poetry by Henri himself. For four or five years until 1905 I was the monitor of that rough-riding class. I use this term advisedly, for its members delighted in the Rooseveltian contribution to the color of the period: the word "strenuous." They took up boxing, handball, all sorts of gymnastics, chinning themselves with the lightest finger grips over all the door lintels. Their baseball team was always victorious, even against those of such larger art schools as the National Academy of Design and the Art Students League further west on 57th Street. They had physical encounters with the students of the League which were presumably proscribed by the academic teaching of Kenyon Cox. These brawls occurred in the school buildings. Police reserves were called to stop an exception- ally violent one at Chase's. Here were art students who could glory in bloody noses, point with pride to the black eye of an evangelical dispute with blacker academicism. This class disintegrated naturally

enough afterwards, but for a time it was an almost miraculously inspired closely knit unit. *(p. 89)*

Patrick Henry Bruce, famous in the Henri school days for his portrait of a delightful hunchback named Hedges, lived in a small studio house set in a garden on the Boulevard Arago. He had not yet heard of the neo-impressionists, cubists, fauves, though he was to study under Matisse. His house became a rendezvous for Americans. He painted enormous full-length figures which narrowly but always escaped looking like Whistler's. Here art was talked of seriously, frowningly, with no funny business. One heard of the tremendous problem involved in painting a white egg on a white tablecloth or a black chunk of coal on black stuff. Maurice Sterne once, in Bruce's sunny garden, discoursed at length on painting a necklace bead by bead. Impressionism and its sloppiness was a thing of the past. Things must now be "realized." Bruce, whose sense of humor was not easily touched, wondered whether life was worth the trouble the painter took in the effort to renew its existence on canvas. Life had often punctured his arrogance. It was a thing, that arrogance, he held to and liked, and it was always being punctured by some giggling indignity. If art begins where representation ceases, as Oscar Wilde said, then why drag in representation? Some years later Bruce had an exhibition of abstractions at the Montross Gallery in New York.

As enormous as his full-lengths, the canvases were covered with colored squares of varying dimensions which seemed to be going nowhere in a sort of blue heaven. Some thought must have been in them, a matter of taste perhaps or of some undisturbing memory of a purity once sensed, something besides that resemblance to a patchwork quilt which, in my meanness or innocence, is all that I saw in it. But then painters have the advantage or disadvantage over virtuosos that the notes of their exercises are not lost upon being played. Cézanne's, for an example of the disadvantage, were saved and shown by Vollard, his over-solicitous friend, when he had left them to rot in the field.

I saw Bruce again in Paris after almost twenty years. We were walking in a dark stretch of the Boulevard Raspail when we hailed each other as though we had last met a day or so ago. Somehow, seated at the Dôme, we went on where we had left off in the Boulevard Arago. The change in him was greater than in me. Perhaps I wear a harder crust. But though he was then in the antique business and had deserted painting, he still talked fervently about it. He had

examined life with rather more condescension than I had known him to have before and had taken painting apart and gone over it piece by piece with, I suppose, a comparative weighing in mind. Painting would never be put together again in this machine age. As a matter of fact, he suspected that it had never been well done since Mantegna. There was austerity after his own heart. The average man is mushy. But Bruce had become suspiciously Parisian, succeeded in supplanting the doer with the talker, seeking to be entertaining rather than combative or convincing as in the earlier, less urbane days. He had rubbed off a lot of cutting edges and become cosmopolitan, a cosmopolitan whose heart still clung to the hard manly virtues of a Mantegna. A smooth surface slips more easily through life. This knowledge gives its reward in repose. *(pp. 110–112)*

Guy Pène du Bois, Artists Say the Silliest Things *(New York: American Artists Group, Inc./Duell, Sloan and Pearce, Inc., 1940), pp. 89, 110–112*

Alice B. Toklas

She introduced a good looking red-haired man, Pierre Roché, who spoke a smattering of several languages including Hungarian; Hans Purrmann, a German painter devoted to Matisse; Patrick Henry Bruce, who with Mrs. Michael Stein had persuaded Matisse to open his school; Sayen, who had been an electrical prodigy at the Thomson-Houston Company but had given it up to come to Paris to paint; a group of Montmartrois who surrounded Picasso like the cuadrilla does a bullfighter; Braque; and Chremnitz, who could sing "The Old Kent Road" with a marked French accent. Also there were Apollinaire, the Spanish painter Pichot, and the false Greco who made jewelry. *(p. 28)*

There was a great deal of disagreement amongst the students, and a good deal of jealousy of Sarah Stein's intimacy with Matisse as the result of the purchases of his pictures by the Mike Steins. Pat Bruce used to come over to the rue de Fleurus after a short visit to the rue Madame on Saturday evenings. Bruce had a sharp eye and a sharper tongue. He thought Sarah Stein overdid the admiration of Matisse, as man not as painter, for Bruce was a sincere follower of the Matisse school of paintings. He said about this time that it was not the struggles of the great painters that were pitiable but of the minor painters. Was he not one?

Bruce agreed with the opinion of Matisse concerning Picasso,

unsympathetic as a man and less than negligible as a painter. Matisse had said that Gertrude's feeling for Picasso and her visits to the rue Ravignan were for the spectacle that she saw there. Gertrude, hearing this, let out one of her fine large laughs. She was not even angry. But I commenced to have my opinion of *cher maître*. (*pp. 38–39*)

Alice B. Toklas, What Is Remembered (*New York: Holt, Rinehart and Winston, 1963, first edition*), *pp. 28, 38–39*

Gertrude Stein, 1 9 3 3

A. B. Frost complained to Pat Bruce who had led Frost [Arthur B. Frost, Jr.] to Matisse that it was a pity that Arthur could not see his way to becoming a conventional artist and so earning fame and money. You can lead a horse to water but you cannot make him drink, said Pat Bruce. Most horses drink, Mr. Bruce, said A. B. Frost.

Bruce, Patrick Henry Bruce, was one of the early and most ardent Matisse pupils and soon he made little Matisses, but he was not happy. In explaining his unhappiness he told Gertrude Stein, they talk about the sorrows of great artists, the tragic unhappiness of great artists but after all they are great artists. A little artist has all the tragic unhappiness and the sorrows of a great artist and he is not a great artist.

The Autobiography of Alice B. Toklas (*New York: Harcourt, Brace and Company, Inc., first edition 1933*), *p. 140.*
© Random House, Inc.

To Annette Rosenshine, Berkeley, California, June 30, 1 9 4 8

5 rue Christine, Paris VI

Dear Annette —

For weeks I've been wanting to write to you but there has been a veritable invasion of compatriots and other foreigners and they— friends and acquaintances and correspondents—fill the flat and my time. But as they come because of Gertrude there seemed to be nothing else to do. Do you remember [Patrick] Bruce (with a gold beard and a son named Tim). After Blériot flew the channel he said one day—Mark my words—we'll live to see them flying to Paris to spend the week end. And a few literally do.

© by William Naughton and Arthur Davis. Reprinted in *Burns, Edward, ed.,* Staying on Alone: Letters of Alice B. Toklas (*New York: Liveright, c. 1973*), *pp. 123–24*

Bruce to Gertrude Stein. Undated but probably late spring 1 9 1 2

Summer's in Spain, Spring is in Paris and Frost is here—Poor Frost [A. B. Frost, Jr. (1887–1917)], he don't seemed [sic] much improved by the sanatorium. He used to box & play & enjoy exercise & now he is afraid to go up steps fast. That's 'cause he's cured—He is much changed in other ways & I sometimes think that the Frost we knew will never be again—There is no telling what a person will do if they get in entirely good health, if all bodily functions work perfectly. Why, they will sometimes not do anything. Frost don't do anything and gets tired—He don't even talk much—He thinks a great deal— thinks before he speaks. That's awful tiresome in Frost—He used to speak right out and people would be amused & laugh & enjoy him & themselves. But this is in the past, just as he thinks before going up the steps, so he thinks before speaking. Frost only does things that are healthy and wise now—He has had a cure—He has spent a year in a sanatorium with Hungarian nobility and he is very careful. He regrets that his father & mother know such a poor class of Americans and he regrets that Jack has tuberculosis—Frost was very impressive in the sanatorium—He never laughed but looked into the dictionary instead—People said it was a pity he was sick he so wanted to work— The Hungarian Nobility were very kind to him & he was admitted where the crowd was not and he has learned that money is power & that Father & Mother have qualities after all—Frost said the other day to me, casual like—Did you ever know many Counts? What? says I—people with handles to their names, says he—No, not many, says I.

Night before last we went to see Leo—Frost and I. Leo spoke heartily for 2½ hours on the ineficiency [sic] of sanatoriums and the foolishness of the tuberculosis cures and then I asked what time it was. Leo & Frost both looked at their watches—& Leo said his was 10 o'clock and Frost said his was 12 o'clock—I presumed that the difference in their watches was that Leo was talking & Frost was listening. Then Frost & I came home. Helen was very glad to see us because Leo had sent her some pain d'epice—

Helen says Frost is a purse-proud conceited ass and a snob—and doesn't care whether he goes to the country with us or not—Frost says

he will go with us—that he would prefer traveling with a Hungarian count or a rich American seeing the world a little but he can't find one to go with him—and that next to that he likes going with us— . . .

Collection of American Literature, Beinecke Rare Book and Manuscript Library, Yale University

CHARLES H. CAFFIN, "Significant Still Lifes by Bruce," 1 9 1 6

Paintings by Patrick Henry Bruce are being shown at the Montross Gallery until December 9. Brought up in Virginia, he studied one year at the New York School of Art before he went to Paris. Here, for a while, he was a pupil of Matisse, whose school he left to become an independent student of Renoir and Cézanne.

UNION OF RENOIR AND CÉZANNE

It is their influence that is directly revealed in the present exhibition; that of Matisse having operated, no doubt, in a general tendency toward organization. But the flat patterning that characterized Matisse's earlier compositions is not reflected here. On the contrary, there is very marked preference for three-dimensional construction, and it is this, prompted by Cézanne's example, that very strongly affects what Bruce has derived in the way of color from Renoir. In fact, it is in the happy union of these two influences that he exhibits his own individuality.

Most of these pictures are still lifes. Now we scarcely need to remind ourselves that the motive of a still-life picture is not primarily to imitate objects, but to use them as the basis of an arrangement or creation of something aesthetically beautiful. Yet there is a difference between the way in which this conception used to be and is now being interpreted.

The older way, originating with the Dutch and continued by modern painters, such as Villon and Chase, reproduced very faithfully the actual characteristics of the objects. The impressionists were disposed to do the same, but in their increasing tendency to illumine the objects with full sunlight, merged the insistence of the forms in orchestration of color. Their motive, in a word, as realized, for example by Renoir, became increasingly abstract.

Then came Cézanne, who, while aiming at abstract expression, restored plasticity to the forms and sought to relate them to one another in a composition that was actually structural in three dimensions. Thus he aimed to base the abstract expression on what the musician would call a more thoroughly articulated and organic counterpoint. By this time the composition is no longer an arrangement; it is becoming a creation.

AN ADVANCE OF MOTIVE

Here is where the younger men, like Bruce, have taken up the motive. To pursue it demands a keen sensibility to color and a capacity of reasoning out one's sensations, joined to a vivid feeling for structural organization. All these qualities appear in Bruce, evidently cultivated by a more than usually close study and thoughtful comprehension of the lessons of Renoir and Cézanne. The result is something that I sense to be in the direction of advancing the motive of both these artists.

Italian Faience and Tapestry, for example, and *Fruit and Italian Faience*, seem to me to present color compositions fully as complex as Renoir's and at once more elaborated and compact; more thoroughly organic, orchestrated. They are built up into a structure of color relations that is comparable to the composition of sound relations. And they create in one's imagination the sensations of music.

Again I would single out *Quinces, Bananas and Ginger Jar* and *Still Life with Red Apple*. Although these involve the same principle of organic building up, they differ entirely from the former in character. They have a bigness and ample simplicity of architectonic structure. They follow the example of Cézanne's landscapes, and he, the pathfinder, as he called himself, would have rejoiced, I believe, to see how far it has carried his disciple in the direction of expression.

UNUSUALLY BIG AND ABSTRACT

For my own part I feel the expression to be quite extraordinarily big and just as surprisingly abstract. The objects are there; I can identify them; but in the total impression, they dissolve into the magnitude of the expression. I found myself thinking of the Red Apple picture as being as big as a village and of the other as being as big as a mountain side in nature. And I set this down simply as it came to me, because it represents my spontaneous reaction to an expression, ampler and more significantly abstract, than I can remember to have hitherto experienced in a still life.

Charles H. Caffin, "Significant Still-Lifes by Bruce," NEW YORK AMERICAN, *Monday, November 27, 1916*

GUILLAUME APOLLINAIRE, MARCH 18, 1 9 1 3

The Neo-Impressionists' room, with Signac, Luce, and Mme Cousturier, will long detain the visitor. This room is playing a key role this year, since it is from Seurat, their initiator, or at least from a portion of his experiments, that the painters who for the first time are exhibiting canvases in the category of aesthetic Orphism also claim descent. This tendency is demonstrated heroically in Delaunay's gigantic entry, *The Cardiff Team, Third Representation,** in Fernand Léger's *Female Nude,* in Bruce's landscapes, in Mlle Laurencin's *Fashionable Ball,* also in Albert Gleizes's *Football,* and even—yes, even— in Metzinger's *Blue Bird.*

Guillaume Apollinaire, "Le Salon des Indépendants," L'INTRANSIGÉANT, March 18, 1913. (Reprinted in CHRONIQUES D'ART, L. C. Breunig, ed. [Paris: Librairie Gallimard, 1960], p. 292.) This and the following reviews by Apollinaire were translated from the French by John Shepley

GUILLAUME APOLLINAIRE, APRIL 2, 1 9 1 3

Bruce—I write this name for the first time**—a daring painter; the zones (this excellent term, which applies to single colored light masses, has been suggested by M. Fernand Roches, editor of the admirable art magazine *L'Art décoratif;*† I am adopting it), the zones in his pictures are almost the living representation of nature. One more endeavor.

Guillaume Apollinaire, "Salon des Indépendants," L'INTRANSIGÉANT, April 2, 1913. (CHRONIQUES D'ART, p. 296.)

GUILLAUME APOLLINAIRE, NOVEMBER 14, 1 9 1 3

In Roger de La Fresnaye's *Conquest of the Air* there is a great effort toward pure color; we are almost in those simultaneous contrasts of which here there is only one other example—Bruce's *Compositions.*

*The exact title of the canvas is: *Third Representation: The Cardiff Team.* [Breunig]
**But see the introduction to the review (March 18). [Breunig]
†This term is not, however, to be found in the various articles by Fernand Roches in *L'Art décoratif.* [Breunig]

Guillaume Apollinaire, "Le Salon d'Automne, 1913," L'INTRANSIGÉANT, November 14, 1913. (CHRONIQUES D'ART, p. 337.)

GUILLAUME APOLLINAIRE, NOVEMBER 19, 1 9 1 3

The two paintings by Bruce advance this sensitive artist's cause. I have spoken of Picabia's entry. I find it very important. And the jeers change nothing. The Bruce and Picabia entries are what strikes one's gaze the most in this Salon, what one *sees best.* Now painting is done above all to be seen. I don't say that there cannot be other qualities, but the best bed is the one in which you sleep best; the other qualities, of style, ornament, luxury, only come later. These paintings have at least the first quality to a very high degree, but they have others besides. Too bad that they have blinded those whose job it is to have good eyesight.

Guillaume Apollinaire, "Salon d'Automne," L'INTRANSIGÉANT, November 19, 1913. (CHRONIQUES D'ART, p. 342.)

GUILLAUME APOLLINAIRE, MARCH 5, 1 9 1 3

I like the canvases Bruce exhibited at the Salon d'Automne better; here the subject of his canvas is so vast that I am not at all surprised if the painter has been unable to take it all in; it is entitled quite simply *Space,* or to be more precise, *Movements, Colors, Space, Simultaneity.*

Guillaume Apollinaire, "Salon des Indépendants," L'INTRANSIGÉANT, March 5, 1914. (Chroniques d'Art, p. 352.)

GUILLAUME APOLLINAIRE, MARCH 15, 1 9 1 4

M. Bruce drags us into the colored realm of realistic abstraction. His composition, however, though even less pleasing than the one in the Salon d'Automne, is more personal.

Guillaume Apollinaire, "Le 30e Salon des Indépendants," SOIRÉES DE PARIS, March 15, 1914, no. 22, 2nd year. (CHRONIQUES D'ART, p. 366.)

ANDRE SALMON, MARCH 1 9 1 4

M. Delaunay uses unmixed colors, distemper paints, with no "melodic" gradation. M. Bruce, on the other hand, treats oil in the

manner of a Renaissance painter. Making no claims to any spiritual or literary subject matter, Mme Sonia Delaunay subjects us to a strictly Slavic individuality.

Suffice it to say that M. Delaunay and his school may well help to bring back some fine manual virtues in these times when painters, having amassed so many failures, more than ever need the certainties of a trade, the fine quality of craftsmanship that is not taught in any academy. Orphism or Simultaneism seem to me risky, as regards the future of miraculously rediscovered form. It is not necessary to revert either to Fauvism or to Impressionism—and yet what I am saying here, I say for others and not for M. Delaunay and his group.

It used to be necessary to walk quite a while before finding oneself stopping in front of a characteristic work. The Simultaneists have changed all that, by decking the threshold. Indeed it is there that M. Robert Delaunay, Mme Sonia Delaunay, M. Bruce, and M. Picabia exhibit; the last, though not a Simultaneist, does not deck any less profusely.

M. Delaunay pays this worship to form, just as he imparts, by this Homage to Blériot, the feeling of a living representation. Form is shattered with Mme Delaunay, and disappears in M. Bruce.

André Salmon, "Le Salon" (Artistes Indépendants), Montjoie!, 2nd year, no. 3, March 1914 (Issue devoted to the 30th Salon des Artistes Indépendants), p. 22

Maurice Raynal, January 27, 1 9 2 2

In Room VI, Bruce is exhibiting three indisputable errors, although they are not without their charm.

Maurice Raynal, "Le Salon des Indépendants," L'Intransigéant, January 27, 1922

Maurice Raynal, November 3, 1 9 2 2

Room XV is of an especially gracious unity. And Room XVI as well. Mme Marval is the leader when it comes to agreeable colors and M. d'Espagnat follows close behind. Henri Matisse, in a corner with two canvas sketches, looks smilingly on. Aubry. . . .

One must be able to make mistakes, but not take things too literally as does M. Bruce.

Maurice Raynal, "Au Salon d'Automne," L'Intransigéant, November 3, 1922, p. 5

Katherine S. Dreier, 1 9 2 3

At about the same time that the Cubists came into prominence in Paris, there appeared another group which expressed this new idea in art. These were the Simultaneists, whose leaders were Delauney [sic], a Frenchman, and Bruce, an American. Their desire was to render motion through abstract forms of color. The reproduction given here of a painting by Bruce (Fig. 46)* is one of a series, the motive of inspiration having been the color and movement at a fancy-dress ball. Since it is only a black and white reproduction, much, of necessity, is lost, as color in all the paintings conceived in the modern spirit forms an essential part of the whole, and cannot be separated from it. In looking therefore at a black and white reproduction of any modern painting, the beauty of line and balance may be seen, but less judgment can be formed as to the complete beauty contained in the original than heretofore. Every picture has its special place from where it radiates its true value, and the beauty contained in these paintings was brought out to their full capacity when hung in a long, narrow passage of which there are many in America. In this setting they shone and sparkled like some wonderful Eastern jewels, which those who saw remarked upon; for they had conquered a serious problem of how to free those long, narrow halls from exercising a sense of depression. These pictures must not be confused with decorative panels, as often happens, especially with us in America. A decoration must retain the character of that which it is to decorate; if a wall, it must retain the flatness of the wall, as that is the inherent part of a wall, whereas pictures must have depth. As Walter Shirlaw, the mural painter and great American teacher of art, used to say:—'one must be able to walk in and out of a picture without bumping one's nose.' And this is as true of modern art as it was true of the art of the past.

Bruce has continued his research, and has developed his abstract movements to a synthetic reality, which is monumental in its

**Composition I, 1916, collection of the Société Anonyme, Yale University Art Gallery (cat. no. C11 and color plate 9). In the text, it was entitled Forms, with no date*

expression. It is interesting to note that Carrà, one of the Italian Futurists, has done the same, though his works represent less of the monumental. This is another evidence of how astray one can go when judging only from appearance or externals, for the dress in which these men clothe their new ideas is forever changing, as all outer forms of necessity must. In consequence many people, seeing only the outer change, think that the new movement in art is passing.

The artists of Italy, imbued with this same desire to express the new spirit in art, called themselves Futurists. They wished to represent the coming moment. Their desire was to break up the slavish mental attitude towards time. When one studies deeply into these various movements, as they have begun to express themselves in art, one is conscious of the close relation between them and the whole modern spirit of today. Take the Futurist attitude towards time and note its relation, no matter how slight to the outward mind, with Einstein's theory of Relativity. For years scientists have been working on this theory of time in connection with space, and it is not a mere coincidence that there should have arisen a group of artists at the same period who were trying to express the effect of these thoughts in their new conception of art. It all belongs to the spirit of the new era. It is the same spirit which impregnated itself upon the French and Spanish artists, who called themselves Cubists, or Bruce and Delauney, who called themselves Simultaneists; it is only the angle of vision which differs.

Katherine S. Dreier, 1 9 2 3, WESTERN ART AND THE NEW ERA: AN INTRODUCTION TO MODERN ART *(Brentano's, New York, 1923), pp. 95–97*

HENRI-PIERRE ROCHÉ TO JOHN QUINN, NOVEMBER 15, 1 9 2 0

Bruce, P. H. American painter in Paris—has exhibited in 1916 at Montrosse [sic] in N.Y. not very significant paintings—has developed [sic] artistic and personal [sic] afterwards. Miss K. S. Dreier has some of his second period works in her flat in N.Y.—but she does not keep interest in his third period of which I enclose some small photographs just to give you an idea.

Bruce works hard (*comme le diable*) without any recognition, without wanting (almost) recognition—his work is very strong, simple, evident, powerful, constructed—brutal, some would say (not I).

I do not think it is possible that he has not an important meaning—hard to crack and discover, undiscovered yet, but quite real and certain. He is a living protest, more than anybody, against the chief vices of almost all painting of today: is that reason enough to make a venture? (virtue). Yes, if I consult the history of art—I leave it to you. Do you want to see some big and good photographs of his work?

John Quinn Memorial Collection, Manuscripts and Archives Division, New York Public Library, Astor, Lenox and Tilden Foundations

JOHN QUINN TO HENRI-PIERRE ROCHÉ, DECEMBER 8, 1 9 2 0

. . . There was also enclosed in your letter photographs of three paintings by Bruce. I knew him as an American. . . .

I return you herewith the three small Bruce photographs which you sent. I haven't the slightest doubt that Bruce works hard, but that does not mean art. So does Jacob Epstein, the English sculptor, work hard. Bruce is trying to evolve some new architectural thing, but it seems to me that with all his hard work and with all his strength he is attempting the impossible.

Granting that he works hard, granting that he does not fight for recognition, granting that his work is "strong," granting that his meaning is hard to crack and discover or is undiscovered yet, granting that he is a protest, more than anybody, against the chief vices of almost all painting—I come to your question whether "that is enough to make a virtue." I answer yes, that maybe enough to make a virtue of industry, a virtue of persistence, a virtue of disinterestedness, but not art. . . . His work seems to be very English, like furniture, English cubism, quite lacking in taste, and while it may be drawing, or it may be architecture, it certainly is not painting. It lacks the smear, the plastic quality.

John Quinn Memorial Collection, Manuscripts and Archives Collection, The New York Public Library, Astor, Lenox, and Tilden Foundations

BRUCE TO HENRI-PIERRE ROCHÉ, MARCH 12, 1 9 2 8

Dear Roché,

The shipment has got off at last and I feel greatly relieved. I have decided to finish up the pictures I have on hand. There should be about ten, incomplete, for which I have all the elements necessary, so that it should not take long to bring them to a final state.

If you and your friend want to postpone your visit for still a month longer I shall have a much more interesting collection to show you. I shall be glad then to see some of them in her flat, to see how they look outside of my own.

In the meantime if you are passing or want to drop in I am always here at two o'clock and shall always be glad to see you both.

With best wishes,

As ever,

Bruce

6, rue de Furstenberg, VIᵉ

Original now in possession of William C. Agee

BRUCE TO HENRI-PIERRE ROCHÉ, MARCH 17, 1 9 2 8

Dear Roché,

I was very happy to receive your note and to learn that you are to have such a nice trip. I hope you enjoy it thoroughly and that it will not be disappointing in any way.

I am doing all my traveling in the apartment on ten canvases. One visits many unknown countries in that way.

You should be well prepared to appreciate my paintings after Greece. Come to see me immediately upon your return and we will compare notes.

Give my regards to Mrs. Hessel and thank her for her interest. I shall be glad to see her too.

Again wishing you a successful trip.

As ever,

Bruce

Original now in possession of William C. Agee

BRUCE TO HENRI-PIERRE ROCHÉ, JULY 3, 1 9 3 3

Dear Roché,

I had to give up Paris and come to Versailles to live on account of my health.

I destroyed all my paintings with the exception of twenty-one canvases which are in a remise in the Quai Malaquai and I want to get rid of these before July 15th.

If either you or Mrs. Hessel would take them I should be very glad to give them to you.

Kindly let me know at once if you will take them. Perhaps you would like to see them first in which case I could meet you in Paris at the remise and show them to you or to Mrs. Hessel.

With best wishes to you both,

Sincerely,

P. H. Bruce

18, rue de la Bonne Aventure,
V E R S A I L L E S
 S. et O.

Original now in possession of William C. Agee

BRUCE TO HENRI-PIERRE ROCHÉ, JULY 30, 1 9 3 3

Dear Roché,

I am glad you have the paintings and that you like them.

As to my intentions regarding them, I have none. You are the only person in the world who likes them. If it were possible to sell them I should say do so and we should each take half of the proceeds, but selling them is out of the question.

I am leaving for a trip now and unfortunately cannot see you next Wednesday as you propose, but will let you know when I return and should be happy to receive you.

As ever,

Bruce

18, rue de la Bonne Avventure,
V E R S A I L L E S
 S. et O.

Original now in possession of William C. Agee

HENRI-PIERRE ROCHÉ: MEMORIES OF P. BRUCE

Henri-Pierre Roché
99, boulevard Arago
Paris XIV

I met P. Bruce in Paris in 1916.

It was Harrison Reeves, that tall boy, smiling and athletic, that American who was so Parisian, who took me to his home. Bruce lived on rue de Furstenberg, near St Germain des Prés, in a spacious old apartment painted with lime, with some well-placed antique furniture and a pleasant panorama of a courtyard and rooftops.

Bruce had a 5-year-old son* who made crocodiles and other animals out of wood and wire, painted with crude colors, which had so much life that Harrison Reeves sold them to his friends, to the profit of the child.

Bruce was an American of Scottish origin, and he had a cool manner. During these long visits I had no personal contact with him, but only with his *Negro* objects and his canvases.

One year later, in 1917, in New York, I saw his name posted in a gallery on Broadway, and I entered. I found myself before an exhibition of his works.—They were "representative" paintings, sober and fine. [I recall one of a table supporting a statue.]† His paintings were selling at a good price for those of a young American painter.

I learned shortly afterward that he had been affected by the wave of cubism, and that he had given up painting the visible to do abstract compositions, of which I saw one (at Miss K. S. Dreier's) that seemed to be related to the canvases of Fernand Léger.

I did not see Bruce again, at his home on rue de Furstenberg, until after the war, in 1919—always with Harrison Reeves.

He invited us to lunch. His food was remarkably [prescribed] pure [and excellent]—he saw to it himself, and had gone to the Halles with his cook to examine what had arrived. His generous and discreet manner of entertaining was in the best Scottish tradition.

He was beginning to collect Negro statuettes and instruments, including surprising stone pestles, for [of] women's hands, that were directly erotic.

* Roy Bruce was born in 1907, and would have been 9 years old in 1916.
† Brackets indicate that the word or words within them were crossed out in ink in the original typed manuscript.

I developed the habit of staying alone with him for an hour or two after Reeves had left.

Conversation between us was difficult and laconic, with leaden words. [We were both sensitive, *but reserved*, and hid it.]

The silences were the best part of it.

Impassively, he showed me objects that were more and more beautiful as the years passed, and we looked at them at leisure. And certain points that were obscure to me he explained patiently and in depth.— [The habit formed of my] I formed the habit of going to see him at least twice a year for an entire afternoon.

[We sometimes liked the same objects and we handled them with respect, like children touching new and mysterious things.]—He knew how to be silent and contemplative [and then time no longer counted for him.]

During all those years, from 1920 to 1930, he continued to paint.— Painting was the passion of his life, and I only became aware of this little by little. It was both his sorrow and his joy. It overwhelmed him. He wanted to escape it. Several times he announced emphatically that he gave it up. He returned to it after a few months.

Little by little, with [considerable] grumbling and modesty on his part and great reserve on mine, we reached the point where we looked at his paintings even more than the new acquisitions in his collection.

He was struggling to "construct paintings, supported mainly by the four edges of the canvas, having a structural quality, the absence of which, in all existing painting, made him suffer, [him personally, rightly or wrongly]."

For several years he exhibited in the Indèpendants. He stopped because no one realized the problem he was posing for himself, and because the enormous, and for him, profound work that he was accomplishing had been considered no more than nicely colored decorated surfaces.

He stopped [exhibiting and] even showing his canvases—a great number of which he destroyed—and he kept for himself alone [his folly, and] "his vice," as he said one day, to which he dedicated his time and effort, and which made him discontent with himself.

Little by little, over the years, I was won over by his silent search and by his calm [and relentless] perseverance—and I sensed that the essential quality for which he was searching was painted on his canvases.

I hardly told him this, for he did not like to talk about "it." He

was angry with himself and with his painting, and with me because he showed it to me.

He was the most discouraging man of whom an amateur, a critic, or an art dealer can dream: particularly during the last years, he bristled in the face of his paintings. Always correct, he was the opposite of pleasant: and whatever one said to him about his paintings, whether good or bad, he found in the depths of himself that it was superficial and intolerable.

And indeed it was, for him, for it touched his nerve-center, something that was [forming] developing within him—he did not yet know exactly what, [and it was with (remorse)* regret that he revealed his search to anyone.]

[As for me,] I remained in complete peace before his works.

[At my side, he looked at them (severely, but) before long was calmed by them, recaptured by them, forgetting himself in them.]

One day I dared to ask him if he would lend me a painting to hang in my study, to "live with" for awhile.

He hesitated and did not respond.—Two months later he brought it to me. Without having the air of doing so, he made inquiries *about my habits*, like a father taking his son to boarding school for the first time.

He accepted, then approved, the frame that I had had made.

I kept this painting for several months.

One day he came to my home unexpectedly (he came there only three times in all) and he found it alone in the middle of a large wall.

He looked at it long and hard.

I saw him for the last time in 1932.—His painting seemed to me [richer,] more complete and more harmonious than ever before. This time I told him so.

He repeated that he was going to stop painting.

I traveled.

One year later, on July 3, 1933, I received a letter from him saying:

"For health reasons I am going to live in Versailles.

" I have destroyed all of my paintings except [twenty-one] a few, *fifteen or so*, and I want to be rid of these before July 15.

*Parentheses within brackets indicate that in the original manuscript the words within them were crossed out separately from the other words within the brackets.

"I am asking you to let me know immediately if you want to accept them."

He sent them to me the next day in a small wheel-barrow.

On July 30 he wrote me:

"I am happy that you have my paintings and that you like them.

"You are the only person in the world who likes them.

"I am leaving on a trip. I will contact you when I return [and would be happy to receive you.]"

Some time passed which had never had importance between us. Twice we were not free at the same time.

In the spring of 1937, I learned incidentally of his death which had occurred several months before, *on 12 Nov. 1936.*

He had told me several times that he had an incurable stomach disease.

Every so often I showed his few surviving [canvases] works to a painter or to a friend. Each time I find them better. Besides their profound virtue, I find them pleasing and excellent company.

In a room where there were two of the best BRAQUES of 1912 and several small PICASSOS, the BRUCES held their own and had their own significance.

They represent the effort of 15 years of the life of an already mature man who abandoned tangible success and started to paint for himself alone, what he had to express, far from public expectations.

Bruce did not even want to sign his canvases.

One day I asked him why: "A signature adds nothing to a painting." he responded. "And it always makes a spot," he said.

Hard on others, Bruce was extremely hard on himself. He earned his living, aside from his art, buy buying antique furniture in Paris for Americans.

I had believed at first that he was simply a minor cubist painter, one of the good ones among those who followed the large movement created by Picasso and Braque.—It is true that he was awakened by them. But I feel more and more distinctly that he was a different being, 100% non-Latin, with his Nordic problem, primitive and essential, [that in the end he resolved "in the joy" of his last canvases, like the Great Deaf One, in his 9th.] playing with the small geometric forms he created.

His canvases, twelve years before his death, represented ensembles similar to large collapsed beams.

His last works express a [strong] vision, clear and fresh: on a [table]

plane throb several small essential forms [innocent and fertile as new-borns.]

What does it prove that no one understood him during his lifetime? Nothing, except perhaps to his favor, when one considers the history of art.

His isolation, his tempermental modesty, and his exclusiveness formed a brusque combination.

His slowness, perseverance, and unpolished seriousness were, for Paris, unbelievable.

This was certainly sufficient to keep people temporarily away.

Bruce holds a message for American youth: [self-] confidence, continuity, construction, and realization.

Young people borrow his canvases from me to live with for awhile.

[These first notes are written from memory and without documents. The dates are approximate.] I wish that those who knew Bruce and who will read this, in Paris or New York, will publish on their part, and send me, [at this review] their memories of Bruce or some biographical facts.

I do not know of a single photo of him.

Was he pure Scottish? Who were his ancestors?

When did they come to America?—How did he begin to paint?— These are the questions that I did not have the time to ask him.

H.-P. Roché
Paris, March 10, 1938

Translation of Synthesis of Roché Texts I & II *first written March 10, 1938; Text I corrected November 10, 1947; Text II corrected and sent to Katherine S. Dreier, December 21, 1948*

REFERENCE ILLUSTRATIONS
William C. Agee, "The Recovery of a Forgotten Modern Master"
1. Paul Cézanne. *Vase of Flowers*, 1900–03. Oil on canvas, 37⅞ x 32⅜ in. National Gallery of Art, Washington, D.C., gift of Eugene and Agnes E. Meyer.
2. Paul Cézanne. *Bouquet of Peonies in a Green Jar*, c. 1898. Oil on canvas, 22⅝ x 25¾ in. Private collection, Paris.
3. Paul Cézanne. *Foliage*, 1895–1900. Pencil and watercolor, 17⅝ x 22⅜ in. The Museum of Modern Art, New York, Lillie P. Bliss Collection.
4. Paul Cézanne. *Vase of Flowers*, c. 1900. Oil on canvas, 26⅜ x 21⅝ in. © The Barnes Foundation, Merion, Pa.
5. Georges Braque. *Road near L'Estaque*, 1908. Oil on canvas, 23¾ x 19¾ in. The Museum of Modern Art, New York.
6. Juan Gris. *The Chessboard*, 1917. Oil on wood, 28¾ x 39⅜ in. The Museum of Modern Art, New York.
7. Arthur B. Frost, Jr. *Colored Forms*, 1917. From Catalogue of the First Annual Exhibition of The Society of Independent Artists, 1917. Whereabouts unknown, presumed destroyed. Photograph courtesy William C. Agee.
8. James Daugherty. *Simultaneous Contrasts*, 1918. Oil on canvas, 35⅞ x 40½ in. The Museum of Modern Art, gift of Mr. and Mrs. Henry M. Reed.
9. Jay Van Everen. Untitled, c. 1918–20. Oil on canvas, 26 x 39¾ in. The Museum of Fine Arts, Houston.
22. Paul Cézanne. *Apples and Oranges*, 1895–1900. Oil on canvas, 29⅛ x 36⅝ in. Musée du Louvre, Galerie du Jeu de Paume, Paris.
23. Amédée Ozenfant. *The Vases*, 1925. Oil on canvas, 51⅜ x 38⅜ in. The Museum of Modern Art, New York, Lillie P. Bliss Bequest.
24. Le Corbusier. *Still Life*, 1920. Oil on canvas, 31⅞ x 39¼ in. The Museum of Modern Art, New York, van Gogh Purchase Fund.

Barbara Rose, "The Price of Originality"
2. Morgan Russell, *Synchromy in Orange: To Form*, 1913–14. Oil on canvas, 135 x 121½ in. Albright-Knox Art Gallery, Buffalo, New York, gift of Seymour H. Knox.
3. Francis Picabia. *Danses à la source*, 1912. Oil on canvas, 8 ft. 3⅛ in. x 8 ft. 2 in. The Museum of Modern Art, New York, gift of the children of Eugene and Agnes E. Meyer: Elizabeth Lorentz, Eugene Meyer III, Katherine Graham and Ruth M. Epstein.
4. Georges Braque. *Still Life: Flute and Harmonica*, 1911. Oil on canvas, 12½ x 15⅔ in. Philadelphia Museum of Art, Philadelphia, A. E. Gallatin Collection.
6. Francis Picabia. *Star Dancer and her School of Dance*, 1913. Watercolor, 21⅞ x 29⅞ in. The Metropolitan Museum of Art, New York, Alfred Stieglitz Collection.
9. Giorgio de Chirico. *The Evil Genius of a King*, 1914–15. Oil on canvas, 24 x 19¾ in. The Museum of Modern Art, New York.
10. Gino Severini. *The Blue Vase*, 1916. Oil on canvas, 36¼ x 28¾ in. Giorgio Cini Foundation, Venice.
11. Jessica Dismorr. *Abstract Composition*, c. 1914–15. Collection unknown. Courtesy of Barbara Rose.
12. Marcel Duchamp. *Chocolate Grinder* from *The Blind Man*, 1917. Philadelphia Museum of Art, Philadelphia, Louise and Walter Arensberg Collection.
13. Mantegna. *St. Sebastian* (detail), 15th c. Oil on canvas. Musée du Louvre, Paris.
14. Le Corbusier. Plan for the Villa Savoye. Fondation Le Corbusier, Paris.
15. Constantin Brancusi. *View of the Artist's Studio*, 1918. Gouache and pencil, 13 x 16¼ in. The Museum of Modern Art, Joan and Lester Avnet Collection.
17. Constantin Brancusi. *Timidity*, 1917. Stone, 14⅜ x 9⅞ x 8⅝ in. Musée National d'Art Moderne, Centre National d'Art et de Culture Georges Pompidou, Paris.
18. Constantin Brancusi. Photo of artist's studio, c. 1923. Musée National d'Art Moderne, Centre National d'Art et de Culture Georges Pompidou, Paris.
20. Constantin Brancusi. Detail of porch of wooden church, Hobitza, Romania, n.d. Photograph from Sidney Geist Collection.
21. Man Ray. Still from film *Emak Bakia*, 1926. The Museum of Modern Art Film Library, New York.
23. Man Ray. *Chess Set*, 1926. Silver. Los Angeles County Museum of Art, Collection of Mr. and Mrs. William Copley.
24. John Frederick Peto. *Bottle, Candlestick and Oranges*, n.d. Oil on canvas, 21¾ x 27 in. Hirschl and Adler Galleries, New York.
26. Henri Matisse. *The Blue Window*, 1913. Oil on canvas, 51½ x 35⅝ in. The Museum of Modern Art, New York.